KU-007-602

In Memory of
Frank Little and Brian Deneke
and
For all the saints, who from their labors rest

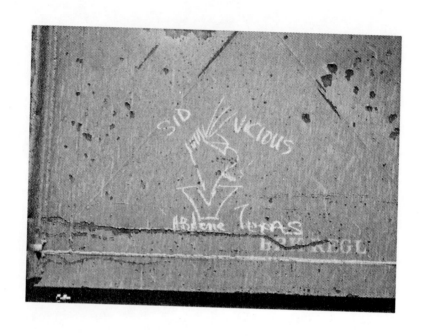

The passion for destruction is a creative passion, too.
—Michael Bakunin

Contents

ACKNOWLEDGMENTS .vi

ONE
A Jagged Line Down the Middle of the Street. 1

TWO
Wild in the Streets. 37

THREE
Taking Back the Streets . 91

FOUR
We Want the Airwaves, Baby . 149

FIVE
The Towering Inferno . 179

SIX
Open City. 221

NOTES . 247

INDEX . 274

Acknowledgments

With each book I write, the list of those to be thanked grows longer; I think that's called community. Members of that community to whom I'm grateful for insights, information, and support include Steve Lyng, Lauraine Leblanc, Marilyn McShane, Trey Williams, Dragan Milovanovic, Stan Cohen, Brian Smith, Deborah Karasov, Michael Welch, David Schlosberg, Mike Presdee, Alex Seago, Karim Murji, Randall Amster, Barb Perry, Barry Smith, David Bradbury, James Davis, Pete Larkin, Kip, Ellie Piper, Mary Jackson, Amy Walker, Stephen Soli, Frank Manson, Matt Pavitch, Kate Desmond, Amy Websdale, Jason Meggs, Caycee Cullen, Richard Edmondson, Stephen Dunifer, and Tracy James. My apologies for offering only a list of names in return for all you've done—and my apologies to those I've inadvertently left off the list.

My thanks also to my editor at Palgrave, Kristi Long, for encouraging a project of this sort and for supporting it as it veered toward one edge and another.

A special thanks to Mark Hamm, Ken Tunnell, and Neil Websdale, co-conspirators in an ongoing attempt to live like it matters.

As always, my thanks to my family—Gil Ferrell, Dorris Ferrell, Joel Ferrell—for an endless gift of personal and intellectual support. To Karen, something more than thanks—since, as she's reminded me more than once, suffering for your writing is one thing, seducing others into that suffering quite another.

And, to every anarchist, punk, and wanderer out there: Keep tearing down those streets.

Small sections of chapters one and two previously appeared, in different form, in Jeff Ferrell, "Remapping the City: Public Identity, Cultural Space, and Social Justice," *Contemporary Justice Review* 4, no. 2 (2001), © OPA (Overseas Publishers Association) N.V. and are used here with permission from Taylor & Francis Ltd. A small section of chapter three previously appeared, in different form, in Jeff Ferrell, "The Velorution," *Alternatives Journal* 26, no. 4 (Fall 2000), and is used here by permission. A small section of chapter four previously appeared, in different form, in Jeff Ferrell, "Free Radio," *Alternatives Journal* 27, no. 2 (Spring 2001), and is used here by permission.

A Jagged Line Down the Middle of the Street

Something's gone wrong. Something has shifted away, away from what it means to live our lives together in public, away from a sense of the city as an open, inclusive community.

I suppose I first noticed it during my time in the Denver hip hop graffiti underground, a subterranean world of street artists, back-alley muralists, and other seekers of alternative style. Certainly those years during the 1990s were defined by the late-night mural painting, by the camaraderie and creative interplay with other underground artists and graffiti "writers," by the illicit community of which we were all a part. But what suggested that it was all going wrong was something else: the hysterical antigraffiti hyperbole in the local papers, the aggressive antigraffiti policing, the enforcement of ever-harsher laws designed to erase graffiti and graffiti writers from public view. And when I was busted for painting a mural behind an about-to-be-redeveloped old building—arrested, tried, and sentenced for "destruction of private property"—I took care to notice some details that confirmed my concerns. The two arresting officers found time for a surly lecture on my gross immorality, and then wrote a special

"graffiti vandalism" notation on my summons and complaint. Later, in court, the harsh condemnations offered by the prosecutor and the judge indicated that they had indeed spotted that special notation and that, like the street cops, they were certain that my crime was a very serious one indeed.

I caught a sense of this same shift some years later, while playing street corner music in the time-honored tradition of the street entertainer, or "busker." I've been playing music on the streets for twenty years or so, always digging the informal freedom and the fluid, interpersonal give-and-take that such playing affords. Now, though, as I joined another street musician and set up to play in a new city, I realized that street playing had changed. My friend had something more than the usual pocket change and dollar bills in his open fiddle case; he had a city-issued permit, a permit he earned by asking permission, by plowing through countless city-provided forms, a permit designating time, space, even legal liability. Worse, I soon discovered, this wasn't just some local regulatory quirk, but part of a larger trend; other cities as well were now burdening buskers with registration fees, "entertainment guidelines," and spot inspections. Robert Bradley, a blind busker who's been at it thirty years to my twenty, has noticed it, too. "These cities these days is making up all these rules and regulations," he says. "Pretty soon you won't be able to sit on the street nowhere in America, and it's really sad. America is not as free as it used to be."[1]

Pretty soon you may not be able to ride a bicycle on the street nowhere in America, either. I've been bicycling longer than I've been busking, increasingly relying on the old bikes I've owned over the years to serve as essential forms of transportation and entertainment. But as bicycling has become more important in my navigation of public space, bicycling has also become more dangerous. It's not just that drivers these days are locked inside bigger and bigger SUVs, with windows tinted ever-darker against the world outside; it's that their anger at anyone who slows their impatient progress, their fear of those who occupy that open world outside, has over the years blossomed bigger and darker, too. And of course automotive transportation, and the anger, fear, and impatience it spawns, over time become self-fulfilling negations of public community as those closed up inside automobiles fear streets made unsafe mostly by

their own presence, and perceive others only as impediments to their individual progress.

If the SUVs and their isolated speed-junkie drivers don't knock you off your bike, by the way, the police will. When some friends and I were busted a while back for bicycling in such a way as to "impede traffic"—meaning, of course, automotive traffic—I sensed again that same shift away from the city as an open community of difference. I was a thousand miles and eight years away from the graffiti bust, but damned if these weren't the same cops, with the same mean-spirited condescension, same righteous anger, same sense that those they had apprehended had committed a very serious offense against the city's flow of public decency and public order.

As may already be obvious, I live as much of my life as possible on the streets, wrapped in the everyday rhythms of the city's public spaces. And hanging out there, spraying graffiti or playing music or doing criminological field research, talking with other outsiders who inhabit the urban streets and sidewalks, my sense of something gone wrong has grown well beyond my own problems with various urban authorities. As the following chapters show, the many denizens of the city's public spaces—young gutter punks and old hobos, skaters and skate punks, buskers, bicyclists, daredevil BASE jumpers, microradio operators—all sense the shift, feel the changing rhythm, understand the ways in which their lives are more and more regulated, their activities outlawed, their living spaces closed down. So, yeah, something has gone wrong, and is still going wrong. Something's happening here in the streets of America and beyond, and while what it is may not be exactly clear, it is clear that it involves contested practices of public life and urban community.

THE MELTING POT IS OVER

You don't have to be a street person, though, or even a discontented troublemaker like I am, to notice what's happening. Hell, Doc Wussow stands about as far as anyone from either of those two identities, and I know he's noticed. Back in 1996 Doc, an aging military veteran, put up a flagpole in his yard so he could fly the U.S. flag. He didn't plan to fly just any U.S. flag; he wanted to fly the flag

that had draped the coffin of his brother, shot down during a bombing run over Germany in 1943. In response, the homeowners' association in his Scottsdale, Arizona, "planned community" informed Doc that his flagpole's public presence violated the community's "covenants, conditions, and restrictions," and ordered the flagpole and flag removed. Doc refused, and by 1997 the homeowners' association— an association that "regulates the look of all of its homes, including flower pots and house colors"—had filed suit against him. A couple of years later, his health and his house lost to the battle, Doc gave up and moved to Colorado—where, at last report, he was flying his brother's flag atop a nice twenty-foot flagpole.[2]

It's a long way from Doc's carefully planned community to the mean streets of Chicago, Los Angeles, and Phoenix—but those who occupy such streets, and those who police them, have noticed some similar developments. In Chicago, tens of thousands were arrested under a 1992 ordinance that allowed police to apprehend any "suspected" gang member who failed to disperse when found "loitering in any public place ... with no apparent purpose," until the ordinance was struck down by the U.S. Supreme Court in 1999—though the justices emphasized that "with a little tinkering, gang loitering could be attacked legally."[3] In California and other states, authorities likewise employ civil injunctions to expunge the public presence, the undesirable street image, of those identified (often erroneously) as gang members. These injunctions prohibit such public activities as climbing fences, carrying glass bottles, standing near beer cans, and "standing, sitting, walking, driving, gathering, or appearing anywhere in public view with any other defendant or gang member."[4] In upholding the use of such civil injunctions, California Supreme Court Justice Janice Rogers Brown argued in a 1997 majority opinion that, after all, "liberty unrestrained is an invitation to anarchy." But Manuel Padilla, the father of a boy targeted by a proposed civil gang injunction in Phoenix, Arizona, offered a different opinion. Tying the injunction sought against his son and others to the increasing gentrification of their traditionally minority neighborhood, the economic redevelopment of nearby downtown Phoenix, and the recent building of the adjacent Bank One Ballpark complex, Padilla saw the injunction for what it was: one more legal lever for prying up the old foundations of his community. "Since the stadium went up, they have been harassing

the neighborhood more," he pointed out. "They are trying to make us a parking lot."[5]

They're not only trying to make the neighborhood into a parking lot; they're trying to make the parking lot, the ballpark, the downtown, into a fortress. While some police officers are sent out to enforce civil gang injunctions, to orchestrate gang roundups, and to institute street curfews, others attend seminars on "Crime Prevention through Environmental Design." Increasingly popular, such seminars teach the "main idea . . . that the proper design and effective use of the physical environment can produce behavioral effects, which can reduce the incidence and fear of crime, thereby improving the quality of life." Promoting strategies such as "natural access control," "natural surveillance," and "territorial reinforcement"—all founded on a proprietary "definition of space"—this environmental design approach quite literally builds policing and social control into public space, and in so doing reconstructs it as significantly less open, less public, and less inclusive.[6]

Critical to this exclusionary model of public life is control of the social and spatial dynamics—the diverse, community-level interactions—that once enlivened it. In order to reduce the potential for social problems, for public crimes such as "people . . . lingering after trains have departed" and "street corner loiterers," environmental design advocates recommend that city authorities and local police "provide clear border definition of controlled space" and "redesign or revamp space to increase the perception or reality of natural surveillance," so as to return control and "proprietorship" to "the normal residents of a neighborhood." Decorative wrought iron pickets atop walls, park benches interrupted by armrests so as to disincline those needing to recline, street surveillance cameras—all help institute this Orwellian project of enforced normalcy. As one report on public video surveillance enthuses, "Big Brother *Is* Watching."[7] In their effort to construct a less-public world of "barriers, both real and symbolic," designers and developers even press the natural environment into prickly service. Going about the process of rooting social control in public "barrier planting," they select from a helpful list of officially approved, socially hostile landscape plants:

White Thorn Acacia	Shrub/tree, thorny
Agave	Succulent, thorny . . . many varieties 1' to 6'

Bougainvillea	Shrub/vine, thorny . . . vines tall growing
Hawthorn	Tree, thorny . . . 15' to 30'
Barrel Cactus	Cactus, thorny . . . 2' to 10'
Holly	Shrub/tree, toothed leaves
Spanish Bayonet	Shrub, sharp leaf ends[8]

Of course, if thorny trees and civil injunctions aren't sufficient for shutting down the possibilities of public space, for improving the "quality of life" of "normal residents," there's always the awful sameness of the theme park. Back in 1976, in the embryonic days of punk culture and punk outrage, the editors of *Punk* magazine set punk's street-tough tone in the magazine's first issue, advising those stuck in the middle of the road, "Kill yourself. Jump off a fuckin' cliff. Drive nails into your head. Become a robot and join the staff at Disneyland."[9] Little did they know that, a quarter century later, the staff at Disneyland would come find them in the street. Certainly Disney Corporation's theme parks have long created a sanitized universe of soft control, a world where "culture is construed as spirit, colonialism and entrepreneurial violence as exotic zaniness"—and community as a consumable, prepackaged, feel-good commodity.[10] Now, Disney is taking that world of fake plastic fun to the streets. Disney's design strategies have driven urban gentrification projects in Boston and San Francisco, and Disney has recently completed the renovation of New York City's 42nd Street and Times Square district.

Revealingly, Disney's New York City project benefited from the enthusiastic support of Republican mayor Rudolph Giuliani, who, the business press reports, has in general "tried cultivating a Disney-like atmosphere" in the city through a legal clampdown on public "quality of life" crimes like graffiti writing, panhandling, and the washing of car windshields by the homeless. In this context Giuliani spokesperson Deidre Picou gushes that "Disney is great for New York. This will change the character of the city."[11] Street artists in and around Times Square are well aware of this changing public character, but disagreeing with Deidre on the value of such change, they urge passersby to Just Say No to Disney. Novelist and critic Samuel R. Delany has noticed the sanitization, too. Witnessing the 42nd Street peep shows and gay movie houses he once frequented give way to tourist shops and corporate theme cafes, seeing places

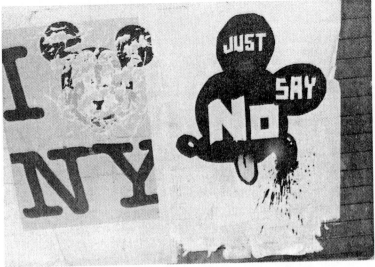

Figure 1.1: Anti-Disney street art, New York City.
Photo by Ellie Piper.

of vibrant marginality and illicit public contact overrun by the homogenized safety and middle-class consumerism of Disney's Times Square, Delany argues that the city has engaged in more than just "a violent reconfiguration of its own landscape." Disney and Giuliani have also undertaken "a legal and moral revamping," Delany writes, and have promoted the public extermination of "a complex of social practices . . . out of an ever inflating fear of the alliance between pleasure and chaos."[12]

If the edgy public confluence of pleasure and chaos has been expunged from 42nd Street, it's been designed right out of existence in Celebration, Disney's 20,000-resident "planned community" near Orlando, Florida. Explaining Celebration's genesis, town manager Brent Herrington points out that "Americans have a great longing for community"; Disney chief executive Michael Eisner agrees, describing Celebration as "a system of how to build communities." More to the point, a builder of competing upscale planned communities in Florida admits that "these days many people want to live like they are in Disney World year around."[13] So, responding to this desire for affluent Fantasyland community, Disney constructed Celebration as

"another theme park, this one reminiscent of another time when life was simpler," as what writer Tom Vanderbilt calls a "'community' for sale, a carefully marketed, private version of the small-town values the Republicans claim to represent."[14] As such, Celebration features nostalgic neotraditional architecture, strictly enforced public design standards, daily flag-raising ceremonies by the town's children—and, by intention, no housing inside the city limits affordable to young, minimum wage workers. Celebrating sameness, Disney has managed to construct the town's public image as a sort of reactionary ideology. But all is not perfect in Fantasyland; carrying on Doc Wussow's fight, a resident was recently reported to be pestering town officials for permission to put up his own flagpole. If I might offer a suggestion: Perhaps a perimeter of Spanish Bayonet planted around Town Hall, a barrel cactus or two near the entrance, would help keep such obstinate patriotism at bay.[15]

Science fiction writer Ray Bradbury, a writer who once purveyed his own dystopian warnings regarding communities of book-burning uniformity, now serves as an "urban design consultant" who has contributed to the development of Disney's EPCOT Center and to the redevelopment of downtown Los Angeles. In this new role, he imagines towns like Celebration to be positively utopian. Asked to describe "the city of the future," Bradbury answers, "Disneyland! They've done everything right. . . . I've visited Disneyland 30 or 40 times over the years, and there's very little I would change"[16]

But if for Bradbury dystopian conformity has somehow morphed into utopian community, it hasn't for everyone. As the following chapters will show, those fighting to preserve public space and public life allude time and again to Disney and "Disneyfication," both as a powerful metaphor for the insidious sanitization of urban life, and as a political economic reality underwriting the closure of urban space. Those inside the new political economy understand this as well. Yves Sistron, a venture capitalist with Global Retail Partners, proposes that the only Main Street in the future is "going to be Main Street, Disneyland"—and maybe the future is now. In Anaheim, California, a commercial strip described as "a non-admission [fee] area of shops and restaurants" links the Disney Hotel, Disneyland, and Disney's new "California Adventure" theme park. The strip's name: Downtown Disney.[17]

Whether employing Disney as metaphor or developer, more and more urban authorities around the United States embrace this futureworld vision of Main Street as Downtown Disney. Cities increasingly stake their economic vitality, and certainly their public images, on urban redevelopment schemes like Disney's Times Square, schemes built around new downtown sports arenas, easy-access freeway off-ramps, parking garages, pedestrian shopping malls, microbreweries, and other affluent lifestyle accouterments. If, as Marx noted, history arrives the first time as tragedy and the second time as farce, contemporary city planning suggests that urban development and urban identity are forged first out of industry, commerce, and labor, but next from the careful marketing of consumption, symbol, and amusement.[18] In this sense, cities today do indeed take on the character of corporate theme parks, selling idealized images of themselves and cartoonish echoes of their former identities to residents and visitors in the form of converted loft living spaces, corporate retail chains, and gentrified historic districts. These "cultural strategies of economic development," these new "consumption spaces," as Sharon Zukin calls them, undergird urban revitalization schemes in cities across the United States, from Denver's reinvented LoDo to Monterey's repackaged Cannery Row and Akron's retreaded downtown.[19]

Not surprisingly, urban officials present this trendy transmogrification of urban life to the public not only as economic salvation, essential to reviving the fortunes of the urban core, but as social and cultural salvation as well—as a strategy for restoring the sort of "quality of life," urban "community," and urban "civility" imagined by Giuliani and Eisner, and embodied in environmental designs like Celebration. Foci of civic pride and staging areas for corporate-sponsored events, these new consumption spaces are marketed as a Durkheimian social adhesive through which fractured cities, lost communities, can be reassembled. In this way, debates over urban economic and cultural redevelopment regularly evolve into debates over social well-being, social order, and social justice. And, significantly, those who would impede or intrude on this redevelopment of image and economy—homeless gutter punks, graffiti writers, gay men, gang members—regularly find themselves characterized as social misfits, even policed as criminal threats to the common good.

This is precisely what I noticed—that I had become a criminal threat to the new common good, an outsider to a new type of urban "community" defined by corporate control, cultural exclusion, and reactionary nostalgia—when I was busted for writing graffiti inside a downtown area caught up in urban revitalization; discouraged from busking too near official downtown consumption spaces; apprehended for impeding the uptown traffic in SUVs. And just as I have noticed, as Manuel Padilla and Samuel Delany have noticed, so have others. L.A. homeboys, and East L.A. bands like *Los Illegals*, noticed it back in the 1980s, witnessed what Raúl Homero Villa calls their own "topographical evisceration, social death"—and so they wrote about legally bulldozed barrios and the intrusive power of the suit-and-tie "Jack Hammer."[20] Camilo José Vergara noticed it and photographed it, recording in a fourteen-year sequence of images an old apartment building's destruction, disappearance, and decay into a field of discarded urban compost—out of which new, private row houses ultimately arose.[21] Engaged in field research with New York City sidewalk vendors, Mitchell Dunier noticed it, too. He watched the passage of new laws restricting the spaces occupied by sidewalk vendors; he listened to local business advocates describing street vending as "an anti-social act," while at the same time denying that "we are trying to Disneyfy downtown and exert fascistic control over public spaces"; he heard calls of the sort my own busking has incited, radioed in to the local Business Improvement District's security bureau: "Post Six to Base. We have two guitar players in front of FAO Schwarz." "Ten four, got it."[22] The following chapters will show the ways in which many others have noticed it—and lived it as well—while being swept off the city's sidewalks and streets, run down in its shopping mall parking lots, invaded in their illicit broadcast studios and underground printing facilities by authorities determined to protect the new urban order.

To the extent that these economic and legal strategies, these "official projects of order and tidiness,"[23] are successful, they attract growing numbers of middle-class consumers—consumers eager to embrace the sanitized hyperconsumption of revitalized downtown shopping districts as a glossy doppelganger for their own little lives. As we'll see, these projects also attract growing numbers of new, affluent residents to the city's center, wealthy urban "settlers" of

the sort sought by city planners and developers. With these well-heeled newcomers flooding into reconstructed row houses and converted lofts, real estate prices soar, and low-income residents—those not already driven out of the central city by the predevelopmental destruction of low-cost housing and industrial jobs—face even greater economic pressures toward dislocation. But unlike the poor, others among the affluent classes remain outside the central city by choice, removing themselves to places where even the suggestion of street vending and street busking, even the echo of the street's chaotic public pleasures, need not be heard. That is, they move to places like Celebration.

In fact, many millions of Americans now live in gated communities carefully designed to exclude not just graffiti writers and gang members, but outside agitators ranging from nonresident children to federal census takers. With their imposing guardhouses and wrought iron fences, such communities market themselves as culturally secure enclaves, as homogeneous residential spaces "where traditional values still exist." Indeed, one real estate agent reports that "to sell a subdivision featuring custom homes, you need to have a gate." Recalling Delany's critique of the orderly new Times Square, a newspaper reporter investigating such subdivisions likewise notes that "a random encounter is the last thing people here want."[24] Another thirty to forty million Americans now live in upscale communities protected not by gates and walls, but by the sort of homeowners' association codes and covenants that Doc Wussow finally fled—covenants that, in conjunction with local ordinances, ban private flagpoles, porch furniture, wash hung outside to dry, and a host of other American institutions.[25] Locked in this exclusionary blandness, of course, residents on occasion wish to escape to the safe theme park excitement of the redeveloped central city. The most affluent among them increasingly do so by private helicopter, flying high above freeways clogged with too many of their own kind.[26]

Evan McKenzie labels this conscious withdrawal from public life and public space the "secession by the successful,"[27] and, like the notion of Disneyfication, his phrase embodies more than metaphor. From New York's Long Island to California's San Fernando Valley, affluent property owners not content with the cultural cleansing of big city streets, not insulated enough inside the picket-topped walls

and bougainvillea-lined borders of their gated enclaves, push for the legal secession of whole wealthy neighborhoods, entire upscale towns and counties, from the larger public life of which they are a part. And why not? "People of the same age and background feel comfortable living with each other. A walled community is one solution to their needs, and it offers a certain neighborliness," explains Barry Berkus, president of B3 Architects and Planners in Santa Barbara, California. And anyway, he adds, "The melting pot is over."[28]

DYSTOPIAN DREAMIN'

Certainly the careful sanitization of street life, the aggressive regulation of open public interaction, the segregation of living and housing arrangements do indeed suggest that growing numbers of public officials, city developers, and affluent consumers wish to extinguish the daily interplay of diverse identities that creates the communal melting pot of urban life. Systematically denying the city's diverse possibilities, the powerful increasingly work to encode privilege and exclusion in the spaces of everyday life, and to arrange the sort of legal and environmental frameworks that will reserve these spaces for their "normal" occupants. Describing what he calls "the revanchist city," urban geographer Neil Smith details this contemporary trend toward the resegregation of urban life, toward the aggressive reclaiming of old privileges, and adds that this revanchist dynamic is in many ways founded on the "destruction of the public sphere."[29] To the extent that this public sphere is closed—to the extent that public places of unanticipated interaction and chaotic pleasure are destroyed—the melting pot may indeed be on its way to being over.

But as the melting pot ends, more than privilege is restored. New configurations of control emerge—configurations that can in fact be glimpsed by considering again the cases just described. So, two questions: If all the homeless folks and "known" gang members could be rounded up, all the street vendors and street musicians swept off city streets, all the graffiti writers and skate punks erased from public view, what would be accomplished, beyond cleaning up new consumption spaces and making the streets safe for middle-class leisure? If all the environmental design strategies and gated communities could be implemented, all the bougainvillea bushes planted and

surveillance cameras activated, what would be the point, beyond offering affluent residents the warm glow of exclusionary security? Perhaps the point would be a police state. Any efficient police state operates so as to round up and neutralize as many undesirables, outsiders, and subversives as possible and, as importantly, to close down those venues in which such groups might make contact. In essence, a functional police state seeks to shut down the social. In a putatively democratic society, though, this program of public closure can't simply be implemented; it must be marketed as something else. And so, as the melting pot today disintegrates, more and more outsiders are hustled off to jail, more and more undesirables herded out of public contact and public view—and not because they're subversives disloyal to the state, we are told, but only because they have violated the growing complex of controls designed to restore "community," revitalize public "quality of life," and protect the normalcy of the common good.

As these controls proliferate, a complementary dynamic also emerges. All those bougainvillea bush barriers and street surveillance cameras, those thousands of restrictive covenants and civil gang injunctions coalesce into a collective message that transcends the locales in which such phenomena appear. The countless "angry lawns" staked out with stern home security signs across America, the new "architectural Stalinism" and parallel "underproduction of public space" described by Mike Davis[30] begin to encode in us a particular sense of self, community, and society. Melinda Stone, Matthew Coolidge, and others at the Center for Land Use Interpretation have documented the Air Force's Nellis Range in Nevada, and the infamous Area 51 within it, as "the largest—and perhaps the most secretive—restricted area in the United States," a starkly sterile space governed by concealed video surveillance cameras, electronic sensors, and roving security patrols. As such, they argue, the Range constitutes a "landscape of suspicion," a self-fulfilling spatial loop in which those under surveillance are sure to become suspicious of those who suspect them.[31] Yet their description of this deathly, panoptic place would seem to apply as well to the everyday streets, sidewalks, and neighborhoods of contemporary cities—public spaces increasingly constructed, experienced, and understood as landscapes of suspicion and exclusion. In such landscapes, as from inside the tinted windows of

an SUV, occupants know each other primarily as threats, understand each other mostly as objects of mutual distrust and surveillance—and so, with the social shut down, the expansion of control, the presence of a protective police state seems a reasonable and necessary option for ensuring "community." In such landscapes, the aesthetics of exclusion becomes an aesthetics of authority; the policing of public space spawns a parallel policing of perception.[32]

These issues of aesthetics and understanding suggest that emerging configurations of urban control are designed not only to regulate and reclaim public spaces occupied by homeless folks and street musicians, but to regulate the *meaning* of such people and spaces as well. From Disney's Times Square to Dunier's sidewalk vendors, the city's public spaces—parks, streets and street corners, shopping districts, residential enclaves—function not only as utilitarian arrangements, but also as deep repositories of meaning for those who own them, occupy them, move through them. Put simply, public space always becomes *cultural space*,[33] a place of contested perception and negotiated understanding, a place where people of all sorts encode their sense of self, neighborhood, and community. Given this, the occupation of public areas remains as much symbolic as physical, the presence and acceptance of particular populations confirmed as much through shopping carts and sidewalk vendors, or alternatively bougainvillea bushes and "barriers, both real and symbolic," as through simple census counts. And in this sense the various reconfigurations of cultural space already seen reveal more than just the dynamics of contemporary urban redevelopment. They mark the changing boundaries of private property and public propriety, the emerging images of the city and its residents, and the forced remapping of cultural identity and public community.

Because these cultural spaces are meaningful, because they matter so much in the public construction of identity, perception, and community—because they are worth fighting for—they emerge as essential zones of conflict and control. It is not by accident that public officials and corporate developers so often encase cultural space controversies in the language of restored community and reclaimed quality of life, and it is not surprising that many of the harshest new forms of social and legal control are exercised in and around these spaces. For the powerful, more is at stake than gentrified neighbor-

hoods and retail shops. At stake is a dream, a dream of spatial and perceptual control that others of us might consider instead a dystopian nightmare—a potential police state of a particularly damaging sort.

The growth of civil gang injunctions and gated communities, of nostalgic Disneyfication schemes and aggressive environmental design, all suggest a dream of sanitized communities rebuilt in the image of consensual cooperation, faux monuments to a past that never was. They embody a vision of streets swept free of marginalized populations, cleared of human trash and the uncomfortable reminders of social decay they present—an urban environment made safe for endless, effortless consumption, for the discovery of plastic-wrapped urban charm and prepackaged urban adventure. They portend spasms of urban development and white-bread gentrification unimpeded by the ugly realities of street survival; a ghettoization of social and cultural life such that the young, the disobedient, and the down-and-out remain sequestered within ghost towns of physical and cultural isolation. Ultimately, they imagine a silencing of unregulated street rhythms, a certain conformity enforced through image and appearance, a reconfiguration of cultural spaces left vacant of all but prescribed sounds, commercial images, and sanitary, top-down "communities."

In the following chapters, city officials, legal authorities, and corporate developers will in fact describe this dream—*their* dream—for us. They'll talk not just about the "quality of life" crimes they despise and the visions of exclusionary community they embrace, but about the strategies they've designed to "force homeless people out of sight," since the problem of homelessness is really only one of "perception," an "image issue for the city." They'll argue that street kids and gutter punks should be removed from public spaces, since they're not "what we're inviting our tourists to see," and since after all such kids are not "the target market" for high-end retailers, what with their poverty, their "public sexual activity . . . defecation and urination," their "body piercings, tattoos, and . . . body odor." Urban officials and developers will worry over maintaining the affluent order of their "well-groomed" communities in the face of such "human carnage." And more than once they will echo Justice Brown's opinion on civil gang injunctions, agreeing with her that "liberty unrestrained is an invitation to anarchy" as they talk among themselves about the

dangers of disorder, and work among themselves to eliminate liberty, to expunge Delany's dangerous alliance of pleasure and chaos, from the cultural spaces of public life.

In "The Work of Art in the Age of Mechanical Reproduction," Walter Benjamin explored the ways in which emerging techniques of mass reproduction altered the meaning and practice of art.[34] Exploring contemporary assaults on public life and public space, we likewise begin to glimpse the ways in which the work of social control takes shape in an age of cultural reproduction. As those in authority increasingly construct the meaning of crime and marginality through sophisticated public relations campaigns, as late capitalist systems move toward marketing lifestyles and conspicuous lifestyle consumption as part of an emerging "symbolic economy,"[35] as systems of state authority perpetuate themselves through the construction and manipulation of understanding, social control more and more takes on the dimensions of a cultural process. Under such systems, controlling marginalized groups and others' perceptions of them, policing the crisis of injustice and inequality as it plays out in the city's public spaces necessitates cultural work; that is, it requires clearing public spaces of undesirable individuals, of course, but as importantly cleansing such spaces of the sorts of undesirable understandings, the cultural uneasiness, that might inhibit development, consumption, and ongoing control.[36]

So, as it turns out, it's not that far from the harsh controls of civil gang injunctions and the enforced indignities of my back-alley graffiti bust to the flagpole privacy of gated communities. All are founded on the same aesthetics of authority, on a sense of ordered style that undergirds the control of cultural space. In the same way that this aesthetic drives the powerful and the privileged to wrest perceptual control of the city from homeless folks and street kids, it drives them to design suburban enclaves and shopping districts with barriers as much stylistic as physical. In each case, those in power work to remake the meaning of cultural space and community, to substitute symbols of safe homogeneity for those of diversity and sensual disorder. And in each case, the powerful enforce a politics and economy of reaction—an illusory return to traditional values, homogenous community, and elevated quality of life—through an aesthetics of authority, an aesthetic that seeks to remove from public view the untidy cultures of undesirable and unmarketable populations.

The police state implied in all of this might be described, with a certain degree of irony, as postmodern—that is, a police state designed to dominate a world of image, meaning, and perception as much as it is meant to apprehend individuals and "disappear" marginal populations. And the dystopian dream? It's certainly one of control, but of a particular sort: the regulation of public interaction, the restoration of exclusionary community, the reencoding of cultural space along lines of order and privilege. Perhaps most important, it's a dream that today is coming true in the spaces of urban life, in the streets of the city.

THROUGH THE PAST, DARKLY

The contemporary constriction of public space within new configurations of power and privilege points to emerging forms of control, and to growing uncertainty as to the very viability of public life. Yet these new forms of spatial control recall historical patterns of conflict and injustice as much as they invent new ones. Certainly the turn of the twenty-first century is not the first period in which mean streets have emerged, public spaces have been contested and closed, new forms of spatial policing have been promoted. In fact, as we will see, past battles over the physical and symbolic control of public space have provided not only the historical antecedents to present conflicts, but political paradigms utilized by those resisting such control today. In discussing "space, power, and knowledge," Michel Foucault has noted the "widespread and facile tendency, which one should combat, to designate that which has just occurred as the primary enemy, as if this were always the principal form of oppression from which one had to liberate oneself."[37] Even a brief, sporadic stumble backward through the past can help avoid this enshrinement of "that which has just occurred" and is now occurring as an immediacy that somehow stands outside time and place.

In 1970, for example, James P. Spradley began his gritty ethnographic account of urban nomads in a key of ascending spatial tragedy. "The American city is convulsed in pain," he wrote. "It is in the streets and alleys, fills the air, crowds into our living rooms. People suffer from hunger, death, loneliness, inequality. . . . The American city is being rent asunder."[38] Around this same time British research-

ers like Colin Ward and Stanley Cohen began to explore the politics of public property destruction. Cohen noted the aesthetic component inherent in contemporary and historical vandalism—the sense of destroying public structures conventionally revered for their beauty—and in addition proposed that much public vandalism in fact operates as "ideological vandalism," destruction designed to "challenge symbolically" the everyday organization of the social world.[39] In his edited book on vandalism, Ward included chapters on vandalism prevention through environmental and architectural design. Anticipating spatial control features that would be taught at police seminars thirty years later, the chapters discouraged "open spaces too large," and recommended "roses or other prickly bushes used for planting" along with "species of berberis, acacia, mahonia and holly . . . prickly enough to protect other planting behind." And for his photographic frontispiece Ward chose an instructive contemporary image, an image whose antisocial lessons will be learned again in this book's fifth chapter: St. Louis's notoriously prisonesque Pruitt-Igoe Public Housing Project, its rows of blankly repetitive windows randomly busted out.[40]

In 1938, Lewis Mumford had already written of a larger project likewise designed to embed social atomization and social control in the publicly built environment. Under the heading "A Brief Outline of Hell," Mumford described a growing "architecture of imperialism . . . a monotonous reflection of the military-bureaucratic mind" that "presents an outward front of power: power as expressed in wide avenues, endless vistas of useless columns, and huge stadiums." This sort of architecture, this "metropolitan regime," Mumford argued, destroys the "many-threaded and variegated cultural pattern" of urban life; it is designed to "regiment, limit, and constrict every exhibition of real life and culture." As a result, Mumford wrote bluntly, it is "deeply antagonistic to every valuable manifestation of life."[41]

A few years later, Walter Firey proposed not only this sort of critical sociology of the city, but a radical reworking of urban ecology itself. Noting that ecological theory had until that time only accounted for economic dynamics, Firey argued for an "alteration" in this theory—an alteration that anticipated the notion of cultural space, and today's conflicts over its meaning and control, by half a century. "This alteration," Firey wrote, "would consist, first, of ascribing to space . . .

an additional property, viz., that of being at times a symbol for certain cultural values that have been associated with a certain spatial area. Second, it would involve a recognition that locational activities are not only economizing agents but may also bear sentiments which can significantly influence the locational process." Through this alteration, Firey added, we can account for "the valuative, meaningful aspects of spatial adaptation."[42]

Long before this, Friedrich Engels had also noticed the interplay of economy and meaning in spatial adaptation. Writing in the 1870s, he blended the old economic ecology with a cultural critique that anticipated Firey's. "The bourgeoisie has only one method of settling the housing question," he argued. "The breeding places of disease, the infamous holes and cellars in which the capitalist mode of production confines our workers night after night are not abolished; they are merely *shifted elsewhere*."[43] And of course, in searching for those who have been herded out of public space and public view, who have similarly been shifted elsewhere, we can stumble back farther still. Tracing the first English vagrancy statute to 1349, and its precursors to the century prior, William Chambliss has documented the long historical expansion of vagrancy laws, such that by the 1700s the laws had been broadened to include "all persons wandering abroad, and lodging in alehouses, barns, outhouses, or in the open air, not giving good account of themselves." And with the importation of these laws to the United States, we stumble full circle back to the present; as Chambliss argues, such laws soon came to function in the U.S. "principally as a mechanism for 'clearing the streets' of the derelicts . . . in our large urban areas."[44]

This little side trip through the past can provide at least some historical perspective on the contemporary control of public space and urban community. But a second, parallel history offers a deeper focus for making sense of contemporary spatial conflicts. This is the history of *resistance* to emerging spatial controls—the history of those who have long fought the regulation and closure of public space; who've time and again countered new forms of spatial exclusion with the inclusive politics of liberty, diversity, disorder; who've battled to create communities of difference and inclusion. This history isn't an easy one to tell; it remains fractured and unfinished, a secret history written more in traces of defiance than in the broad sweep of the

official past.[45] Like those little high-mountain streams I hiked during my days in the Denver graffiti scene, it runs aboveground for a while, then disappears below—but always continues its work of eroding all that is solid, undermining all that is certain. As such, it cuts a jagged historical gash through official projects of spatial order, time and again bubbling up to bust open public spaces that have been closed, to subvert projects of spatial regulation and control.

This history, this jagged line, is the history of anarchism. In confronting authority in all of its manifestations, anarchists have for centuries fought not just the attempts by outside authorities to control shared public space, but also the insidious encoding of authoritarian arrangements in public life itself. In embracing instead autonomy, spontaneity, and playful uncertainty, anarchists have long sought to unleash these unregulated dynamics in the spaces of everyday life, and to build emergent communities out of their confluence. Cutting through the past in this way, unraveling historical configurations of spatial control, this jagged anarchist line runs right into the present as well. As the following chapters show, anarchists of all types today take to the streets in confrontation with contemporary projects of spatial control and exclusion. Some of these anarchist street fighters coalesce into small, ephemeral groups; others work to "dis-organize" larger assaults on the new spatial order. Some quite consciously base their actions on anarchist principles and theories; others invent their anarchy more out of their own direct actions and experiences. Almost all know the history of anarchist resistance, and proudly claim practical or spiritual affiliation with anarchists and anarchist groups of the past. Because of this, a short stumble through the history of anarchist spatial resistance, a hopscotch tour back along that jagged line, can provide not only a bit of perspective on contemporary conflicts; it can provide a sort of guidebook to the anarchist actions and orientations that will surface repeatedly in the following chapters.

Coming and going as it does, that jagged line doesn't offer a clean beginning—but 1871 will do. In that year the citizens of Paris launched the largest urban insurrection of the time, igniting what Stewart Edwards calls an "unplanned, unguided, formless revolution" against France's National Government.[46] Dismissing the centralized, static authority (and monarchist leanings) of the National Government, the people of Paris fought to create an emergent social

and cultural community as fluid as it was inclusive, to create what came to be called the Paris Commune. In a "Declaration to the French People," the Commune proclaimed its intention to "universalize power and property according to the necessities of the moment," and defined itself in terms of "the permanent intervention of the citizens in Communal affairs by the free manifestation of their ideas," the "voluntary association of all local initiatives, the free and spontaneous co-operation of all individual energies."[47] Even Karl Marx—like Engels, no friend of anarchy and anarchists—acknowledged at the time that "the Commune did not pretend to infallibility, the invariable attributes of all governments of the old stamp. It published its doings and sayings, it initiated the public into all its shortcomings."[48]

Significantly, the Commune revolted as much against spatial authority as political authority, and as part of this revolt, the Commune invented a new sort of politics by reclaiming and reinventing the public spaces of Paris. In the years before the Commune, Baron Haussmann, Napoleon's prefect of police, had reapportioned Paris through an extensive urban development scheme that had forced working families, the poor, and *la boheme* out of Paris's central districts. Yet, as Firey's analysis would suggest, these marginalized groups maintained a passionate sense of place, a fierce allegiance to their old communities, and so they barricaded their streets with paving stones and broken bottles and fought to reclaim them as part of the revolution. Others in the Commune likewise reinvented the politics of Paris's public places, rewriting the past and the future by rewiring the cultural spaces of the city. To symbolize their disgust with new, "speedier" governmental guillotines, and their more general opposition to the death penalty, Communards dragged these "servile instruments of monarchist domination" out into the street and burned them in public rituals of "purification" and "consecration."[49] They undertook, but didn't ultimately accomplish, the razing of chapels earlier erected as public memorials to generals and kings. Most spectacularly, they succeeded in destroying the Vendôme Column. Paris's most prominent public symbol of Napoleonic empire, the column was pulled down for the pleasure of a huge crowd gathered around it, and to the accompaniment of band music. "The excitement was so intense," said one report at the time, "that people moved about as if in a dream."[50]

LIVERPOOL JOHN MOORES UNIVERSITY
LEARNING SERVICES

Even after the Commune was suppressed by the military of the National Government, this war of cultural space continued. Anticipating Disney's neoreactionary Celebration architecture, the National Government reerected the Vendôme Column in precise replica so as to erase the Commune's act of destructive accomplishment, and by extension the Commune itself, from public memory and public view. In response, ex-Communards organized a demonstration of 25,000 at the Wall of Père-Lachaise cemetery, the scene of the Commune's final resistance. Before that final, failed resistance, though, the Paris Commune accomplished something beyond its seventy-two days of political and spatial insurrection: it coalesced into an impossible moment of riotous public celebration, a historical moment that anarchists and others still call the *"festival of the oppressed."*[51]

It wasn't just the public celebrations of destruction that defined the revolt as festival; there were also countless concerts, public ceremonies, episodes of general merriment and pleasure in the streets. "Would you believe it? Paris is fighting and singing," reported the poet Villiers de l'Isle-Adam. "Paris does not only have soldiers, she has singers too. She has both cannons and violins. . . . Paris is the city of heroism and laughter." Louis Barrón found himself caught up in the same spirit of revolutionary festival: "Eating and drinking their fill, making love, the Parisians . . . have no energy left to imagine, even vaguely, the horrific consequences of defeat."[52] And this spirit endured even as the Communards faced those horrific consequences; on the day National Government forces reentered Paris, many Communards were fighting them in the streets—but many others were partying at ground zero, attending a public concert where they reveled in *La Canaille* (*The Rabble*) and its defiant refrain:

> They're the Rabble!
> Well—I'm one of them![53]

Casting their revolution as a festival of the oppressed, a carnival of insurrectionary pleasure, a community of subverted meaning, the Communards embraced the essential disorder of urban life, and celebrated their own disreputable marginality just as Jean Genet and other French subversives of a different sort would do years later.[54]

As subsequent chapters reveal, this precise sense of festive subversion pervades contemporary battles to revitalize public spaces and restore communities rendered sterile by those who control them. But others before now have figured out the festival of the oppressed, too. Hell-raiser of the first order, feminist and free love advocate Emma Goldman was born in Russia two years prior to the Commune's birth in Paris. Immigrating to the United States at age seventeen, she spent the following decades crisscrossing the country as an agitator for anarchist causes. Like the Communards of Paris, Goldman fought not to replace one form of order and authority with another, but to create conditions of disorder out of which unforeseen alternatives might emerge. "Anarchism is not . . . a theory of the future," she said. "It is a living force in the affairs of our life, constantly creating new conditions . . . the spirit of revolt, in whatever form, against everything that hinders human growth."[55] As Goldman understood, a revolution that reproduces existing arrangements of authority in its execution, that draws on strategies of drudgery and domination, that offers up a new boss the same as the old boss, is no revolution at all. The festival of the oppressed, of course, confronts this contradiction directly, intertwining singers with fighters, weaving playful disregard into the serious politics of revolution, inventing an inclusive, communal alternative to authority out of the revolt against it. Or, as Goldman said famously, "If I can't dance, it's not my revolution."

The Wobblies had this figured out as well. The Industrial Workers of the World—popularly known as the IWW or the Wobblies—was a defiantly anarchistic union that fought, and against all odds won, labor battles across the United States in the first two decades of the twentieth century. Organizing migratory farm workers in the West, taking on the lumber trust in the South, leading massive strikes against the textile owners in eastern cities like Lawrence and Paterson, the Wobblies enacted the festival of the oppressed, gladly incorporating into their union those on society's margins—ethnic minorities, women, itinerant and low-wage workers—when no one else dared do so. Their inclusive festival of the oppressed, though, ran not just on the diversity of its participants, but on the ongoing anarchist affirmation of Villiers de l'Isle-Adam's "fighting and singing." Carrying with them their "Little Red Songbooks," the Wobblies

sang in the streets, sang in the union halls, sang as they organized job actions inside factories, sang from inside their jail cells.

Their self-written songs, their self-produced newspapers and circulars would in time become the model for the sort of do-it-yourself media essential to today's anarchist battles over public space. For the Wobblies, though, their newspapers, songs, poems, and jokes served more immediate purposes, inviting workers to join the fight, rousing those already in it, disseminating strike information, parrying and parodying the bosses' propaganda, even offering encoded encouragement for sabotage against the bosses' machinery.[56] Their songs captured their defiance, their dark humor—and their critique of spatial control and exclusionary community. Dating from around 1907, "My Wandering Boy" not only presented the pervasive phenomenon of "hard traveling" the country in search of work, but anticipated Chambliss's understanding of vagrancy law ("the vag") and its sanitizing functions:

Where is my wandering boy tonight,
The boy of his mother's pride?
He's counting the ties with his bed on his back,
Or else he's bumming a ride. . . .

His heart may be pure as the morning dew,
But his clothes are a sight to see.
He's pulled for a vag, his excuse won't do.
"Thirty days," says the judge, you see.[57]

Even more to the point, "Everywhere You Go" recorded the inhospitable conditions in cities across the United States, and ended with a keen sense of closed-down public space:

In the face of all such rumors,
It seems not far wrong to say
That no matter where you're going,
You had better stay away.[58]

Of all the cities from which it would have been better to stay away, those in which the Wobblies undertook "free speech fights" proved

"MOVE ON" FOR SPEAKERS, LATER WILL INCLUDE PICKETS

Figure 1.2: Wobbly commentary on the San Diego, California,
free speech fight, published in the Wobbly newspaper
the *Industrial Worker*, May 9, 1912.

the most inhospitable and dangerous. A commentator at the time
noted that "Lawrence, together with San Diego, and one or two other
'free-speech' cities, really introduced the Industrial Workers of the
World to the American public."[59] That being the case, the free speech
fights in turn introduced the strategic importance of cultural space,
and the ruthless proprietorship of those who control it, to the
Wobblies. The free speech fights emerged out of the Wobblies'
efforts to educate and organize western workers through street
speeches and street meetings and city authorities' attempts to prevent
this through the passage of ordinances outlawing such street speaking
and street gatherings ("move-on laws," as they were popularly

labeled), especially in business districts. When such laws were passed, the Wobblies responded with a strategy as subversive as it was effective. Putting out a call to IWW members, wandering boys, and "footloose rebels" around the country, the Wobblies flooded the city with those willing to ride the rails into town, mount soapboxes on city streets, make a short speech ("soapboxing," they called it)—and get themselves arrested. As a result, local jails and courts became crowded far beyond capacity, and, in many cases, local authorities were forced to rescind their new spatial regulations.

The price the Wobblies paid for these public victories, though, was horrendous. Foreshadowing the street battles for civil rights decades later, officials used fire hoses and clubs to disperse illegal street meetings. Inside the jails, brutality against Wobblies was common, and jail diets often consisted, quite literally, of bread and water. Frank Little, one of the Wobblies's most effective and courageous organizers, served thirty days on the rockpile for the crime of publicly reading The Declaration of Independence during the Spokane, Washington, free speech fight. In collusion with local police, business owners also organized vigilante squads of the sort John Steinbeck labeled "about the worst scum in the world"; when Emma Goldman and her companion Dr. Ben Reitman arrived in San Diego to support the free speech fight there, Reitman was kidnapped by vigilantes who beat and kicked him, forced him to run the gauntlet and kiss the flag, and burned "IWW" into his buttocks.[60] Joe Hill suffered a worse fate. Author of many of the Wobblies' most popular songs, Hill came to Utah to help with an upcoming free speech fight, but never got the chance. Framed for murder, he was arrested, convicted, and later executed by firing squad at the Utah State Penitentiary. At a postexecution press conference, Utah's governor put Hill's case into proper perspective, as he promised to prevent subsequent street speaking.[61]

Paying this awful price, the Wobblies bought not just their own right to occupy public space, to transform it into a cultural space of organization, resistance, and alternative community; they bought a stake in future occupations, too. In the following chapters, we'll hear the old move-on laws and vigilante abuses echo in contemporary campaigns to drive the marginalized out of public space—but the singing and fighting of the Wobblies echo louder. Activists will be

seen using the Wobblies' tactics, calling up their ethos, as they fight for the rights of the homeless and other marginalized groups to inhabit streets and sidewalks. More remarkably, activists fighting today to free the public airwaves from corporate domination, to organize alternative networks of community radio, will be heard identifying themselves as Wobblies, characterizing their activities as "soapboxing the airwaves," explaining their on-air battles as latter-day "free speech fights."[62] New, mediated public spaces the Wobblies of San Diego and Spokane could never have imagined, they will argue, can best be liberated with the Wobblies' old anarchist street strategies.

For these new Wobbly activists as for the old Wobblies, the underlying strategy, the broader orientation in all such battles, is *direct action*. At its most basic, direct action constitutes anarchists' disavowal of external authority, of elected "leaders" and of state-sanctioned legal systems, in favor of grounded, autonomous agitation. Emma Goldman argued that anarchism "stands for direct action, the open defiance of, and resistance to, all laws and restrictions, economic, social, and moral"; on trial during the San Diego free speech fight, Jack Whyte put it to the judge a bit more bluntly: "To hell with your courts, I know what justice is."[63] But beyond its rejection of present arrangements, direct action also suggests something of future ones. As the following chapters show time and again, the practice of direct action demands doing the impossible—or at least that which is presently thought to be impossible—and, in doing it, demonstrating it to be possible. Without asking permission, without lobbying for legal approval, anarchists simply and directly take action against existing arrangements of authority—and in accomplishing such action prove to themselves and others that no permission is needed, that authority is neither timeless nor absolute, that alternative actions and arrangements are imaginable. Most radically, anarchists understand that direct action is not undertaken in the service of some predetermined future result, but is instead embraced as the disorderly, open process out of which future possibilities emerge. So, for Emma Goldman, the Wobblies, and anarchists fighting for public life today, the revolution is always under way—and never over.

I always get a kick out of seeing one of the Wobblies' best-known direct action slogans—"Direct Action Gets the Goods"—still floating around, scrawled on kids' notebooks, sewn onto their backpacks. And

Figure 1.3: Wobbly "Direct Action Gets the Goods" sticker.

most of the time when I see this affirmation of direct action it's on the backpack of a punk. This is of course no surprise. Maybe it's some sort of cultural reincarnation, but, I swear, the punks are the Wobblies of the new millennium—same in-your-face defiance of authority, same disavowal of a Disneyfied world, same black humor, same progressive ideals.

The punks even operate along the lines of the Wobblies' direct action—they just call it "do-it-yourself," or DIY. From the beginning in the 1970s, punk culture was built on DIY—that is, on the principle of direct action, of doing it yourself—as a way of stepping outside a world in which everything from music to food to fucking had become a corporate commodity, and of inventing instead a new world out of your own active disobedience. Three-chord punk "garage bands," self-produced punk albums and 'zines (fan magazines), punk clothing ripped, torn, and reinvented by its wearers—all were overt attempts to create an alternative community based on antiauthoritarian autonomy. Interviewed in the punk 'zine *Sniffin Glue* in 1976, The Clash's Mick Jones affirmed it: "The important thing is to encourage people to do things for themselves, think for themselves and stand up for what their rights are."[64]

And it's still the important thing for punks. Punks and punk bands self-organize concerts, festivals, and tours in support of the homeless, multiracial understanding, animal rights, and veganism. Younger punks gather in the parking lot of Disneyland itself, just across the fence from TomorrowLand, for a little do-it-yourself subversion; resplendent in their tattered punk regalia, they spook the customers, dodge the "special enforcement" police operations aimed at running them off, and keep busy "ragging on this whole tourist scene."[65] The punk magazine *Punk Planet* features "The DIY Files"; in a recent issue the files contained articles on DIY lovemaking and DIY soap making and, echoing the old Situationist notion that "work is the blackmail of survival," an article on ways to "Fuck Work." In this same issue, the gay punk band Limpwrist explained the homo-erotic undercurrents of machismo, and Elizabeth Elmore—ex-front-woman for the punk band Sarge, now training in child welfare law—explained punk as an open community of do-it-yourself mutual aid and activism, adding, "I don't think of girls like us as particularly assertive—I think of us as normal and all the other girls as weird. . . . I'm a feminist."[66]

If all this sounds like anarchy—like direct action, like Emma Goldman's granddaughters jammin' with the Wobblies—it's because it is. As "art director" for Malcolm McLaren and the essential punk band The Sex Pistols in the 1970s, Jamie Reid wrote what came to be called the "perfect slogan" for punk: "Anarchy Is the Key, Do-It-Yourself Is the Melody." In doing so, Reid, McLaren, and others consciously drew on the earlier traditions of the Situationists, a subversively anarchic assemblage of French writers, artists, and troublemakers who sought to undermine and unravel the very order of everyday life. As the Situationists saw it, the Paris Commune had been "the only realization of a revolutionary urbanism to date," what with its festive refutation of daily drudgery and its "understanding [of] social space in political terms," and so the Situationists set about to reinvent the Commune's urban revolution. The punks especially were drawn to the disorientingly anarchist strategies and aesthetics, the dadaist slogans and performances, that the Situationists invented during the 1950s and 1960s and put into outrageous public practice during the Paris upheavals of 1968. In fact, one of these old Situation-ist slogans in particular—"Boredom is Always Counterrevolution-

ary"—foreshadowed with eerie exactitude both the stale cultural conditions against which the punks revolted, and the redemptive excitement offered by the punk's spastic festival of the oppressed.[67]

As it did for the Wobblies, music affirmed this punk anarchist sensibility. "Anarchy in the U.K.," The Sex Pistols's howling punk anthem, offered a dead-on account of anarchist practice; as Malcolm McLaren said at the time, "'Anarchy in the U.K.' is a statement of self-rule, of ultimate independence, of do-it-yourself."[68] So when Johnny Rotten yelled "I wan-na be an-ar-chy," he wasn't joking—or he was, but the joke was all about anarchy—and in fact, a particular couplet from the song provides the best single statement I've heard on direct action's emergent potential. (The lawyers won't let me reproduce the couplet here, but it has something to do with not knowing what you want, yet knowing how to get it.) A host of other punk bands, infamous and unknown, then and now—The Clash, Against All Authority, X, Rancid, Resist and Exist—have likewise played out the anarchy inherent in punk. Anarchy is the key, all right, do-it-yourself the melody—and punk is the cranked-up, three-chord powerhouse pumping out the politics of the beat.

That punk beat reverberates throughout the spatial conflicts recorded in the following chapters. And as the following chapter shows, the beat booms especially hard for one group of punks. Punker than punk, embracing punk's anarchy in all its degraded glory, they've decided to take it directly to the streets, to play out punk's politics in the public spaces of everyday life. The Wobblies announced that "the moment a movement becomes respectable ... it loses its revolutionary character. . . . Therefore we are not respectable. We admit it and we are proud of it."[69] The punks who occupy the streets agree, admit it, and are proud of it, too—and because of this find themselves and their raggedly self-made public community in ongoing conflict with those determined to make the streets safe for respectability and exclusion.

Stumbling with the punks along the jagged line of anarchy back to the present day, I'll at least mention some other individuals and groups who, like Emma Goldman and the Wobblies, will also emerge from the historical shadows to appear now and then in the contemporary spatial conflicts documented in the following chapters. The Spanish anarchists, for example, fought Fascist military forces throughout the Spanish Civil War of the 1930s, and also invented

among themselves complex agricultural communes and industrial collectives. Decades before, the Russian philosopher Peter Kropotkin developed a perspective on which many of these communes were based—an anarchist understanding of human community as founded on mutual aid, tolerant diversity, and support. Along the way, Kropotkin also constructed brilliant critiques of legal and political authority.[70] During the Russian Revolution, Nester Makhno and his anarchist guerrilla forces fought to win the Ukraine, worked to set up similar anarchist communes there—and were ultimately betrayed by the Bolsheviks.

Michael Bakunin could have predicted that betrayal. Anarchist revolutionary, longtime adversary of Marx and Marxism's dogmatic politics, Bakunin was well aware that Marx "lacks the instinct of liberty; he remains from head to foot an authoritarian."[71] Bakunin, on the other hand, could best be described as an antiauthoritarian punk— because if punks are The Wobblies of today, Bakunin was surely the only punk to occupy the nineteenth century. Freethinker, troublemaker, prisoner in the dungeons of Russia until his escape in 1861, Bakunin fought for a world of fluid disorder, a world open to spontaneous human action. But to create such a world, Bakunin understood, the existing world of authority, order, and domination couldn't simply be accommodated; it had to be confronted and destroyed—and in its destruction, reinvented. And so Bakunin proposed a heretical idea, an idea that directly animates each of the public space conflicts recorded in this book, an idea burned down the middle of many a city street then and now:

The passion for destruction is a creative passion, too.[72]

Burning bright with the passion for destruction, Bakunin's heresy in turn illuminates a contradiction that has animated this introductory chapter—a contradiction played out, a war of the worlds waged, inside a single concept: community. Referencing the idea of "community"—as they do over and over again—developers and Disney, police officials and politicians imagine a place of manufactured security and preplanned pleasure. In such a community, conformity to the common good comes about from the collective consumption of commodified identities, and from passive participation in public spectacles

organized by the demigods of sport, leisure, politics, and shopping. This conformity is of course undergirded by an enforced homogeneity, by a stern exclusion of those people and cultures that might induce discomfort, doubt, or disorder. And in all of this, the model of community is not just hierarchical and exclusionary but sadly nostalgic, as developers and public officials look backward, look to "restore" some reactionary image of "community" and "civility" they seem to have lost inside emergent cities of uncertain possibility.

For anarchists, of course, this model of public life has everything to do with control, and nothing to do with community. For them, "community"—as played out in the Paris Commune, local anarchist collectives, militant labor unions, and the do-it-yourself mutual aid of the punk underground—suggests not the accomplishment of conformity, but an open-ended process of mutual engagement and exploration. It implies a sense of common purpose forged out of the ongoing, collective battle against authoritarian domination, and thus a living fabric of community relations woven just tightly enough to offer comfort and self-determination, but always left loose enough to ensure difference. As such, anarchist communities don't simply tolerate misfits and make do with the margins; they embrace them as the cutting edges of social change, celebrate them as the unraveling ends of social order. In anarchist communities, this rejection of external authority and enforced conformity in favor of do-it-yourself uncertainty produces a place that looks less like Disneyland, and more like some goofy federation of difference and disorder. And so, when the occupants of these communities look back to Goldman or Bakunin, they look not to restore the past, but to resurrect some subversive ideas for inventing the future.[73]

Ideas such as Bakunin's heresy. In a time when the authorities increasingly enforce a corporate, exclusionary model of community on the city and its inhabitants, Bakunin would know what to do—and so do those who remember him today. If community is sold as a prefab commodity, destroy it; if community is defined by exclusivity and conformity, adulterate it; if community is encased within the castle wall, breach it. If the streets are constructed only as means of automotive access, as passageways from one damn store to another, tear them down. If public space is closed, bust it open. And here's the beauty of it, as Bakunin would remind us, and as we'll see throughout

the following chapters: Confronting and destroying the present public order doesn't just make room for anarchic communities; it begins to directly do the impossible, to invent and organize anarchist communities out of the very process of destroying their opposite. After all, the passion for destruction is a creative passion, too.

I WANNA BE ANARCHY

As it turns out, those authorities who work to clear the streets, close down public space, and constrict the possibilities of community face a tougher task than they imagine. They're not only going up against homeless folks and street musicians; they're going up against anarchy. And they're going up against me. Bakunin's passion burns in me, always has. As a kid my nickname was "El Destructo," and it wasn't just my propensity for physical mayhem that earned me that moniker; it was the punk kicks I got from busting up unexamined assumptions, tearing down the authority of teachers and bosses and security guards, all as a way of creating some space for pleasure and possibility. I was caught on the jagged line of anarchy from the first, an anarchist before I knew it. In fact, later reading Bakunin and Kropotkin, all my early episodes of defiant disobedience began to make sense—or more to the point, they stopped making sense, at least within conventional frameworks of understanding. Like The Sex Pistols and Emma Goldman and the Wobblies, I've never known what I wanted, but I've always known how to get it.[74]

This sense of anarchy and direct action has defined the way I've wandered through my life, and has shaped the approach I've followed in writing this book. That approach might be thought of as something along the lines of existential ethnography—that is, direct, ongoing, open-ended immersion in the disorderly moments and diverse communities of everyday life. Looking to find such moments as they emerge in the city's public spaces, walking has evolved for me as an essential method, a critical spatial practice. Moving about by foot creates a subversive anarchist vulnerability, a sense of being directly situated, sometimes stuck, inside the collective street politics of the moment. Walking sets a pace keyed to particularity, allows me time for talking with those around me, for indulging in the lived texture of authority, resistance, festival.[75] Bicycling offers similar advantages,

and in addition has allowed me many times to sweep down unannounced, images of Makhno's guerrilla fighters flickering in my head, into some closed public space or incident of street conflict. So, living my life or writing a book, I wander around mostly by means of DIY, walking or biking or, failing that, sharing public space on a city bus. However I get there, though, I try to spend as much time as I can lost in urban space, overcome by its complexities and its communities, hanging out with its streetwise inhabitants. Desolation Row I particularly prefer—existential ethnography, I suppose.

Following anarchy's jagged line, employing this shambling approach, I've fallen into a variety of adventures. Some years ago I traveled the backroads of east Texas and western Louisiana, sharing time with elderly ex-members of the Brotherhood of Timber Workers, an old IWW affiliate, listening to their stories about sabotage and bastard mill bosses. As this chapter's opening paragraphs suggested, I've also made music on the streets for a couple of decades, and recently spent six years as a directly (and defiantly) active member of the hip hop graffiti underground. The following chapters will have more to say about all this, and about other of my anarchist adventures in public space: riding with militant urban bicyclists, raising hell in the company of gutter punks and skate punks and go-for-broke BASE jumpers, chasing freight trains, broadcasting pirate radio, getting busted. Through it all, I've kept the Wobblies, the old free speech fighters and Brotherhood members, alive in my head and heart. Hell, one morning a while back I woke up with a big IWW tattoo on my right arm, inked in with the Wobblies' traditional red and black, of course, but also a little purple, turquoise, and yellow, just for the playful pleasure of it. I knew the old Wobs wouldn't mind.

This dedication to direct action and direct anarchist involvement also explains certain omissions here. There of course exist far more contemporary conflicts over cultural space and the meaning of community, far more instances of public anarchist resistance, than I record in the following chapters; for that matter, I don't even talk much about that little anarchist action that went down in the streets of Seattle in 1999. But while these other cases have much to tell, the adventures found in them are not mine, the communities not my own—and, lacking direct involvement, I leave their telling to someone else. In addition, while many of the cases omitted here offer spectacular

images of, for example, a single day's big street protest, the instances of spatial conflict I've chosen to explore tend to remain more embedded in the ongoing, everyday rhythms of public life. So, this book certainly doesn't provide a comprehensive account of contemporary public space conflicts. Then again, I'm not sure what "comprehensive" means to an anarchist anyway, to someone who lives life as a fractured, always unfinished adventure.

But enough of this introductory chapter. History, theory, introductory overviews are all best read, it seems to me, in the rearview mirror, on the move away from them. They're all places worth a visit but no more, places to know but not to linger. The real action's always to be found in direct action, in on-the-ground engagement with the possible and the impossible. The real adventure's to be found in tearing down the streets, in ripping a jagged anarchist line right down the middle of some closed-down avenue just to see where it goes.

TWO

Wild in the Streets

You can take the punk off the street, but you can't take the street out of the punk.

—Anonymous in Arizona

HOMELESS FOLKS AND HOMELESS ACTIVISTS: WHO'S CAUSING TROUBLE?

Flagstaff, Arizona, is a tourist town. Sitting in the shadow of snow-capped peaks, serviced by a ski area carved from a sacred Navajo mountain, Flagstaff also catches the glow of the nearby Grand Canyon, the Navajo and Hopi Nations, and other natural and cultural "wonders" marketable as attractive tourist destinations. For this reason Flagstaff and its business and political communities are careful to maintain the city's tourist-friendly image of clean air and clean living. They also take care to point out to local citizens the importance of tourist dollars and the local two percent "Bed, Board, and Beverage (BBB)" tax to the city's survival; as the city's official *Cityscape* publication reminds residents, "Tourism is Flagstaff's Business. . . . The city's economy is dependent on our visitors who contribute just

as much in tax dollars as year-round residents via the BBB tax dollars."[1] The dense Ponderosa pine forest that presses in on Flagstaff from all sides, though, hides a different sort of living, and a different sort of visitor.

A mile or so south of the Northern Arizona University campus, across a stretch of Interstate 40 that imports tourists and bisects the city east to west, lie a couple of square miles of pine forest, boxed in by city streets, and now slowly diminishing as housing developments eat away at their southern and western edges. Hidden here in this isolated parcel is a remarkable feat of human construction: a hobo's handmade shelter, fifteen feet square, walls built of stacked stones plastered with pine needle and mud insulation, a partial roof made from broken tree limbs laid in neat parallel lines. With its walls stacked higher on the north to block the wind and cold, left lower on the south to catch the winter sun, the shelter features a fireplace of small rocks encircling a scrap metal platform, and incorporates a large, fallen tree trunk as a bench. Like many other such shelters I have visited in the area, this one has been neatly kept, with little trash save a half-burned Marlboro Red pack in the fireplace. An old piece of carpeting even serves as a covering for the dirt floor, and a series of small rocks forms a short walkway leading to the entrance.

On one of my visits I find, on the floor near the entrance, a torn paperback book, now half-frozen from the recent snowfall: *Thin Air,* dedicated by its author, Robert B. Parker, "For Joan: Still the Taste of Wine." As I pick up the book and sit on the log bench reading it, I can just hear the auto-hum of the interstate to the north, and the arrival of still more tourists in Flagstaff. If they're typical, they'll visit the local Museum Club, described on one glossy postcard as an "enormous log cabin . . . presently the hottest roadhouse on Route 66."[2] Perhaps they'll even visit the old Riordan Mansion, characterized in a promotional brochure as "a remarkable example of Arts and Crafts architecture featuring a rustic exterior of log-slab siding, volcanic stone arches, and hand-split wooden shingles"[3] It's less likely they'll visit the marvel of hidden, handmade engineering in which I now sit.

It's even less likely that they'll see a similar site a mile east, across Lone Tree Road, hidden within a much larger patch of as yet undeveloped forest. Here, a ten by twenty foot natural indention, formed by rocks falling away along the edge of a cliff, has been crafted

into an informal amphitheater, a squared circle of do-it-yourself innovation. To the back, up under the cliff, pine needles have been gathered and laid in for bedding. On one side, discarded plastic bottles—Diet Coke, Crystal Geyser, Gatorade—have been refilled with water and stored away. Across from the bottles and in front of the pine needle bed, an old appliance of some sort has been gutted and converted into a fireplace and cook stove, with charred wood inside, rocks piled on top for stability, and a tin can hanging from a piece of wire off to the side. Beside the fireplace, flat rocks have been wedged in to form a firescreen, and nearby, kindling wood is neatly stacked, lengthwise. Like the shelter a mile away, this site is also reinforced against the north winds, and left open on its other side to catch the south sun.[4]

Three hundred feet below this cliff, down below this little hobo amphitheater, is the floor of a small canyon, worn smooth by the passage of mountain bikes and off-road vehicles. Should any of the canyon's recreational travelers look up, they wouldn't see the amphitheater, sheltered as it is by overhanging rocks and trees. But they're not likely to look up in any case, because the canyon at this point serves only as the functional entrance to something more interesting down the way. It provides one of the main access points into a webwork of canyon trails that, unfolding eastward, leads to Walnut Canyon and the Walnut Canyon National Monument. Another of Flagstaff's primary tourist destinations, Walnut Canyon National Monument houses the remains of cliff dwellings built by the Sinagua people some eight hundred years ago. Remarkable feats of human engineering, these handmade rock dwellings cluster in and around the edges of Walnut Canyon, the Sinagua having used and modified natural ledges and gaps in the rock in building them. And, juxtaposed with the handmade hobo amphitheater, these dwellings suggest a rather obvious irony regarding the meaning of cultural space: while one do-it-yourself construction comes to be institutionalized within the purview of the federal government and the attentive gaze of a thousand tourists, another much like it remains invisible and, for many, reviled.[5]

History doesn't end with the Sinagua of the thirteenth century any more than it does with the homeless builders of the twenty-first, though. Now, the City of Flagstaff is grading and paving over the

mountain bike tracks in the feeder canyon below the hobo amphitheater, expanding the chain of auto roads and automotive traffic that increasingly choke the city. And up above, another sort of choke chain now encircles the land around the hobo amphitheater. These woods are the site of Coconino Community College's future campus, and they have now been precisely surveyed and marked, rationalized and made ready, with hundreds of bright orange survey stakes strung out across gullies and hilltops. Or at least they had been made ready. Recently almost all the survey stakes have been uprooted, stowed inside hollow logs and wedged under rocks, as Ned Lud(d), or George Hayduke, or some other eco-anarchist has used the forest's own topography to save it, to keep its little amphitheater and its sparse inhabitation, if only temporarily, from the bulldozer and the chain saw.[6] And so, if these survey stakes trace the trajectory of Flagstaff's "development," if they cinch a tightening circle around hobos and other homeless wanderers, they inscribe in their uprooted absence the possibilities of resistance and direct action.

But of course if the contemporary histories of policing and development hold, George Hayduke will soon enough lose out to the bulldozer, and move on to other patches of pine forest and other battles, and the builders of the amphitheater will lose out, too, and fade into the vast, multistrand necklace of homeless camps, fire circles, dugouts, and lean-tos strung around the edges of Flagstaff. As an inveterate crosswoods wanderer, I have in fact come across hundreds of these sites since coming to Flagstaff a few years ago—but never directly, it seems. You have to know where to look. They're always down a draw, up under a ledge, just over the hill; near enough to a path or road, but not noticeable; and, ideally, hidden from the special Flagstaff Police Department squad sent out periodically to sweep the woods of such intrusions.[7] For those who can see them, though, these many illicit camps and little fire circles not only document the lives of homeless visitors and other accidental tourists; they write a secret history of Flagstaff and towns like it, an alternative account to that marketed by business leaders and the tourist bureau.[8]

Faced with the building rumble of bulldozers and police patrols, other wanderers won't bother to carve out the next camp in the local woods, though; like hobos and Wobblies before them, they'll just move on down the line. For many of them this means the bus station.

A while back I met a middle-aged Navajo man, shivering cold on a late winter afternoon, trying to hitchhike from the Navajo Rez to Phoenix, 150 miles south, by way of Flagstaff. Already picked up once by the police since his arrival in town the night before, he and I both knew he'd never make it on foot through the cold, and past the police patrols, to his intermediate destination: the warmth of the bus station. Besides, he reminded me, "they won't let you stay in the bus station without a ticket." So, gathering up a blanket and old coat for him, I loaded him into a car, drove to the bus station, bought him a ticket for the next Phoenix bus, and sat down to talk for a while (mostly about Jesus, as it turned out).

A few months later, this time myself hopping an early morning bus to Albuquerque, I remember his claim and decide to ask about it. No, an employee behind the counter assures me, it's not a problem for folks to hang out in the bus station without a ticket, "as long as they're not causing trouble." Walking back to my seat in the waiting area, curious as to what might constitute "trouble" and on whose terms, I'm just awake enough to realize that the bus station's all of a sudden become Apocalypse Now. The prerecorded, computer-simulated sounds of punches and pain have begun to fill the small waiting area as a gangly twelve-year-old kid—in camouflage shirt and camouflage shorts—jams quarters into a combination combat/kickboxing video game. With little brother watching attentively from just off his left elbow, he leans in, pumping the joystick and talking loudly back to the game. I can almost catch the smell of napalm in the morning. And I wonder: Does he have a ticket? And who's causing trouble?

An Image Issue

In the same way that homeless folks in and around Flagstaff use rock, wood, pine needles, and a dose of DIY ingenuity to build living space, people elsewhere put to use the particular detritus of their found environments. In Phoenix, for example, one group of homeless folks constructed a down-and-out geodesic dome out of found PVC pipe, covered it with carpet scraps, and thus invented a sort of neo-Native American hogan. Others in Phoenix scrounge large cardboard boxes and reassemble them inside rows of thorny bougainvillea bushes; in

this way they not only manage to manufacture shelters that protect them from thorns and discovery, but to subvert the bougainvillea bushes' intended function as social and environmental barriers. Some folks even tap into landscape irrigation systems, attach tubing for makeshift showers, and fill small plastic swimming pools for bathing.

The local television stations and daily newspaper in Phoenix on occasion take note of such innovative engineering; in fact, the geodesic dome and similar cases were once featured in a front-page article in the daily paper. Yet, significantly, the theme of the article was not the politics of do-it-yourself living, nor the remarkable range of human ingenuity that evolves in the face of adversity. Instead, the article was headlined "Phoenix Crews Brace for Damage Transients Cause to Landscaping,"[9] and went on to document a revealing misappropriation of public space and public priorities. In a city dominated by gridlocked freeways and choking on freeway smog, city and state agencies, it seems, focus not on alternative transportation or managed growth, but on policing the homeless in the interest of freeway aesthetics. In the article, officials lament the damage that "transients" allegedly do to landscaping plants and trees, and argue that "it usually doesn't smell too good" in and around their makeshift quarters. So, to keep the homeless out of those bougainvillea bushes planted along freeway sound walls, landscaping crews prune the bushes to "eliminate hiding places," even when "this kind of pruning is not necessarily the best thing for the plants." To roust the homeless from their hidden living quarters underneath freeway ramps and terraces, the roadside authorities take calls from office workers who spot such quarters from their high-rise panopticons, then send in ground-level local police to follow up with tickets and arrests for trespassing. As the head of "frontage road landscaping" for the city says, "It's a battlefield out there."

Indeed it is. And, as case after contemporary case show, it doesn't take a Flagstaff pine forest or a Phoenix landscaping crew to hide the homeless, to render marginal populations invisible; inequalities of age, ethnicity, class, and power are increasingly enforced, and at the same time erased, up and down the mean streets of small town and big city America. As insulated office complexes, truncated transit routes, and privatized parks and shopping districts fracture or destroy previously existing public space, a growing army of public and private

police utilizes sophisticated technological tools to monitor and over-see this emerging spacial segregation.[10] The caretakers of these newly segregated spaces—politicians, business leaders, community associa-tions—contend that such closed spaces are essential to the economic vitality, interpersonal safety, and emerging identity of the city.[11] And because of this, they readily bring down the full weight of law and commerce on those who, by choice or chance, trespass on them.

Subsequent discussions in this and following chapters will con-sider a variety of such trespassers—but any discussion of the crimi-nalization and control of cultural space must begin with the homeless. A population of which children and young people constitute a significant and growing proportion, the homeless today are hounded by a host of new or newly enforced laws regarding loitering, vagrancy, trespassing, public lodging, public camping, panhandling, and exist-ence as a "public nuisance."[12] Such laws criminalize the presence of homeless persons on public sidewalks, in parking lots and public parks, and in business districts—and in combination with aggressive zoning ordinance enforcement aimed at closing homeless shelters and soup kitchens, criminalize the spaces occupied both by the homeless and by those who seek to help them. In total, these laws ensure that homeless populations are perpetually in the wrong place, that they are perpetually and unavoidably occupying space that has been legally defined as outside their rights and control. Peter Marin has said of the homeless that "we owe them, at least, a place to exist, a way to exist. ... A society needs its margins as much as it needs art and literature. It needs holes and gaps, breathing spaces let us say, in which men and women can escape and live, when necessary in ways otherwise denied them."[13] For homeless kids and adults, the margins have been closed, the breathing space exhausted.

But to be homeless, of course, is not only to exist as an individual without lodging, an outsider in search of breathing space and living space. It is also to engage a set of symbolic codes—a mix of voluntary and involuntary signifiers ranging from tattered clothing and weath-ered skin to shopping carts and cardboard shelters—and therefore to declare by one's individual identity and collective public presence the dirty scandal of inequality. And lest there be any doubt that it is this public presence, and its clash with the carefully manufactured operation of proper and profitable cultural space, that lies behind the

public criminalization of the homeless, some recent cases can be noted.

Prior to Super Bowl XXX in 1996, for example, Tempe, Arizona, officials hold a "brainstorming session" to consider strategies to "force homeless people out of sight," including a tent encampment outside city limits, restrictions on city parks, and "using sprinklers to chase homeless people from parks."[14] Similarly, pre-Olympic ceremonies in Atlanta that year include new nuisance ordinances, the installation of park benches designed to inhibit loitering, a "special crime sweep" by the police that results in the arrest of 9,000 homeless people, and other measures backed by "a major downtown business group" and developed as part of "a systematic effort to purge [the homeless] from the streets and other public places."[15] Activists resisting this plan note police harassment "if you look homeless," point out that those going to jail are those "who look different," and add that "the central business district has been working to push the poor from the city center as a way to get conventioneers, tourists, and suburban white people to come downtown and spend their money. To do that, the corporate sector has had an agenda for some time."[16]

Over the past decade or so, city officials and local police in San Francisco have likewise set up undercover sting operations (and video cameras) to "protect monied citizens from beggars." In 1999 alone, police issued some 20,000 citations to homeless individuals for offenses such as trespassing and "camping in public."[17] They have also aggressively evicted squatters and members of the Homes Not Jails movement from abandoned buildings, in one case utilizing MPs from the Sixth Army to roust squatters and protestors from an empty residential complex on the Presidio army base.[18] Special hostility on the part of the authorities has been reserved for Food Not Bombs, an anarchistic, direct action group that distributes vegan meals to the homeless in cities nationwide, often in highly visible or politically symbolic public settings. In San Francisco, city authorities have systematically denied Food Not Bombs the permits required to distribute such food publicly—and then systematically arrested Food Not Bombs members for distributing food without a permit.[19] And recently, San Francisco's Mayor Willie Brown has attempted to implement a plan whereby police would seize the shopping carts used by the homeless and cite them for possession of stolen property. As

an attorney for the Coalition for the Homeless concludes, "Mayor Brown wants to turn the city into Disneyland."[20]

As seen in the previous chapter, New York's Mayor Rudolph Giuliani knows something about Disneyland as well. As Giuliani's administration has targeted public "quality of life" crimes like panhandling, obstructing public sidewalks, public sleeping, and graffiti writing, homeless populations have been herded out of areas popular with tourists—often out of Manhattan itself—and the operations of homeless service providers like Housing Works have been obstructed by city policies. In addition, city police have aggressively strip-searched thousands arrested for minor "quality of life" crimes such as disorderly conduct or loitering. This focus on the homeless and their "quality of life" crimes has of course emerged not simply out of political mean-spiritedness, but as a key strategy in the city's broader class-cleansing of its public areas, and the city's remaking of its cultural spaces and cultural identity in conjunction with the Disney Corporation. The business press reports that "the cash-strapped city is hoping tourists and much-needed revenues follow."[21] In response, rappers like Screwball and Cocoa Brovaz ridicule Giuliani's policies, with Screwball even imagining him gunned down at City Hall.[22]

Meanwhile, back in Phoenix, officials push for more than just the pruning of bougainvillea bushes; like Giuliani, they close public parks and other public spaces to the homeless, allegedly as a crime-fighting measure. As a police sergeant tells the media, "any time you have a transient problem, you're going to have high crime."[23] In addition, the city council approves a "crackdown on panhandling and vending" in the "revitalized" downtown area, and focuses aggressive enforcement strategies especially on those homeless persons who attempt to gain some measure of personal and economic control by selling the *Grapevine* newspaper on the streets.[24] Orchestrated by downtown business owners, the crackdown in reality revolves, as usual, around public space and public perception. The director of the city's Community and Economic Development Department argues that panhandling and selling copies of the *Grapevine* is "dangerous and has a negative impact on the perception of Phoenix." The executive director of the Downtown Phoenix Partnership—the group "which is leading the cleanup campaign"—puts it most clearly: "It's part of an image issue for the city."[25]

Gutter Punks. Street Kids.
and the Politics of Mill Avenue

What is punk? . . . Punk is doing something totally
insane, or saying "Fuck off" to the authorities. . . . Punk
is living on the streets, "squatting" in a run-down
house, stealing money for food, eating out of a garbage
can, wearing the only clothes you have day after day.
Punk isn't a hairstyle or even a hair color . . . it's the
way you live out on the streets. . . . "You can take the
punk off the street, but you can't take the street out of
the punk."

—Anonymous in Arizona,
in *Thrasher* skate magazine, 1997[26]

Tempe, Arizona, officials and their version of neighboring Phoenix's
Downtown Phoenix Partnership—the Downtown Tempe Commu-
nity (DTC)—have their own little image issue, and one that didn't
go away with the final play of Super Bowl XXX. Tempe city officials
and their developer friends are determined to build the city's main
downtown commercial thoroughfare, Mill Avenue, into an upscale
consumer destination, and standing in their way—or as we shall see,
sitting in their way—is a group that Downtown Tempe Community
officials regularly deride as street kids, slackers, and gutter punks.

"Gutter punk" does in fact accurately describe many of those on
Mill. A subterranean strata emerging out of—or more accurately,
underneath—the larger punk scene in the 1990s, the world of gutter
punks is occupied by kids for the most part cut loose from traditional
networks of support. While many of them embrace the particular
stylistic or musical codes of the larger punk movement, they define
themselves more by their willingness and ability to live on their own
terms, and to find among themselves the ability to survive on the
margins. Traveling around the country by freight train or Greyhound
bus, squatting together in abandoned buildings, hanging out on the
streets, gutter punks practice the DIY and antiauthoritarian politics
of punk with a remarkable sense of purpose, and defiantly take these
politics to extremes not always embraced by others. In doing so, of
course, they present themselves to legal authorities and store owners,

to shop patrons and passersby, as a group of outsiders with the audacity to be young, homeless, and adventuresome at the same time.

Tempe officials are not the first to encounter gutter punks, and to confront their occupation of public space; as punk and gutter punk subcultures have emerged around the United States, Canada, and elsewhere, so have conflicts over their public presence. In Montreal, for example, police arrest and fine gutter punks for a crime that Giuliani would appreciate—unauthorized car windshield washing—and city officials move to rezone a public punk meeting place, Berri Square, so as to institute a curfew. When local punks, Food Not Bombs, and members of the anarchist group Démanarchie demonstrate against the rezoning, more arrests are made. And when authorities move to drive panhandling gutter punks out of the Berri subway station, the situation spills over into a conflict of sonic, even operatic, proportions. Drawing on a similar strategy utilized in Toronto, the public transit authority decides to broadcast opera music in the station, believing it to somehow serve as a form of sonic punk repellent. But of course the punks stay to enjoy the arias, and to participate in the failed *opera buffa* created by the authorities.[27]

In another French-flavored city a couple of thousand miles south, a similar conflict unfolds. As part of their attack on French Quarter gutter punks, New Orleans tourist agencies and business associations call for stricter enforcement of existing laws, and for new laws prohibiting public sleeping. With their "spiked leather bracelets, nose rings, close-cropped hair and tattoos," and their "lack of respect for themselves or anybody else," the gutter punks are accused of fouling the carefully orchestrated tourist appeal, the manufactured authenticity, of the Quarter. The president of the convention and visitors bureau publicly laments that it's all "just a disgrace. This is what we're inviting our tourists to see?" But sixteen-year-old Coral Cronin offers a familiar rebuttal: "They've got to realize this is a city. It's not a Disneyland."[28]

In Tempe, it *is* increasingly a Disneyland; officials and developers are inviting tourists and local consumers to see a Mill Avenue gradually being remade into a commercial wonderworld. Drawing, ironically, on the pseudo-hip, youthful appeal generated by nearby Arizona State University, Tempe officials have worked to bring in major retailers as a way of transforming Tempe's "decrepit central

core" into a uniformly appealing location for shopping and nightlife; as the local newspaper glowingly reports, "Tempe planners spent the last 10 years attracting businesses and investors to help them create a sort of theme-park downtown."[29] As a result, the traditional mom-and-pop shops of Mill Avenue are closing, replaced by what local activist Randall Amster calls "a sort of Manhattanization of our little spot here in the desert . . . a kind of chain-store process . . . The Gap and Ambercrombie & Fitch and Starbucks. . . ."[30] Indeed, one local shop manager—her own shop soon enough driven out of business—reports that "we've watched one small store after another close. . . . The big national chains are taking over and Mill Avenue is becoming an open-air mall."[31] And the process continues. A new $70 million, high-end retail and condominium project has Tempe's mayor salivating over "having people with that kind of disposable income walking around your downtown."[32] A damming and refilling project that has made "Town Lake" out of the bone-dry bed of the nearby Rio Salado—drained dry over the years by too much development and population growth, and too many artificially green desert lawns—has already driven up neighboring home prices, just as the police of late have begun to drive the homeless from neighboring parks. And when a proposed 900,000 square foot shopping, entertainment, and office complex is completed next to the lake, longtime residents fear, it will once and for all "break the backs of the mom-and-pop businesses along Mill Avenue."[33]

Of course, this sanitization and homogenization of the local business climate requires a certain cultural sanitization as well. Local authorities therefore increasingly target the homeless folks, slackers, and gutter punks who have traditionally hung out in and around the seductive spaces of the avenue's coffeehouses and shops, arresting them repeatedly for urban camping, trespassing, and loitering. A city council member publicly claims that "we're very concerned and we need to do something" about Mill Avenue's teenage population. Tempe police launch regular curfew sweeps and aggressively enforce the local anticruising and car stereo volume ordinances. And the executive director of the Mill Avenue Merchants Association adds, "We don't want to run the kids out. But there's not a whole lot to do but hang out. Twenty-one and older is definitely the target market down here."[34]

To further ensure the comfort of its emerging target market, the Downtown Tempe Community supplements curfew sweeps and anticruising ordinances with a touch of one-on-one soft control. Euphemistically described in the local media as an "ambassador to the homeless," Rhonda Bass is employed by the DTC as the point person in what she more realistically describes as "a security program, an outreach program."[35] Formerly working in the DTC office on issues of tourism promotion, she now patrols Mill Avenue with a cell phone and radio, on the lookout for those she describes as "homeless kids, slackers . . . old Deadheads that are lost or something . . . hardcore homeless people . . . younger kids [that] travel more in little gangs. . . . They're all on some kind of substance . . . or not mentally capable of understanding or taking care of themselves. . . . They're all kind of extreme." Upon encountering such human extremities, she works to get them off the avenue, either through the temporary provision of social services or by calling in the local police, since, as she says, the presence of the homeless affects business owners and "it does hinder their businesses when you have a group of ten, twenty smelly human beings sitting outside of their shops just aggravating people when they walk by." She reports that business owners are pleased with the program, and that her boss at the DTC is pleased with her efforts—"the only thing he asks is that our streets are safe and clean"—but adds that the younger street kids especially seem to resent her offers of assistance. Strange—perhaps their pervasive mental incapacitation leaves them unable to recognize the real value of that which they are offered.

For the DTC and Tempe authorities, though, even curfew sweeps, anticruising ordinances, and the street cleaning work of Rhonda Bass haven't been enough to rid the avenue of the smelly human beings sitting outside the shops. So, in December 1998, the Tempe City Council and the DTC pushed through a new ordinance that criminalized "sitting or lying down on public sidewalks in the Downtown Commercial District," with a maximum $500 fine and 30-day jail sentence.[36] Modeled on "sitting bans" in other cities around the United States, the ordinance was defended by Tempe's mayor and others as targeting not the homeless, but rather issues of safety and accessibility; as Rhonda Bass argues, "it's not a strike against the homeless people or anything. It was just to kind of free-flow our

streets more so the pedestrians have more room." Whatever its alleged intent, the positive effects of the ordinance were soon celebrated. The local media reported a few months after the ordinance's January 1999 implementation that "Mill Avenue is clearly safer at night than it has been in recent months. . . . As recently as December, potential visitors were turned off by an environment populated by unruly youths." Local business owners noted that "we used to have panhandlers out in front . . . every night. Now we don't have any," and approvingly likened the local clampdown to the one in San Francisco, where "street people really got out of hand." Rod Keeling, executive director of the DTC, added, "everybody that I've talked to over the past six months has noticed a marked improvement."[37]

Apparently Rod Keeling hasn't talked to Leif, Kat, and their friends. As I'm slouching down Mill a couple of months after the sitting ban went into effect, I discover them in front of a local bookstore. Even among the ragged company of Mill's gutter punk community, Leif stands out, his face tattooed with a variety of new tribal designs; his friend Kat exhibits a rather more graceful dishevelment. Passing around Ice House beers poured surreptitiously into plastic soda cups, rolling cigarettes or cadging them from passersby, they invite me to sit down with them—on the flat edge of a low flowerbed, that is. They know the details of the new ordinance—know that sitting on the sidewalk is prohibited, but that sitting on "permanently affixed" structures isn't—and so we sit eighteen inches above illegal, and talk.

Describing their lives on the streets, Leif and Kat talk about the ways itinerant kids their age—teens, maybe early twenties—consistently help each other out by sharing a fluid, informal network of squats. "You don't realize how many people there are out there who'll help you out," Kat tells me. Because of this, Leif says, his problems are "more about food than about a place to sleep."[38] He notes that this lack of food results directly from the difficulty in finding a decent job, but figures it matters less to him and his friends than to others anyway, since "we're not so materialistic." Kat agrees, noting that her friends on the streets "are nicer than all the Babylon people, more about brotherly love than in their material world." She and Leif go on to emphasize the sense of community and support that exists on the street. "It's all about friendship—that's what counts," says Kat. "If you're a good person, you'll run into somebody who will help. It's totally karma."

By this time another dharma bum has arrived—Scum, carrying a fresh sixpack of Ice House under his shirt—and talk turns to the emerging economics and control of Mill Avenue. Kat argues that "they're upset because they envy our way of life and can't handle it, so they like to make dumb laws to fuck with us." She in turn compares Tempe's sitting ordinance to the various laws and regulations she's encountered while hitchhiking around the country, and to her prior arrest in another city for standing too long in the same spot: "Of course I threw the ticket away." Leif notes that, despite the new ordinance, "we sit wherever we want. We don't sit on the ground when they're looking. We find ways around it, to invade them." And indeed, Leif does know when they're looking; as we're talking, he points out the private security personnel—"weekend badges"—watching us from the balcony of a Hooter's across the street. As I get up to leave, Leif invites me to an informal drum circle that he and friends will be holding later on the street, if the police don't break it up. Due in Tucson by evening, I can't make it. But walking back down Mill, I do run into a different sort of circle, this one apparently quite legal. A group of Girl Scouts rings a cookie sale table they've set up right in the middle of the sidewalk.

If Rod Keeling is under the impression that everyone sees the new sitting ordinance as an improvement, that Mill Avenue is now safely in the hands of Gap stores and Girl Scouts, he probably hasn't talked with Randall Amster, either. Doctoral student and instructor at Arizona State University, anarchist troublemaker and political activist, Amster offers a critique of the emerging Mill Avenue that goes beyond the "chain-store process" underpinning its economic development. He points out the close economic and political ties between the city of Tempe and the DTC—the way in which the DTC functions as the city government's "alter ego"—and describes this "concerted effort of corporate and governmental entities" as "a kind of neo-fascism." Out of this arrangement, he argues, has come a "rise in persecution of people and things that don't fit into the larger plan," a "sanitization process" whereby gutter punks and other street folks have "basically become the equivalent of street trash." As an alternative to such arrangements, and as a foundation for opposing them, Amster cites a remarkable mix of traditions, including "anarchist direct action, the Wobblies, the IWW . . . the

civil rights movement . . . the philosophies of Gandhi and King . . . passive resistance, civil disobedience . . . the burgeoning WTO, world bank anti-globalization movement." And, describing an alternative vision to that of city planners and business groups—an alternative vision much like those of Samuel R. Delany and other defenders of the city's eclectically democratic spaces—Amster notes that "for me, it's all about maintaining public spaces. The conceptual link that I operate from is trying to preserve spaces that are historically dedicated to the public, because it's my belief that without public spaces, any kind of talk about democracy basically goes out the window. . . . I'd like to see the public spaces in Tempe become revitalized again; that would be my ultimate goal . . . keeping the spaces that historically were for the public . . . vigorous meetings spots and places that everyone can enjoy."

Toward this end, Amster and his friends did indeed decide on anarchist direct action—and they aimed it directly at the new sitting ordinance. Putting together Project S.I.T. (Sidewalk Initiative Team)—a group whose website features an anarchist/sitter logo, and a commemoration of the Wobblies' first U.S. sit-down strike in 1906—Amster and others set in motion a series of Mill Avenue street sit-ins in protest of the new ordinance.[39] Beginning with a January 1999 Martin Luther King, Jr., Day protest, groups of activists, homeless folks, Arizona State University students and faculty, and local children sat in circles on the sidewalks of Mill Avenue, in intentional violation of the ordinance. Some of the sit-ins drew intense media coverage, others less; one included a pounding drum circle of the sort Leif would like, and drew the praise of an onlooker the media later described as "a homeless man . . . whose right arm bears the tattoo 'Food Not Bombs.'"[40] But in every case, as Randall Amster recalls, the sit-ins reclaimed and reinvented the very sorts of cultural space that he and others cherished—and the very sorts that the new ordinance was designed to erase: "They were like little mini-moments of autonomous zones. There was this aspect of liberating a street corner just for a day or so, and really creating a kind of space for spontaneity. We had people playing drums. We had a bunch of street people join us. One sort of crazy couple . . . had a van, on the side was painted 'Fuck the Police.' . . . It was definitely a day of spontaneity and open-endedness that you can't really find down there anymore."

Subsequent chapters will document this same dynamic time and again: the power of anarchist street politics to reclaim public space, to reinstitute autonomous pleasure and spontaneous excitement in places where such disorderly conduct has been outlawed or otherwise eliminated. For Amster and Project S.I.T., these disorderly street politics generated an added benefit as well. Trained as a lawyer—though having earlier "left the legal profession because my anarchistic feelings made it impossible for me to practice law"—Amster intended to mount a legal challenge to the sitting ordinance, but knew that such challenges often fail when those bringing them cannot demonstrate direct involvement in the issue at hand. In this case, though, direct action in the street evolved into the basis for legal action in the courts:

> The idea was that by sitting my own butt on the sidewalk, and along with all the other folks that joined us, conceptually we were able to link our rights with the rights of the street people, really the target of the ordinance. . . . Now I have to say that I can't take credit for that in terms of seeing it ahead of time and really pushing that—that's just the way it naturally evolved. . . . We were able to show that there was clearly a time when sitting was used specifically to convey something. In other words, the act of fifty people sitting down in defiance of the law that makes sitting down a crime, on Martin Luther King Jr. Day, was in itself an expressive act.

Establishing this linkage between expressive street protest and the rights of street people, Amster was able to challenge the legality of the ordinance, and in early 2000 a U.S. District Court Judge overturned Tempe's sitting ban, ruling it unconstitutional.[41]

So it seems that for Rod Keeling, the DTC, and Tempe city officials, even with all their cash and political clout, you can't always get what you want. But of course, if you keep trying, you might get what you need. Randall Amster points out that the city has continued to operate in "the Disneyfication mode," has continued "selling off the sidewalks downtown," deeding them to developers in such a way as to "convert public space to private." In this way, new developments such as the CenterPoint area are able to claim adjoining sidewalks as private property, to hire a private police force to patrol them—and, as

Amster and others found, to regulate or deny the right to political activity on them. And because of this, Amster says, "you could win the legal battle, the immediate battle, the public opinion battle, and in the end the city could still just sell it right from under you and say, sorry, now it's private property and you no longer have any First Amendment rights." Moreover, victory in the immediate battle hardly halts the ongoing and ever-inventive cultural sanitization work of economic and political authorities, an excremental whiff of which filtered out of the DTC back in 1997.

Early in that year, Keeling and the DTC proposed to ban cats and dogs from downtown sidewalks, arguing that their presence had become a public health matter, since "we have had people step in dog waste and track it into stores. We've had a woman slip and fall." In a letter to Tempe's mayor and city council, Keeling elaborated, alleging that Mill Avenue's street kids create "public disorder" with their "public sexual activity . . . defecation and urination in public areas, and possession of dogs, cats, and other animals that can intimidate the public."[42] After all, Keeling later argued, "the lifestyle we're talking about is horrific. . . . The human carnage is unbelievable. Our community shouldn't let this behavior go on. . . . It includes kids from 12 up to their 20s." A local business owner added that such kids are typically covered in "body piercings, tattoos, and reeking of body odor."[43] Though the proposed ban wasn't passed by the city council—due, apparently, to opposition from middle-class pet owners, and concerns about pet-owning shop patrons—the campaign for its passage did reveal an odious ideology. As subsequent chapters will show, this ideology pervades conflicts over cultural space, as likely to be directed at graffiti writers or gay men as it is at gutter punks. And in every case, its essentials are the same, drawing on evocative images of filth, disease, and decay as a way of demonizing economic outsiders, stigmatizing cultural trespassers, and thereby justifying the symbolic cleansing of the cultural spaces they occupy.[44]

Even now, after years of such cultural and spatial cleansing— after years of economic homogenization and privatization, of curfew sweeps and anticruising enforcement, of antisitting ordinances and homeless "ambassadors"—the promotional literature of the DTC laughably invites visitors to a Mill Avenue marketed as "urban and eclectic by day, with a pulsating street scene at night," a place where

"culture is abundantly on display."[45] But the work of city officials and the DTC sends a darker message, writes an ironic subtext to be read by the homeless and the marginalized, by Kat and Leif, by street dogs and alley cats, by anarchist gutter punks and by the anarchist activists who defend them:

Don't sit. Don't stay. Don't beg.

SIDEWALK MUSIC: PLAYING DOWN THE STREETS

Those who wish to play music or otherwise perform on Mill Avenue, those who might actually try to sonically construct a "pulsating street scene," aren't particularly welcome anymore, either. At the same time that it passed the sitting ban in December 1998, the Tempe city council also amended the city code so as to more thoroughly regulate "street entertainers." Under the newly amended code, prospective street players are put through a bureaucratic grinder, beginning with a registration application detailing location, hours, activities, and equipment, and submission of a nonrefundable registration fee. Those approved must in turn perform in accordance with the city's "entertainment guidelines." They're required to stay within a designated "entertainment location area," to be determined exclusively "by the city or its designee"; to keep this area "neat, clean and hazard free"; to utilize only preapproved equipment and performance techniques; and to make themselves and their equipment available for "inspection by the city at all times."[46]

An assistant city attorney argues that these spatial and aesthetic constraints constitute "reasonable time, place and manner restrictions."[47] Kat and Leif disagree, and note the insidious irony by which aspiring street musicians without money aren't able to earn any, because they don't have money for the permit that would allow them to do so. Randall Amster adds that, like the sitting ban, the amended street entertainer code is "just another one of these attempts to eliminate anything that's potentially spontaneous or evades their control web. A permit or licence always gives the issuer a kind of editorial control, a kind of censorship control."

Hard times as well for buskers in Flagstaff, which, like Tempe, Boulder, and cities nationwide, offers its street musicians a mix of

regulation and discouragement. An itinerant street musician, Chuck was busted on a loitering and panhandling charge for, as he says, illegally "uncasing" his guitar on a downtown Flagstaff sidewalk—that is, taking out his guitar, tuning it to play, and leaving his guitar case open as a symbolic solicitation of money. Now as I meet him and strike up a conversation in Joe's Place,[48] an old-time downtown bar on Route 66, he's just hitchhiked in from Albuquerque to fight the charges in court the following Monday. During our long talk, he details the current erosion of constitutional liberties and bemoans the growing power of the insurance industry: "The more we pay insurance companies, the more they can pay lawyers to see that they don't pay our claim." Like Kat, he knows, and carefully explains to me, the road techniques and legal precautions needed for successful hitchhiking these days. And, as our conversation comes back around to the loitering charge that cancelled his street performance, Chuck summarizes current trends: "They're not enforcing the law, they're enforcing someone else's agenda."[49]

A year later, September 3, 1999, and I'm out on the streets myself, tuning up to play music and test the law with my friend Barry, a local fiddle player. We're on a downtown Flagstaff street corner a couple of blocks from Joe's Place—the same corner where I had first met Barry just a week prior. Coming out of an alley, I had heard the sounds of "Soldier's Joy," a soaring Irish (and later American Civil War) fiddle tune whose popping lyrics match its musical intensity: "Twenty five cents for the morphine, fifteen cents for the beer, twenty five cents for the morphine, they're gonna send me away from here."[50] I was amazed to hear this old tune floating on the streets of Flagstaff; Barry was amazed when I walked up to him, identified myself and the song, and complimented him on his playing of it; and so a street partnership was born.

It wasn't my first. Over the years, I've been lucky enough to busk around the United States and the world in partnership with various mandolin, fiddle, guitar, and harmonica players. Playing on "The Drag" in Austin—the section of Guadalupe Street that parallels the University of Texas—money tossed in my open guitar case helped pay my way through graduate school. But of course it wasn't only about the money—the presence of one street musician generally attracted others, and by the end of the day an impromptu band would

form, playing The Stones' "Dead Flowers" or some other underground standard for the crowd of students and street people. Years later, on my first busking trip to Amsterdam, a mandolin player friend and I ended a street session with a guitar case full of Dutch money. Unsure of its value, we decided to convert it into a currency we knew; it bought eight overpriced Heinekens at a nearby pub. Playing another time in the acoustically rich (and beautifully graffitied) space under a bridge in Amsterdam's Vondel Park, three of us—mandolin, guitar, and fiddle—had begun to draw a large crowd. In the middle of a fast fiddle tune, an older woman emerged from the crowd and began a wild, swirling jig, hands and scarves flying—which, much to our pleasure and the crowd's, she managed to sustain through the next ten tunes or so. Later that day, an older man joined us as well, a French pennywhistle virtuoso who, we discovered, was well known to locals as a regular performer in the park.

And on Prague's historic Charles Bridge, we had once set up in front of one of the great old gray statues that border the bridge, playing a set of up-tempo fiddle and bluegrass tunes, when we noticed a young man squatting close in front of us, face half-hidden by a wide-brimmed hat, head cocked to the side. At the end of one particularly fast (and money-making) tune, he said slowly, in heavily Czech-accented English, "Blackberry Blossom." He was right—that was the tune—and in much the way that Barry and I got together by way of "Soldier's Joy," his knowledge of the song led to conversation, and to our understanding that he was himself an accomplished local mandolin player. Soon we were playing together and sharing Pilsner Urquells and good Czech liquor on the bridge; by the next day we were playing music at his friend's flat, and that night drinking and playing at a local working-class pub. By our last day there, we had assembled an on-the-fly six-piece band—three Americans on mandolin, fiddle, and guitar, three Prague musicians on mandolin, standup bass, and banjo—and were earning travel money for ourselves, and some serious rent money for our friends, back on the bridge.

In every instance, from The Drag to the Charles Bridge, this sort of street playing has caught me up in the transformation of public space, as the music has remade sidewalks and bridges into stages for performance, entertainment, and shared pleasure. Like the sax players I've heard over the years echoing their songs off the tiled walls of

Figure 2.1: Busking on Prague's Charles Bridge.

tube stops in London's West End, I and other musicians have time and again converted underpasses, bridge abutments, and other features of the found environment into little concert halls, complete with informal backstage areas, audience gathering spots, and structures of acoustic amplification. And inside these sonic spaces, I've watched from behind my guitar as communities of musicians, listeners, and dancers form and fade away, as the very sort of musical and social spontaneity to which Randall Amster alluded undermines the legislated rigidity of "entertainment guidelines" and busts the legal boundaries of "entertainment location areas."

Tonight, as Barry and I are getting ready, sowing the open fiddle case with a little seed money, the talk is likewise about the tension between law and music. An Australian guitarist busking his way through Flagstaff stops by to tell us about the recent arrest of a local street musician who, like him, was playing downtown without a permit. Leaving to return to his own favorite busking location, he's back thirty minutes later to report, in finely reflexive fashion, that in walking over previously to tell us of the arrest, he lost his own spot, and now is having trouble finding another one public enough

to make some money but secluded enough to avoid arrest. Our own status in this regard is uncertain. Barry has a permit to play; I don't. When two police officers circle by later in the evening, they pause to listen to the music and look over the crowd, but don't threaten arrest. Perhaps this is because both of them turn out to be graduates from my department at the university, and remember me from class. Or perhaps it's because I don't fit the profile of the earlier arrestee who, as our Australian friend had reported to us, "was sort of hippie looking."

Barry's permit does indeed afford him some protection, but at a price. His second night playing in downtown Flagstaff, two police officers warned him that, like Chuck, he would be cited for panhandling if he didn't close his fiddle case while playing. Disgusted, he closed up and went home, but the next day decided to walk down to City Hall and check on legal requirements. Not surprisingly, he discovered a tangle of bureaucratic obstruction much like that engineered in Tempe and other cities. As Barry recalls, a city official told him that "you need to fill out a form to get a business licence.... Then he said we have these designated areas for peddlers and vendors downtown, and here's what's available. He showed me a map and pointed out these areas.... He said you've also got to get permission from every business within at least a half-block radius, to operate your business, and you've got to make sure that you're not in competition with those businesses because competition's bad for business. Yeah, as if."[51]

Barry soon learned that the city bureaucracy was even more tangled than this, as he ran into additional requirements (and additional forms) regarding obstruction-free sidewalks, liability insurance, and state taxes. Stuck in the tangle, he found an unusual ally—an ex-L.A. rock drummer turned Flagstaff city bureaucrat—who helped him get the necessary permits and licences. But, as his ally informed him, the city's controls were both formal and informal, spatial and aesthetic: "We heard from the police that you've been playing out there, they know you and they've gotten reports from other police that it adds to the city's ambience. So the cops like it and they think you're adding to the city rather than taking away from it, so we'll go ahead and give you a permit and a licence." For these reasons, as Barry points out, other Flagstaff buskers playing music

less likely to garner police approval don't bother with the application process; they just shut down when told, move around the corner, and open up the case again.

Playing hour after hour through the evening—one of us permitted, the other not—our presence intermingles with that of other street denizens, and together we remake the public spaces of downtown Flagstaff. The sidewalk in front of us fluidly shifts between a passageway, a standing and sitting area for listeners, a dance floor, and a locus for sonic and monetary negotiations. Despite the fact that we are mostly playing Appalachian and Irish fiddle music, one drunken reveler requests that we play "some Ozzy," and another the "Fur Elise," in consideration of substantial financial contributions to the case; we comply with both requests. At one point in the evening we find ourselves engulfed in an impromptu red light show, as police cars and an ambulance respond to a medical emergency down the street; at another time, two bikers revving Harley-Davidsons just behind us in the adjoining parking lot provide a sort of 1812 Overture finale to a fast dance tune. Later, some kids stop by, members of a band heading to California, and join us in a street rendition of Graham Parsons's "Grievous Angel." And toward the end, around 1:30 A.M., with nearby bars shut down and the street crowd mostly gone home, two homeless guys wander up, one supporting a broken foot by leaning hard on a single crutch. He mentions how much he'd like to hear "some Stones" before we pack up and leave; we rev up "Country Honk" and "Dead Flowers"; and soon we're all singing about a basement room, a needle and a spoon, and some other girl to take our pain away.

This is in fact the disorganized human beauty of busking on the streets, this emergent mix of encounters and interactions, all enlivened by the shared pleasures of the music, all coming to life as momentary subversions of regulation and predictability. As Barry emphasizes, he plays music on the streets for the money, and for the sake of his craft, but also because "it's very interesting, 'cause you never know what person's coming around the corner. . . . It's completely unscripted. . . . And if I want to stop and talk to somebody interesting, which happens quite often . . . I put down my fiddle and talk to them, as long as I want." Night after night, someone different

does indeed come around the corner, and with that person new songs, new scripts and conversations, new transformations of the street:

Friday September 10, 1999. Couples dance on the sidewalk in front of us. Some musicians from a local club stop by, talking with us between songs about the local scene. A young woman enlists my help in confronting the driver of a big, black SUV, parked in a handicap zone nearby. Given my transportation politics (as outlined in the following chapter), I'm happy to help, and together we yell at him through tinted windows until finally he pulls away. Late in the evening, an appreciative listener puts in the open fiddle case a pizza, still warm in its carrying box; Barry and I each take a slice, and share the remainder with the crowd.

Friday September 17, 1999. Tonight, along with the usual change and bills, two cold Bud Lights are donated to the case; Barry tells me that a condom was contributed the night before. In fact, Barry tells me later, "I've kept about everything I've gotten from the street," because such donations signify a bond of respect and appreciation between him and his listeners. Along with pizza, beer, and condoms, Barry's fiddle case has drawn bottles of Irish whiskey and Absolut vodka, guitar picks, flowers, and "full-on hippy crystals." Most important was a drawing done by a little girl, which Barry received while playing outside a restaurant during lunch hour one day. Her mother suggested she keep it, Barry recalls, but the girl said, "I want to give it to the violin player," and put it in his case. "It was awesome," Barry says. "Self-doubt can bounce off the walls just like the music, and she really made my day."

Throughout the evening, a young man stops by to listen again and again. Finally, he tells us he's from Tennessee, that he hasn't heard such music since he left there, and that our old-timey fiddle tunes "take me back home." Telling us this, I wonder if he knows Merle Haggard's "Sing Me Back Home," and if he gets choked up over it like I do. Finally, at 1:30 A.M., worn out from hours of playing, Barry and I sit on the sidewalk, drinking the donated Bud Lights. A police cruiser circles by once, then on a second pass taps the siren. Getting the message, and packing to go, Barry recalls similar instances where an informal police curfew has cut him off short of the 2 A.M. limit spelled out on his permit.

Friday October 1, 1999. Mixed in with the usual smiles and appreciative comments from those listening, Barry and I both sense a meaner edge to some in tonight's street crowd. Maybe Homecoming Weekend, and its blend of booze and boosterism, has something to do with it. Late in the evening, three drunk fraternity boys walk by, and one grabs at Barry's bow while we're in the middle of a fiddle tune. Breaking the first rule of busking—namely, keep playing—I stop the song and yell *"fuck* you" at him as he walks away; Barry yells something as well. The frat boy of course turns and begins to walk back toward us, fists clenched, yelling, friends beside him. While I'm considering how to defend myself and still abide by the second rule of street playing—protect your instrument—I realize that a rough-and-tumble street person, who's been hanging out with us and enjoying the music, has already sprung into action. Putting himself between us and the frat boys, he tells them, "Hey, you don't fuck with street musicians," and, "If you want to fight them, you'll have to fight me." Backing them down, he shouts over and over again as they walk away, "You may be tough, but you're not cool! You may be tough, but you're not cool!"

While this little morality play over masculinity and the meaning of cool is in fact unusual—neither Barry nor I can recall any fistfights or other real problems in years of playing around the United States and Europe—its resolution is not. Street musicians and other side-walk habitues maintain a remarkable ability to resolve differences and to set the boundaries of public space, sans weapons, sans police officers, sans official "entertainment guidelines." Barry notes that "there is respect for a street musician . . . people respect what I do out there," and that in so doing people form a protective human shield between him and potential problems. Moreover, he adds, street musicians themselves share a certain collective presence; Barry thinks for awhile, then says "the word is *solidarity*." Cooperating more than competing, buskers look out for one another, and negotiate a sort of sonic spacing whereby each is able to play with minimum interruption. I've been a part of such street negotiations time and again, most remarkably on Prague's Charles Bridge, where numerous street musicians from a variety of cultural backgrounds regularly spaced themselves along the bridge, each just beyond earshot of the other. Barry likewise recalls an instance in Flagstaff when, finding another

busker in his usual spot on the street, he was told, "Well, I've seen you out at this spot. You weren't here, so I sat here, and now you've showed up, I'll give it back to you again and I'm going over to Heritage Square." And while busking in New York City, Barry recalls, "you didn't fight over a spot . . . musicians in New York had so much respect for all the other street musicians. . . . I felt a solidarity, it was great." As we will see, this sense of street solidarity, this do-it-yourself auto-policing of the subculture and the spaces it occupies, emerges not just among street musicians; it flourishes among BASE jumpers, graffiti writers, and other street communities as well.[52]

Friday October 8, 1999. Playing in the cold of a fall Flagstaff night, fingers near-frozen, Barry and I notice a young guy standing off to the side, listening. After a few more songs, he introduces himself as the keyboard player with a band playing at a club down the street, out on his set break to catch some fresh air and street tunes. Heading back to work, he invites us to join the band for its last set; on his next set break he returns to reissue the invitation. So, late in the evening, Barry and I leave the streets for the smokey warmth of the club. As it turns out, Barry knows two other members of the band from his days of playing in Phoenix punk bands; reunited, they crank out Waylon Jennings's "Are You Sure Hank Done It This Way" as the night's last song, with Barry ripping a hot fiddle lead right through it. Back in their motel room, we drink and talk music till 3 A.M. or so.

This may seem a heartwarming (and handwarming) story of our ascent from street to club, of music as a common medium that transported us from playing for pennies to a moment of commercial comfort, and certainly the graciousness of our musical compadres was much appreciated and enjoyed. But for many street musicians, this seeming musical hierarchy is inverted.[53] To begin with, street patrons often pay much better than do club owners; as Barry says, "people ask me all the time, 'why don't you play in clubs? You're good, why don't you play in clubs?' Well, I'd have to take a huge cut in pay." (Barry and I both laughed when we read a Tempe councilman's justification for a street musicians' registration fee there: "A good street performer can make $25 in one night at least."[54] Yeah, on a slow night, anyway.) More importantly, the streets offer a degree of dignity and autonomy not available in club work or, for that matter, in most any sort of work these days. Before he turned to busking, Barry remembers that "I had

to bust my ass, slave and make somebody else rich, busting my ass doing something I hate" in various low-wage jobs. Even playing clubs, he felt more like "an alcohol salesman for some club owner" than like a musician. On the streets, though, the ethos and aesthetic of DIY take hold: "The energy is different. . . . Clubs are good for certain things, but for what I'm doing, it's definitely better on the street. I'm my own entity. I come and go as I please. I'm my own boss, in its truest form. . . . It's just really interesting on the street, the social thing. . . . You're giving to people. You're sharing with people. You're making people happy. . . . I play what I want to play, when I want to play it, how I want to play it." And, as it does for graffiti writers, BASE jumpers, and others, this experience of autonomy and emergent community ultimately provides more than freedom from alienating work; it provides a sense of self: "It helps me build myself as a person. . . . It's been one of the greatest experiences of my life, it really has, because it's one of those things that makes you go inside and figure out who you are. It tests who you are as a person. . . . It's a great character-builder. I've learned so much about myself."

Saturday January 22, 2000. Back in October, I swore I wouldn't play out here again until the cold and snow of Flagstaff's winter melted into spring, but here I am, junkie for the streets, hands wrapped in cutaway gloves, jamming with Barry at our usual sidewalk spot. As a couple with a small child comes by, they encourage her to pay attention, to listen, and soon all three are dancing to the music. When they come back later, now with a dog in tow as well, they end up waltzing along the sidewalk as we play "Our Old Home Waltz." Toward the end of the night, a local guy confined to a wheelchair, a Joe's Place regular I recognize, rolls up. Laughing and digging the music, probably more than a little drunk, he decides to dance, wheeling and turning and rocking the wheelchair on the sidewalk in front of us, legs pumping and flailing to the beat as they splay out in front of him. I'm having too much fun to remember how cold I am. Like so many times before, like the homeless guy with a broken foot and a yen for dead flowers, this is indeed the festival of the oppressed, or at least the down and out. All of us are in the gutter, yeah, but some of us are looking at the stars.

Saturday February 27, 2000. We're cranking it in the cold again, mid-twenties with a little north wind drifting down off the mountain.

Early on, a young woman stops to listen, and asks if we know any Dave Matthews. "No, sorry." "Well, you ought to learn some," she tells us sincerely. "You'll get lots of money from the women. Or you'll get laid." Later in the evening a remarkable set of music emerges out of our interactions with those around us, a set of music as fluid as it is eclectic—though, sadly, still lacking the aphrodisiac presence of Matthews. Two Latino guys stroll up, wanting us to do "something Spanish." Finishing the fiddle tune we're playing, we break into "La Bamba," which after a few minutes and a few more folks stopping to dance and sing becomes an extended version of "Twist and Shout." At about this time two Brits walk up, just in from Nottingham for a teaching stint on the Navajo Rez; in their honor we blast off on The Sex Pistols's "Anarchy in the U.K." And as we end the song and they turn to leave—with the usual talk, thanks, and money tossed into the case—one turns back: "Know any Clash?" We jump into "Death or Glory," the Clash's cutting threnody to compromise.

Taking a break after this spontaneous street jam, Barry and I talk about the sonic, even lyrical, similarities between hard-driving, old-timey fiddle music and modern-day punk, and agree that we ought to play more punk on the street. Barry mentions The Clash's "London's Burning," and we stumble around trying to remember it; then finding the beat and the four chords, we're off: "London's burnin' with boredom now!" After a few verses, a new crowd has begun to gather, we're picking up momentum, and I begin to pogo up and down, and to invent a local variation: "Flagstaff's burnin' with boredom now!" Soon enough, folks are singing along, loudly and passionately— "Flagstaff's burnin' with boredom now!"—with one young woman making up her own verses as we go. And now people are pogoing on the sidewalk in front of us. "Flagstaff's burnin' with boredom now! Flagstaff's burnin' with boredom now!"

But of course for that moment, anyway, it isn't. In fact, after years of busking on the streets, it's this moment of on-the-fly musical anarchy as much as any other that confirms for me the power of do-it-yourself music, of do-it-yourself street culture. I realize that if Barry and I weren't out here, all these people dancing and singing, all these different sorts of folks converging in a bit of shared sonic space, would just be individuals hurrying to the next club or the car home. But on the good nights, at least, we and those who join us achieve something

remarkable, something beyond ourselves as individuals: we set off a sonic bomb right in the middle of all that boredom.

Holder of a hard-won business license based in part on the police approving of his traditional fiddle music, dependent on street playing to pay bills and rent, Barry understandably has a somewhat different take on our foray into punk—especially when, a few weeks later, a police car cruises by slowly during a boisterous rendition of "Flagstaff's Burnin.'" "I mean, it's great music," he agrees. "But I might get a little nervous sometimes when there's a cop going by and we might be yelling something about Flagstaff being boring."

Friday March 3, 2000. Barry and I are winding up a set of old-timey fiddle tunes when two young guys walk up. "How about some Sex Pistols?" We counter, "Yeah? How about some Clash instead?" and reprise "Flagstaff's Burnin'" with a vengeance; high-fives all around when we finish. Later, as one of my students is strolling by, he suddenly realizes who's playing guitar from underneath the mirrored shades and the big b-boy wool cap pulled down low against the cold:

"Hey, man, you're my professor!"

"Yeah, maybe."

"Don't worry, man, I won't tell anybody you're playing on the streets."

"Just don't tell anybody I'm your professor."

Saturday March 11, 2000. Standing amid patches of snow on the sidewalk, we play fast tunes and long sets to keep warm. A young goateed guy dances an elaborate hoedown to "Soldier's Joy"; as the song ends, his girlfriend kicks in with some a cappella Irish singing. Four high school girls dance and throw dollars in the case to "Brown Eyed Girl." A talkative tourist promises to buy us a much-needed bottle of Jameson's; he returns without the whiskey, but with a ten dollar bill for the case. And later, an earnest young man requests Marley's "Redemption Song," and high-fives me as we finish playing it.

Friday March 17, 2000, St. Patrick's Day. By the time I get to the corner around nine P.M., Barry is already disgusted and ready to quit for the night. A half block up the street, one of the college bars has set up a tent out front for the holiday crowd, and hired a cover band to blare loud, bad pop music. There's a sonic war on this block tonight,

a battle over the boundaries of sonic and commercial space, and with only a fiddle and acoustic guitar, we're not well armed. "If they were playing Irish tunes, I wouldn't mind," says Barry. "Yeah, or some punk" I add. "Yeah, that too." Still, the arrival of my guitar provides a little bottom end, Barry's spirits improve with the two of us playing old Irish tunes, and we manage to carve out some of our usual sonic space around and in front of us, with its typical mix of sidewalk dancers, listeners, and hangers-on. But it is St. Patrick's Day, after all, and it doesn't seem right that our Irish and Appalachian fiddle tunes have to fight an overamplified and distinctly non-Irish Top 40 band for audience and attention. "Hey, excuse me for playing Irish music on St. Patrick's Day," Barry yells at young passersby hurrying to the tent. To keep that righteous anger alive, we mix in a little Clash and Sex Pistols as the night wears on, and sip from Ice House tall boys stashed behind the cases.

Saturday April 8, 2000. Last night Barry and I played our first indoor gig in a while: happy hour at a local brew pub. Not bad, but with heavy sound equipment to move and bar owners to mollify, not the streets. Now we're back out here and glad of it, high on the steady stream of good vibes coming from passersby and listeners. Even folks walking down the other side of the street clap and yell, and in many cases cross over to us; people wave and clap from slow-moving cars. Reprising the encounter from a few weeks ago, a group of college kids walks by, and one of them sidles up, leans in, and tells me, "Hey, man, we're in your class. We know it's you out here, but it's cool." And late, as the bars are closing, two young BMXers roll up, bouncing their bikes on the sidewalk, talking with us about the pleasures of being on the streets, of using their bikes and their street smarts to outmaneuver the police.

BMXers and hoedown dancers, homeless folks and club drunks, locals and tourists—all flow in and out of the little sonic space that Barry and I construct each night, finding there a conversation, a dance, a moment of pleasure. In turn, Barry and I jump genres, play requests, invent new songs, rolling with the ever-changing rhythms of the street as much as orchestrating them. In this way we and other street performers put into practice the anarchist ideal of fluid, give-and-take negotiation as a human alternative to the rigidity of rules and preplanning. Out on the streets we embrace some other anarchist

notions as well: vulnerability, tolerance, respect. Never knowing, as Barry says, "what person's coming around the corner" next, left happily unprotected by security guards or club bouncers, we remain vulnerable to whatever the street has to offer. Yet this very vulnerability breeds not fear, but common courage; it spawns a taste for tolerance, a practical respect for diversity, and ultimately a pleasure in the ambiguous, uncertain community of what's to come.

Ron Parks, a longtime busker and self-described "acoustic street-musician-on-a-bicycle," in this way talks of the "eccentric, anarchist nature of the busker, a natural, spontaneous, unique, original folk entertainment," and adds that, "Despite their individuality, minstrel buskers remain public property. They are accountable daily to the people. They are naked, vulnerable, and open to judgment every time out. . . . This closeness to hand-to-mouth existence is what expunges the tyranny of the pop show and by example strengthens resistance to it."[55] Parks's comments of course affirm the anarchic social dynamic that Barry and I discovered, a dynamic whereby buskers transcend their conventional roles as individual performers to become "public property," humble participants in a community of the street they and others continually create. His comments also suggest a related, antiauthoritarian agenda inherent in busking: do-it-yourself autonomy not only from minimum wage jobs and parasitic club owners, but from the corporate "pop show" that these days passes for music and culture. Barry in fact explicitly contrasts his street music to today's "Madison Avenue driven, media driven" culture, to "GAP ad" culture, and in reference to those who don't dig his old-timey fiddle music says, "If I was sold to them on television without them really knowing it, they would dig it." Parks adds that "street performers are beginning to see their art as a vital expression for people to counterbalance the megabusiness of global TV culture. . . . In the politics of fun, individual participation is the beginning and end of democracy."

In providing at least a fleeting alternative to corporate media culture, buskers' do-it-yourself politics of fun also resists and reshapes the spaces of corporate downtowns and commercial districts. As buskers set up to play and begin to accumulate an audience, they interrupt the usual structures of the street, creating little islands of cultural resistance and sonic inclusion amid the everyday river of isolation, commerce, and consumption. Years ago, Howard Becker

detailed the process by which working jazz musicians kept themselves "spatially isolated" on their own performative islands, often by rearranging instruments and furniture so as to barricade the band from its audience.[56] For buskers, the islands on the street function differently, encouraging spatial inclusion more than exclusion, but the importance of rearrangement remains. Buskers rearrange the sounds and spaces of the street, rearrange the ebb and flow of its occupants, but perhaps most importantly rearrange the meaning of street life, the experience of street spaces and, at least for a while, the intentions of those passing through them.

Eye Six, an accomplished hip hop graffiti writer, has said that "I go out where the winos are, where the bums are, and where it's rotting and fucked up, and I beautify it . . . puttin' up wallpaper for winos and bums."[57] That's not a bad description of what Barry and I and other buskers do as well, but with a twist; we try to put up a little sonic wallpaper, spray a little sonic graffiti, beautify cities increasingly fucked up not by rot but by "redevelopment," by homeless sweeps, corporate homogenization, and gentrification. As a later chapter will show, this is more than metaphor. At almost every turn, the spatial and cultural politics of graffiti writing mirror those of busking; on the streets, graffiti is to art precisely as busking is to music. And as we'll now see, these are not the only parallels; like buskers, others glimpse a street corner, a sidewalk, a bridge, and imagine them as something more.

TO MOVE THROUGH SPACE IS TO REMAKE IT

If our focus is on the meaning of public space, and the ways in which such meaning is contested through a mix of anarchy and illegality, we would want to notice not only those who occupy public space—buskers, squatters, sidewalk sitters—but those who move through it. Outlaw motorcyclists, for example, have over the past fifty years or so spectacularly taken over and transformed the safe, everyday meanings of the roads they ride, and have done so with such a finely tuned disregard for law and respectability, such an "anarchic, para-legal sense of conviction," that Hunter S. Thompson has likened them to Joe Hill and the Wobblies.[58] During these same decades, Latino and

Latina cruisers and lowriders have collectively transformed the streets into a mobile festival of cultural identity, into a "mobile canvas for cultural representation," into what R. Rodriguez has called "a Chicano alternative to Disneyland"—and for their trouble now increasingly face anticruising ordinances and "no-cruising zones" designed to remove cruising, and its potent ethnic symbolism, from public view.[59] As the following chapter will show, militant bicyclists likewise embrace this dynamic of space and movement, transforming the politics of the streets as they invent new ways to travel through them. Here we can consider two worlds where what first appears as simple, even self-indulgent recreation in fact functions as anarchic recreation, as a reinvention of space, body, and self. And in these two worlds, as in the physics of lowriders and bikers, the movement of energy through a system—specifically, illicit energy through a system of spatial and legal control—alters the meaning of that system.

The Skating Urban Anarchist

Skaters by their very nature are urban guerrillas. The skater makes everyday use of the useless artifacts of the technological burden. The skating urban anarchist employs [structures] in a thousand ways that the original architects could never dream of.

— Craig Stecyk, Dogtown artist[60]

Back on Tempe's Mill Avenue, the signage suggests the encompassing scope of the street's exclusionary spatial politics. Along with the "No Cruising, 8pm to 4am, Tempe City Code" signs posted along the way, almost every intersection features "No Bicycling, No Skateboarding on Sidewalk" messages, supplemented by wall-mounted signs warning that "Bicycles, Skateboards, Rollerskates, Loitering Prohibited A.R.S. 13-1501 A1." Taken together, such signs serve to encode cultural space, and to collapse the worlds of gutter punks, unlicensed street performers, street cruisers, skateboarders ("skaters") and others into an undifferentiated lump of marginalized illegality. For many skaters, though, this forced statutory cohabitation with the homeless and the marginal makes for a surprisingly comfort-

able fit, since skaters often embrace their degradation more than they deny it. Interviewed in *Thrasher* skateboarding magazine, Liz E. Beta, bassist with the band Clone, reminds readers that, "I like those kind of boys where when you're two blocks away, you think it could be a really fine boy or it could be a homeless person. You have to get within twenty paces to find out." Boone Doggle, whose poem appears in the same issue of *Thrasher*, must be pleased:

> I had an urge to purge my soul
> To grind a slab of 'crete
> The very first board I ever owned
> I was living on the street[61]

Where, though, would a bunch of kids, caught up in skateboarding as a youthful hobby and a recreational pastime, sitting around reading *Thrasher*, find such a sensibility, such a taste for cultural estrangement? To begin with, they might find it among themselves, if in fact this "hobby" existed for them not as a pastime but as an inclusive way of life, intertwined with alternative cultural identities and oppositional politics, and stretching across prescribed boundaries of age and social class. If not there, they might find it in the face of the ongoing and increasing criminalization of their lives and their activities; after all, any kid who skates the streets is accustomed to being illegal, to encountering "No Skateboarding" signs as pervasive as the strip malls and parking garages they punctuate. Or, if this residency in an increasingly criminalized subculture is not enough, skaters might well discover their sense of estrangement, of defiant affiliation with gutter punks and homeless folks, as they join them in fighting back against it all. Many skaters see *Thrasher* magazine as a relatively quiet echo of the real action on the streets, but even there some sense of this skater resistance can be glimpsed. One skater reports that upon seeing a "No Skateboards: Violators Will Be Prosecuted By Local Police" sign, "feelings of rage and rebellion" took over, and "a short time later, after I conquered that which threatened my livelihood, I attached the sign to my wall." Two other skaters send in a photograph to the magazine's "Photograffiti" section, to "show off their booty from a two-night skate spot liberation spree." Hiding behind masks and shades, they display a rich collec-

LIVERPOOL JOHN MOORES UNIVERSITY
LEARNING SERVICES

tion of "No Skateboarding" signs ripped from tennis courts and walkways.[62]

As the language of "skate spot liberation" would imply, these publicly celebrated acts of skater vandalism embody more than mindless destruction; like the acts of vandalism explored by Stanley Cohen[63] and others, they aim to reclaim more than a few cheap signs. For skaters, such acts exist as skirmishes in an ongoing battle, a battle to liberate public space from legal regulation, and to reencode the meaning of public space within the experience of skating. Toward this end, skaters who don't bother removing "No Skateboarding" signs from strip malls and parks still counter them with a touch of subcultural signage, pasting them over with "Know Skateboarding" stickers that have become almost as common as the signs themselves. Like the illicit countersignage of bicycle militants documented in the following chapter, like the hip hop graffiti recorded in chapter five, such symbolic counterattacks accomplish a double purpose: they both reclaim public space for the activities of marginalized groups, and confront the legal codes that have kept such space from them. Yet while the pace of this spatial conflict seems to be picking up—with increasing criminalization of the skater subculture, and increasing politicization and resistance on the part of skaters—the essence of the conflict is nothing new. All along, skating has involved illicit intrusion into public and private spaces, a form of trespass as much cultural as legal, and always the imaginative, illicit remaking of these spaces and their meanings.

Early on, some of the most significant spaces emerged in and around "Dogtown," the name locals give the rundown areas of Venice and Santa Monica in southern California. There, in the early 1970s, a group of "poor kids with something to prove," self-acknowledged "little rats in surf trunks" bred to the beach and the water, began to ride not just surfboards but skateboards, and to imagine ways of surfing the streets. Discovering a hillside junior high school playground with sloping fifteen-foot paved embankments, they imagined the embankments to be what Dogtowner and skate legend Tony Alva has called "huge, glassy waves," and made them just that as they deployed their ocean surfing skills in negotiating a new world of asphalt curls.[64]

Soon the Dogtowners discovered something even better: the drought-dried backyard swimming pools of southern California's wealthy. In Bel Air, Brentwood, Malibu, the kids uncovered some

significant cultural space—O.J. Simpson's football-shaped swimming pool, a magician's rabbit-shaped pool—and decided to engage in a bit of cultural and class appropriation, a little skate spot liberation of their own. Organizing an informal network of pool-hunting skaters, rolling down back alleys and perusing real estate listings on the lookout for unoccupied homes and dehydrated pools, they found in the failed aqua-aesthetic of backyard beauty and upper-class indulgence a veritable skate punk playground. The pools' concave surfaces, vertical walls, and smooth edges provided a near-perfect laboratory for inventing the sorts of aerial and edge-walking maneuvers now commonplace in the skate world. But of course for all their appealing features, these pools weren't exactly public property, and so the Dogtowners jumped fences, set up lookouts, and otherwise engaged in trespass with a serious sense of purpose. The effect of this organized illegality and illicit access—an effect we'll see with BASE jumpers, graffiti writers, and others—was certainly some arrests on trespass charges, but more so a sharpened experience of these newfound spaces. "The adrenaline rush of jumping over a fence and actually skating in someone's backyard and getting out of there before they came home . . ." remembers Alva. "That was totally crazy."[65]

Crazy also was the context in which all of this was unfolding. By the mid 1970s, southern California's emerging hardcore skate scene was crossing over into the L. A. punk scene. Mike Muir, lead singer for the seminal southern California punk band Suicidal Tendencies, was the younger brother of Jim Muir, one of the original Dogtown skaters, and the Dogtowners began to attend shows by Suicidal Tendencies, Black Flag, and Circle Jerks, and to otherwise affiliate with the punk world. The affiliation was as much attitudinal as musical, with both groups pumping out an angry disregard for private property and public propriety. Referencing Malcolm McLaren's and The Sex Pistols's inflammatory use of Nazi iconography, photographer Glen E. Friedman—who began at age thirteen shooting images of skate friends in action—recalls that "When girls used to ask Jay [Adams] for his autograph, he'd draw swastikas on their breasts. He wasn't a Nazi, he just did it to be fucked-up. What The Sex Pistols started doing in 1976, Jay and Tony were doing a year earlier."[66] The Dogtowners drew on another outlaw subculture, and outlaw iconography, as well: urban graffiti. One of Friedman's remarkable photographs from this period shows Jim Muir

riding up over the top edge of a swimming pool, the underside of his skateboard flying out toward the camera—and painted on it a perfect rendition of "DOGTOWN" street graffiti, the "DOG" and "TOWN" crossed at the common "O."[67]

Today these same dynamics continue to shape skating. Skaters still confront the webwork of law and regulation that closes public and private space to them; invent new ways of skating, and thus remaking, such spaces; and do so within an eclectically oppositional politics informed by punk, hip hop, and other alternative aesthetics. Tired of skating (and damaging) plastic park benches, pro skater Joe Pino pours his own concrete bench and sets it up in a San Diego park; utilized by skaters, sat on and slept on by other park patrons, it is ruled "not up to code" by city officials and confiscated.[68] Likewise, in Chicago, skater Stevie Dread allegedly pours "non-city-approved concrete" over vacant lots "in order to turn them into skate spots," a do-it-yourself solidification "not well appreciated by Chicago's law enforcement agents."[69] Another group of skaters embarks on (and videotapes) an anarchic cross-country skating journey, undertaken "with or without a car, with or without money, and with or without a destination." Along the way, they stop to climb the giant highway signs marking state borders, and manage to affix their oversized logo—a distinctive cutaway cube—to signs welcoming travelers to Colorado, Kentucky, North Carolina, Massachusetts, Illinois, and Nevada. They take time out to ride freight trains, walking the tops of cars and huddling in plastic and sleeping bags on their rear decks, getting busted by the railway police. They skate an astounding array of found objects and locations—sidewalks, streets, outdoor restaurants, underpasses, bridge abutments, parking garages, stairs, handrails—and send themselves and their boards flying over stairwells, construction barriers, and parked cars. At the end, as their video fades to black, they offer a little poem that Bakunin or Kropotkin—or for that matter Kat and Leif back on Mill Avenue—might admire:

Less Is More

Stay Pure Stay Poor[70]

Meanwhile, back in *Thrasher*, skate equipment manufacturer GrindKing runs a series of double-page advertisements, juxtaposing

various legal activities—Klu Klux Klan marches, for example—with the illegality of skating. (My favorite: A photograph of a hunter with a freshly killed snow hare, captioned "This Is Legal." Next to it, a photograph of a skater, grinding a parking garage railing in front of a parked Mercedes-Benz, captioned "This Is Not."[71]) *The New York Times* tries to explain skating to its readers, helpfully pointing out that skateboarding "is a sport that uses the urban landscape as its playing field." Exploring skating in Boston, the paper records an older resident's concerns—"I'm sorry, that's not the way Boston should be represented"—and quotes the director of *Transworld Skateboarding* magazine: "Kids don't see the world the same way adults do. They see a beautiful marble ledge as being a great thing to jump off of."[72] But *The New York Times* or not, the skaters themselves best explain their appropriation of public space, partly by placing it in the context of graffiti writing and other spatial innovations: "Both skaters and [graffiti] writers view the environment differently from everyone else. Staircases, handrails, curb cuts, train tunnels, truck yards, and city streets have become the new playgrounds for the next generation. We find value in what others deem useless. Empty pools and abandoned buildings become our offices. But no need to punch a timeclock here—we work on our own schedules."[73]

James Davis shares this lust for the skating life, and its transformative effects on the found environment. A Flagstaff skate legend, Davis knows the contemporary history of skating inside out—he reminds me that now, twenty-five years later, "Tony Alva's still skating pools"—and locates his skating squarely in the Dogtown tradition of appropriating pools and playgrounds. Commenting on local authorities' attempts to confine skating to city-sanctioned skateparks, he argues that these legal spaces in fact provide the justification for further crackdowns on skating in illegal public spaces, and adds that in any case such parks "kill the heart of skateboarding. . . . It's much more fun to stake some guy's house out, hop his fence and skate his pool. Find some abandoned house in the middle of nowhere and clean [the pool] out, you and eight friends and brooms and a bucket. Clean it out and skate this thing, try like hell not to hit the diving board. . . . Seek and destroy; skate and destroy; skating shit that wasn't meant to be skated."[74] If Davis's comments echo Bakunin's dictum that the destructive urge is a creative one as well, his

views on crime and resistance likewise reflect a distinctly anarchist disregard for legal boundaries, wherever they may fall. Detailing the increasing criminalization of skating, and the growing resistance to such criminalization among skaters, Davis says, "You see the shirts and the stickers everywhere and people yelling all the time, 'Skate-boarding is not a crime.' Yes it is. You know, we don't need your sympathy. We don't care; we never have, we never will. You can throw up all the signs you want. You can take us to jail; we'll get out. You can put up a fence; we'll find a way over it."

As evidence of this resiliency and resistance, Davis describes the latest antiskating spatial control tactic—the installation of protruding bolts along handrails, so as to wreck skaters who attempt to grind such rails—and he suggests that I check out an underground skate video, *Welcome to Hell*.[75] Sure enough, there in exquisite slow-motion detail is pro skater Ed Templeton, gliding his board down a long handrail—and then deftly kickflipping the board over the endbolts, and into a graceful aerial dismount. Like the radio rebels to be seen in chapter four, James Davis and other skaters don't just fight legal and social control; they dismiss it, and consistently find ways around its next permutation. And like BASE jumpers and graffiti writers, James Davis and countless other skaters find resistance not just in their attitudes toward authority, in their disregard for the law, but in the finely honed, pleasurably illicit skills of their subcultures.

Significantly, Davis didn't bring this sense of politics and resistance to his skating so much as skating brought it to him; while transforming public space atop his board, he found himself transformed by the experience. At eight years old, he saw his first skate video, and discovered "this wonderful glorious thing called skate-boarding . . . that spoke to me like nothing I've ever found before or since." Yet as soon as he had polished his skills enough to "take it off my mom's driveway and into the streets" he found himself "harassed by a cop." And so, at ten years old,

> It was the first time that sort of conflict arose in me. Because I loved it so much and I could not understand why they were trying to stop me from doing it. And it was the first time in my life I'd ever thought, fuck you, I'm not stopping this. Take me to jail. I don't care. I'm not stopping for nothing. And that

definitely opened the door and paved the way for me to start to think about problems. And the older I got, and the more times this happened, the more I set out looking for answers to, "What is the problem?"—and the more problems I found.

Many of these problems Davis found in the spaces he skated. As he began to skate more widely around Flagstaff and other cities, he began to ask himself, "Why is this guy so ready to beat me over the head?" The answer, he realized, was the same from Mill Avenue to New York City: "We're skating in front of his store. . . . In any commercial district you're asking for trouble. You pick any city in the United States and you try to go skate their downtown, you're getting ticketed or going to jail or the cops are going to take your board." Retreating to the safety of a college campus, "coming to school to get my degree" didn't help much, either; his encounter with campus police while he was skating in front of the Northern Arizona University bookstore sparked a public confrontation between the campus police and students.[76]

As with many skaters—one of whom we'll meet aboard a bicycle in the following chapter—the everyday politics of illicit skating ultimately led Davis to a broader involvement in politics and political activism. Today, he works with Food Not Bombs to feed the hungry around Flagstaff, and he has helped put together a punk/hip hop pirate radio collective for much the same reason that Barry fiddles on the streets: "combatting the pop culture crap . . . heartless, pointless candy-coated shit." In all of this, Davis sees himself operating within the sort of skate/punk ethic embraced by Kat, Leif, and others, an ethic that blends the experiential anarchy of "craziness, creativity, insanity, don't care, whatever-happens-to-my-body type skating" with a wider social commitment to antiauthoritarian "nonviolence, anarchy, and peace." Within this ethic he has put into practice the do-it-yourself autonomy of anarchism, as embodied in the informal, self-organized "skater patrol" through which he and others watch over the local skate park and "won't let anyone fight inside the gates." But he has also come to see the expansive, inclusive nature of both problems and solutions. "You start to realize that there are a lot of people that realize what's going on and are doing something about it. But as an anarchist you have to see that there's so much to do, there's so much to be done." So, for James Davis, skating's "not a hobby, not

recreation, not something I'm going to grow out of"; it's an ongoing experience, a way of life and way of living that continues to transform self, space, and politics, *por vida.*

Trying to help me understand this, James Davis has provided me with a remarkable array of videos, magazines, news clippings, and self-produced stickers, each revealing something of skating's complex culture and politics, some even reproducing old Wobbly slogans in this new context of skate punk anarchy.[77] But among all these, one small piece in particular stopped me short. It's a quotation, taken from a 1998 *Thrasher* article on "Understanding the Urban Blight"—an article that explores the links between skating and hip hop graffiti writing, an article that includes images like a "GRIND" graffiti mural, a skateboard painted in place of the "I." The words are from "Crisis," a kid looking back on his life (so far) as a skater and graffiti writer:

When I was younger, I spent many midnights grinding curbs, carving banks, shooting hills, and skating my city's streets aimlessly. Nowadays, I often trudge through the AM with a flooded Pilot [marker] or a can of Rusto Regal [spray paint]. This mission has brought me to strange and beautiful places that average civilians will never see. Whether lying in a snowbank watching a maze of monstrous freights crash and roll or taking in the desert sky at an old drainage ditch in the middle of Nevada, I've gained a lot from this quest. I've found parts of who I am in long stretches of train tracks, in abandoned parking lots with makeshift quarterpipes on banks, under bridges, on rooftops . . . alone, with the view of the entire city beneath me. I've easily caused thousands of dollars in damage, gotten in fights, and injured myself and others. But at the same time, I've busted a perfect Smith grind on my favorite curb, beautified a cold train with a colorful wildstyle piece, hit a perfect line at my old local bank, and caught tags all over the country. For me, it's about an eternal search for a feeling, a vibe, an attitude that's found in the curve of a letter or the way you grind over the death box. No matter how commercial this shit gets, it's this essence that true writers and skaters know as "style."[78]

Listening to Crisis, thinking about James Davis, I hear the long grind of the skateboard, the nocturnal hiss of the spray can, coming together in the stylish remaking of public space. I hear the equation that Barry, Eye Six, I, and others have formulated on the streets—graffiti is to art as busking is to music—expanding along those drainage ditches and rooftops that Crisis describes, such that graffiti is to art as busking is to music . . . as skating is to sport. But I hear something else, too. I thought I'd caught a little of it in that earlier on-the-road skate trip, in those kids riding freight trains, skating city streets, daring to suggest that "less is more," that we should "stay pure, stay poor." Now with Crisis, I'm sure of it. Those aren't just the echoes of Bakunin and the Wobblies ringing in the words and lives of Crisis and James Davis; they're the echoes of the old dharma bums, of Kerouac and Cassady and Ginsberg, crisscrossing the country, finding themselves along train tracks and under bridges, losing themselves in some eternal search for a feeling, a vibe. Mad for those who are mad to live, the beat poets aren't gone; they're still around, running with skaters and graffiti writers, tearing down the streets with them.[79] Yeah, maybe. But are they jumping off Christ with them as well?

BASE Jumpers:
Like Going to Rio and Jumping Off Christ

Once I hit the air it felt like I was home again.
—Gravity Girl, 1997

I'm back on a bridge again, but a long way from Prague's Charles Bridge and the street band we put together there. Surrounded by the rolling hills of Fayette County, West Virginia, I'm standing in the middle of the New River Gorge Bridge, at 876 feet above the gorge the second-highest bridge in the United States. Actually, I'm not standing so much as leaning, hanging out over the railing as far as I dare. With a slight breeze blowing it's a tough balancing act, made more difficult by the camera in my left hand and the microcassette recorder held out in my right. The body rushes of what's going on up here don't help, either; I can feel the tingling surge of adrenaline up

under my shoulder blades, the light-headedness of altitude super-charged with excitement. And I'm the one playing it safe.

A number of people near me, you see, are jumping off. Today is Bridge Day, an annual event that attracts some 100,000 people, "the day of days around here," as a local television reporter tells me up on the bridge, the day in which the bridge itself is transformed from a transportation structure into a festive staging area for locals and tourists. Among all those thousands of locals and tourists, though, attention remains focused on the handful of people sharing the small area I now occupy, a staging area of a more specific sort. Here, for this one day a year, the center of the New River Gorge Bridge becomes a legal home for BASE jumpers from around the world—for those who parachute from buildings and bridges—and they're parachuting now, a jumper leaping from this mid-bridge exit ramp every thirty seconds or so. This is what the tourists and the locals come to see, this beautiful day-long display of multicolored parachutes settling toward the river and woods below, and more so, this day-long public confrontation with the possibility of injury and death. It's what the media comes to see, too. Around me is not just this one reporter, but a frenzy of image production, as local, national, and international television news crews and documentary filmmakers push for position, interview jumpers as they wait their turn, train their cameras on the jumpers as they go airborne. But that's not what's giving me the chills. It's the jumpers, many of whom I've come to consider friends, grinning back at me as I grin up at them on the exit ramp, yelling "Let's go" and "3,2,1, see ya!" as they leave me behind.

While this public accumulation of BASE jumpers at Bridge Day is unusual—300 or so on any given year—the act of BASE jumping is not. Over the past couple of decades, BASE jumping has grown into a distinctly underground, largely illegal world that mixes moments of extreme risk with the aggressive appropriation of public and private space. In fact, the "BASE" acronym itself references the act of parachuting from four distinct locations: Buildings (downtown skyscrapers, completed or under construction; grain silos; smoke-stacks), Antennas (television and radio towers), Spans (bridges, railroad trestles), and Earth (cliffs, outcroppings). Semi-official "BASE numbers," highly valued symbols of subcultural status, are granted only to those who have successfully jumped all four loca-

tions. Like the skaters who employ parking garages and pools, the "useless artifacts of the technological burden . . . in a thousand ways that the original architects could never dream of," BASE jumpers convert the structures of industry and commerce, the residues of economic development and environmental erosion, into an infrastructure of extreme excitement.

Years ago, before I had heard the term "BASE jumping," that infrastucture almost killed a buddy of mine. In those days, back in Austin, my friend Steve Lyng and I were deep into what we might call an integrated culture of extreme risk. Steve and I were riding and racing stripped-down Harley-Davidsons as part of a loosely organized, generally intoxicated group known as the Maddogs. But Steve was also a jump pilot, flying the jump plane at the local skydiving center, and so many of the Maddogs came from this world as well, bringing its skills and attitudes along with them. The "relative work" of skydiving, for example—an experience in which skydivers join hands during freefall to form momentary patterns and alliances—was offloaded onto the motorcycles, such that those of us riding separate bikes would join hands for relative work during high-speed backroad runs. One such dual risk-taker among us was Rick, an accomplished skydiver and motorcyclist who rode a very fast Harley-Davidson Café Racer very dangerously. One day Rick turned up missing, and a few days later we heard the terrible story. Rick had gone down to Houston to parachute off the Texas Commerce Tower, but on his descent had caught a gust of wind up under his chute, throwing him into and through another building's glass awning. Broken bones, deep lacerations, and arrest resulted.[80]

At the time, Steve and I were also in graduate school, reading Hunter S. Thompson and Paul Feyerabend and Michael Bakunin, trying to make sense of our behavior and that of friends like Rick. We knew that, somehow, these near-death confrontations were also affirmations of life, were attempts to negotiate some boundary between chaos and order, creativity and destruction, and so we stole Thompson's notion of "edgework" and begin to apply it to ourselves and our friends. Eventually, Steve would develop this notion into a full-blown theory of "voluntary risk taking."[81] But even back then, when the theory was just beginning to emerge out of our everyday experiences, we had no doubt that Rick was one hell of an edge-

worker. We just didn't realize he was what people would come to call a BASE jumper.

Now, after years of living and teaching on opposite ends of the country, Steve and I have gotten back together. He's up here with me on the New River Gorge Bridge, and together we're exploring the BASE jumping world we first glimpsed with Rick, thinking about its connections to edgework. Dragan Milovanovic, the colleague who organized this expedition, is also up here. A veteran skydiver, Dragan jumped the bridge at Bridge Day in the 1980s, and now a decade later is back renewing old acquaintances and interviewing BASE jumpers. As Dragan first suggested when the three of us were putting together this research project, and as our interviews and experiences with BASE jumpers confirm, BASE jumping does indeed offer an extreme manifestation of edgework. BASE jumping ups the ante appreciably on the already risky sport of skydiving; in comparison to skydivers exiting a moving plane at altitude, BASE jumpers have no forward velocity to help pull open their chutes, no time to correct for mistakes or deploy backup chutes, and little control over exit points or landing areas, which BASE jumpers are most often forced to access surreptitiously and illegally. In BASE jumping, the edge between chaos and order, creativity and destruction, is a thin one indeed.

This thin edge emerges specifically in the spaces occupied by BASE jumpers, who organize their world around the fleeting, illicit transformation of buildings, bridges, and smokestacks into sites of pleasure and risk. In this sense Bridge Day, with its stable repetitions of public approval and festive legality, is atypical; at Bridge Day, the predictability of the event begins to transform BASE jumping into a phenomenon that is equal parts public spectacle and media commodity. Yet even here, BASE jumpers have succeeded not only in gaining access to a very desirable jump location, but in transforming the meaning and experience of a beloved local landmark, and in fact reconstructing its history, as they continue year after year to jump off of it.

More typically, though, BASE jumping incorporates an ongoing, illicit search for new locations and new experiences, a fluid, transformative vision and practice that reinvents spaces as they are encountered. At Bridge Day 1997 the three of us sat in a local bar, drinking and talking over the music with Bart S., a legend in the BASE jumping

Figure 2.2: BASE jumping from the New River Gorge Bridge on Bridge Day.
Photo by Jeff Ferrell.

underground and survivor of hundreds of illicit jumps at locations around the world. Compact, tough, and intense, at the same time funny and engaging in a way that puts those inside and outside the underground at ease, Bart talked about his journey as a BASE jumper—a journey that led him to arrive at Bridge Day the following year with a broken neck. (He jumped anyway.) As you become more involved with BASE jumping, Bart recalled, "you start to look at buildings and antennas differently." And as for his arrest for BASE jumping off the Eiffel Tower, well, he understood; it was "insulting to them, just like going to Rio and jumping off Christ."

Outside of the few sanctioned events like Bridge Day, this potent intersection of illegality, risk, and spatial transformation defines the BASE jumping experience. The substantial risk and adrenaline rushes of the jump itself build from the illicit activities that necessarily precede it, as BASE jumpers launch nighttime ascents on buildings under construction, scale the exterior ladders of water towers and smokestacks, and make their way up off-limits cliff faces, all while

packing full parachute rigs. Likewise, the rush remains even upon a safe landing, as jumpers scramble to elude authorities by hiding gear, sprinting to getaway cars, or, in one famous case, hailing a getaway cab in the middle of New York City. Two other well-known cases, involving Yosemite National Park and its El Capitan Mountain—an out-of-bounds favorite of BASE jumpers—suggest that, in certain cases, the illegality of BASE jumping doesn't just enliven the experiential mix; it creates a self-fulfilling spiral that overrides it entirely. In the summer of 1999, BASE jumper Frank Gambalie III safely landed a jump from El Capitan, but drowned in the nearby Merced River while on the run from park rangers intent on arresting him and confiscating his equipment. Later that year, during a five-person jump organized to protest Gambalie's death, BASE jumper Jan Davis died when her chute failed to open. Park officials argued that her death proved that BASE jumping remained too risky to be allowed in the park. BASE jumpers knew better—knew that, in a way, the officials themselves had pushed her over edgework's carefully negotiated line. Aware that her own, top-of-the-line jumping gear would be confiscated by park rangers upon landing, Davis had jumped with unfamiliar, borrowed gear—a deadly accommodation to the authorities, as it turned out. Meanwhile, on the ground, a protestor held a sign whose irony James Davis and other skate punks might appreciate: "BASE Jumping Is Not A Crime."[82]

But of course, as James Davis would point out, BASE jumping *is* a crime, and as such nicely embodies the extra-legal, antiauthoritarian politics of anarchism. It's not just that BASE jumpers predicate their activities on undermining the law and eluding legal authorities; they actually fold their identities as anarchist outlaws into the experience of BASE jumping itself. This is in fact just what Steve and I had begun to realize about edgework over the years: it functions as a form of experiential resistance precisely because its practitioners—outlaw motorcycle riders, graffiti writers, BASE jumpers—are so adept at subverting the meaning and experience of social control, at translating their own criminalization into enhanced excitement and richer rushes of adrenaline and pleasure.

And we came to understand something else, too: edgework embodies, as part of this anarchic inversion of authority, the anarchy of autonomy and self-invention. Appearances to the contrary, edge-

workers aren't driven by a death wish, but by a lust for life—a life that they invent not just in edgy moments of risk, but out of their ability to confront and conquer those moments through their own self-made skills.[83] On these terms BASE jumping beats deskilled, downsized, and downright unexciting office work every time, in the same way that busking beats "busting my ass doing something I hate" for Barry. On these terms BASE jumpers mock the mass-produced bluster of the "No Fear" clothing line, wearing instead T-shirts that say "Know Fear"—because knowing fear means knowing yourself. And on these terms a member of the Gravity Girls—a women's BASE jumping team—talks with me immediately after landing a jump at Bridge Day.

"Once I hit the air it felt like I was home again. You never get enough, you know, and to see the ground coming up the way it does and once you pitch [your chute] to just be snatched from the jaws of death. . . . But it isn't a death wish like everybody thinks it is. You know you're alive when you do this; every sense is working. . . . You want to live so you can do it again."

"Yeah, right, if you die it's your last jump."

"Damn it. I hate when that happens."

If BASE jumping produces an autonomous politics of the self, if it embodies for each jumper the pleasure and price of stepping outside the everyday, it also spawns a subculture operating on much the same collective principles. Gravity Girl tells me that "it's such a small world . . . it's like a family. Everywhere you go even if you don't actually know that person you feel like you do. . . . We kind of watch each others' back in that way." With this BASE jumping world becoming the focus of growing mainstream media attention—top jumpers like Marta Empinotti are featured in everything from *The Los Angeles Times* to *Vogue*[84]—BASE jumpers increasingly watch each others' backs through a little media of their own, also. In classic do-it-yourself fashion, they employ helmet-mounted and body-mounted cameras to videotape themselves and each other while jumping; produce and circulate underground jump videos, and sometimes sell them to the mass media; and share information and identities by way of their own auto-mediated channels. In doing so, BASE jumpers, like buskers and skaters, counter popular culture as much as they participate in it, creating a world of sounds and images as autonomous as the events they capture.[85]

Back at Bridge Day, the anarchic ethos of BASE jumping survives, bubbling up past the park rangers and the cops, past the funnel cake stands and the portable snake pits set up to snare tourists near the bridge. I must admit, on my first visit to Bridge Day I thought that maybe here, maybe at this public event, with hundreds of BASE jumpers risking their lives and a hundred-thousand spectators looking on, the underground would give in to commodification, and worse, to careful organization and centralized authority. I was wrong. While there is certainly sufficient coordination among the jumpers to keep the day moving, there's obviously no more than necessary. At the exit point up on the bridge, participants are jumping off in yellow chicken suits, Elvis costumes, prison stripes. Those BASE jumpers put "in charge" of offering assistance are also offering some subversive perspective:

"Any competitors? Competitor BASE jumpers? There's only going to be one round of the competition. It took a little bit longer than expected. It's a free-for-all. We're back to Bridge Day."

"You guys go ahead and take the day off. Yeah, go ahead. I'm fired."

And this advice, from Bart to a novice jumper he's befriended, as the novice nervously readies for takeoff: "Look at the horizon; jump. Go 'one Mississippi,' and if you're still stable, go 'two Mississippi,' but if you're not stable, go ahead and throw the damn pilot chute. And if you're screaming and flailing and stuff like that, don't tell anybody you know me."

Meanwhile, down at the landing area, where jumpers must fly in precisely over the river and drop in on a small stretch of gravel shoreline, hundreds of people have illegally hitched rides down the gorge and gathered around. But there are no heavy-handed security guards working crowd control here, no strictly cordoned-off areas— just on-the-ground BASE jumpers yelling "heads up," and urging folks to take a few steps back, as a comrade flies in. Of course, if I'd thought about it, I should have known it would be this way. Arriving the night before our first Bridge Day, Dragan, Steve, and I immediately noticed the "Sky Punk" T-shirts and windbreakers worn by many of the jumpers around the headquarters hotel. Finding the event "organizer" there also, we thought it a good idea to check in with him, ask him if our research would be allowed. A veteran BASE

jumper, resplendent in his shaved head and skull tattoos, he offered in response a definitive statement on edgework and anarchy: "You have my permission to do whatever the fuck you want."

SOME OVERBURSTS OF AMERICAN JOY

And his "criminality" was not something that sulked and sneered; it was a wild yea-saying overburst of American joy. . . .
—Kerouac, *On the Road* [86]

Maybe Kerouac and Cassady, Bakunin and the Wobblies are up there with the Gravity Girls and the Sky Punks after all, going to Rio and jumping off Christ, doing whatever the fuck they want. I know they're rolling with James Davis and the skate punks. I know they're around when Barry and I are playing the late-night streets, when homeless folks and college kids are dancing around us on the sidewalks, and Flagstaff's burning. And I'm certain they inhabit those handmade hobo camps around Flagstaff, that they ride the bus with out-of-luck Navajos down to Phoenix, distribute outlaw sandwiches with Food Not Bombs in San Francisco, squat on Mill Avenue with Leif and Kat. Peter von Ziegesar is certain, too. Writing about his homeless stepbrother in the documentary journal *DoubleTake*, he recalls keeping his itinerant stepbrother's spirits up by reading him passages from *On The Road* over a long-distance cell phone call, and says of him, "he boards the Greyhound bus for nowhere, anywhere; he's a Neal Cassady without women, without Jack Kerouac for a biographer, a beat figure riding through the night without friends, fresh clothes, a shower, or money—and, of course, without glory." [87]

Skaters, BASE jumpers, gutter punks, homeless folks, street musicians—they all occupy worlds that do indeed blend beat poetics with touches of anarchist insubordination. Time and again, their worlds throw uncertainty up against predictability and order, offer moments of autonomous pleasure in the face of orchestrated entertainment, celebrate a sort of shambling marginality in counterpoint to an emerging economy and aesthetics of middle-class life. And while it's clear that troublemakers like Randall Amster and James Davis know and act on the essentials of anarchist theory and history, this

isn't a necessary prerequisite; appropriately enough for an orientation founded on direct action, many seem to find their anarchist politics right there in the experience of everyday life. There's much to be learned about dignity and freedom from Bakunin and Kropotkin and Goldman; from Kerouac and Ginsberg, too. But there's as much to be learned from standing up (or sitting down) to Rod Keeling and the DTC, from skating a curve that's never yours to skate, from hearing your music flow and fill the street, from watching yourself and your world wander away from the regulations meant to contain them.

Ah, but that wandering, that exuberance, that insubordination— you see, there's the problem. None of this is particularly helpful to city managers and corporate developers, especially when it exists in forms not readily amenable to being bought and sold. And so, to be a skate punk or street musician or BASE jumper these days is to be caught up in conflicts over the occupation of cultural space, to find yourself not only skating or sitting or jumping, but resisting a widening web of legal and spatial controls. As that web continues to widen, continues to be sold as a reasonable response to public "crime" problems and the need for "community," it's worth remembering precisely what's being regulated, and more often criminalized: hanging loose with friends on the street; playing music; skating benches and handrails; parachuting off buildings and bridges. Of course, engaged in these wild yea-saying overbursts of American joy, the practitioners of street life and street culture are indeed guilty—guilty of putting adrenaline, pleasure, and the quest for shared authenticity ahead of corporate law and economy. Worse, such folks are not only wild, but wild in the streets, wild in ways that display their disregard for the mandates of legal control, that openly obstruct the avarice of economic development. As such, these people and groups constitute image problems, symbolic threats even, to be regulated and rationalized or, failing that, simply expunged from everyday life.

Now I've been accused before of romanticizing resistance and lionizing outlaws, so let me be clear: Am I suggesting that essential issues of human dignity and freedom, of individual autonomy and social welfare, are at stake in the everyday battles between gutter punks and downtown developers, skaters and cops, street musicians and city bureaucrats? Am I really suggesting that a war is being fought in the streets, a war between joy and injustice, marginality and privilege,

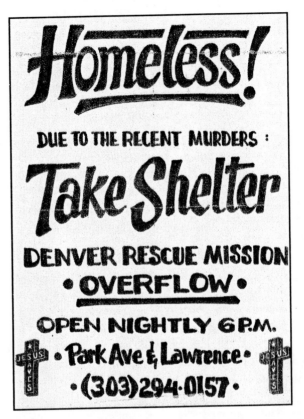

Figure 2.3: A sense of what's at stake: Street flier, Denver, Colorado.

anarchy and authority? Well, yes. But to avoid wandering too far into the romance of it all, let me also note some rather more concrete issues running just below the surface of this war—issues that suggest just what is at stake, day to day, in the street fight over cultural space.

As a start, it's worth recalling that homeless activists, gutter punks, and street cruisers have all argued in this chapter that their cities are "not Disneyland," and have bemoaned the "Disneyfication" process already underway. As suggested in the previous chapter, their complaints embody more than metaphor; they reflect the corporate closing of public space, the closing down of what Randall

Amster and others see as the spatial foundations of democracy. Reporting on the proliferation of antihomeless ordinances, *The New York Times* offers another clue as to what's at stake, noting that such ordinances seem aimed at "soothing shoppers' eyes" and at redeveloping urban neighborhoods in such a way that they're "scrubbed clean."[88] Explaining the rise in homelessness itself, an Urban Institute researcher adds that the well-to-do "are pushing the price of housing up and taking over more space." Accounting for the growing number of fatal assaults on the homeless, the executive director of the Chicago Coalition for the Homeless cites urban gentrification and the heavy enforcement of antihomeless laws, which provide "the underpinning of these hate crimes" by promoting the image that "these people don't count. These people are criminals for being poor."[89] But the Rev. Amos Brown, a San Francisco supervisor who has proposed an ordinance that would ban standing on a street corner for more than five minutes, summarizes the stakes best. "We need to decide," he says. "Are we going to be a society where there's a sense of order, or do we want a disorderly society where anything goes?"[90]

Bad news, Rev. Brown. Growing numbers of gutter punks, skaters, buskers, BASE jumpers, and everyday anarchists are deciding for disorder, for five minutes or more where anything goes. And it's worse than that. They don't just mean to go wild, to embrace a sort of criminality convulsed in overbursts of American joy. They mean to desecrate your sanitized streets, to undermine the foundations of order and ordinary life on which they're built. They mean to take them back.

Taking Back the Streets

The first time I ever went to Critical Mass, what struck me was that it reminded me of a Take Back the Night march. You know, it's like, by yourself, singly, you're powerless. You're subject to violence, you're subject to death, you're subject to a lot of aggression and harassment. . . . And that's what makes it so powerful, that you feel that you're reclaiming the space, that by yourself is not yours.

—Caycee Cullen, Women's Critical Mass activist,
Berkeley, California

ADVENTURES IN STREET ANARCHY

At a little before 10 P.M. on a cool summer night, I'm cruising along in the dark on a borrowed bike, running stop signs and dodging car traffic, down through the back streets of West Berkeley toward the Bay. Riding alongside me is "The Twenty Inch Crank," a bicycle militant and alternative transportation activist, an agitator for the radical cycling movement known as Critical Mass, a pirate radio disc

jockey, and, as a result, a regular and involuntary visitor to the squad cars, courts, and jails of the Bay Area. In fact, as we ride along, now and again intentionally impeding the progress of car traffic and otherwise testing the street's legal boundaries, The Crank outlines for me the fine points of California law regarding bicycle and car traffic. Earlier in the day, he had mentioned his goal of attending law school, because the world needs "more bike activist attorneys." Tonight, though, our focus is on pirate radio, which has just returned to the airwaves of the East Bay after a Federal Communications Commission (FCC)–enforced yearlong absence. Previously, Berkeley's pirate radio fix existed in the form of Free Radio Berkeley; tonight, it's on the air in the form of Berkeley Liberation Radio, and more specifically Bicycle Liberation Radio in the 10:00 P.M. to 12:00 A.M. slot—if we get to the studio by then.

First, though, the couch. A few blocks from the studio, and just short of a major north/south parkway through Berkeley, we spot it and stop. A big, heavy, back-busting foldout bed model, stinking of too many years of sweat and spilled beer, it sits abandoned on the sidewalk next to trash cans and dumpsters. Dismounting the bikes we begin a discussion: should we put it in the middle of the intersection, or on the landscaped strip in the middle of the parkway? Initially we lean toward the latter, since on the park strip it would provide a seat, albeit a fragrant one, an interlude among the park strip trees for pedestrians trying to cross the busy street. But we decide ultimately on the middle of the intersection, because of its better political symbolism. So, we pick up the couch and, waiting for a break in car traffic, stagger with it out into the intersection. Aligning it north and south with the park strip, we slouch on its sagging cushions and rest as traffic speeds by before and behind us. And as we mount our bikes and ride away we look back, pleased by the way it occupies the center of the street, a big, dirty nonautomotive presence glowing in the yellow radiance of the streetlights.

As it turns out, Tooker Gomberg and Angela Bischoff know something about illicit couches too. A few months before our sofa relocation, they had found a similarly discarded couch on a Montreal sidewalk, pushed it into the street, and sat down—for two hours. Pedestrians laughed, a crowd gathered, the police arrived. Arrested for interfering with the flow of automobile traffic, Tooker was

handcuffed, driven to the police station, held three hours, and fined $135. Upon his release, he took the Metro back, found the couch moved to the sidewalk, and sat back down again.[1]

Earlier in the day, The Crank and I had sat in his apartment—where he is currently under an eviction notice, brought about by the lifting of rent controls in the Bay Area—and watched some videos. In these videos folks like Tooker and Angela could be seen pushing more than just couches into the street. Hell, they were pushing the whole living room into the road, along with plants, artwork, playground equipment, barricades, and most anything else other than automobiles. And once there, they were partying, dancing, and producing and playing music.

Now, though, it's our turn to produce music, and commentary as well. Leaving the couch behind, we've made it to the Berkeley Liberation Radio studio just at 10:00 P.M. Until our arrival, the studio's location had been unknown to me; it's kept unknown for protection from the FCC and the cops. Finding myself in a small room equipped with little more than some minimal broadcast equipment, stacks of alphabetized CDs, and a couple of chairs, I settle in as the show begins. The Crank announces his full pirate radio moniker—"This is the Twenty Inch Crank of the Bicycle Revolution"—and reminds listeners that they are tuned into Bicycle Liberation Radio on Berkeley Liberation Radio, or as he jokes, "BLR squared." Over the next two hours, we report on a couch that has somehow made its way into an intersection nearby. We describe an SUV spotted earlier in the day that someone had "keyed" with a long jagged scratch from headlight to taillight; note that University of California–Berkeley police have apparently acquired new SUV patrol cars, perhaps for chasing student protestors up into the hills above campus; and, in general, question the morality of the sort of people who clog city streets with these paramilitaristic gas-guzzling behemoths. We report on the recent remodeling of the Bay Area Rapid Transit (BART) station in Berkeley, noting that parking spaces for cars seem to have increased as bicycle access has decreased. We discuss the extent to which bicycle lanes constitute the ghettoization of bicycle transportation. And between reports, The Crank plays songs off punk and rock CDs, on occasion urging me to join in as he dubs spontaneous pro-cycling raps over the beat.

In between all this we read on-air from "Bike Summer," a sixteen-page newspaper and events calendar produced through "a collective process by an ad hoc group of bicycle advocates," the Bikesummer Editorial Collective.[2] Promoting "Bikesummer 1999," a series of events "dis-organized" by the Bikesummer Ad Hoc Organizing Committee, the newspaper features articles on walking in San Francisco, the battle for a bike messengers' union, "SUV Terrorists," and "Class and Traffic"; tips for bike commuting; and poetry from bicyclists and from the Pedestrian Poetry Project. It also provides a "Bibliography for a Velorution," with works ranging from James Howard Kunstler's *The Geography of Nowhere* and Ivan Illich's *Energy and Equity*, to Edward Abbey's *The Monkey Wrench Gang* and Jack Kerouac's *Dharma Bums*. And, of most concern to us, it includes an extensive calendar of summer 1999 events. As we outline on-air, the variety and number of events—roughly three a day from late July to late August—is remarkable: bicycle art shows, "traffic calming" actions, Critical Mass rallies, political theater workshops, film screenings, bicycle tours, bicycle polo, bicycle scavenger hunts, bike dating and socializing seminars, self-defense classes for women cyclists, Hiroshima Day ceremonies, a bike guerrilla boot camp, and a "bring out your bike's inner fabulousness" workshop, featuring fake fur, glitter, toys, and stickers.

With all this to promote, we don't manage to highlight everything in the newspaper. For example, we don't get around to reading the quotation that the Editorial Collective has borrowed from the Zapatista uprisings in Chiapas and printed on page two: "'We hope you understand that this is the first time that we have tried to carry out a revolution, and we are still learning.' Subcomandante Marcos, EZLN, 10 June 1994."

A few minutes past midnight we close the show and, with no one else apparently coming in to take the next shift, The Crank puts the CD player in perpetual loop mode so as to leave Berkeley Liberation Radio on illicit autopilot. Gathering up gear to leave, The Crank and I stop to paper the studio walls with Critical Mass fliers that he has produced by pulling still images off of a videotape he shot at the last Critical Mass event. And as we're leaving, I realize that his full on-air tag, the "Twenty Inch Crank of the Bicycle Revolution," sounds familiar to me; until I'd heard him announce it on-air a couple of hours

earlier, I had only known him by his given name. A week later, back in Flagstaff and rummaging through my office files, I fish out an article from the October 1995 issue of the progressive periodical *Z Magazine*. Sure enough, there he is. The article reports on his live recordings at a Critical Mass ride, which he used later as part of his show. The recordings begin, "You're listening to the Twenty Inch Crank of the Bicycle Revolution on Free Radio Berkeley 104.1 FM." The recordings go on to document police harassment during the ride and to report the badge numbers of police officers as they arrest cyclists.[3]

Our ride from the studio back to The Crank's apartment is a bit calmer, as we encounter neither cops nor couches. Gliding down the late-night residential streets, though, we do come upon a couple riding along on a tandem bicycle. They recognize The Crank and report that they've just finished listening to the show. So, in the middle of the night and the middle of the street, The Crank gives them some Critical Mass fliers to put up while out on their ride, and we stand straddling our bikes long enough to discuss the politics of alternative media and alternative transportation.

But just what are the politics of this alternative world? In what sort of universe—or, with Subcomandante Marcos, in what sort of revolution—does one construct the repositioning of a couch as an act of political resistance, willingly risk jail time for simply riding a bicycle, and take time on an illegal radio broadcast to rant against SUVs and the autocentric drift of the local mass transit system? The following chapter explores the politics and practice of pirate radio. Here, we can begin to assemble some insights into the politics of bicycles, couches, and cultural space.

As a starting point we can revisit Tooker and his arrest in Montreal for public couch-sitting. Tooker's report on the episode was published not in *Time* or *Newsweek*, not even in *Z Magazine*, but in the magazine *Car Busters*[4]—which, in the same issue, includes articles on Exxon and British Petroleum, airport expansion and airplane pollution, cars and climate change, and anticar and pro-bicycle activism around the world. His report is in turn reproduced in the "Bike Summer" newspaper, which includes in the magazine listings of its "Bibliography for a Velorution" not only *Car Busters*, but magazines like *Auto-Free Times*, *Sustainable Transport*, and *Transportation Alternatives*. Moreover, Tooker identifies himself as an "activist, writer and

former Edmonton city councillor who now works for Greenpeace Canada," an organization that itself knows something of symbolically reclaiming public and natural spaces from whalers, toxic dumpers, and others. And in his report, Tooker notes that in pushing the couch into the street, "We gloried in giving back a bit of space to people. Imagine mini 'Reclaim Some Tarmac' actions popping up all over the paved planet. A sofa here, a carpet there, a rocking chair. Little chunks of convivial, neighbourly space can be found in any city. Tiny plazas; non-commercial people-places. Liberated space. 'Beneath the tarmac: the beach,' wrote a 1968 Paris graffitist."[5]

So, it seems that there is indeed a revolution underway, or at least a political movement, and that it hinges on taking back the streets from automobiles and their corporate sponsors, on reclaiming and reinventing the cultural and environmental spaces of the city, on reworking the rhythms and meanings of everyday life. If "Beneath the tarmac: the beach," then beneath the streets and beyond the automobile: buried communities ready to be resurrected, alternative lives waiting to be invented, and thus the street insurrection / street party videos that The Crank and I had watched at his apartment. But as this quotation from Paris 1968—from the Paris of Situationists, anarchists, graffiti writers, and students—suggests, this political movement is not one of centralized organization, top-down leadership, and statehouse lobbying. Rather, it is one characterized by interwoven but largely autonomous groups and events; by the sort of "dis-organized," do-it-yourself approach taken by the Bikesummer Ad Hoc Organizing Committee; by an affectionate appreciation of "organized coincidences" and spontaneous direct action in the streets; by a sense of playfulness, of celebration and decoration, in bringing out the "inner fabulousness" of yourself, your bicycle, and your politics. That is, it is a movement defined and enlivened by the politics of anarchism.

As such, the movement to take back the streets from cars and corporations resonates with the activities of homeless advocates, buskers, skaters, and BASE jumpers, embodying both their commitment to direct, decentralized insubordination and their passion for inventing alternative public space. As with these groups, and with others to be seen in the following chapters, those fighting to take back the streets likewise envision not only immediate urban issues, but a

different sort of city itself, dis-organized in ways that must seem unimaginable. Like others seen throughout this book, like the protestors seen fighting the WTO in the streets of Seattle and beyond, those battling today to take back the streets practice a new sort of progressive politics—a politics emerging more from the direct action of Emma Goldman and the Wobblies, from the subversive cultures of punks and Situationists, than from the authoritative ideologies of Karl Marx or Bill Clinton. And because of this, those taking back the streets join other urban anarchists in forming a larger political "movement" that is in many ways no movement at all, but more a fluid convergence of insurrectionary moments.

Tooker's arrest, and The Crank's own lengthy arrest record, his field reporting on arrests of Critical Mass bicyclists, and his resultant desire to become a "bike activist attorney" also suggest something of the legal politics surrounding this movement. On the one hand, in typical anarchist fashion, movement activists seem to care little for the law of the State one way or another, arguing in any case that it serves mostly to protect existing arrangements of power, property, and public space. As we will see, this disavowal is more often whimsical than confrontational. But in either mode, it engenders both small acts of couch relocation and traffic law disregard, and larger acts of civil disobedience as well. On the other hand, political officials, police officers, judges, and others do in fact seem more than eager to bring the weight of state law, even state-sanctioned violence, down on those who would disrupt the patterns of property, movement, and space that order everyday social life. In chapter one we saw that emerging structures of political and economic power foster new forms of crime, criminalization, and social control. Here we see a parallel development: new forms of protest, new ways of doing politics, engender among those involved in them new understandings of law and crime, and among those threatened by them a renewed commitment to the sorts of social and legal controls that will preserve their positions. As always, law and crime, control and resistance emerge each in the image of the other.

A particular juxtaposition captures this dialectic nicely. Throughout the United States, familiar red, six-sided stop signs regulate the movement of traffic, and in so doing embody existing traffic codes and partition public space accordingly. But of course for bicycle

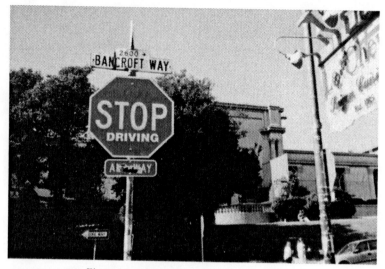

Figure 3.1: Amended stop sign, Berkeley, California.
Photo by Jeff Ferrell.

activists and street militants, that's just the point; stop signs, in their
taken-for-granted familiarity, write existing autocentric arrangements
into the practice of every street corner, and help to impede the
possibility of other transportation forms. So, on the stop signs of
Berkeley and other cities, bright red stickers with white print have
been strategically affixed; they read "driving," with some adding in
smaller print "start: walking! biking! using public transit!" Juxtaposed
properly, the effect is striking.

In this way, Critical Mass activists and others alter the meaning
of city spaces not only by moving through them on two wheels instead
of four, reclaiming them on the run with transitory street actions, or
broadcasting ideas and information out into them, but by illicitly
altering the physical markers by which such spaces are organized.
Like the Situationists, they engage in acts of *détournement*, acts
"launched to seize the familiar and turn it into the other," such that
"any sign is susceptible to conversion into something else, even its
opposite." Like the Wobblies, they invent new cultural spaces in the
shell of the old, and invert the machinery of law and meaning such

that an automobile traffic sign becomes instead a sign of resistance to automobile traffic itself.[6]

AUTOMOTIVE INTERMEZZO

Resistance to automobile traffic itself? Why bother? Aren't there surely more pressing injustices to resist, more important political movements to invent, than one embodied in the gluing of stickers to stop signs? Certainly millions of people in the United States, Europe, and beyond not only see little wrong with the automobile, but revel in the status and spatial freedom it affords. In fact, of all the progressive hell-raising and generally militant living I've done, I've found nothing so dangerous and difficult as challenging the taken-for-granted value of the automobile in the lives of those around me. "Hegemony" is a word not much used anymore, and with good reason, since it was generally associated with an exaggerated analysis of political and ideological domination. But cars, it seems to me, come close to the hegemonic; for many, criticism of them remains unthinkable, alternatives unimaginable.

So, here I offer an intermezzo, a brief sketch of contemporary car culture and its discontents, as context for the antiautomotive activism of Critical Mass and others. Given the pervasiveness of car culture, though, where to start the critique? As a lifelong bicyclist, I could recount my ongoing, everyday experiences in being cursed at, spit on, cut off in traffic, and run off the road by car drivers and their occupants. I could mention the times that fists or sticks have been swung at me out of passenger-side windows. But in fairness, I would also need to note my usual, yelled response in such situations: "Get the fuck out of the car!" While I suppose I first yelled this phrase out of unthinking outrage, I've actually come to like it, embodying as it does both an interpersonal challenge to the car-courage of those encased in a ton or two of steel, and a broader critique of their car dependency as well. And, so far, it hasn't gotten me killed.

Or perhaps a wide-ranging collage of car culture's large and small ecology might better communicate the problem. In Tehran, residents wear masks as they attempt to survive suffocating automotive pollution, and city officials on occasion must bar cars from the central city.

In Paris, Rome, Bogata, and other world cities, the extent of automotive pollution and congestion is such that city officials are forced to institute similar car-free days. In Colorado's once-pristine upscale ski resorts, city planners alarmed over growing traffic pollution and congestion work to develop gondolas that can move tourists not only up the ski slopes, but around the resort areas themselves. In Phoenix—where parking garages are described as the "icons of the desert," and the editor of *Architecture* magazine notes that residents seem willing to "subsume the building within its parking garage"[7]—the local newspaper offers a steady litany of pedestrians, bicyclists, and wheelchair occupants killed by cars. In a single edition one January day it also offered its own sort of unintentional car collage, with articles on a road rage killing; a young bicyclist struck by a car; emigration from the city due to auto traffic and pollution; and the Arizona house speaker's suggestion that those not in favor of freeway widening should simply move away from it.[8] Meanwhile, researchers report that the pace of automotive-driven urban sprawl has doubled in the past decade; that the growing use of recreational off-road vehicles is fast destroying wildlife and wildlife habitats; that new rural highways create "wilderness ghettos" for many species; and that the consumption of fossil fuels continues to exacerbate global warming.[9]

A little "sociology of the car" might help bend some taken-for-granted automotive frames as well. As sociologists and historians have long noted, one of contemporary consumer society's defining features—and one of its central mechanisms of influence and control—is the thoroughgoing atomization of social life. As communities are dissolved and individuals isolated, collective resistance to centralized authority is undermined, and political and economic commodities are more easily marketed as ready-made solutions to problems large and small. From this view, it's difficult to imagine a feature of contemporary society that both embodies and reproduces this atomization more effectively than the private automobile. Locked inside their automobiles, often driving alone, commuters and other car junkies transform city streets from lively human avenues to sterile traffic corridors, and mostly encounter those fellow travelers who also crowd the streets as obstacles or inconveniences. Writing in "Bike Summer," Perry Brissette argues that as a result, "vast sections of our urban landscape stand inaccessible to

everyday experience. Choked by congestion and blocked by long-eroded access, many city streets exist as an urban no-man's land."[10] Bay Area Critical Mass activist Caycee Cullen reminds me that, like all social forces, these atomizing, autocentric dynamics in turn become self-fulfilling: "The infrastructure is set up in a way that's just self-perpetuating; it just encourages you to drive. It's dangerous to walk, it's dangerous to bike, it's a hassle to take public transportation. So supposedly the easiest thing to do is drive. But then, you know the reason why the streets are so dangerous is because there are so many cars. And nobody wants to walk, nobody wants to bike because of that. And public transportation isn't efficient because of that, too."[11] Within this world, she notes, people "want their individual spaces, and they want their individual cars. . . . People are then less apt to talk to each other, scared of each other, and don't want to live in close quarters. . . . Everybody drives everywhere, so you're just isolated all the time. So where do you get the real experience from? . . . Television." "And," adds bicycle activist Emily Bulmer, talking about the fearful occupants of this world, "they don't like public space," either.[12]

Come to think of it, maybe this isolated automotive anonymity helps write a sociology of those fists and sticks flying out of car windows at me. But in any case, this being a book about meaning, do-it-yourself direct action, and cultural space, I'll close the intermezzo with a few folk memorials from the automotive wars—memorials that in various ways transform and consecrate the automotive spaces that they confront.

Throughout the southwestern United States, generations of residents have built roadside shrines to friends and family members killed in auto accidents. Over the last decade or so, as the number of such shrines has increased dramatically, so has their dispersion into areas beyond the southwest. Growing out of the Latino/a and Native American tradition of *descansos* (resting places) designed to mark and memorialize the place of death, these shrines typically center around a small cross constructed of wood, stone, or rock, and decorated with flowers and other memorabilia.[13] In my decades of living and wandering in Texas, Colorado, Arizona, and New Mexico, I have seen hundreds of such shrines, approaching them with reverence and a certain inquisitive embarrassment, and recording and photographing

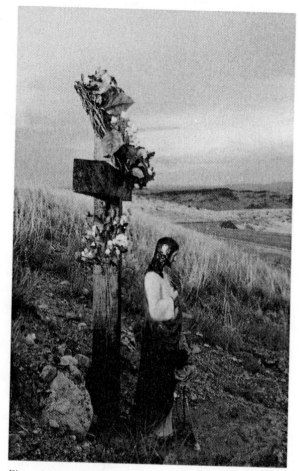

Figure 3.2: Roadside shrine, Highway 60 (revisited), New Mexico.
Photo by Jeff Ferrell.

those I could. The beauty and pathos of these shrines I find over-
whelming. Riding the Greyhound from Flagstaff to Amarillo, I watch
them dot the interstate like a broken string of prayer beads: two little
white crosses in the median, one with pink plastic flowers, the other
with purple. A white cross strung with red plastic roses; another ringed

by *luminarias*. An old cowboy hat affixed to a cross off the side of the highway, and just beyond, a second cross, purple and white flowers encircling it, yellow flowers atop.

They're also there along the two-lane backroads, punctuating the open spaces, clustering especially around the dangerous sweep of a blind curve or hilltop. East of Muleshoe, Texas, twin crosses rest under a shade tree, encircled in plastic flower bouquets. On Highway 6 through central New Mexico, another set of twin crosses sends a message unbearable in its sadness. Draped in plastic flowers and rosaries, the crosses for "Dad" and "Mom" support a broken car mirror, and next to them a pinwheel flutters in the wind, "we-love-you-forever" written on its blades. In fact, rosary beads hang from many of the crosses that I find in New Mexico, and shattered car parts, physical reminders of the fatal crash, are often collected at or near a cross's base. West of Willard, New Mexico, a cross constructed from silver iron tubing features at its base a sturdier reminder: a rough rock headstone with the deceased's name and dates of birth and death carefully carved into it. And along a long-abandoned stretch of old Route 66 near Mesita, New Mexico, sits a shrine that I have visited many times, amazed by all it seems to embody. There, along a forgotten remnant of the very "Mother Road" that carried the Dust Bowlers all the way to Barstow and San Berdoo, that opened the American West to automotive touring, a forgotten cross hangs on, its broken, white-painted wood charred by brush fire, its uneven lettering composed from old upholstery tacks pressed into the wood one by one.

In marking the deaths and commemorating the lives of those they honor, these folk shrines accomplish something else as well: the profound transformation of the roadsides on which they are erected. Working with little more than wood, stone, and plastic flowers, families and friends are able to affix identity, to celebrate meaning, in locations that otherwise would remain empty, transitory, anonymous. In so doing, they remake the roadside as memorial, salvaging the sacred from the everyday profanity of speed, exhaust fumes, and litter. Sociologist Clifton Bryant argues that families and friends who build such shrines create an "anchor in space," because for them "the place of death is as important as the time and cause," and because "the anonymity of modern life is frightening."[14] But the poet Carl

Sandburg said it better. Recalling the countless forgotten battlefield dead at Austerlitz and Waterloo, Gettysburg and Verdun, he wrote, "Two years, ten years, and the passengers ask the conductor: What place is this? Where are we now?"[15] Each roadside shrine answers these questions, forcing us to confront the lives and deaths of those who travel with us, to remember, as we glimpse a cross and flowers, what place this is and where we are now. And taken as a whole, encountered mile after mile and one after another, these shrines accumulate into a collective condemnation and remembrance of ongoing automotive carnage; they commemorate a mass battlefield and graveyard, as deadly as Gettysburg and Verdun, strung out along the open road.

Activist Ken Kelton believes that, in the same way rural highways constitute mass killing fields, urban streets harbor a sort of automotive "serial killer." Outraged about the way in which "automobiles seem to have taken over the streets and society," Kelton travels the streets of San Francisco, map in hand, searching for sites at which pedestrians have been killed by automobiles. Once a site is located, Kelton lays a life-sized body stencil on the pavement, outlines it with white spray-paint, and writes an asphalt epitaph: "5-15-99 Nameless Man Killed Here By Traffic"; "4-15-99 Woman 71 Killed Here By Traffic." Though police officials confirm that Kelton risks citation for public vandalism, he continues to consecrate city streets because, as he says, "there's something wrong with the whole traffic layout, the whole system." If this analysis echoes Caycee Cullen's comprehensive critique of an autocentric social order, Kelton's more intimate concerns reflect the work of those who erect crosses on rural highways. A pedestrian death "doesn't seem to matter. It doesn't even make the paper," he says. "I'm trying to underscore that this is life and death."[16]

For bike messengers in San Francisco and other cities, the streets also offer life and death. Weaving around cars and buses, earning their living along traffic-choked avenues, they face one of the highest death and injury rates of any occupation. The 'zines and web sites produced by various bike messenger communities in the United States and Canada thus catalog bike messengers's ongoing encounters with street violence and death; as writer Gary Genosko notes darkly, "perhaps this makes the obituary the stylistic model of messenger writing."[17] But like those who erect roadside crosses, like Ken Kelton

and his body stencils, bike messengers also commemorate life and death in the streets they ride. The day after messenger Thomas Meredith was run over and killed, bike messengers blocked a major thoroughfare, with fifteen of those present arrested. In the following weeks messengers and friends maintained flowers at the street site of his death. And, when the next Critical Mass ride rolled around, with 1,200 bicyclists taking to the streets of the city, the ride was dedicated to the memory of Thomas Meredith.

CRITICAL MASS:
"WE AREN'T BLOCKING TRAFFIC. WE ARE TRAFFIC"

The revolution will not be motorized.
—Bike Summer bicycle bumper sticker, 1999

It is out of the moments of this intermezzo—out of the accelerating automotive drive toward road rage and social atomization, toward individual tragedy and ecological death—that Critical Mass in fact emerged. In the fall of 1992, Bay Area cyclists began to come together in loosely organized, late Friday afternoon bicycle rides, designed to celebrate and embody alternatives to the usual rush hour automotive congestion, and dubbed by those bicyclists involved as their own "Commute Clot." When some of the participants got a look at Ted White's *Return of the Scorcher*—a film released that same year in tribute to world bike culture—they decided on a more appropriate name for their emerging adventure. In the film, as hundreds of Chinese bicyclists are shown flowing through streets and crowded intersections, bicycle activist and designer George Bliss narrates, describing the scene as, "a kind of critical mass thing, where all the cyclists would pile up and then go; all the cyclists going, say, turning left in an intersection would wait in the middle until they had enough numbers to force through the cars and make them stop."[18] Seeing in the dynamics of the Chinese cyclists the same sort of collective, spontaneous energy they sought, Bay Area cyclists decided that indeed it was "a kind of critical mass thing," and Critical Mass was born. A decade later, Critical Mass has affirmed the inspiration it first took from world bike culture, with Critical Mass rides now regularly held

Figure 3.3: The little handmade Critical Mass flier, Flagstaff, Arizona.

in hundreds of towns and cities throughout North America, Europe, South America, Africa, the Middle East, Australia, and New Zealand.

As Critical Mass has continued to gain participants and territory, it has retained the fluid, spontaneous rhythms of its beginnings, such that some now characterize it as a "large scale, decentralized grassroots movement."[19] Perhaps more to the point, riders and activists describe each local Critical Mass ride as an "organized coincidence," and ride after ride does in fact develop within a pliable, participatory framework structured just enough to keep (most) everyone rolling in the same direction. Appropriately, one of my first encounters with Flagstaff's Critical Mass came in the form of a little handmade flier, left behind on a lightpole from some earlier ride. Weathered but still legible, it read "Join the Critical Mass, Oct 10 Saturday 11:00 am - ?, Sponsored By: Nobody, Ride at Your Own Risk, Be Kind, Everyone

is Welcome," and included a rough route map with the destination "To Wherever."

Critical Mass's Bay Area originators emphasize this same sense of each event as an inclusive, open road to wherever. Beth Verdekal describes Critical Mass as a "perfect combination of do what you want to do but be a nice person." Chris Carlsson adds that the goal of Critical Mass has been "to create an unexpected and unpredictable space, with unpredictable consequences and unpredictable reactions, both for people in it and people outside it," a space "left wide open for people to make it their own." And he notes his pleasure in hearing first-time riders explain Critical Mass to bystanders, even when he disagrees with their explanations. "We will only organize the detonation," the Situationists said back in 1963. "The free explosion must escape us and any other control forever."[20]

These open anarchistic politics come into play during the rides themselves, as routes are negotiated, strategies discussed, and decisions made on the move. They become especially vivid in the practice of "corking." So as to keep the ride safe from intruding automobiles and aggressive automobile drivers, Critical Mass riders have developed this strategy of blocking each lane of oncoming side traffic as the ride moves through an intersection. This practice is essential to the safety of the ride, as certain riders must stop their bikes in each intersection and effectively detain car traffic until the ride clears. But like BASE jumpers, whose life-or-death maintenance of jump exit and landing points emerges with a minimum of organized control, Critical Mass riders accomplish corking with a remarkable degree of inclusive informality. A Critical Mass publication notes that "no one needs to be officially designated as a cork, and people will largely take on this role of their own initiative.... Corking... is usually done on an ad-hoc basis, as needed, by cyclists who decide spontaneously to fill those gaps."[21] Caycee Cullen—herself recently ticketed by local police for corking during a Critical Mass ride—elaborates. "No one has the job of corking," she tells me. "Like there are no 'control corkers.' It's just like as you're going through, people will notice, wow, and just speed up and jump out, and everybody appreciates that, and then the next time, you'll do it. You know, it's like an unwritten dynamic."

As the Wobblies knew decades ago, though, the unwritten dynamic of anarchist politics makes for more than inclusive, egalitarian

bike rides; it also produces effective, nonhierarchical resistance to authoritarian control. Demonstrated time and again in Wobbly free speech fights and strikes, the anarchist practice of "leaderless resistance" undermines authorities bent on arresting (or coopting) opposition "leaders" with the intent of derailing the collective actions they allegedly orchestrate. When no one and everyone is in charge, when leaders are indistinguishable from followers, what's to be done? Arrest a few, in which case a few more will take their place? Or arrest them all?

In the summer of 1997, San Francisco Mayor Willie Brown—he of the crackdown on the homeless seen in the previous chapter—confronted this very dilemma in regard to Critical Mass. By this time San Francisco's Critical Mass was drawing four or five thousand riders for each monthly ride, and the mayor was getting annoyed. His administration initially attempted to elicit the cooperation of Critical Mass's leadership in negotiating preplanned routes and police escorts—but could find no one in charge, no one who could assure ongoing cooperation. Caycee recalls that "when the mayor was trying to crack down on Critical Mass . . . there were no leaders . . . it worked by everybody just doing their own thing and deciding where to go and what to do and when to meet. And so you couldn't ask one person because that person can't speak for all. So, it really I think frustrates them." National news coverage at the time confirmed this assessment. "The normally unflappable Mayor Willie Brown, a world-class deal broker, seemed ready to snap," wrote *Time*'s Steve Lopez in an article entitled "The Scariest Biker Gang of All." "Critical Mass . . . had got his goat by having no one for him to cut a deal with."[22]

By the July ride, with participants yelling "There aren't any leaders is the thing" and carrying signs saying "No Leaders! No Spokespersons! Let Your Spokes Do the Speaking!," official frustration boiled over, the mayor snapped, and local police were ordered to arrest Critical Mass riders and to stop the ride. Yet once again, official control failed in the face of leaderless spontaneity, as only a few riders were arrested while the majority scattered along spur-of-the-moment routes. Jennifer Granick, an attorney for some of those arrested, summarizes the summer's events: "It was not possible for the mayor to engineer what would happen with Critical Mass. How was he going to stop the ride? There just wasn't any way. There's no leadership. There's nobody you can convince, ok, don't bring your people out

here to ride. And what were they going to do, arrest everybody? There's just too many people to arrest everybody. And I realized that. And I think the bicyclists realized that. And eventually the mayor's office begin to realize that."[23] Or, as Emily Bulmer says, "Arrest 5000 people and throw them in jail at once? It could be entertaining."

In fact, resistance of all sorts—especially playful resistance that could be entertaining—is one of Critical Mass's fortes. As Critical Mass participants demonstrate time and again, resistance means something more than simply holding out or holding on against the authorities; at its most potent, resistance inverts the usual relations of meaning and power, turns the machinery of everyday domination back on itself.[24] So, as seen earlier, those in and around Critical Mass convert the pervasive stop sign into a suggestion that those viewing it "Stop Driving" entirely. Others borrow directly from the worlds of culture jamming and billboard alteration, employing the scale and visibility of automobile billboard advertising for their own antiauto-motive ends. With a little paint, for example, a Lincoln Navigator "Most Powerful Luxury SUV on the Continent" billboard becomes an advertisement for the "Most Wasteful Luxury SUV on the Continent."[25] Rigo, a Bay Area artist associated with Critical Mass, paints his own large outdoor murals that, as he says, play off the "authoritar-ian" signage of the city in a different way. Through his murals, he works to replace the authority of official signage "with a doubt, or a puzzlement"—as with his giant "One Tree" mural in the shape of a "One Way" traffic sign.[26] And, as they cork intersections during Critical Mass events, riders employ their own small-scale signage of resistance. As part of an approach that conceptualizes corks as "the diplomats of the ride" who work to adopt a "friendly, non-antagonistic stance with motorists," corks hold up signs that say "Thanks for Waiting," and attempt to diffuse tension by talking and joking with stopped motorists.[27] If this fails, though—if backed-up drivers con-tinue to honk and yell angrily—corks flip their signs over, showing the drivers the side that says "Honk If You Like Bikes." In the same way that activists transform traffic signs and car billboards into ongoing critique, corks manage to convert on-the-spot anger into endorsement—or, better yet, enjoyment.

The amended stop signs and altered billboards, Rigo's murals and the corks's homemade signs held up to held-up traffic, exist as part

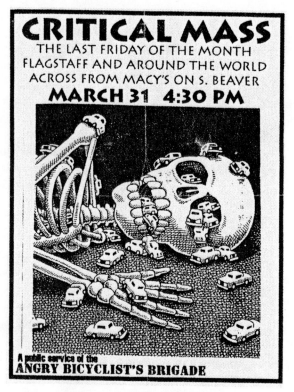

Figure 3.4: Flagstaff Critical Mass flier.
Flier artwork by Andy Singer, http://www.andysinger.com/

of Critical Mass's multidimensional world of do-it-yourself media. The Crank, of course, records field reports during Critical Mass rides, pulls information off police radio transmissions, and broadcasts all this and more over local microradio as part of Bicycle Liberation Radio. But he also produces, edits, and distributes videos that record Critical Mass rides and advocate alternative transportation, and he and others maintain a multitude of web sites highlighting various dimensions of the movement. As glimpsed during our evening of broadcasting Bicycle Liberation Radio, The Crank in turn utilizes images from his videos as fodder for Critical Mass's most ubiquitous form of DIY media: the flier. Participants produce an astounding array of street

fliers and leaflets, and do so within their usual model of resistance: access to a copy machine, even as a powerless minimum wage employee, means powerful access to the means of media production. So, just as I first encountered Flagstaff's Critical Mass through an old flier, I got back in touch in the same way, when I later saw a flier promoting an upcoming ride posted at a local music shop. Taking it down, I bicycled to a copy machine, made copies, returned the original, and posted my copies around town. When I subsequently met Clayton, the flier's author, he liked my approach, but added that I might want to push do-it-yourself a little further still: "Yeah, and you should do your own fliers, too—different kinds—that'd be great."

Clayton's comment nicely captures the larger context of meaning in which Critical Mass's DIY media operations have taken shape. For Critical Mass activists, do-it-yourself media not only provides an inexpensive means of reproducing images and ideas; it builds a framework of democratic inclusion, a "xerocracy," that undermines the hierarchies of top-down political organization and the exclusionary practices of top-down mass media. Like Barry busking on the streets in chapter two, like the microradio operators documented in the following chapter, Critical Mass activists and participants understand that the collective self-production of sounds and images is both a means to effecting anarchic social change and itself a key embodiment of this change. Put simply, they understand that the medium is the message. Writing about xerocracy, some of Critical Mass's originators note that

> Organizational politics, with its official leaders, demands, etc., has been eschewed in favor of a more decentralized system. There is no one in charge. Ideas are spread, routes shared, and consensus sought through the ubiquitous copy machines on every job or at copy shops in every neighborhood—a "Xerocracy," in which anyone is free to make copies of their ideas and pass them around. Leaflets, flyers, stickers and 'zines all circulate madly both before, during and after the ride, rendering leaders unnecessary by ensuring that strategies and tactics are understood by as many people as possible. Xerocracy promotes freedom and undercuts hierarchy because the mission is not set by a few in charge, but rather is broadly defined by its participants.[28]

Indeed, Emily Bulmer recalls that, just before she left her hometown for the Bay Area, "we organized a Critical Mass, and it was all put up with fliers and . . . word of mouth. . . . It just gets bigger and bigger . . . we don't really have a leader." This xerocracy has likewise helped launch Critical Mass not just in particular cities around the United States, but around the world, as images and information have been informally circulated and reproduced by way of videos, mailings, and web sites. Beth Verdekal's summary of Critical Mass and its history highlights the importance of xerocracy, and provides an apt synopsis of anarchist dynamics as well. As a "slow, grass roots, evolving movement," she argues, Critical Mass was built on "word of mouth, xerocracy, no leaders, everybody doing things on their own, people who were self-responsible, who could cork their own ride, who did their own thing and then came together and did it with other people."[29]

In all of this, from corking intersections to producing micromedia, Critical Mass participants practice the politics of direct action. At its most basic, the simple, direct act of bicycle riding en masse alters the meaning of riding for those involved; rolling along together, cyclists invent new experiences from the immediacy of their own collective activity. Critical Mass riders regularly emphasize the otherwise unknown sense of street safety that comes from riding in "a mass of bicyclists so dense and tight that it simply displaces cars," a mass where "we aren't just on the sidelines of traffic, we are traffic now."[30] Out of this collective security there also emerges a sort of spontaneous euphoria; as Emily Bulmer says, "you can't help but have fun. You can't help but say, 'Oh my God, this is fabulous!' . . . You just can't help but be ecstatic with all the bikes that are around and you're safe and you're meeting together." And if this sense of collective empowerment is emotional, even spiritual, it's physical as well. As a regular bicyclist, I've come to know my abilities and limitations intimately, calibrating them daily by the pain of aching muscles and spent lungs. Yet time and again on Critical Mass rides, I've discovered myself moving with less effort and greater endurance than I could imagine—including one collective winter ride up a steep hill, brisk north wind and snow in our faces, laughing and talking all the way. Caycee Cullen has experienced this shared body rush as well—and, like me, not as something predicted or expected, but as an altered state emerging from the activity itself: "There's the whole solidarity issue that

Critical Mass invokes. And you don't even expect it, you know—at least I didn't the first time I went. I had no idea I was going to feel so one with the whole ride, to the point where when you go up hills in Critical Mass, it's easier to get up hills, because you just feel like you're such a part of a large group. You know, like you lose your individuality."

As this direct action teaches those inside the ride new lessons about safety, pleasure, and collective empowerment, it's meant to teach those outside the ride some new lessons, too. Critical Mass rides embody the anarchist sense of the "propaganda of the deed," or in this case perhaps the "ecology of the deed," demonstrating by their very existence the feasibility of ecological alternatives and the hollowness of arguments against them. Rather than relying on the mass media for coverage and exposure, Critical Mass participants simply and directly produce their own media. And rather than lobbying politicians to create alternative transportation, or legal authorities to allow it, they simply invent and display it in the streets. "I used to make fliers" advertising Critical Mass rides, says Caycee, "that said 'Come Show Berkeley Ideal Commute Conditions.'" This same spirit of direct action, of action as ideology, illuminates related activities that might seem oddly inefficient to those stuck inside conventional notions of politics and property. Bay Area bicycle activists maintain the Baatt Cave Bicycle Library, a plethoric assemblage of old bicycles and bicycle parts available free of charge to Critical Mass riders and more generally to anyone desiring to repair or build a bicycle. Like bicycle activists in Amsterdam, Austin, Denver, and other European and U.S. cities, they also refurbish bicycles and place them on the streets, free to circulate among those who need them.[31] And it's not just bicycles that circulate in and around the dynamics of direct action. Participants time and again note new networks of friends that have emerged out of Critical Mass rides. In Berkeley, the Bicycle Republic—the collective living space that houses a number of Women's Critical Mass activists—came together from contacts made during the rides themselves.

Most radically, Critical Mass activists understand direct action to be a moment of experiential insurgence, a moment in which they are able to live the impossible—in the words of the Wobblies once again, to form "the structure of the new society within the shell of the old."[32]

LIVERPOOL JOHN MOORES UNIVERSITY
LEARNING SERVICES

Discussing direct action on a *Reclaiming the Streets—Direct Action Update* underground videotape, Critical Mass activists Jason Meggs and Jesse Palmer speak of an approach designed to "rupture the normalcy" of everyday life, to let them and others "live the way we wish it could be," to open "a window into a different world."[33] Others note a dynamic of self-fulfilling liberation, in that "the expectations of what you can do, of what you can get away with, are altered because something has been gotten away with." But perhaps Chris Carlsson provides the best statement of direct action's radical potential, fixing the transcendent politics of Critical Mass in the anarchic experience of the ride itself:

> You are going to be on the street, you're riding down the street, you don't know what's going to happen, and you're going to have a tangibly different experience of the urban environment while you're moving through the city. And so there's a little bit of living that better world's experience in Critical Mass, which can't help but influence your imagination, because suddenly you have tasted it, you know what it's like to actually be in a new free space with a bunch of vibrant, interesting, good looking human beings. Anything can happen—well, you hope it can.[34]

Inner Fabulousness.
Outer Spaces. and the Politics of Gender

> If you only knew, citizens, how much the Revolution depends on women, then you'd really open your eyes to girls' education. And you wouldn't leave them like they've been up to now, in ignorance! Fuck it! In a good Republic maybe we ought to be even more careful of girls' education than of boys'!
>
> —Article in the newspaper
> *Le Père Duchêne*, during the Paris Commune[35]

Chris Carlsson's notion of a "new free space" created out of the direct action and interaction of assembled Critical Mass riders catches a key dimension of Critical Mass activism: In working to invent the impos-

sible, to open a window to a better world, participants understand that they must recapture and reinvent the spaces of such possibility—that they must rearrange the spatial dynamics of urban life and urban ecology. In at least temporarily taking back the streets from automotive traffic, a Critical Mass ride carves out spaces of safety and pleasure that otherwise wouldn't exist—spaces that move and flow through the city as the ride takes its course. And while these fluid spaces evaporate with the end of each ride, the memory and imagination they spark do not; the rides, and the activism that surrounds them, accumulate into an outline of new cultural and spatial arrangements. "Bicycles are the liberators of space in our communities," writes Perry Brissette. "As we ride in cities everywhere, we transform streets from dark, inaccessible stretches of pavement to prideful places more accommodating to life on a human scale."[36] Commenting directly on Critical Mass's origins, Beth Verdekal adds that "first off, Critical Mass was created as a social space"; and Jim Swanson recalls that "the notion of public space was also important, to see if we could establish something on the streets, a space, where people could get in front of each other and actually converse, and talk, and interact. The street had become not so much a place that had any community anymore, it was only a place to drive."[37]

Significantly, though, Critical Mass's attempt to reclaim the city's spaces operates as something more than a quixotic spatial conquest, more than a revanchist ecology in which bicycles and their riders are meant simply to physically displace automobiles. As Beth Verdekal's comment suggests, Critical Mass is as much a hopeful social conquest, a gamble that new forms of human interaction in the streets can construct de-atomized city spaces open to just such ongoing interaction. And perhaps most of all, Critical Mass constitutes a cultural conquest, an attempt to inscribe new values, new images, new pleasures in the street—and thus to construct new cultural space. Emily Bulmer's bliss, and the collective euphoria that other Critical Mass riders describe time and again, certainly emerge spontaneously from the rides themselves, but they also come to be encoded in the ongoing rituals that shape Critical Mass rides. And that Bike Summer workshop on "bringing out your bike's inner fabulousness?" That's not just a seminar on bicycle decoration; it's a dress rehearsal for the festival of the oppressed.

Critical Mass activists make it clear that they are interested in just such a festival, that they are attuned more to the carnivalesque politics of the street busker and the skate punk than to the dour machinations of the statehouse sycophant. In the introduction to a collection of suggestions gathered under the heading "How to Make a Critical Mass," a group of activists argues that "Critical Mass is foremost a celebration, not a protest . . . a festive re-claiming of public space."[38] Chris Carlsson concurs, noting that "this exhilaration, this open-endedness, this human creativity that was unleashed by this experience has as much or more to do with it being a new kind of public space."[39] The fliers that participants pass out before and during rides reinforce this notion, announcing "a revelatory, celebratory ride," "world class whooping and showboating," plans to "whoop it up all over the streets of Berkeley," car piñatas to be smashed, bicycle cakes to be eaten.

Indeed, a Critical Mass ride resembles nothing so much as a mobile festival of the automotively oppressed, an outlandish middle-of-the-road celebration staged by those usually relegated to bike lanes, sidewalks, gutters, and other margins. Critical Mass activists in Berkeley tow an old couch (and assorted human and canine couch-sitters) behind a bicycle as part of their collective rides, and feature this rolling sofa under the heading "The couch must come through!" at one of their web sites.[40] Women's Critical Mass participants hand out fliers urging others to "plan to decorate and fancify your bike" in preparation for their next ride, and regularly costume themselves and their bikes for rides. During one of my visits with Berkeley Women's Critical Mass participants, they talked with me while cutting out paper decorations for that evening's event. Jason Meggs, among the most thoughtful and committed activists I've known in my many years of fighting the power, likens a Critical Mass ride not to a political rally, but to "a picnic," and describes his involvement in a related public event: "What's really funny, we do this thing . . . we make our bikes as big as cars . . . you can just do it with PVC or bamboo, or make it more elaborate . . . two five-foot and two ten-foot [lengths], and get anchor braces for three or four bucks, and some twine, you can hang a frame off of it—and you're as big as a car. . . . We went out on parade with them the first night . . . we're out on the road, the three of us, tooting along all happy."[41] If "tooting along all happy" hardly

describes a typical car commute along a constipated freeway, or an endless wait at a gridlocked intersection, that's just the point. Critical Mass activists don't just mean to replace the automobile with the bicycle. They mean to replace the culture of the car—the atomized anonymity of driving, the road rage, the ever-sprawling graveyard of roadside crosses—with a bicycle culture as gentle and inclusive as it is vivacious.

This sense of Critical Mass as celebration and pleasure certainly emerges from anarchist traditions of liberatory festival and playful subversion, but it also emerges directly out of the gender politics that pervade Critical Mass. Beth Verdekal, Caycee Cullen, and many other women have been instrumental in creating Critical Mass in the Bay Area and around the world, and continue their direct and passionate involvement with the rides and the movement. Even so, the gender dynamics of Critical Mass rest on more than a simple headcount of women and men involved. Throughout the literature and language of Critical Mass, these broader gender dynamics surface time and again. In the same way that playful celebration rejects the stern authority of mainstream politics, it discards the aggressive, machismo posturing that defines so much of conventional straight-male masculinity. For women, men, or anybody in-between—for anyone involved in a Critical Mass ride—this inclusive, nonconfrontational ethos defines the experience of Critical Mass and the street actions it embraces. In fact, of the few guidelines that activists offer participants regarding Critical Mass rides, almost all address this issue: "Antagonizing pedestrians or motorists, either verbally or physically, is counterproductive and no fun for anyone. . . . Speak softly and calmly, and explain that this is a peaceful ride. . . . Try to defuse tension whenever possible. . . . Please let trapped pedestrians pass. You might help them by escorting them across the road. . . . Relax and enjoy the ride. Encourage other riders to do the same."[42]

Activists emphasize that these gentle gender politics are essential components of humane and enjoyable Critical Mass rides—but beyond this, essential components of their long-term strategies for social change, and of the sort of community they wish to create from such change. Activists and participants for example regularly talk of problems with the "testosterone brigade"—that is, with those (male) members of a Critical Mass ride looking for confrontation with

motorists. Yet the problems created by the testosterone brigade extend beyond the moment-to-moment negotiation of the ride. "For some bicyclists, Critical Mass is an opportunity to berate motorists, now that *we* own the road. Our society's over-reliance on motorized traffic is a massive and overwhelming social problem, and it won't be changed through the use of bitchy, ineffective tactics by a small minority of pissed-off bicyclists," argues one publication. "But a movement for change based on a reclaiming of public space and the building of human community, open to people from across the social and political spectrum, could contribute to a deeper and more fundamental change in the way our society operates."[43] Jason Meggs adds a note on the politics of inclusion. "I think one of the best things we can do is join with them and empathize with them," he says, speaking of automobile drivers, "and not have it be what I as a lifetime bicyclist tend to fall into, which is us versus them. . . . They aren't out on a bike and you want to get them on a bike." Jason's words also reflect a hard lesson that I've begun to learn from talking and riding with him and other Critical Mass participants: my habit of yelling "get the fuck out of the car" at offending motorists may be better personal therapy than it is politics. And his words carry a broader lesson in gender politics and social change as well: for many, the choice for inclusion and nonconfrontation over machismo-charged conflict grows not from fear of the present world, but courageous commitment to a better one.

Caycee Cullen embodies this commitment. When I first met her at the Bicycle Republic—a place of outdoor bicycle-wheel sculptures, and bikes leaning against indoor walls covered in bicycle art—she reiterated Jason's comments, arguing that friendly, inclusive Critical Mass rides are the key to enticing people out of their cars, onto bikes, and thus into more progressive ways of living and moving. Seeing her for the first time, she reminded me of someone—someone whose identity I didn't figure out until I returned to Flagstaff. Hanging out in a used clothing store there a month later, I noticed a young punk woman's elaborately detailed "Rosie the Riveter" tattoo. And while we compared tattoos—she appreciated that "IWW" insignia I carry on my right arm—I realized who Caycee is. She's Rosie the Riveter—same powerful physical presence, same can-do attitude mixed with a hellacious joie de vivre. Except, of course, Caycee's not building

bombers for the war effort. She and others like her are building bikes, and building new communities of women around and on them.

Caycee grounds the dynamics of Critical Mass directly in this larger politics of gender and space. Describing her initial Critical Mass ride, she recalls that, "The first time I ever went to Critical Mass, what struck me was that it reminded me of a Take Back the Night march. You know, it's like, by yourself, singly, you're powerless. You're subject to violence, you're subject to death, you're subject to a lot of aggression and harassment. . . . And that's what makes it so powerful, that you feel that you're reclaiming the space, that by yourself is not yours." While remaining an active participant in Critical Mass rides and the broader bicycling movement, Caycee in time began to work with other women bicyclists in developing this collective, gendered reclamation of space, and in further confronting moments of male aggression inside and outside Critical Mass. Out of this work developed Women's Critical Mass, regular rides organized by and for women cyclists. Caycee describes these rides as "an all-women's space . . . it's good in terms of getting people on their bikes and getting active, to have a space for women." Yet true to the inclusive spirit of Critical Mass, she emphasizes her hope "that especially men see it as something that we have to do for ourselves, and it's not exclusionary at all, but just that a space needs to be provided for us." In this light she suggests that the future of Critical Mass may well develop around this sort of "subculture within the subculture"—around these alternative spaces blossoming within the larger alternative space of Critical Mass—and notes the recent development of lesbian/gay Critical Mass rides, and children's rides.

Caycee's sense of Critical Mass as a sort of rolling Take Back the Night march also highlights the double danger that women cyclists face—and that Critical Mass helps them confront. For women cyclists, Critical Mass rides and other collective endeavors offer not only the general sense of safety from car traffic that all participants experience while riding, but a sense of safety from sexual assault and harassment, and freedom from proscribed gender roles. Given this, Women's Critical Mass activists have organized seminars and web sites offering information on the history of women's cycling and its role in liberating women from traditional codes of conduct and comportment.[44] They have also begun to work for the welfare of women cyclists not

Figure 3.5: Caycee's "Women on Bikes" flier, Berkeley, California.

protected by the collective security of a Critical Mass ride. Caycee, for example, has produced and distributed a flier offering safety tips for "♀ on Bikes." The flier reminds women to avoid riding alone if possible, to let friends know of their route, and to "ride confidently and fast (but safe)—no one will try to stop a bike rippin' thru the streets." The flier also acknowledges that the nonconfrontational politics of Critical Mass may not always be appropriate, especially when a lone woman on a bike encounters the amalgamated aggression

of men and automobiles. "Use your voice if necessary," the flier says. "And don't be afraid to say *Fuck Off!*"[45]

Maybe You Should Read
the Statute and Consider What's Reasonable

During the 1990s, Critical Mass rides migrated from their Bay Area origins to Flagstaff, just as they did to hundreds of large and small cities around the United States and the world. In many of the larger cities, the rides quickly began to attract participants, with hundreds of riders regularly coming out for the event. By 1996, even Flagstaff's Critical Mass, though based in a city of only 50,000 people, had drawn enough interest and attention to force a confrontation between a hundred participants bent on taking back Flagstaff's streets from automobile traffic and, ironically, local bicycle-mounted police officers intent on keeping such traffic flowing—even to the point of arresting a number of Critical Mass riders. What with Flagstaff's often inclement winter weather, though, and the coming and going of students from the local university, Critical Mass rides themselves came and went over the next few years. Then, in the spring of 2000, the rides began to re-form. As with earlier Flagstaff rides, participant numbers even at their best were no match for the thousands of riders in the Bay Area. Yet the numbers were sufficient to achieve a critical mass, a collective experience of spatial reclamation and celebration; to ignite within this experience the usual dynamics of direct action and do-it-yourself resistance; and, like all critical masses, to set in motion the possibility of some other explosion.

My involvement in this resurgence begins in late February of that year when, as noted earlier, I discover and then reproduce a flier promoting a ride scheduled for the usual Critical Mass date: the last Friday of the month. Bicycling up to the designated meeting spot that Friday—some picnic tables across the street from Macy's, a popular alternative coffeehouse—I notice two signs: "Seating for Macy's Customers ONLY. No Loitering, #13-2905," and a larger "No Loitering" notice posted on a nearby building. With nothing on me but six bucks, a pocket knife, and a microcassette recorder, and no Macy's

coffee in hand, I sit down and proceed to loiter. After awhile a young woman bicycles up.

"Is this where we're meeting for Critical Mass?"

"Um, I think so."

"Well, maybe I'll swing back by in a while to check if the ride goes." She does; it doesn't. And sometime later, after it's clear that indeed a critical mass won't be achieved today, a young guy walks over from Macy's. It's Clayton, writer of Critical Mass fliers and local anarchist agitator, a guy I've been meaning to meet. Along with discussing fliers and xerocracy, we talk about his and others' attempts to launch an underground radio station, his work with the local Food Not Bombs chapter, and other forms of activism past and present. All the while he sips from his mug, filled with strong Macy's coffee and pasted over with Wobbly stickers, including "An Injury to One is an Injury to All."

Clayton's comments remind me of the ways in which the anarchic, do-it-yourself dis-organization of Critical Mass and like undertakings provides threads of activism and community, but no ties that bind. Fliers get made and posted, sans membership list or map grid; Clayton and I and others meet, interact, learn, but with no one in charge of the meeting. And Clayton, like James Davis and other street activists seen in the previous chapter, stretches his web of anarchist sensibilities across Critical Mass, Food Not Bombs, underground radio, and other sorts of activism, not because they're all coordinated under the same organization, but because, after all, an injury to one is an injury to all.

Sitting in the cold after Clayton leaves, getting ready to ride home, I think about Bakunin, too, and the multitude of ways in which destruction is creation; failure, success. Today the Critical Mass ride didn't come off; despite our fliers and our on-the-spot convergence, we failed. But in not happening, it seems to me, the ride exists as an accomplished anarchist event, preferable in its shambling failure to whatever success might be brought about by bylaws, committees, and a designated event coordinator.

A month later, bicycling uphill and against a cold wind to our gathering spot, I almost turn back, sure that nobody's as crazy as I am, and that we'll fail again. As I arrive, though, Clayton comes over from Macy's and, gesturing to a motley crew across the street, tells me that

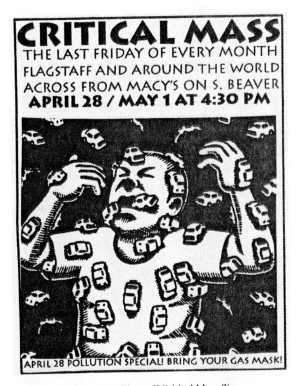

Figure 3.6: Flagstaff Critical Mass flier.
Flier artwork by Andy Singer, http://www.andysinger.com/

this time we've reached critical mass, albeit a small one even by Flagstaff standards. So, the nine of us set off down the street—eight guys and one girl, most all in their teens and twenties, sporting a collection of ragged pants and shorts, longjohns, and anarchy patches, astride a hodgepodge of mountain, touring, and BMX bikes. Despite the fact that we're at this point occupying only one of two southbound lanes, horns are honking within thirty seconds, and a tough boy is leaning out of an SUV and yelling. "Single file, assholes." We smile and wave. Over the next hour and a half I lose count of the number of middle fingers shot at us from behind the rolled-up windows of cars and SUVs, though I do remain aware of an ongoing, angry horn

cacophony. Unfortunately, no one's remembered the "Honk If You Like Bikes" signs.

From the first, the mass emerges as an exercise in fluid, on-the-fly cooperation, collectively negotiating the next twist or turn in what is largely an unplanned route anyway. Rolling around corners, changing lanes with a flurry of hand traffic signals, the mass moves like some multiwheeled amoeba, riders ebbing and flowing from front to back. Early on, a young kid coming toward us on a skateboard smiles, yells "Hey, Critical Mass!" and reverses his course to skate along with us for a few blocks. A few minutes later, we decide to circle back toward Macy's, hoping to pick up a couple of riders we seem to have left behind—and there they are, two kids just passing through Flagstaff, in from Vegas, veterans of Critical Mass there. Ready to resume the ride, we decide to wait until a train has finished crossing the street north of us, so that we can pull out in front of a nice tight group of overheated motorists. And, aware that our gender balance seems a bit askew today, I'm pleased to see that Lyndsay, the lone woman in the ride, takes an active role in this and other decisions.

As the ride moves along, we're amazed by the power of our direct action—by the ability of nine dis-organized bicyclists to directly and effectively interrupt the usual, taken-for-granted flow of automotive traffic. We manage to shut down one or more lanes on major thoroughfares, to completely block downtown streets, and to pile up some one hundred cars behind us while we climb Humphreys Street, a two-lane road rising from downtown to the northern suburbs—all the while smiling and waving at those caught around and behind us. (In fact, it's this Humphreys hill climb that I described earlier in terms of a Critical Mass ride's collective empowerment.) Indeed, we joke and laugh all the way to the top, riding into the wind and now-falling snow—Clayton's joke is, "This isn't Critical Mass, it's Critical Masochists!" As we ease back down the hill, another long line of cars forms behind us, and finally an SUV driver has had enough. Whipping around in front of us, he stops his vehicle dead in the street—we appreciate the help in blocking traffic—and jumps out. "What do you think you're doing?" he screams back at us. As we ride up to him, someone in the group simply smiles and says, "We're riding bicycles." "Um, ok," and he gets back in the SUV, apparently a bit braver behind the wheel than in the street.

Just as Beth Verdekal and Jim Swanson would predict, the ride also emerges as a "social space," a street space where people can "converse, and talk, and interact." By riding slowly and in a relatively tight formation so as to more effectively interrupt auto traffic, we also set a leisurely pace for ourselves, and facilitate bike-to-bike conversation. Putting ourselves and our bicycles on the line, confronting automotive dominance through direct action, we invent the impossible: an island of safety, calm, and conversation in the middle of a busy street. And, in fine reflexive fashion, we inhabit this island with talk of Critical Mass rides in other cities, strategies for surviving encounters with motorists, sabotage in the workplace, anarchist history, and other subversions. As we hook a collectively illegal U-turn in the middle of one car-choked street, Clayton leans over to me and says, "No manmade law governs my bicycle."

Later, I'm telling my friend Barry—the fiddler and street busker from the previous chapter—about the ride, the rolling blockade of car traffic, the pissed-off motorists, the pleasure of it all. A veteran bicycle racer and bicycle mechanic himself, I figure Barry might want to join us for the next ride. "That's punk rock, man! That's punk rock! Hell yes!" he says as I recall the ride. And indeed it is—punk rock on two wheels. Johnny Rotten and The Sex Pistols would understand, I think—understand anarchy in the Flagstaff streets just like anarchy in the streets of the U.K. You know, something about giving a wrong time, stopping a traffic line.

When the next ride comes around at the end of April, Barry does indeed join in the anarchy. The weather's better, and it's obvious early on that this will be a larger and even more energetic ride than the last one; twenty or so riders have pulled up across from Macy's, and everyone's talking and laughing in preparation for getting underway. It's obvious also that this time we have a gender mix more in keeping with the tradition of Critical Mass, as an equal number of women and men head off down the street. By the time we get to Milton Avenue, a major north/south thoroughfare near the university, we've picked up a few more cyclists, and we now have enough bikes to effectively block both southbound lanes. Hundreds of cars are backing up behind us amid the usual soundscape of horns and shouts; some accelerate through the left turn lane and blow by us, with one car cutting fast a foot or two in front of the lead bikes as its driver and

passenger yell obscenities out the windows. Surprisingly, though, we're seeing "thumbs up" gestures mixed in with the middle fingers, and hearing almost as many shouts of "Alright!" from motorists and pedestrians as we are curses. I ride up alongside a couple of first-time Critical Mass participants; they're grinning, and one says, "Wow, this is amazing; this feels great!"

As we swing a U-turn though a strip mall parking lot and head back up Milton, with both lanes of northbound traffic now slowed behind us, I'm feeling great, too, high on the adrenaline of the ride and the reactions to it. Then I notice the cops. Intercepting us from the north are two Flagstaff officers in a patrol car, the driver shouting out his window for us to pull over into an adjacent parking lot. We all glide over into the parking lot, but while some roll slowly through it, others accelerate, splitting off and scattering along various frantic trajectories. Ten of us keep the mass together, and as we coast out of the parking lot and onto the university campus, the patrol car catches up to us, lights on, the driver demanding over his loudspeaker that we pull over—now. We do.

By the time he's out of his patrol car, he's already yelling. "How many people here think that's the stupidest thing they've ever seen, riding like that down the middle of Milton?" Judging from the lack of response, the answer is two: himself and the officer riding with him. Within a couple of minutes, automotive reinforcements arrive— another Flagstaff police officer in a second patrol car, and a university police supervisor driving a large, official SUV—and the lengthy process of identification and ticketing begins. We're informed that we're being charged with violation of Arizona Revised Statute 28-704A, that is, proceeding "at such a slow speed as to impede or block the normal and reasonable movement of traffic." Invoking Critical Mass's essential concept, we of course immediately counter that we weren't blocking traffic, we were traffic—and the officers just as quickly dismiss the notion. During this process, the university police supervisor also begins to ask whether everyone involved is a student at the university. Everyone (except me) is—which is lucky since, as some in the group recount from previous run-ins with university police, his question is actually one of spatial control: trespass charges can be filed against anyone found on campus who is not a student or otherwise involved in official university business. And just as these

interactions evidence a certain disagreement regarding the nature of traffic and the control of cultural space, an off-and-on civics lesson that the cops deliver while writing tickets seems designed to emphasize the desirability of representational democracy over direct action. "There's a reasonable way to go about" achieving better bicycling conditions, they tell us. "There's an easy way to do it . . . you know how to go about doing that, instead of driving in the middle of the street? Go to the city council . . . easy way to do it, right next to the courthouse . . . then what are you doing out here causing problems? Go to city hall . . . if you have a problem, you need to go to city council . . . that's the way you should take care of it. . . . If you guys didn't know, in May, the next election's coming up, there's some initiatives on there to get more bike paths."

Just like back in high school civics class, I don't pay much attention, instead passing the time in a reverie of direct action and free association. Our ticket for impeding the "normal and reasonable" movement of traffic reminds me of the old "move on" laws enforced during Wobbly free speech fights, and reminds me of an image I'd seen in a more recent Critical Mass video. It's a big Critical Mass ride in Austin, Texas, and a patrol car rolls alongside the riders, an officer wagging his finger out the window and warning them:

"If you don't pick up the pace you'll be issued a citation for impeding traffic; you better move on. You better move on!"

"I'm moving."

"You're not fast enough, you better move on!"[46]

The ongoing tension between the civics-teacher officers and the members of our group produces a more violent confluence of images as well. After thirty minutes or so of ticket writing, as all three police vehicles continue to idle within a few feet of us, Clayton asks the nearest officer, "Can you turn your cars off?" "My car's always running," he says, and elaborates: "Next time when you're getting your ass kicked over here, and I have to take the time to turn my car on to get to you to help you, you'll wonder why my car's always running, ok? When you're bleeding and sitting on the ground and need help right away, that's why my car's always running. . . . I can let you sit there and bleed for as long as I want, I'll do that for you. That's why my car runs all the time." Hearing this, I can't help but wonder who's doing the ass-kicking, and who wants to let it bleed—

and can't help but think of a previous ass-kicking image involving a police officer and a Critical Mass rider. Widely circulated in the bike activist underground, the photo comes from Willie Brown's July 1997 crackdown on San Francisco's Critical Mass. It shows a helmeted San Francisco cop, his right arm locked in a chokehold around the neck of a female Critical Mass rider, his left hand, partially hidden behind his police motorcycle, grabbing at her around the waist.[47] Once she's released, I think to myself, perhaps she should report the incident to the city council, or vote for more bike paths.

Once we're released, the ten of us cycle over to some benches to sit, exchange phone numbers and email addresses, and begin the process of planning a court challenge to the tickets. Riding away from this impromptu meeting, Barry laughs and says, "Nice of the cops to get us organized like that." But Clayton is less amused. Echoing James Davis's recollections about skateboarding and politics, Clayton says that today's events in a way bring his own politics full circle, that it was just this sort of street dynamic—being harassed by the police when, at age twelve, he was riding his skateboard in the streets of his neighborhood—that radicalized him in the first place.

A month later, eight of us appear in court. The arresting officer testifies that while he had probable cause for charging us with both obstructing a public thoroughfare and unlawful assembly, and could have "arrested and taken [us] to jail," he found it "in the best interest of the City of Flagstaff to issue a civil citation." Though the judge finds the first two riders "not responsible" on a legal technicality regarding the officer's identification of them, she finds the next four guilty. Then it's my turn. Putting the officer on the stand, I decide to try a new approach. Questioning him about the incident, I argue that the motorists' cell phone calls that brought him to the scene may have reflected nothing more than anticycling bias on their part; that the bicyclists were part of a heavy rush hour traffic jam, not demonstrably the cause of it; and that, in any case, the officer's dealings with us were evidence more of interpersonal hostility than competent police work. The judge seems persuaded, addressing probing follow-up questions to the officer, asking me for clarification and elaboration, consulting the statute in her law books. Then, after more consideration, comes the verdict. "No, no," she says, seeming to stop herself just short of reversing her prior decisions. "This was intentional. Guilty."

Returning to my seat in the gallery, I'm reminded of a comment the arresting officer made during the ticketing process, upon discovering that unlike the rest of the group he had apprehended, I wasn't a student but a faculty member. *"Professor,"* he said, wrapping his suggestion in a full metal jacket of derision, *"maybe you should read the statute and consider what's reasonable."* I'm not sure I've gotten around to doing that, or that the judge got around to it that day in court, but someone else has. The senior police officer in the first 1996 police confrontation with Flagstaff Critical Mass riders—an officer who at the time made the decision to arrest and handcuff one of the riders in order to "clear the road of cyclists and allow cars to proceed"—later enrolled in our graduate program, and decided to write about his experience. Looking back on what he had seen then as "a simple traffic jam," he now argued that "Critical Mass riders attack the meta-narratives of current culture by challenging taken-for-granted notions of car-culture and transportation issues." But beyond this, he suggested that, for cops as much as for Critical Mass riders, what at first seems reasonable might not be what's right: "Bicyclists taking over roadways established and dedicated to motor vehicles interrupt and confuse, and therefore threaten. Police arrive and attempt to establish order out of apparent chaos. . . . Police, agents of social control, are at times 'agents of the status quo,' even if it is not recognized at first glance."[48]

Anarchist Biker Gangs

Critical Mass isn't the first collection of two-wheeled anarchists to create threat and confusion, and to encounter agents of the status quo intent on restoring order in the streets. As mentioned earlier, the Hell's Angels and other outlaw motorcycle gangs have over the past half century ridden what Hunter S. Thompson calls an "anarchic, para-legal sense of conviction" into countless battles with local police, state troopers, and federal agents determined to safeguard the streets from the bikers' engulfing presence. In elaborating on outlaw bikers's convictions and conflicts, Thompson posits some further parallels as well:

One night about halfway through one of their weekly meetings I thought of Joe Hill on his way to face a Utah firing squad and

saying his final words: "Don't mourn. Organize." It is safe to say that no Hell's Angel has ever heard of Joe Hill or would know a Wobbly from a bushmaster, but there is something very similar about the attitudes. . . . [The Angels'] reactions to the world they live in are rooted in the same kind of anarchic, paralegal sense of conviction that brought the armed wrath of the Establishment down on the Wobblies. . . . The Wobblies were losers, and so are the Angels . . . and if every loser in this country today rode a motorcycle the whole highway system would have to be modified.[49]

Well, indeed, as Thompson would say. Indeed there are some striking anarchic similarities between what might seem the most disparate of groups, between down-and-out Wobblies flooding by freight train into San Diego or Seattle for all-out free speech fights, outlaw bikers overrunning highway traffic and highway law astride big thumping V-Twin engines, and Critical Mass cyclists propelled into direct, collective action against cars and cops by their own two legs.

But there are some significant differences as well, differences suggested in the title of *Time* magazine's 1997 article on San Francisco Critical Mass and its encounter with Willie Brown's police: "The Scariest Biker Gang of All." Certainly this choice of title emerges less from ethnographic insight on *Time*'s part than from the usual sort of moral panic peddled by *Time* and others in the mainstream media. In fact, *Time*'s article carefully constructs the very "folk devil" image that Stanley Cohen argues is essential to successfully selling moral panic over marginal groups, and to deflecting attention from the misdeeds of authorities.[50] The article doesn't reproduce that photo of the police chokehold on a female bicyclist, or feature accounts of police or automotive violence. Instead, the article's subheadline describes a "civil war" fought as "bicyclists take on drivers," and the article's highlighted quotation from one Kathleen Shuey declares, "I wasn't frightened until they threatened to flip our car over."[51] Of course, *Time* has had plenty of practice in describing scary biker gangs, and inventing folk devils and moral panic; during the 1960s, the magazine took the lead in promoting a menacingly overblown image of the Hell's Angels, reporting with gross literary license that members "swap girls, drugs, and motorcycles with equal abandon."[52] Yet for all

of *Time*'s history of inflammatory inaccuracy, the magazine may have stumbled on an insight this time. Critical Mass may indeed be different. Critical Mass may be the scariest biker gang of all.

Unlike the Angels, running hard on machismo and rolling toward the next violent confrontation, Critical Mass is fueled by a commitment to nonconfrontational celebration, by a willingness to playfully abandon leaders and authority, by a passion for inventing a calmer and more humane world inside the automotive hell of the present one. As such, Critical Mass presents a moving, amorphous target for mayors and police officers, and challenges not just those who presently control the streets, but controlling assumptions about transportation, politics, gender, and social change. Unlike the Angels, Critical Mass riders don't mean to substitute one gasoline-powered machine for another, the mass riding of which would force "the whole highway system" to be "modified." They mean to tear down the streets, and to reinvent them in a way more damaging to auto manufacturers, more dangerous to petroleum companies, more threatening to SUV drivers, than the menace posed by any motorcycle-mounted, chain-swinging Angel. And unlike the Angels, many Critical Mass riders would in fact know a Wobbly from a bushmaster, do in fact know the legacy of Joe Hill, and do know how to reproduce and revitalize longstanding traditions of anarchy in the streets.

RECLAIM THE STREETS

In Berlin... police officers... used water cannons, tear gas and nightsticks against a crowd of 10,000 anarchists. ... In London... demonstrators... covered the lower part of Nelson's Column, the slender white tower that anchors Trafalgar Square, with anarchy symbols and scrawled "Reclaim the Streets 2000" across it.
—Associated Press, in bewilderment, May 2, 2000[53]

Joe Hill and the Wobblies employed a variety of objects and images as symbols of anarchy in the streets, and in the fields and factories. Its back arched in anger and defiance, a black cat became the "sabo-tabby kitten," its appearance on a wall or union flier suggesting the threat

and practice of sabotage. (That same black cat is still making appearances, by the way; the last time I looked, one was pasted on the guitar of Tom Morello, of the progressive band Rage Against the Machine.) The Wobblies sent the same sort of message about sabotage and direct action with the image of the wooden shoe, the *sabot*, calling forth the shoes worn and tossed into machinery by recalcitrant French workers; during their fight with the southern lumber trust, the Wobblies even printed a report on sawmill "accidents" authored by "The Wooden Shoe Kid."[54] For Edward Abbey, George Hayduke, and later generations of eco-anarchists, the monkey wrench has functioned in the same way, a practical and symbolic tool for stripping the nuts and bolts of industrial domination.[55] As anarchists battle to take back the streets in the new millennium, though, it's not so much cats, shoes, or wrenches that have come to embody their intentions; it's couches. The Crank and I carrying a couch into a Berkeley intersection, Tooker Gomberg busted for couch relocation in Montreal, Berkeley's Critical Mass riders towing a couch and announcing that "the couch must come through!"—all of these actions, oddly enough, center on that most domestic of objects, seemingly more appropriate to a living room than a street fight. But you see, that's just the point; practically and symbolically, a well-placed couch begins to turn a street into a living room—to carve out room for living in an otherwise uninhabitable automotive wasteland.

While there's no telling how many sofas have been shoved into the streets over the years, we can pinpoint the furniture that first came to be upholstered in the politics of contemporary street anarchism: the couches and chairs sitting in the middle of little Claremont Road, London, circa 1994. Scheduled for demolition in order to extend the six-lane M11 motorway, its houses condemned and its longtime residents evicted, Claremont Road was by this time illegally occupied by an eclectic community of squatters and antiroad activists. Closing the road to cars, they built barricades, towers, art installations, and tunnels—and converted the street itself into a room for living and partying, complete with furniture, snooker tables, dining areas, and a stage. Encouraged by their experiences at Claremont Road, activists soon began to revitalize Reclaim the Streets (RTS), an appropriately disorganized antiautomotive movement that, like the broader antiroad campaign, had come together in the early 1990s. During the next couple

of years, Reclaim the Streets struck at various locations around London, blocking off streets and motorways to car traffic, pushing domestic objects and domestic life into the car-free streets, and staging illicit, all-day, on-the-fly festivals on the reclaimed pavement. And that May Day 2000 Trafalgar Square convocation reported by the Associated Press? It wasn't the first one. In the spring of 1997, tens of thousands occupied the square, partying and battling riot police beneath a giant banner that read, "Never Mind the Ballots, Reclaim the Streets."

Much like Critical Mass's emergence from the Bay Area, Reclaim the Streets has now spread beyond its London origins to cities around the United Kingdom, Europe, Australia, and North and South America. And much like Critical Mass, Reclaim the Streets—wherever it's sprung to life—has retained an uncanny knack for fomenting anarchy in the streets.

That big banner hung in Trafalgar Square—"Never Mind the Ballots, Reclaim the Streets"—provides a couple of clues as to the sort of anarchy advocated and practiced by Reclaim the Streets. The slogan, developed as part of Reclaim the Streets's campaign against the 1997 British general elections, embodied a call for direct action in place of ballots and traditional representational governance. As one flier argued, "RTS believes that . . . change will be brought about, not through the mediation of professional politicians, but by individual and collective participation in social affairs. In short—by direct action."[56] The slogan and the campaign in this way echoed the old Wobbly strategy of direct action in the workplace, of "demands legislated in the union hall," and the IWW's parallel disavowal of representational politics. It likewise recalled a well-known Wobbly cartoon featuring a class-conscious worker in confrontation with "the great hocus-pocus game" of mainstream politics.[57] And the campaign remembered Joe Hill and George Hayduke, sabots and monkeywrenches, in yet another way, featuring under the "Never Mind the Ballots, Reclaim the Streets" headline on one widely distributed poster another phrase: "Don't be a cog in the machine—be a spanner in the works!"

The specific phrasing of Reclaim the Streets's "Never Mind the Ballots" slogan quite intentionally recalled a more recent outbreak of anarchy as well. Reinventing the title of The Sex Pistols's (in)famous album, *Never Mind The Bollocks, Here's The Sex Pistols*, the banner called

Now He Understands The Game

Figure 3.7: Never Mind the Ballots: Wobbly commentary on representational politics, published in the Wobbly newspaper *Solidarity*, November 11, 1916.

up the ghosts of punks and Situationists, and the disorderly, do-it-yourself dramas they had staged decades earlier. In fact, a few years before he became "art director" for Malcolm McLaren and The Sex Pistols and designed the cover for *Never Mind the Bollocks*, Jamie Reid—son of leftist parents and, like McLaren, an art school student and Situationist—produced a series of stickers in support of the 1973 Miners's Strike, among them "Save Petrol, Burn Cars," and "Keep Warm This Winter: Make Trouble."[58] So, when the British mainstream newspaper *Mail on Sunday* sought to encapsulate, dramatize, and dismiss the 1997 Reclaim the Streets campaign with its own headline slogan—"Rallying Cry of Mob . . . Don't Vote, Make

Trouble"[59]—the newspaper, like *Time* magazine and its reporting on Critical Mass, accidentally got the heritage about right.

As Reclaim the Streets has written its anarchic message into slogans like "Never Mind the Ballots," it's inscribed it just as clearly in the media by which the message is delivered. During the same period that he was producing Situationist stickers in support of the Miners's Strike, Jamie Reid was starting an anarchist newspaper, *The Suburban Press*, and using it as a springboard for various anarchist/ Situationist events—including the posting of stickers on Oxford Street department stores reading, "Special Offer. This Week Only: This Store Welcomes Shoplifters."[60] As part of its 1997 anti-election campaign, Reclaim the Streets revisited this bit of subversive Situationist street theater. Spoofing the London newspaper *The Evening Standard*, Reclaim the Streets self-produced 20,000 copies of *Evading Standards*, complete with a banner headline announcing "General Election Cancelled." When London police confiscated all 20,000 copies just prior to distribution—and arrested three RTS members for "incitement to cause affray and incitement to cause obstruction of the public highway"—Reclaim the Streets simply self-produced and distributed 20,000 more.[61] But even if the police had seized the printing presses and copy machines as well, Reclaim the Streets members could have turned to other of their do-it-yourself media. They could've cranked up pirate radio station Tree FM, first broadcast from up a tree at an earlier street protest; or Interference FM, a pirate station designed to prey "on the frequencies of mainstream commercial broadcasters"; or "RTS radio, the decentralized pirate radio sound system."[62] Or they could have rolled in the Rinky-Dink bicycle-powered sound system, a multibike, day-glo, do-it-yourself outfit just as likely to show up at British Critical Mass events.[63] In any case, Reclaim the Streets's approach confirms it: reading Marshall McLuhan or digging Malcolm McLaren, inventing xerocracy or evading standards, the medium is the message—or, in the words of Jamie Reid, "Anarchy is the Key, Do-It-Yourself is the Melody."

Though remarkable in their own right, spoof newspapers, pirate radio stations, and bicycle sound systems also serve Reclaim the Streets's larger, self-named goal: taking back the streets. To accomplish this, Reclaim the Streets relies on the same sort of leaderless resistance practiced by the Wobblies and Critical Mass, offering

authorities little or nothing in the way of identifiable leadership or structure. Reclaim the Streets also augments its DIY media with a good dose of direct action and on-the-ground resistance, managing, like Critical Mass, to convert the conventional practice of everyday domination into its own undoing. Standing P. J. Proudhon's anarchist maxim that "property is theft" agreeably on its head, "pixies" emerge at night from the Claremont Road occupation to damage M11 construction machinery, and to steal good, sturdy materials from M11 motorway work sites—materials then used by activists to construct reinforcements along Claremont Road. Remembering the street barricades of the Paris Commune, Claremont Road squatters rebuild them, this time not from cobblestones but from old tires and the carcasses of junked cars, and decorate them so elaborately that the squatters' "direct action" becomes "performance where the poetic and pragmatic join hands." Inventing moments of reflexive, antiautomotive street theater, RTS members deflate the tires of automobiles so as to block streets from automotive traffic, and in another instance stage a fight between two "motorists" that explodes into the hammer-pounding destruction of both their cars, a blocked street— and a beat-pounding street party.[64]

For Reclaim the Streets, that particular explosion is no accident. In reclaiming the streets, in retaking urban space from the automobile and the motorway, RTS activists work to detonate the festival of the oppressed. Masterful creators of cultural space, Reclaim the Streets participants flood retaken avenues with furniture, of course, but also with fiddlers and techno/rave sound systems, drummers and dancers, jugglers, clowns, and children, all the while hanging banners, painting graffiti, chalking sidewalk art, and otherwise overturning the arid aesthetics of the automotive corridor. Sampling the twin spirits of The Beastie Boys' "fight for your right to party" and Public Enemy's "party for your right to fight," Reclaim the Streets writes a song in which those typically excluded from the streets now celebrate defiantly right down the middle of them.[65] "Cars Cannot Dance" proclaims one Reclaim the Streets flier—but people can, especially people who invent the space and the spirit to do so. Reclaimed, this celebratory space spawns new "living rooms" in the street, new interactions and pleasures, even new forms of practical resistance. When Reclaim the Streets retook London's M41 motorway in 1996,

for example, the subsequent "festival of resistance" featured a big banner with the Situationists's old slogan—"The Society That Abolishes Every Adventure Makes Its Own Abolition The Only Possible Adventure"—and two thirty-foot-tall female carnival figures, each wearing a giant hooped skirt. These figures offered more than dramatic decoration, though; hidden under those huge skirts, drowned out by the booming music of the festival, activists kept busy busting the pavement with jackhammers and planting saplings saved from the construction of the M11.[66]

As Reclaim the Streets participants invent new spaces and new forms of resistance, they remain well aware of the old traditions out of which they operate, of their role in breathing new life into old subversions. One group of RTS activists writes that, in escaping conventional Left politics, movements like Reclaim the Streets "allow the ghosts of past revolutions to guide us from our nightmarish slumbers."[67] Reclaim the Streets agitator Phil McLeish explicitly calls forth the festival of the oppressed, arguing that RTS is animated by the spirit of "great moments of revolutionary history, the enormous popular festivals of the Bastille, the Paris Commune, Paris '68. From the middle ages onwards the carnival has offered glimpses of the world turned upside down, a topsy turvy universe free of toil, suffering and inequality. Carnival celebrates temporary liberation from the prevailing truth and the established order; it marks the suspension of all hierarchical rank, privileges, norms, and prohibitions."[68]

As McLeish's comments suggest, this resurrected spirit of the anarchist past, of Communards and Situationists, opens the way as well to an anarchic future. Like Critical Mass participants, Reclaim the Streets activists emphasize this spiraling historical dynamic: in confronting the car and the ballot today, direct action in the streets invents alternatives to them, inaugurates a future without them. Aufheben, a magazine/political collective deeply involved in the anti-M11 Claremont Road occupation, writes that the daily practice of the occupation was "simultaneously a *negative* act (stopping the road, etc.) and a *positive pointer* to the kind of social relations that could exist: no money, the end of exchange values, communal living, no wage labour, no ownership of space."[69] John Jordan—one of those arrested for "incitement to cause affray" in 1997—echoes the experiences of BASE jumpers and other edgeworkers in recalling

the personal transformation and radicalization brought about by his immersion in the edgy dangers of direct action. But he goes on to write about a larger transformation, about RTS street parties that embody a "surging spirit of imagination" and a "propaganda of the possible . . . where . . . immense cracks appear in the facades of authority and power." And he recalls Raoul Veneigem's evocation of carnival as a "revolutionary moment"—a moment of "placing 'what could be' in the path of 'what is.'"[70]

Of course, Reclaim the Streets activists realize that there exist revolutionary moments other than the car-free carnival, other ways of placing the future in the path of the present. Even in the midst of actively retaking streets from the automobile, they acknowledge that "cars are only the most visible and tangible representative of an inhuman consumer society which is smashing community, constricting human spontaneity and freedom, and destroying the Earth's life support system."[71] Putting this broader critique into practice, Reclaim the Streets has consistently integrated its street politics with other battles against such a society. In a reprise of Jamie Reid's Situationist-style support for the 1973 Miners's Strike, RTS activists have formed alliances, and danced and marched arm in arm, with striking dock, transport, and medical workers in England, and RTS activists closely coordinated the infamous 1997 RTS anti-election campaign and Trafalgar Square party with a workers' March for Social Justice. So, when Reclaim the Streets, like Critical Mass, echoes the Wobblies once again—describing a process of "building counter-institutions within the shell of consumer society"[72]—they do so with a mix of street action and labor solidarity the Wobs would appreciate. Their healthy disrespect for the laws of consumer society the Wobs would dig, too. Early on, many Reclaim the Streets activists framed their beat-heavy, techno/rave street parties not just as alternatives to car culture, but as direct assaults on England's notorious 1994 Criminal Justice and Public Order Act—an act that criminalized a variety of alternative cultural spaces, including "raves" and other events at which "music includes sounds wholly or predominantly characterised by the emission of successive or repetitive beats."[73]

As it has begun to take root in the United States, Reclaim the Streets has found the ground, or more specifically the streets, well-turned by Critical Mass and other groups. As seen in the previous

chapter, Tempe's Project S.I.T. fights to reclaim the street spaces of the homeless. In neighboring Phoenix, anarchists block downtown traffic during a May Day rally—and are arrested for "obstructing the thoroughfare."[74] In San Francisco's Mission District, the increasing gentrification of the neighborhood and displacement of its lower income residents is confronted by a counterforce: the Mission Yuppie Eradication Project. With street fliers and posters calling for the vandalizing of yuppie luxury cars and SUVs and the destruction of high-end bars and restaurants, the Project gets the attention of well-to-do neighborhood newcomers and police alike. In fact, in a raid on the apartment of one of the Project's alleged instigators, police report confiscating a framed picture of Malcolm X, and some seventy books "related to anarchism, communism, or revolution."[75] Likewise, when Reclaim the Streets begins to launch block parties in Eugene, Oregon, it does so in a climate where local anarchists and eco-anarchists are already focusing on "issues like upscale restaurants and condominium developments, new downtown parking lots and logging of local forests," advocating "intentional, targeted property destruction as a response to gentrification and the ills of modern society," and promoting "neighborhood self-destruction" as a creative alternative and deterrent to urban development.[76]

Like Critical Mass, though, Reclaim the Streets introduces a particularly playful politics into this existing climate of anarchy—in the words of the Bay Area's Reclaim the Streets, a determination to turn "the pavement into a playground."[77] And so, in Berkeley, this sense of playful resistance produced a variation: Compost the Streets. That's right; like their London counterparts engaged in under-the-skirt jackhammer tree planting and other "guerilla gardening" actions, Berkeley RTS activists began to compost the pavement. Hanging out and talking before we go on the air with Bicycle Liberation Radio, The Twenty Inch Crank recalls a particular Fourth of July "compost in the street bash" that erupted in a busy Berkeley intersection. "The night before," he tells me, "about a thousand little fliers went up on all the parking meters around downtown, [that] said 'Reclaim the Earth, Compost the Streets.' And then it had a picture of this banana peel going da-la-la down the streets crushing cars, this huge banana peel. And so someone, who I won't mention, went out and gathered tons of juiced orange

peels. . . . And so we took that stuff and put it in buckets and put it around the area . . . and took these buckets out in the middle of the intersection [the next day] and dumped them." Hurrying down the road, perhaps on their way to a patriotic Fourth of July picnic, motorists arriving at this moment of insurrection encountered a disturbing interruption to their usual travels; allowed to roll through, but forced to navigate an intersection full of slippery orange peels, they at the same time had to dodge Reclaim the Streets activists whooping and hollering, dancing, smashing televisions, and burning U.S. flags amid their self-made sea of orange.

The Crank adds, though, that the intent of all this was not only to invent a Fourth of July festival of the oppressed, but to swing a slow-motion sledgehammer at the pavement, to put into practice the notion of "beneath the tarmac: the beach." "It painted the intersection for days," he remembers happily. "There'll still be little orange splitches." And better yet, "one of the ideas is that you throw your compost in the street. It interferes with the cars, confuses them, it opens their minds a little, something new that breaks the mold. And theoretically, as it breaks down, all the interaction will find the cracks and help breakdown the asphalt, trying to turn it back into soil." For Reclaim the Streets, then: the playful, anarchic absurdity of a city street painted in the colors of direct action, of orange peels undermining asphalt. And as for those motorists The Crank mentions, confused, minds opened a little, made unwilling accomplices as their wheels grind orange peels into the pavement: What must they have thought, caught in an orange marmalade morass of their own making? That perhaps the future had momentarily gotten in the way of the present?

Whatever their thoughts, some basic thoughts remain in regard to Reclaim the Streets. Above all, Reclaim the Streets activists retain a remarkable facility for enacting Bakunin's dynamic; flying "Free The City/Kill The Car" banners from atop smashed-up automobiles, undermining the asphalt with jackhammers and orange peels, inventing the vision of a better world in their assaults on the present one, RTS participants well understand that the destructive urge is a creative urge, too. Though perhaps more likely than Critical Mass riders to fight for their right to party, to invite confrontation rather than to calm it, Reclaim the Streets participants know what Critical Mass riders know: that a better world, a world of festive pleasure and

open inclusion, can blossom only when the present world is broken open. Just as clearly, Reclaim the Streets activists know that this better world will be brought about not by way of the ballot box, but by directly retaking and reinventing the cultural spaces of the city. And in this light, a final thought, a final image: a giant green Reclaim the Streets banner, spanning a retaken street, floating above the festival of the oppressed that has erupted along its traffic lanes and sidewalks, imprinting the street with a self-fulfilling injunction:

LIBERATE SP④ CE

CARMAGEDDON

Of course, this liberation of space from the automobile and affiliated arrangements of power won't come easily. It's not just that the combined political economy of the oil oligopoly, the automobile industry, and the road construction lobby underwrites every automobile and undergirds every mile driven; or that the modern nation-state manages to encode this ecocidal configuration in laws prohibiting, quite literally, the "obstruction of traffic." There's also the simple everyday fact that those who drive, and wish to continue driving, operate remarkably efficient killing machines, machines that grow bigger and faster with the purchase of each new SUV, machines quite effective at clearing the road of alternatives and in so doing contributing to the body count of roadside carnage and roadside crosses. And, beyond all this, there's the enshrinement of the automobile and of automotive privilege in our collective consciousness, in our everyday assumptions about moving bodies, acquiring status, and solving problems, to the point that many folks couldn't climb out of their cars, emotionally anyway, if they wanted to. So, if the emergence of groups like Critical Mass and Reclaim the Streets portends a journey away from the politics and culture of the automobile, it's not likely to be a smooth ride. If anything, that journey would seem to point us toward some future Armageddon, some final oil- and blood-stained, Road Warrior–style battle between the automobile and its alternatives.

Or maybe Armageddon is already underway. Among the many currently popular video games that reduce life and death to a touch

of the reset button, one in particular displays its politics with all the subtlety of a head-on collision. "Carmageddon," and subsequent versions like "Carmageddon High Octane" and "Carmageddon 2 Carpocalypse Now," offer a driving game in which players race their cars against each other, or against the computer, in a variety of virtual environments. But "Carmageddon" comes with a homicidal twist: players earn points, and eventually win, not just by completing the race course, but by killing pedestrians. And it's this twist that has online reviewers raving. One, who lists his interests as "technology, cars, anything fast," offers a sanguine summary: "The point of the game is simple, drive over pedestrians, farm animals, and destroy other cars, or race them. . . . To put it in a simple way, drive and kill, and you will win!" "Carmageddon captures a feeling of power behind the wheel," adds another reviewer, "leaving only your wheels on the road and the screams of anyone who falls between them. . . . In addition to the graphic presentation of splattered pedestrians, players are also treated to extremely colorful language." A third reviewer is moved to a more descriptive account. "Fleeing, screaming pedestrians . . . aren't safe from your raging red death mobile as you can run, skid, backup, and land on them creating bloody messes you can later run over with squishy, slippery results." "And best of all," he notes helpfully, "you get bonus points for causing all this havoc."

Interestingly, these reviewers link "Carmageddon" to the everyday realities of an autocentric world, while at the same time denying any such link. One player, who describes his interests as "classic automobiles, muscle cars, wrestling," points out that he wouldn't recommend the game for "people who take things way to [sic] seriously," but also allows that "Carmageddon is wonderful stress relief for those days you feel like choking someone." Another writes that the game is "not for the weak of stomach," but that on the other hand "if this [game] doesn't get rid of any amount of road rage you might have, I have no idea what would!" And "Kfgecko," a reviewer of "Carmageddon High Octane," echoes this idea. "After a hard day's work and stressful commute in traffic home, I'd say a lot of people need this game to release their tension so they can lead peaceful lives and keep their sanity. Carmegeddon is a smash 'em bash 'em race 'em crazy game that is truck loads (pun intended) of fun. This game let's [sic] you do everything in a car that you wouldn't, shouldn't, and can't

do in real life." He goes on to enumerate the types of pedestrian victims the game offers up for stress-relieving virtual slaughter—"business men in suits, regular men and women, old grandma's [*sic*] with walkers, grandpa's [*sic*] with canes, cows, policemen, punks"—but adds: "Just remember that this is a game and isn't training grounds for the real world."[78]

Were he still alive, Brian Deneke might disagree. Until his death in 1997, Deneke had spent most of his nineteen years in Amarillo, a city of 200,000 cut adrift on the high plains of the Texas panhandle. I can empathize. Growing up in Texas, I also spent some time off and on in Amarillo, and today I retain a couple of sharp memories from amid the town's mostly flat affect. The first is a seemingly endless night in the little Amarillo bus station, waiting in a cloud of bus fumes for my delayed connection to Ft. Worth, jammed in shoulder-to-shoulder with a hundred or so other down-and-outers lost in the inefficiency of America's nonautomotive mass transit. The other, in counterpoint, is Texas eccentric Stanley Marsh III's famous Cadillac Ranch, the collection of ten old Cadillacs, planted all in a row, fins-up, in a farmer's field west of town, a few hundred yards from the new Caddys and sixteen-wheelers blasting by on Interstate 40.

Brian Deneke's last memory of Amarillo is a Cadillac, too—the one that secured his place at the end of Kfgecko's list of (virtual) victims. A high-profile figure in Amarillo's small punk community, organizer of punk concerts and the force behind other alternative projects, Deneke enjoyed the adulation of younger punks in the community, and at one point even ended up employed by Stanley Marsh III to paint punk road signs around town. Like other members of Amarillo's punk scene, though, Deneke paid a heavy price for his public identity. Regularly harassed while traveling around town by foot, often targeted for assault as the perceived leader of the local punk scene, he earned an all-too-descriptive nickname: Fist Magnet. And most prominent among those throwing beer bottles and throwing fists at Deneke and other punks was a single group, themselves identifiable by their ritually white baseball caps. These were the rich boys from Amarillo's Tascosa High School, football and baseball players, student council representatives, and future oil company executives. "Those guys have a real big issue with pride," said one Tascosa student. "That's why all their cars are so big."[79]

This ongoing conflict came to a head in December 1997. Looking to settle scores from an incident the week before, punks and white caps had come together to brawl in a mall parking lot across from the local IHOP hangout. It was already violent enough—fists, beer bottles, baseball bats, batons, and by most accounts "a shitload of guys" ganging up on Brian Deneke—when Dustin Camp rolled up. Member of Tascosa's white cap elite, junior varsity football player, Camp was driving two friends to the brawl in his big beige Cadillac. Arriving at the scene, caught up in all that aggressive adrenaline, he didn't even bother to get out of the car. Camp first spotted local punk Chris Oles, swerved toward him and bounced him off the hood of the Caddy. Then he gunned it for Brian Deneke. The Cadillac "looked like a monster, like this metal monster coming after him," Oles remembers thinking as he climbed up off the pavement. Indeed it was. Camp hit Deneke full speed, rolling him under the wheels of the Cadillac and killing him instantly. Deneke's punk friends rushed to him; the crowd of white caps cheered; and inside the Cadillac, according to testimony at the subsequent trial, Camp found himself playing his own game of Carmageddon. "I'm a ninja in my Caddy," he said. "I bet he liked that one."[80]

At that trial in late August 1999—Camp's trial for the murder of Brian Deneke—Camp's defense attorney argued that in reality the case was not about Dustin Camp, but about Brian Deneke and the punks, about "a gang of young men who choose a lifestyle . . . designed to intimidate those around them, to challenge authority, and to provoke reactions from others." "The lesson of this case," he added, is that the punks' aggressive lifestyle "has consequences." And to emphasize the aggressive disregard that punks like Brian Deneke had for authority, automotive and otherwise, Deneke's favorite T-shirt was also displayed in court, its motto cutting Bakunin's dictum perfectly in half: "Destroy Everything." With all this in mind, the jury retired for deliberation, and returned with its verdict on the first day of September. Dustin Camp was guilty not of murder, but of manslaughter. He would not be put in prison, but on probation. And he would be fined $10,000—not even the price of a good used Caddy.[81]

While an Amarillo jury didn't find sufficient meaning in Dustin Camp's actions to convict him of murder, a larger meaning, a larger message, seems clearly to emerge: Carmageddon is indeed underway.

And if the battle between two distinctly different ways of moving and living is underway in Amarillo, it's equally underway every time I and other bicyclists take to the road's shoulder to dodge another Dustin Camp or, on better days, glide past a line of backed-up car commuters; every time we bring ourselves together in a critical mass of riders large enough to reclaim the streets; every time we boom Bicycle Liberation Radio or Tree FM or Interference FM out into the car-congested city. But significantly, activists for Critical Mass and Reclaim the Streets don't call all this Carmageddon, don't name their actions after a bloody mess of a video game. They have another name for it: revolution.

The Crank, it will be recalled, gives his full name as "The Twenty Inch Crank of the Bicycle Revolution"; the Bike Summer Editorial Collective quotes Subcomandante Marcos's apologia for a first-time revolution; and a Bike Summer bicycle bumper sticker announces that the revolution will not be motorized. Activists for Reclaim the Streets likewise call on the ghosts of revolutions past, and situate their own actions within "great moments of revolutionary history" like the Paris Commune. But, to ask again the question posed at the beginning of this chapter, What sort of revolution is this? What happens if the Brian Deneke Memorial Committee achieves its goal of replacing parking lot brawls and Cadillac death machines with "nonviolent unity and solidarity"?[82] What happens if we break the sort of "car addiction" that Jason Meggs and others describe, if we shut off the gasoline—surely the purest and most addictive smack of modernity? "Socialism can only come riding a bicycle," said Jose Antonio Viera-Gallo, a Chilean official during the time of Allende.[83] But what happens when anarchy comes riding a bicycle?

Certainly activists for Critical Mass and Reclaim the Streets envision some structural changes. Caycee Cullen, for example, foresees an ongoing effort to "eliminate privately owned automobiles and promote alternative forms of transportation," to create "more greens, more town squares . . . community based infrastructures." Along the way, many activists recognize that the sorts of direct action needed to accomplish these changes will remain outside the law. Altering stop signs, relocating couches, smashing cars, blocking streets, impeding traffic, broadcasting pirate radio—all are essential to the process of building a better world, and all remain crimes under the present one. Of course for Reclaim the Streets and Critical Mass activists, this

contradiction offers little in the way of surprise or concern. After all, revolutions aren't generally legal.

Mostly, though, their revolution isn't designed to confront the legal structures of the present so much as it's intended to ride around them, to operate outside of them, as activists go about the direct retaking and remaking of public space. Occupying space, moving through it, the communards of Critical Mass and Reclaim the Streets simply reinvent it. Collective rides saturated with pleasure and newfound power, street parties animated by exuberance and smiles of defiance—these insurrectionary moments both set the revolution in motion and sketch the trajectory that motion might take. "We take back our cities when we ride our bikes," says Perry Brissette. "On bicycles, we serve to reshape urban experience. On bicycles, we rekindle what it means to live in a city, a community."[84] And inside those retaken urban spaces, what then? New rules, new laws more amenable to bicyclists, pedestrians, and community? No, probably not. More likely, some sort of "enlightened anarchy" in which decisions and structures emerge cooperatively, tentatively, out of the contingencies of the moment.[85] If participants in Reclaim the Streets and Critical Mass are in fact engaged in some sort of revolution, then, it's one that doesn't seem to have much more of a structure or a destination than that first Critical Mass ride I saw advertised in Flagstaff, that "organized coincidence" headed "to wherever." And that's just the point. Like any good anarchist revolution, this one remains more an ongoing, unfinished process than a means to an end. Like The Sex Pistols, activists for Critical Mass and Reclaim the Streets don't know quite what they want, but they sure as hell know how to get it.

Most of all, those that participate in Critical Mass and Reclaim the Streets know that their unfinished revolution is as much cultural as political—or better yet, that it is political because it is cultural. They know that if the spaces they reclaim are to be remade, they must be reinvented as new cultural spaces. Most of all, it seems, their revolution rides on new meanings and new images, on Bike Summer's decorated bicycles and Claremont Road's decorated barricades, on the playful encoding of impossibility in everyday life, on Critical Mass's notion that all of this is "foremost a celebration, not a protest." At that big 1997 celebration that Reclaim the Streets staged in

London's Trafalgar Square, the celebration at which tens of thousands played, partied, and fought riot police beneath a "Never Mind the Ballots, Reclaim the Streets" banner, there was a second banner, too, hanging just to the left. It called up the ghosts of past revolutions, all right, and of one revolutionary in particular: Emma Goldman, the go-for-broke grandmother of modern-day anarchism. "If I Can't Dance, It's Not My Revolution," the banner said, repeating Emma's famous invocation. Don't worry, Emma—it is your revolution. Caycee and Emily and their friends in Women's Critical Mass are dancing at the revolution. John Jordan and The Twenty Inch Crank are dancing on Claremont Road in London, dancing on orange peels in Berkeley. Cars can't dance, but revolutions can. At the festival of the oppressed, everyone dances.

But of course dancers need music, want a beat, want a sound to carry them beyond themselves. They want to hear The Crank on Berkeley Liberation Radio, to catch the revolutionary static on Tree FM and Interference FM, to rock the day-glo techno-rhythms booming out from the Rinky-Dink bike-powered sound system.

They want the airwaves, baby.

We Want
the Airwaves, Baby

By way of introducing issues of street politics and bicycle activism, the previous chapter opened with a bit of sonic disturbance, as The Twenty Inch Crank and I pumped two hours of Bicycle Liberation Radio out over Berkeley Liberation Radio. Secreted away in a small studio, we utilized the technology of an illegal community radio station to broadcast a mix of bicycling information, antiautomotive ideology, and music into the surrounding neighborhood. In so doing, we not only promoted alternative transportation, but carved a bit of illicit sonic space out of Bay Area airwaves crowded with Top 40 music and McDonald's commercials.

Those two hours The Twenty Inch Crank and I spent on the air that night hardly constituted the first confluence of bicycle activism and microradio politics, though. Long before my arrival, The Crank and others had been making sound recordings at Critical Mass rides and elsewhere, and broadcasting these recordings and other bicycle information over illicit microradio stations like Berkeley Liberation Radio and Free Radio Berkeley. More broadly, Japanese microradio

activist Tetsuo Kogawa argued in the early 1990s that a community microradio station's broadcast range should in fact replicate the bicycling range of the community itself. "In that way you can be assured of community participation in whatever is being broadcast over the air," he said. "If [people] do have an opinion, they can bicycle over to the station and express it in a timely way."[1] In this light, Kogawa would be pleased by the couple that The Crank and I met after our broadcast; having listened to the show, they bicycled up to us in the street to discuss various issues raised. And in this light, Kogawa would no doubt agree with The Crank and others that the effective rebuilding of communities and the cultural spaces they occupy must intertwine lines of alternative communication, alternative transportation, and alternative politics.

ADVENTURES IN SONIC SPACE

Those two hours on the air with Berkeley Liberation Radio were not my first experience with illicit sound and alternative communication, either. As recounted in chapter two, years of busking have taught me the power of live street music in reshaping the meaning and experience of public space. Effective street musicians change the flow and feel of the areas they often illegally occupy, setting little sonic traps for tourists and tough guys who find themselves listening, dancing, and dropping cash in an open instrument case against their better judgment. As the cash accumulates and the interactions multiply, the music itself serves to organize impromptu audiences, to spark collective dances and sing-alongs, and, on the good days, to transform the functionality of the street into the informal excitement of the festival.

But of course it's not just street musicians and microradio operators who are hip to everyday sonic subversion. By whatever mix of accident and intention, people of all sorts find ways to orchestrate sonic spaces inside and against dominant arrangements, and to invent moments of collective resistance out of their own sounds and their own music. Such moments often reveal something of the subtle dynamics by which public interaction and public spaces are controlled—generally in the interest of efficiency and consumption—and also something of the boisterous human process by which such control is undermined.

One such moment unfolds in the spring of 1994, on an upper floor of a towering corporate hotel in the heart of downtown Chicago. It's Sunday morning, and I'm stumbling, hungover, the victim of yet another academic conference, down the labyrinth of hallways that lead from my room to the elevator, and then down to the check-out desk and the cab to the airport. As I drag myself and my bags down the hallways, I begin to notice—to hear, that is—a pattern. Room after room has its door propped open, and inside each room a black woman, a hotel maid, is hard at the job of cleaning bathrooms and making beds. In each room, though, the television is also on. In each room the television is tuned to the same program: a black church service featuring soaring gospel music. And in each room the television volume is cranked. The effect is remarkable; the whole floor swings to the sound and rhythm of the music, and I find myself smiling, at least temporarily cured of a hangover brought on by too much booze and too much arid academic discourse. The effect of all this on those who have orchestrated it is, I imagine, equally pleasurable and more profound. Pulled away from their church services by the demands of minimum wage work and a racialized service economy, these women manage to remain connected by way of shared sounds and amplified voices. Working alone in the corporate boxes that pass for hotel rooms, in the sterility of understated colors and mass-produced affluence, they break open the boxes by working together inside the music.

Five years later, half a continent away, and a few economic notches down: late night in the Del Taco, Flagstaff, Arizona. A fast-food chain catering in this case to the tourists pulling in off I-40 and to the local college student population, Del Taco is notable for the carefully planned mix of enthusiastic aesthetics and food service efficiency it presents to those who dine there. Bright primary color plastic booths, pseudo-Southwestern art on the walls, exposed ventilation ducts painted in more bright colors—all suggest a brittle, hurried charm blended with the facilitation of quick consumer turnover and ease of cleanup.[2] Or, as Del Taco president Ron Petty puts it, the restaurants are "designed to be exciting and upbeat. We want people to feel like they're in a very festive, somewhat party atmosphere."[3] This festive mix is auditory as well. The dining area tonight is awash in the type of pleasantly bouncy-bland music loop designed to ease digestion without offending the diner; featured is

Shania Twain's pervasive crossover hit, "Still the One." But filtering out from a boom box in the kitchen—and from the uniformly Latino and Latina crew that staffs it—is a different sound, mixing with, spicing up, contaminating, overriding Shania's mainstream assurances. It's Tex-Mex, and as the horns hop and the accordion takes a jump stop lead, I realize something: in my repeated visits, this is the one and only time I've heard "Mexican music" played in this "Mexican food" restaurant. I suspect the hotel maids in Chicago would appreciate the sonic intrusion, the messy musical recapturing of sanitized space, and the somewhat less than delicious irony.

Along with keeping one's ears open in hotels and fast-food joints, a little knowledge of music history also helps in appreciating the significance of sonic space. I'm a junkie for jazz, and especially for Thelonious Monk. After writing and editing a book exclusively to the late-night sounds of "'Round Midnight," "Blue Monk," and "Epistrophy," for example, I thought it only appropriate to dedicate the book to Monk.[4] And this is not to mention Bemsha Swing, my Monkishly cool cat. Given this, the story of 821 Sixth Avenue exists for me as a parable, a psalm perhaps, on the power of sound and space. There, beginning in the mid-1950s, jazz musicians transformed a squalid semi-abandoned building in New York City's wholesale flower district into a squalid all-night musical space and all-round jazz loft. Jamming until dawn or beyond, chain smoking cigarettes, crashing on old recliners, jazz musicians from Charles Mingus and Art Blakey to Hall Overton and Thelonious Monk composed, scored, and rehearsed their music, and in so doing created a collective cultural enclave for those on the margins of the mainstream. As trombonist Bob Brookmeyer recalls, "Guys played with people they'd never seen before. Whites, blacks, old guys, young guys. Nobody cared about that stuff. We were all outlaws. Our profession wasn't considered respectable. There was a sense that we were all in it together."[5]

Like so many of the cultural spaces explored in this book, though, the transformation of 821 Sixth Avenue went forward in more than one medium. From 1957 on, (in)famous photographer W. Eugene Smith also lived and worked in the loft. Embraced by the musicians as "a comrade, a fellow outcast,"[6] Smith hung around the edges of the rehearsals and jam sessions, photographing and recording people and events, and eventually producing some twenty thousand negatives

and eight hundred hours of reel-to-reel tape. Anticipating postmodern notions of looping, reflexive media dynamics,[7] Smith thus produced a photographic (and sonic) record of an emergent musical transformation, and at the same time transformed this transformation in his recording of it. His starkly beautiful photographs not only show the intensity of Monk and Overton composing at the piano, of Rasaan Roland Kirk leaning low into his saxophone, but the presence of Smith's own reel-to-reel recorder propped up nearby. The photographs exist both as images of cultural and sonic space, and as conspirators in the construction of it.[8]

A similarly subversive mix of alternative music and alternative ethnicity emerged for me decades after Monk and Smith, as a participant and researcher in Denver's hip hop graffiti underground. Cruising through central Denver's Capitol Hill neighborhood one night with a carload of graffiti writers—some Latino, some white, most all with arrest records for graffiti "vandalism" and other offenses—a police car passes. As it passes, someone in our car begins to rap a verse from the NWA—that's Niggers With Attitude—song, "Fuck the Police." Soon, everyone in the car is trading off verses, saying it with authority, singing it with feeling; I even jump in with the one verse I know. In that moment the power of marginalized ethnicity, the verve of youthful defiance, the cumulative clout of alternative art and alternative music, comes alive—not as the criminogenic antecedent to some drive-by shooting or cop killing,[9] but simply as an illicit pleasure shared at large in the city. And in that moment, the hip hop graffiti underground resides in that crowded car, in that music, as surely as it does in the images it leaves in streets and alleys.

That same graffiti underground started me down the road that would lead to The Twenty Inch Crank and Berkeley Liberation Radio. During the early 1990s, an old building on the edge of downtown Denver served as an alternative art space, informal graffiti museum, and come-and-go living quarters for graffiti writers and other wayward artists. On some nights its upper floor also became a pirate radio studio. Setting up a microtransmitter, graffiti writers and other members of the underground art scene would send information on alternative gallery openings, rants against local police and politicians, and rap music like "Fuck the Police" out into the neighbor-

hood. Transmissions were sporadic, to avoid detection, and it was never entirely clear who was receiving them and who wasn't. But there was a large homeless shelter nearby, and I like to think that folks there found some pleasure or comfort in catching a few minutes of our outlaw radio—because as we will see, the politics of outlaw radio and similar sonic disturbances time and again point to the transformation of cultural space in the interest of those on the margins of it.

SONIC SUBVERSION:
YOU CAN SEE IT ON THE RADIO

If you listen carefully you can hear little eruptions of illicit sound, catch the scattered echoes of sonic insubordination, all around the United States and other countries. But you do need to listen carefully. Like the other movements for the transformation of cultural space explored in this book, the politics of alternative sound are decidedly decentralized; there exists no Pirate Radio Politburo, no central clearinghouse organizing or cataloging the action.[10] Instead, loose federations form within and between realms of activity and activism, and sometimes fade, with many activists and groups operating outside even these tenuous boundaries. Yet if centralized, static organization doesn't hold these moments of sonic subversion together, shared orientations—toward cultural reinvention, anarchic do-it-yourself media, progressive politics, and solidarity with marginalized groups—certainly do. Collectively, these moments form a spider's web of illicit sound, a series of small sonic filaments stretching around mainstream media and mainstream politics alike.

As already seen, the type of sonic insubordination embodied in outlaw radio mirrors similar insubordinations that emerge in the everyday lives and sounds of street musicians, jazz players, maids, and fast-food workers. It also exists in the context of a larger movement in the United States toward what is variously labeled media hacking, media jamming, or culture jamming. This movement seeks to confront the monolithic, mind-numbing power of corporate media by constructing alternative media that can both provide outside information and, in a nicely ironic twist, appropriate and remake the plethora of images and information bits produced by corporate media them-

selves. Groups like "The Immediasts," for example, produce pamphlets designed to expose the "ecology of coercion" created by mainstream media, but at the same time argue that current technology provides "media hackers . . . the resources to take back the airwaves and seize the media through nonviolent public insurgence." Referencing the anarchist notion of "direct action," they offer a number of recommendations, among them: "start up your own radio station or infiltrate an existing one."[11] The anarchist 'zine *Iron Feather Journal* likewise offers general information on hacking and "monkeywrenching," and provides technical information on building a DIY pirate television station. And in yet another moment of reflexive media looping, Craig Baldwin produces the film *Sonic Outlaws*, documenting the work of media jammers like the Barbie Liberation Organization, the noise band Negativland (which uses homemade technology to broadcast concerts over telephone lines), and the Emergency Broadcast Network, all of whom see themselves as do-it-yourself "media recyclers . . . folk artists, like Caribbean musicians who convert industrial waste into steel drums."[12]

Outlaw radio and other do-it-yourself media in the United States also reflect a remarkable range of activity elsewhere. Tetsuo Kogawa's views on microradio, bicycles, and community highlight the larger Japanese microradio/"free radio" movement—a movement that draws on previous free radio experiments in Italy and France to promote "Mini FM" stations in Japan. And, as Kogawa's earlier comments on community participation suggest, these Mini FM stations do often serve as sonic community centers, "gathering place[s] with a transmitting device" for neighbors, workers, artists, and the unemployed.[13] In The Netherlands, the squatters movement of the late 1970s and 1980s achieved a number of similar successes in building do-it-yourself communities, among them the takeover of a block of interconnected Amsterdam canal houses known as "The Groote Keyser." As the squatted houses became "a national symbol of revolt," forced eviction by means of police riot squad became a distinct possibility as well. In response, the squatters shored up their defenses: "The ammo room was filling up, the radio station The Free Keyser was set up and went on the air from the squat, and the bedsprings were replaced by steel planking welded together, supported by builders' props."[14] As seen in the previous chapter, mobile

DIY sound systems have similarly emerged as part of British Reclaim the Streets and Critical Mass movements; especially notable is Rinky-Dink, the bicycle-powered system specializing in "African-American gospel inspired garage" music.[15] Also in Great Britain, video activists—"camcordistas"—videotape environmental actions, infiltrate and videotape corporate shareholders' meetings, and edit and produce alternative news videos, all as part of what they call the "Direct Action Movement" or "DIY Movement."[16] In post-Communist Eastern Europe, thousands of small pirate television and radio stations have blossomed from amid the economic and political rubble—including Prague's Radio Stalin, broadcasting in full stereophonic irony from the base of a downed Stalin statue.[17]

Back in the United States, the band Pearl Jam sets up a seventy-five-watt pirate radio station at each stop of a recent tour—and broadcasts selections from Noam Chomsky.[18] Meanwhile, old tour bus guide Ken Kesey, his son, and other Merry Pranksters revisit past wanderings by self-producing and distributing film-to-video compilations of the original 1964 bus trip, Neal Cassady rocking and ranting behind the wheel. But Kesey and his compatriots have also organized new bus adventures (including the "Search for Merlin" tour of Great Britain), and have included a technological twist that Cassady himself would surely dig: the use of a portable transmitter to broadcast freeform sounds and suggestions to passing motorists, under the call letters KBUZ Radio.[19] Lesser-known cultural saboteurs are at work as well. The hip hop DJs and emcees behind the Shiggar Fraggar Show construct looping layers of media hacking and DIY media production by sampling and mixing existing sounds in their shows, sending these shows out as "Pirate Fuckin' Radio," and subsequently distributing videotapes of the shows as well.[20] Down in Texas, the group Red Asphalt Nomad takes media hacking, culture jamming, and DIY production to an extreme appropriate both to anarchist politics and the Lone Star State. Utilizing the largely discarded technology of CB radios ("They're cheap, or easily stolen") Red Asphalt Nomad broadcasts sampled audio mixes (including reports on and by the police); jams and overrides the audio portion of commercial television broadcasts; and works to communicate with the growing numbers of people drifting along two-lane blacktops, "people living in cars . . . with an ear for subversion."[21]

Around the United States, a broader microradio movement is also emerging. Though many illicit microradio stations of course remain below the radar, we can get some sense of the movement's breadth. Various published estimates put the number of illegal microradio stations around the country at 1,000, and certainly hundreds of such stations have begun broadcasting in the past few years. Lawrence Soley's recent research, for example, documents a remarkable array of stations, from Free Radio Fresno and Orlando's Dogg Pound Radio to Radio Free Memphis and New York City's (Hoffmanesque) Steal This Radio, originally broadcast, like The Free Keyser, from a squatted tenement.[22] A loose Microradio Empowerment Coalition has even formed recently, to campaign for the legalization of such stations. But perhaps the most precise—and as we will see, politically revealing—number comes from the Federal Communications Commission, which reports shutting down some 400 illegal microradio stations in a single two-year period during the late 1990s.[23]

Whatever the precise number of microstations currently operating (or shut down), it is clear that their lineage can be traced to one Mbanna Kantako. Resident of Springfield, Illinois', John Hay Public Housing Project, former house party DJ and victim of a police beatdown that left him blinded, Kantako helped organize a Tenant Rights Association (TRA) for the projects in the mid-1980s. In November 1987, he went on the air with an illegal one-watt microradio station, WTRA, named after the association and designed to promote its goals. Over the subsequent dozen years or so, Kantako, his wife and family, and others (including local university professors Mike Townsend and Ron Sakolsky) have continued to build the station, and to develop affiliated programs. Early on, the TRA created the Malcolm X Children's Library from scrounged and secondhand books. Now, the Kantako family operates, on a volunteer basis, the Marcus Garvey School of Human Rights for low-income kids, and runs the Senseia Kankaji Human Rights Club, named for their mentor and former Black Panther Senseia Kankaji. As with other producers of sonic subversion, Kantako and his associates clearly aim not just to disseminate sound—they aim to transform the social and cultural spaces they and others inhabit. Toward this end, the station has also moved from early, sporadic broadcasts to a 24/7 broadcast schedule, and has changed its identity from WTRA to Zoom Black Magic Radio,

to Black Liberation Radio—and now to Human Rights Radio. Along the way, it's picked up some interesting support. As it turns out, for example, Noam Chomsky is more than a voice on Pearl Jam pirate radio; Chomsky, Ed Herman, Ben Badikian, Herbert Schiller, Michael Parenti, and Sidney Willhelm each contributed $100 to the station's new, 15-30 watt transmitter.[24]

There in Abe Lincoln's hometown, Kantako and Human Rights Radio have also confronted abuses perpetrated by the local police and by the Federal Communications Commission. Since its early days, the station has monitored and reported on police brutality and, like Red Asphalt Nomad, has even rebroadcast local police dispatches. Like the carload of graffiti writers cruising Capitol Hill, like their pirate radio broadcasts, Human Rights Radio has also filled the interludes between police reports with bands like Public Enemy— and with songs like NWA's "Fuck the Police." In the midst of this sonic activism, Kantako has faced a variety of obstacles, including the arrest of his wife and his son, police harassment of visiting station guests like writer Luis Rodriguez, even gunfire aimed his way while interviewing a victim of white supremacists. Yet this activism seems also to have led to a dramatic decrease in cases of police brutality and police pressure against Springfield's black population.[25] Pressure from the FCC, on the other hand, has been ongoing. After the Springfield chief of police complained to the FCC, Kantako was ordered off the air by the FCC and fined $750 in 1989. FCC cease-and-desist orders and visits have continued over the following decade, and in the fall of 2000, a "multi-jurisdictional task force" including flak-jacketed federal marshals and FCC agents twice raided the station and seized equipment. Through it all Kantako has remained defiant. He has vowed "to go to jail before he runs out of transmitters," and echoing Tetsuo Kogawa and The Twenty Inch Crank, he has suggested that if necessary he can continue to broadcast on the run, with a mobile transmitter small enough to carry on a bicycle.[26]

In this way Mbanna Kantako—"still blind, still black, still broke," as his friend Mike Townsend describes him[27]—has survived to engineer an against-all-odds marvel of DIY media and sonic resistance, and along the way has become the foundation and inspiration for others. Based on Kantako's work, similar Black Liberation Radio stations have emerged in Decatur, Illinois; Richmond, Virginia; and

Chattanooga, Tennessee. Like other microradio activists around the country, the organizers behind two of the most powerful and politically engaged microradio stations—Free Radio Berkeley and San Francisco Liberation Radio—openly acknowledge Kantako's influence as "the pioneer of the micro radio movement."[28] But perhaps Kantako's own children say it best, in the "'Ghetto Radio' Rap Song" they wrote about the station:

> They say the revolution won't be televised
> They said this not long ago.
> But if you're ever in the place called Springfield
> You can see it on the radio.[29]

SAN FRANCISCO LIBERATION RADIO

San Francisco Liberation Radio occupies the front room of an unremarkable row house in the Richmond district of far western San Francisco. As I arrive at the studio one afternoon, a volunteer DJ, due to go on the air in ten minutes or so, is taking out the trash; Richard Edmondson, cofounder with Jo Swansan of San Francisco Liberation Radio, is on the Internet gathering news for the upcoming broadcast. As the broadcast begins, Richard kids that the chatter of the old dot matrix printer hammering out the day's news some five feet from the broadcast microphone constitutes the sounds of "the newsroom" for listeners.

Meanwhile, the room itself offers evidence of a microradio station caught between community service and criminalized activity, a station fighting to carve a little cultural space out of a world all too thoroughly mass-mediated and state-governed. On the front door, a sign reading "NO WARRANT NO ENTRY" is juxtaposed with an elaborate flowchart detailing the interworkings of the emerging world media monopoly, its subsidiary lines and linkages grouped under headings like Time-Warner, Viacom, and Disney. On the refrigerator are posted guidelines for dealing with apprehension, arrest, and interrogation by the police and FBI—guidelines that show up in various forms elsewhere in the microradio movement, sometimes under the heading "When the FCC Knocks on Your Door."[30]

As Richard Edmondson points out, such postings are more than evidence of some overblown outlaw fantasy; they're evidence and residue of past experience. When Edmondson and Swansan first put the station on the air in 1993, they broadcast on the run and from various locations, for fear of having their home raided if broadcasts originated there. One night in September of that year, Edmondson parked his truck on a hill in eastern San Francisco and began broadcasting from the truck's camper. Soon an FCC agent arrived, demanding to come into the camper, inspect the equipment, and interrogate Edmondson. Edmondson refused—as he says, "I explained to him that I felt my role was to be non-cooperative"[31]— and as the agent went back to his car to call the police, Edmondson took off. As he cut down a side street a few minutes later, he found himself surrounded by police cars, ordered out of his truck, and handcuffed. After being ID'd, Edmondson was released—but "six weeks later I got a letter in the mail from the FCC saying I was being fined ten thousand dollars."

Years of conflict with the FCC have followed, with San Francisco Liberation Radio contesting the fine, temporarily leaving the air in the face of ongoing FCC harassment, and even applying for an FCC licence. Finally, with no FCC response to the application, the station held a press conference in early 1999, and announced its return to the air after an absence of seven months. And as Edmondson recalls: "Maybe two weeks after we went back on the air, two FCC agents showed up at our door and wanted to come in and inspect the equipment . . . and we refused to let them in. They went away and again, it was a week or so later, I got a kind of hostile, threatening letter in the mail, only this time the fine was to be a hundred thousand dollars and I would be facing a year in prison."

Despite this ongoing and unresolved battle with the FCC, San Francisco Liberation Radio has grown into a significant sonic presence. On the air from four to eleven each evening—and planning, like Human Rights Radio, to expand eventually to a 24/7 format—the station provides an edgy mix of politics, news, and music. As Richard Edmondson points out, "we have our cultural crew and the political crew, and I think we manage to have a pretty good balance of those." Indeed, the station broadcasts a variety of news and political programming, including shows focusing on "fascism and the underground

reich," nonviolence and community self-reliance, the homeless and homeless activism, labor battles, and gay and lesbian issues ("Radio Free ACT UP"). But it also features alternative music programs like "San Francisco Underground" and "San Francisco Live" that range across reggae, classical, dance, and other styles. Such programs are designed especially to promote local songwriters and musicians, and to link local music to street politics—as with the station's airing of music by Berkeley street musicians and, as Edmondson says, its playing of the "street version," rather than the sanitized commercial version, of contemporary rap songs.

Jackie Dove embodies this grounded mix of cultural and political activism. A journalist by training and profession, she was surfing the radio dial one evening and discovered something a Pearl Jam fan, or Human Rights Radio listener, might appreciate: San Francisco Liberation Radio's broadcast of a Noam Chomsky talk. Discovering sometime later that the station's founders were vegetarians and animal rights supporters like herself, she wound up on the air, producing an animal rights program known as Unheard Cries. Going into the streets to tape (and later broadcast) animal rights protests, exchanging information and programming with other microradio outlets such as the Animal's Voice show on Vancouver's Cooperative Radio, she does in fact broadcast "unheard cries" not found on commercial radio—including those of foxes caught in leghold traps, and monkeys abused in laboratory experiments, as recorded by underground animal rights activists. "Community radio, human freedom and animal rights to me are now one struggle," she says. "It is what I went to journalism school to do."[32]

In all of this Richard Edmondson and others at the station emphasize the advantages of small-scale, local radio, and the importance of direct action and involvement with the immediate community. Though an ardent supporter of KPFA, the embattled Berkeley affiliate of the Pacifica and National Public Radio networks, Edmondson invokes the politics of scale in arguing that, "from the standpoint of theirs being a huge mega-watt station, and ours being a small microstation, they can't cover local issues like we can. . . . They can't cover issues in our neighborhood without alienating listeners, their entire northern California listening area. I think KPFA suffers a lot from what large mega-stations in general suffer from, and that's just

basically a lack of responsiveness to the people in their community."
In contrast, he echoes Tetsuo Kogawa, and my experiences across the
Bay broadcasting with The Crank, in noting that "we don't have an
Arbitron survey . . . [but] I'm forever running into people on the street
who'll say, hey yeah, I was listening the other night and you were
talking about such and such."

At the same time, the station utilizes available technology to
reach individuals and issues well beyond western San Francisco. The
station draws news and information from email lists such as those
produced by Earth First! and Food Not Bombs; participates in an
emerging microradio email listing; and itself sends to subscribers
around the country (and the world) regular email updates under the
title "SFLR News." The station also maintains a web site, and is
working to develop the sort of Internet broadcasting capabilities
already being utilized by microradio stations like KIND Radio in San
Marcos, Texas.[33] As Edmondson says, "There are all kinds of com-
munities—geographic, or communities with people with like-minded
ideas and concerns. . . . Without the Internet, the microradio move-
ment I don't think would enjoy quite the support that it does."

This dialectic of communities small and large, of communities
grounded in neighborhood geography and those defined by larger
commonalities of technology and politics, is reflected in the station's
engagement in both local and global battles. Like Jackie Dove, other
DJs and volunteers at the station don't simply report on Bay Area issues;
they go into the streets to participate in protests, record speeches,
document and confront police misconduct, and provide live, on-the-
scene reports. Through this sort of activism the station has been a
particularly courageous participant in the sorts of homeless struggles
discussed earlier, time and again supporting rallies and food distribu-
tion, and interrogating those police officers and city officials who would
stop such activities. The words of a Coalition for the Homeless speaker
at a Bay Area rally capture something of this intertwining of micromedia
and street activism: "What you have to do is be willing to stand up and
say 'First, you're gonna look me in the eye; you are gonna treat me like
an equal; you are gonna treat me with respect because I demand it.'
And if enough of us—from our little funky street newspapers, from our
taken-over airwaves with our independent liberation radio station, and
our manipulating the media and learning from the way they ignore us—

if we are saying the same thing then we create the national dialogue." Likewise, the station's support of KPFA has included airing recordings of speeches and protests, smuggling news and information past KPFA's internal "gag rule," and providing an alternative outlet for ousted KPFA staff. But of course this approach extends beyond the Bay Area as well. The station broadcast local protests of the war in Yugoslavia, and a subsequent inquiry into U.S. war crimes there, for example, and carried the World Trade Watch Radio coverage of the Seattle WTO protests.

Engaged with these sorts of street battles, broadcasting illegally and fighting the FCC, facing prison time and a crippling fine, Richard Edmondson knows the risk. "I know there's going to be a struggle, but I'm prepared for that. Mentally, you have to prepare yourself— mentally, psychologically—to go to jail. I think I'm ready for that. Not that I want to go to jail, but. . . . I just hope that when the time comes, I would have the courage to follow through with it." Yet in accepting the consequences of civil disobedience, he also knows the potential of the microradio movement he fights to defend—a movement with the power to reinvent both street politics and cultural space. Noting the new century's arsenal of street policing, from pepper spray to stun guns that "can shock whole crowds into submission," Edmondson argues that "the possibility of effecting change by mass protest the way we effected change back in the 60s is diminishing. Democratizing the airwaves may be the only way we're going to be able to effect change in the future. . . . I think microradio has the potential to radically transform the broadcast landscape of the century." And in this regard, even if he is cut off from San Francisco Liberation Radio by a prison sentence, Edmondson can at least continue promoting a book he's written about the streets, the station, and the movement: *Rising Up: Class Warfare in America From the Streets to the Airwaves.*[34]

FREE RADIO BERKELEY
(AND SOME ECHOES OF RADIO FREE DIXIE)

Like Richard Edmondson and the folks at San Francisco Liberation Radio, the activists involved with Free Radio Berkeley know something of the FCC's punitive approach to public communication. Begun in 1993 by Stephen Dunifer as "a free speech statement, as an

alternative voice, and as a direct challenge to the FCC's regulatory policies,"[35] the station and Dunifer were immediately hit with a $20,000 fine, and by the following year faced the threat of court injunction. With the station eventually forced off the air in 1998 by such an injunction, microradio was just returning to Berkeley at the time The Crank and I went on the air in summer 1999 with the Bicycle Liberation Radio show on Berkeley Liberation Radio. Perhaps by that summer night Berkeley Liberation Radio had emerged as an impermanent permutation of Free Radio Berkeley, perhaps not; in these troubled legal times, it's difficult to say. But in any case, as Dunifer points out, he's "not involved" with Berkeley Liberation Radio, and with neither Dunifer nor anyone else claiming the directorship of Berkeley Liberation Radio—with the old anarchist strategy of "leaderless resistance" in play—"there's no way a [legal] paper can be served . . . there is no one person to identify."

Current ambiguities notwithstanding, Free Radio Berkeley itself clearly emerged out of Dunifer's activist politics, and out of the culture and politics of Berkeley. Begun by Dunifer in his workshop above a West Berkeley electronics repair store, broadcast for a time live and on the run from the hills of Berkeley, later moved to a 1960s-era collective living space occupied by punks and punk rockers, the station has both reflected and helped construct the local community of which it is a part. Along with Bicycle Liberation Radio, the station airs programs like Copwatch, the Native People's Hour, Street Spirit (by and for the homeless), The First Amendment Show, Kidsoundz, The Art of Parenting, and The Radical News Hour, and plays music ranging from reggae and hip hop to the Grateful Dead. Like San Francisco Liberation Radio, the station has also publicized the battles at Berkeley's KPFA and provided a broadcast home for progressive programmers purged from KPFA. In fact, Dunifer's first broadcast, in February 1993, originated from a local "Save KPFA" protest.[36]

By the time I catch up to Free Radio Berkeley six and a half years after that first broadcast, its production facilities are now housed in an old West Berkeley building that mixes warehouse space with craft industry. Across the corridor at J & S Candles, workers are busy pouring striped candy cane candles; with great blobs of red, white, and green rejects piled in bins around the place, the smell of fresh wax pervades the corridor and the surrounding work spaces. In the

next bay down, the Earthworks Pottery folks are marshaling bowls and cups, and setting up display tables. Out the front door, workers from the surrounding facilities sit on old folding chairs, lean on a telephone pole featuring fliers for nearby music studio rentals and bicycle repairs, eating sandwiches and noodles and talking through their lunch break.

Free Radio Berkeley's production space thus sits about as far from the glass and chrome towers of corporate media as does Richard Edmondson's crowded front room. But it sits just where it should be, here among the candlemakers, potters, and other denizens of small-scale craft production and distribution—because, over the past six years or so, Dunifer and Free Radio Berkeley have worked to produce and reproduce the local politics of microradio, and to distribute them globally. In fact, the sign hanging above the entrance embodies both a classic statement of anarchist do-it-yourself politics and a mission statement of sorts for Dunifer and the station: "Free Radio Berkeley. Start your own community FM radio station with: low cost, quality micro radio transmitters and accessories. Professional audio and sound equipment." As the sign suggests, Dunifer and his associates have used this production space to develop reliable microradio systems at remarkably low cost. Dunifer notes that "we have been able to reduce the cost of a six watt transmitter to twenty dollars worth of parts, at mass production level—a little more at smaller quantities—we can make it 15 watts for an additional eight or ten dollars." Moreover, Free Radio Berkeley's IRATE (International Radio Action Training Education) program provides microbroadcasting workshops on topics ranging from webcasting and digital audio editing to interviewing and field recording techniques.[37] This down-to-earth technology and this shared knowledge have laid the foundation for the recent emergence of numerous microradio stations around the United States.

But, as IRATE's name implies, Dunifer has also exported this technology and information beyond the borders of the United States. His transmitters have been shipped to activists in Mexico City's barrios (resulting in Radio TeleVerdad), and are utilized by the Zapatista rebels and others in Chiapas.[38] Helping to build a network of Haitian microradio stations in the tradition of Jean Dominique and Radio Haiti, Dunifer has likewise worked to build a DIY political dynamic there, a down-to-earth form of "coup insurance":

In Haiti we're calling it coup insurance, in a sense that you get hundreds of people growing their own small stations around the country. The army just can't roll into Port Au Prince and take over the radio stations. In fact you have all these small stations running around, run on car batteries if necessary, and you have people trained to set them up, to build transmitters, to repair them and to maintain everything. Then you can make it much more difficult in any circumstance, whether in Haiti or other countries—there's hundreds or thousands of independent voices running around.

If this spirit of leaderless resistance echoes anarchist traditions, so does Dunifer's philosophy of local autonomy: "We basically would like to see every pueblo, every village, every community have its own station. . . . We want people to become as self-reliant as possible . . . a do-it-yourself ethic. We don't want to be the big American expert. We want to spread the knowledge base." A sympathetic writer has described one of Free Radio Berkeley's earlier production spaces as a sonic "bomb factory,"[39] and the present space is bombing as well—bombing the airwaves, and bombing the boundaries of nation-state politics.

As Free Radio Berkeley works to build local autonomy around the world, it continues to fight for it in Berkeley, too. Some distance away from this West Berkeley production space is the station's temporary studio, signified only by a little card taped to the window: "Congress shall make no law respecting an establishment of religion, or prohibiting the free exercise thereof; or abridging the freedom of speech, or of the press; or the right of the people peaceably to assemble, and to petition the Government for a redress of grievances." Walking around to its unmarked back entrance one afternoon, I'm greeted by an imposing figure, a tall man dressed in black boots, black jeans, black shirt, and black hat pushed down over a shock of gray hair.

"You looking for FRB?"

"Yeah I am."

"Well, you understand we have to be careful."

As we make our way into the studio, I discover that this is The Blair Witch, who's just wrapping his show. While his broadcast partner takes a turn—her radiant purple dress and multistrand beads sadly lost on the listeners out there in radioland—The Witch tells me about

the station's battle to maintain its daily lineup of shows in the face of FCC pressure, and its ongoing commitment to broadcasting live music even while confined within its temporarily smaller studio space. Reminding me of BASE jumpers, graffiti writers, and other illicit cultural workers I've known who balance initial caution with a taste for inclusion, he then mentions a gap in the lineup, and asks, "Wanna sit in? Take the next shift?" I reluctantly decline, and he returns to the air with a concisely defiant signoff: "Listeners, you know where to find me. And if the Feds are listening, you know where to find me too."

Tracy James shares The Witch's distaste for authority and injustice, federal and otherwise. Host of the Slave Revolt Radio program on Free Radio Berkeley, he situates his participation in the contemporary microradio movement within the long history of black resistance to white authority in the United States and elsewhere. Referencing Frederick Douglass, Douglass's use of existing media of communication, and the broader slave revolts after which James's program takes its name, James argues that, "we do have a struggle and a history, a successful history of militant resistance, our resistance, but also communication is absolutely imperative to reinforce, recrystallize, and structure what direction, and how you want to go in a particular direction. And that's what's so crucial about what we're doing. It's not just playing alternative music. It's formulating ideas and communicating with our constituents . . . [as to] what is the best way we can get to the next step."[40] Like Dunifer, Edmondson, and others, he argues that the conglomerated ownership and commercial formats of corporate media render them unable (and unwilling) to support this sort of communication, leaving micromedia as the only viable means of radical organization. And for James as for Dunifer and Edmondson, this mediated organization must in turn link local battles with international issues, from gentrification of San Francisco's Fillmore district—"the Harlem of the West . . . where Louis Armstrong and Coltrane played"—to toxic dumping and environmental racism in Louisiana, from "the Phillippines . . . to the reservations to rural areas to the urban centers."

On Slave Revolt Radio, the local and the global, cultural identity and ethnic resistance collide in a kaleidoscopic mix of issues, sounds, and critique. On a single show, for example, James and other DJs and

reporters mix a recording of a Madeline Albright interrogation with sounds of bomb explosions and their own analyses of U.S. foreign policy. They back discussions of HIV, biological warfare, and the Aryan Nation with a swirling sonic wall of world beat, funk, and jazz (mostly Monk), and transition from an analysis of Army germ warfare tests to Hendrix, wondering "will I live tomorrow?" They take on "the head fixing industry—radio, the television, the corporate-owned media," and urge listeners, "brothers and sisters, support your Free Radio Berkeley, ya'll." They report on local picket lines and international labor issues, noting, like the Wobblies, Clayton, and other militants, that "an injury to one is an injury to all." And, to wrap things up, Tracy launches into a brilliant stream-of-consciousness riff on a new Ku Klux Klan museum while a swinging Monk improvisation unwinds behind him.

Animating all of this radio activity, from Berkeley's airwaves to Haiti's coup insurance, is a distinctly anarchist orientation. Dunifer identifies himself as an anarchist, and he and his station are commonly identified as such publicly, even linked to the unfinished revolution of the Spanish Anarchists.[41] As Dunifer says of his and Free Radio Berkeley's approach: "It's pretty much an anarchist position. It's all about self-determination, taking direct action to establish resources and infrastructure you need to function as a community without seeking permission from anyone to do it. . . . And if the government doesn't like it, too bad . . . People not only questioned authority in this matter, they just went out and ignored it altogether." The "free radio handbook" *Seizing the Airwaves*, edited by Dunifer and Ron Sakolsky—himself an anarchist and IWW member—is in turn published by AK Press, an anarchist publisher.[42] (On its *The Battle of Los Angeles* CD, the progressive band Rage Against the Machine includes the song "Guerrilla Radio" and a web link to AK Press.)[43] Moreover, Wobblies are directly involved in operations and programming at Free Radio Berkeley, as they are elsewhere in the microradio and alternative media movement.[44] The Frank Little Club—named for the great Wobbly organizer and martyr—broadcasts over Free Radio Berkeley. As station DJ Internal eXile explains, in linking microradio's "soapboxing the airwaves" to Wobbly soapboxing and free speech fights of old: "I'm one of about sixteen Bay Area Wobblies doing a show on Free Radio

Berkeley. Stephen Dunifer himself is a Wobbly, so it's not as though we're unrepresented at the radio station. . . . The analogy that Stephen Dunifer likes to use [is] comparing our struggle to the free speech fights of the past by Wobblies in Centralia and Everett, Washington. This is a modern version of a free speech fight."[45] Or, as Ron Sakolsky argues, "as the century turns, we could give new 'state of the art' meaning to the old Wob slogan, 'direct action gets the goods.'"[46]

But as the Wobblies themselves would be the first to point out, you don't need an IWW membership card to engage in anarchist direct action, in the liberation and transformation of cultural space— just a passion for self-determination, a commitment to local auton- omy, and a healthy disrespect for authority. Tracy James—who I suspect would identify himself as a black militant or freedom fighter more than an anarchist—reminds me of this one day when, in talking about the history of black resistance to white domination, he mentions Robert F. Williams. In the late 1950s and early 1960s, Williams organized and led armed black resistance to Klan nightriders and other violent racists in the American Deep South. On the run from the FBI, Williams subsequently utilized "a modern-day Underground Railroad" of friends and supporters to escape to Cuba;[47] and as Tracy James says, Williams "went over to Cuba for awhile, and he was kickin' it with Fidel, and he started a free radio station."

Indeed, soon after arriving in Cuba, Williams began Radio Free Dixie; broadcasting at 50,000 watts, it could be heard all around Dixie, and throughout other regions of the United States.[48] On Radio Free Dixie, Williams broadcast news of the civil rights movement and stinging attacks on white racism. But he did something else as well: he played the sorts of traditional jazz and "new jazz" that couldn't be heard elsewhere on the airwaves, often mixing this music with news and commentary. Before long, though, Williams and his station were in trouble with the Cuban authorities, not only for his criticisms of Cuban (and Soviet) party lines on class, race, and revolution, but for his music. Communist Party officials denigrated jazz as "imperialist music and degenerate"; Williams countered that jazz "was actually the music of the black people in the United States." And so, ultimately, Williams shut down Radio Free Dixie and left. "I don't see any difference in being a socialist Uncle Tom than being an Uncle

Tom in capitalist and racist America," he said. "I am not cut out to be an Uncle Tom no matter who it's for."[49]

Unwilling to submit to Klansmen or Communist Party officials, using guns, jazz, and information to blast out some space for an emerging black politics and culture, Robert F. Williams does indeed recall anarchist principles of autonomy and self-determination. At the same time, Williams and Radio Free Dixie anticipate and remind us of the cultural threads woven through the microradio movement, and through broader sonic transformations of cultural space. In Williams and Radio Free Dixie, we hear Monk and Mingus rebuilding the meaning of 821 Sixth Avenue with the same sonic tools that Williams was wielding to rebuild the politics of the South. We hear Mbanna Kantako, carrying on the mission of the Black Panthers and becoming himself an "electronic Black Panther," in the same way that Williams became the model and inspiration for Huey P. Newton and the first generation of Panthers.[50] We hear Richard Edmondson, his "cultural crew" and his "political crew" working together to produce the same potent mix pioneered by Williams. And we hear Tracy James, his Slave Revolt Radio show going out over Free Radio Berkeley with its Williamsesque overlays of Monk and anti-Klan militancy.

Tracy James and his jazzed politics, Robert F. Williams and the Communist Party's dislike of his Free Radio Dixie jazz broadcasts, remind me of something else as well. Back in the 1980s, my participation in the exploding world of do-it-yourself media and media hacking was not sonic but visual; it involved creating collages from found mass media materials, and incorporating these collages in the editing and production of various underground 'zines. One collage, which appeared on the cover of the 'zine *Infinite Degree of Freedom*, salvaged an old newspaper headline, "The Nazis Hated Jazz," and combined it with an image of Charlie Parker and a quote from Paul Robeson: "The artist must choose to fight for freedom or slavery. I have made my choice. I had no alternative."[51] Now, a decade or two later, I realize something:

The Nazis hated jazz.

The Communist Party hated jazz.

And the Federal Communications Commission hates jazz, especially when cut with a dose of cultural politics and blown out over illicit airwaves.

Figure 4.1: The Nazis Hated Jazz. By Jeff Ferrell.

DON'T NO GOVERNMENT OWN THE AIR

Jazz is not all the Federal Communications Commission hates. As already seen, Mbanno Kantako and Human Rights Radio, Richard Edmondson and San Francisco Liberation Radio, Stephen Dunifer and Free Radio Berkeley have all been targets of aggressive FCC surveillance and punishment, and of local police interference. Other less visible stations have suffered as well. Phoenix's ten-watt Arizona Free Radio, for example, was knocked off the air in the early 1990s by a $17,500 FCC fine, and the FCC has continued to fight the station over its refusal to seek a license.[52] Radio Free Venice, California's original microradio station, was also silenced in the early 1990s when two FCC agents and four federal marshals staged a guns-drawn raid, seizing equipment and audiotapes.[53] In Decatur, Illinois, Napoleon Williams and Mildred Jones began Black Liberation Radio in 1990, modeling it on Kantako's Human Rights Radio and intending it to be "a voice to those who have no voice of their own through the mass media." The price of that independent voice—

which Williams and Jones began paying within two weeks of going on the air—has included SWAT team battering-ram invasions of Williams's and Jones's home; the police seizure of the station's broadcasting equipment; lengthy jail terms for Williams and Jones; the removal of Williams's daughter from the home by the State of Illinois; and, as with Arizona Free Radio and others, a $17,500 FCC fine.[54] Likewise, Jahi Kubweza's Black Liberation Radio 2 in Richmond, Virginia, was shut down in the mid-1990s when, as Kubweza says, he "made a mistake." Seeking to be accommodating, he agreed to let FCC agents inspect his broadcast equipment—and they then seized it.[55]

With the turn of the new millennium, though, the FCC itself turned toward a more accommodating form of control, proposing to develop application and licensing procedures that would, in theory, support a thousand or more legal community microradio stations throughout the United States, each with up to 100 watts of broadcast power. Dennis Wharton of the National Association of Broadcasters—an organization defined by increasing corporate conglomeration and out-of-town ownership—worries with no apparent irony that "thousands of people won't be able to hear their hometown radio stations" if such local microstations proliferate. Those with a less vested interest in corporate media have other worries. Even if the FCC's proposed changes were to survive political and corporate campaigns to scuttle them, the application process would at best be cumbersome and costly, and subsequent regulations rigid. Exacting technical standards would exclude many stations. No frequencies would be available in many large cities, including New York, Chicago, Los Angeles, and Philadelphia. And, most tellingly, existing outlaw microradio stations would be denied licenses; only those who previously ceased broadcasting within twenty-four hours of being "reproached by the FCC" need apply.[56]

Beyond identifying these particular problems, the pioneers of the microradio movement point out the larger dangers in any legalization and legitimation of the movement. Though the FCC's focus has been on noncommercial microradio, for example, the licensing of commercial microradio stations remains a possibility. Yet, as Richard Edmondson argues, such commercialization would profoundly change the dynamics of microradio. "If you're going to

be a voice for the community, you need to be a voice for all members of the community," he says. "Not just the wealthy owners." Moreover, the commercialization of microradio would begin to recast the movement in the image of the very corporate media it stands against. "If microradio is going to be a force for change, I think it needs to be noncommercial. I don't think we can bring about change by imitating the larger stations. . . . Microradio has to forge a new direction, and I don't think you can forge a new direction by imitating the people you profess to hate." So, despite his thousands of hours of work in building and defending San Francisco Liberation Radio, Edmondson concludes that, "I would just rather see the station go under, financially just go broke, go off the air, than become a commercial station."

Given their anarchist sensibilities, many in the movement are even less enamored with the dynamics of legalization and regulation. Long before the FCC's millennial change of heart, for example, Mike Townsend offered his support for Free Radio Berkeley's ongoing legal challenge to the FCC, but noted, "I hope things stay like they are. We're not legal. There are no rules. Being declared legal could be like having a noose around our necks."[57] Now that at least some sectors of microradio may be "declared legal," activists continue to echo Townsend's take on crime, law, and media. Edmondson, who stands among the moderates in supporting some degree of nonintrusive legal regulation, argues nonetheless that "the real battle in this war . . . will be fought in the streets, over the air, and over the Internet."[58] Stephen Dunifer pushes it further. "Why be content with just a few crumbs from an ever-diminishing slice of an ever-diminishing pie? I guess I'm one of these people that it's either the whole damn pie or nothing at all. And throw in the bakery for good measure. . . . You can't be content with what Washington may or may not give us. Rights are only secured when you take them back through effective direct militant action. . . . We are going to extend the terms of engagement. . . . We're going to take back what belongs to us: the airwaves." And as founder of the microradio movement, Mbanna Kantako perhaps best captures this anarchist disavowal of state authority, whatever its momentary alignments: "Anything the government gives you, they can take away. . . . Don't no government give you freedom of speech. Don't no government

own the air. . . . How the hell we gonna argue with them about their laws? That is insanity. We've already tried that for 500 years. I don't give a shit about their laws."[59] As Townsend and others understand, the medium is indeed the message—and nowhere more dramatically than with microradio, an illicit medium whose alternative message could well disappear inside the dynamics of legalization and commercialization.

A recent episode suggests the sorts of deformities these new dynamics might produce. In the spring of 1998, the Tampa Bay, Florida, airwaves came under assault by a new pirate microradio station, its DJs broadcasting from a boat and utilizing a hip hop playlist to jam the signal of a local easy listening station. Though a "huge buzz" about these radio "renegades" resulted, it soon came out that they were in fact employees of CBS-owned station Wild 98.7, whose general manager had invented the "radio outlaw shtick" to promote the station's conversion to a "Rhythmic Top 40" format.[60] In the commercial environment of Top 40 radio, the street allure and underground legitimacy of microradio, of alternative media hackers and media jammers, were not only converted by a station like Wild 98.7 from threat to benefit; they were appropriated and sold as promotional commodities.

But, ironically, Wild 98.7 was able to generate a "huge buzz" with this fraudulent illegality only because its "outlaw shtick" was promoted within a public context already primed by the real thing. In March 1996, federal agents had raided Lutz Community Radio in the Tampa area, seizing its transmitter. In December of that year, FCC agents from Tampa had raided a microradio station in Orlando, also seizing its transmitter and forcing it off the air. And in November 1997, only a few months before Wild 98.7's stunt, FCC agents, SWAT team members, and others participating in yet another "multi-jurisdictional task force" had raided three microradio stations in the Tampa area—including 102.1 FM, "Tampa's Party Pirate," where they broke down the front door, handcuffed its operators, and dismantled equipment. Local media coverage of the raids, and highly publicized protest demonstrations against them, followed.[61] And so, for the Party Pirate and Wild 98.7 as for the city planners seen in chapter one, history arrived the first time as legal tragedy, the second time as commercial farce.[62]

EXTRA STATIC . . . DEVASTATING INTERFERENCE . . . CHAOS, ANARCHY ON THE AIRWAVES

In their ragged independence and street-level engagement—and despite the best efforts of the FCC and local legal authorities—the microradio movement and other contemporary efflorescences of sonic subversion begin to fulfill the challenge Bertolt Brecht issued some seventy years ago. Witnessing the emergence of radio as a powerful apparatus for the distribution of ideas and information, Brecht argued that we must "change this apparatus over from distribution to communication," and must set in motion the possibilities for "a kind of resistance by the listener," for the listener's "mobilization and redrafting as a producer."[63] The microradio movement, and the broader underworlds of media hacking and media jamming, invent these very possibilities as they engage communities in do-it-yourself communication, provide for the local production of media, and in many ways dissolve the boundaries between media production and media consumption. Before being silenced by the FCC, for example, Radio Free Venice was "open to the community on an equal basis," and set up so that "listeners could become program producers." Likewise, Napoleon Williams and Mildred Jones started Black Liberation Radio with the goal of "total community involvement, so anybody can be on the air," and to facilitate this involvement invited listeners to assist in program production and loaned out tape recorders to those interested.[64] For Williams and Jones, as for Kantako, Edmondson, Dunifer, and others, this mix of down-to-earth technological innovation and community engagement has of course been designed for more than "prettifyng public life," to use Brecht's phrase; it has been designed to promote resistance to existing social and sonic arrangements, to foster any number of little cultural revolutions. Given this, these microradio activists—and with them, assorted media hackers, hotel maids, and Del Taco workers—would doubtless agree with Brecht's conclusions as well: "But it is not at all our job to renovate ideological institutions on the basis of the existing social order by means of innovations. Instead our innovations must force them to surrender that basis. So: For innovations, against renovation!"[65]

These illicit sonic innovations, these small sonic revolts, coalesce into a powerful anarchist politics. Microradio activists and other sonic

outlaws employ both the defiant ideology and the practical technology of cultural autonomy, of do-it-yourself resistance, and ground this homemade resistance in the needs of local communities. At the same time, they parlay this micropolitics into larger federations of support, into Internet links and informal networks of mutual aid, and they battle to reproduce local autonomy throughout a global universe saturated by multinational media and caught within expanding state control. The name of a longtime Free Radio Berkeley program—"Acting Globally and Revolting Locally"—captures this dynamic nicely, this corrosion of sonic conformity and legal authority that emerges in one situation and bleeds over into others. Yet while many microradio activists have developed this approach directly from anarchist traditions and IWW affiliations, just as many—from Robert F. Williams to Mbanno Kantako and Tracy James—have developed it out of their ongoing direct action against racial discrimination and oppression. Certainly one of the defining dimensions of the microradio movement is this intersection of anarchist politics and ethnic militancy, the blending of broadcast power and Black Power—or, with San Francisco's Radio Libre, the integration of "Latino homeboys and white anarchists."[66]

In airing these political affiliations, microradio operators and other sonic outlaws create new cultural spaces, new arrangements of public meaning. Tetsuo Kogawa, for example, notes how Japan's Radio Home Run emerged as a "catalytic space" that produced not only new sounds, but affiliated forms of alternative art, theater, and print media, and he also notes how another guerrilla station, Radio Contemporain, broadcast music and protests from a crowded Tokyo street, thereby "temporarily creating a free space of live sound and airwaves."[67] Likewise, Dutch "free radio" operators, whose programs feature a swirling and generally illegal mix of sampled sounds and information, argue that such programming creates for all involved "a new space . . . a parallel universe that no longer intersects with the classic space of the polis."[68] As these cases suggest, and as this chapter has revealed, the creation of alternative sonic space thus enables and underwrites other cultural remakings as well, from the defense of homeless populations and promotion of street musicians to the mobilization of Critical Mass activism and the awakening of black communities. As before, the medium of microradio and media hacking is itself the message—a message about autonomy, resistance,

sonic community—and also the medium by which other messages are sent and received, other cultural spaces carved out. Stephen Dunifer explains:

> Communication is the core at all levels. We're seeing an attack on communication, whether it's broadcasting free radio, or the ordinances in cities against people posting fliers, ordinances against graffiti, noise ordinances so people can't hold rock and roll parties in the street. That's a form of communication, a way of organizing community. . . . So, a part of this is all about building a community struggle, about people seeing the necessity for solidarity and for trying to get past the issues that compartmentalize liberation.

The following chapter will describe a different medium of do-it-yourself communication, a different means of hacking and jamming dominant arrangements: graffiti writing. But though the domains are different—one visual, the other sonic—the politics of graffiti and of microradio are mostly the same. Like graffiti writers, microradio operators and sonic hackers construct alternative channels of communication, create alternative cultural space for themselves and others, out of little more than their own illicit knowledge and righteous defiance. Like graffiti writers, they transmit unregulated images and signs into public spaces, inscribing a sort of sonic graffiti on airwaves otherwise bought, sold, and regulated. And like visual graffiti writers, sonic outlaws elicit sputtering condemnation from guardians of the legal and economic order—condemnation that could just as well be directed at street buskers, gang members, and other cultural trespassers. "Extra static," says the head of a major media corporation, dismissing microradio. "Devastating interference," warns the president of the National Association of Broadcasters, lobbying against microradio's development. "Chaos, anarchy on the airwaves, and irreparable harm," argues an FCC lawyer, characterizing Free Radio Berkeley.[69] Well, indeed—extra static, devastating interference, chaos and anarchy—we can only hope for such self-made subversions, on the airwaves and on the walls.

But damned if we'll leave the last words to the FCC and the NAB, even if ironically. Instead, the sign-off should appropriately come

from microradio itself. And so, Robert F. Williams, writing a letter of thanks for a supporter's contribution of phonograph records to Radio Free Dixie: "Keep the jazz and blues flying and dig RFD."[70] And Mbanna Kantako, offering a classic statement of DIY politics and direct action as advice to his supporters—advice I suppose I heeded without ever having heard it, broadcasting with the graffiti underground out into the Denver night and pumping out Bicycle Liberation Radio with the Twenty Inch Crank:

"Go on the air! Just go on the air!"[71]

The Towering Inferno

Skript,
You would not believe the railyards now. Elitch, Ocean
Journey, Pepsi Center, Coors Field etc. All places I will not
visit due to the fact they have e nuf $ without me helping out.
Also for we all know we were painting the Mickey Thompson
Wall where center ice is now. Or smoked a fatty or two near
home plate at Coors Field.

—Rasta

The Denver graffiti underground of which I was a part itself exists as part of an illicit cultural web stretching across the United States, throughout Europe, and into Australia, New Zealand, Japan, and other countries. In fact, one of the most striking contemporary wars of cultural space continues to be fought between this growing subculture of non-gang, hip hop graffiti writers and the growing army of control agents sent out to stop them.

Developing in the Bronx and other New York City boroughs during the 1970s as part of the homegrown, do-it-yourself hip hop

culture of music and dance, hip hop graffiti took shape as a streetwise alternative to gangs and gang graffiti, providing its practitioners a medium for gaining respect and resolving disputes based more on image and aesthetics than violence and intimidation. Operating in this way, and continuing to intertwine with the larger hip hop world of music and movement, hip hop graffiti quickly emerged as a stylized system of subcultural status and street-level communication, a sort of visual rap laid down on the surfaces of the city. "Tagging" subcultural nicknames on walls and subway cars, spray-painting larger two-dimensional "throw-ups" and still larger, multicolored murals known as "pieces," hip hop graffiti "writers" and the "crews" they organized remade New York City's public spaces and public meanings. And soon enough, the aesthetic codes and wildly stylized images of hip hop graffiti exploded out of New York, and hip hop graffiti undergrounds began to take hold in other cities large and small.

Since then this subculture has continued to offer countless kids creative options outside the usual degradations of gang, school, or work; spawned thousands of often trans-ethnic graffiti crews around the United States and the world; provided writers in these crews with self-made measures of status and identity; and in fact generated an underground economy that provides many writers a modicum of economic and artistic autonomy. In expanding the cultural horizons of writers, the subculture has also expanded the visual horizons and cultural spaces of the city. In addition to painting individual throw-ups and pieces, writers gain status and pleasure from "going city-wide"—that is, from tagging or piecing as broadly as possible within an urban area. They also earn subcultural visibility by violating vertical urban boundaries—by "tagging the heavens" at the highest reaches of buildings and street signs. And in all of this widespread desecration and decoration of public space, the orientation is strictly DIY; as Denver graffiti writer Eye Six has said, "Your average person is just subservient to whatever is thrown up. Whatever building is built, whatever billboard is put up—whatever. They just sit on their asses. . . . We go out and get paint."[1]

As graffiti writers have gone out and gotten paint, political and economic authorities determined to defend urban space from them, to preserve what one antigraffiti publication calls "well-groomed" communities,[2] have gone out and gotten an army of police and citizen

surveillance teams armed with home video cameras, remote control infrared cameras, night-vision goggles, two-way radios, and cellular phones. They've supplemented these teams with razor wire, helicopter patrols, stakeouts, sting operations, and ongoing undercover programs, and have put into play a plethora of harsh new civil and criminal sanctions against graffiti writers. And they've underwritten these campaigns with a wealth of corporate dollars, coordinating them through business/political associations like the National Graffiti Information Network, and conducting them with the cooperation of those in the mainstream media eager to aid in constructing an image of graffiti writers as mindless, immoral vandals.

Like the BASE jumpers seen in chapter two, hip hop graffiti writers respond to their increased criminalization with spiraling experiential anarchy. Engaging in the slippery resistance of an enhanced "adrenaline rush," they convert the aggression of antigraffiti campaigns into an ever-more-wired and pleasurable experience of successfully writing graffiti in situations of grave legal and personal risk. They also fight back with direct attacks on those authorities who would expunge them and their images from public space. Led by Jose Lopez-Madrigal, the Bakuninesque graffiti crew "Kids of Destruction" executes a middle-of-the-street, middle-of-the-day tagging attack on an Oakland city truck involved in the local antigraffiti campaign. Other writers tag the heavens atop Los Angeles City Hall while participating in a city work program; paint poems, political commentary, and a "recall the mayor" piece along the Denver mayor's jogging path; and tag the Boston courthouse in which they are being tried for graffiti tagging.[3]

Writers make clear that their war for cultural space has in this way also become, increasingly, a war of anarchy versus authority, a war fought around "the subversion of the authority of urban space . . . the transgression of official appearance."[4] Los Angeles writer Asyl'm points out that "there's so many laws out there, especially geared to the minorities, and we're just fed up. . . . We all have freedom of expression, but we have to pay the consequences because of the laws that are written." Thirteen-year-old Los Angeles tagger Creator (CRE8) notes defiantly that, in response, "most of the time I get up [tag] on stop signs and city-owned stuff."[5] Berkeley graffiti writer Ader adds a historical perspective to the young Creator's claim.

"Essentially, modern-day graffiti started with kids who didn't have access for expression besides an art class here or there, so they said fuck it, I'm gonna bomb [write graffiti]," he says. "I love that mentality. I love to be able to tell the system, no, you don't have control over me." But old-school New York City writer Omar, bombing the streets since the early 1980s, puts this anarchist sensibility most succinctly: "I feel good breaking the law. Laws are made to control people. The people who make laws are not affected by them, and laws are usually directed at minorities, and made to prevent people from getting to their level. . . . Even if you're poor, you can live your life like it's a work of art. . . . I'm also into changing ads, hitting billboards, and just being a public menace."[6]

My friend Rasta 68 has been known to express such antiauthoritarian sentiments himself—including his announcement in a local newspaper's feature story that "personally, I want to hit on city stuff, like bridges, rather than some other person's property. They build the boringest crap around, so why not beautify it?"—and most memorably his public denunciation of Denver's virulently antigraffiti mayor as "a peckerhead."[7] Rasta and I have been friends for over a decade now, having first become compatriots and co-conspirators while both members of Denver's hip hop graffiti underground. One of the young founders of the graffiti scene there, Rasta reigned as a local hip hop graffiti "king" during the 1980s and 1990s. These days he uses the artistic skills he honed during those years in a variety of less illicit, though equally do-it-yourself, art enterprises. My own membership in the underground began in 1990, continued through the original publication of my book on hip hop graffiti in 1993, and ended in 1995 when I left the Denver scene, reluctantly, for a job in Flagstaff. Since that time Rasta and I have continued to trade mail, sending back and forth a steady stream of art, images, and newspaper clippings regarding graffiti and antigraffiti campaigns. A while back Rasta sent me yet another letter—a letter that was about graffiti, sure, but even more so about the shifting dynamics of anarchy, crime, and cultural space. "Skript," he wrote, addressing me as usual by my old underground name, "You would not believe the railyards now. Elitch, Ocean Journey, Pepsi Center, Coors Field etc. All places I will not visit due to the fact they have e nuf $ without me helping out. Also for we all know we were painting the Mickey

Thompson Wall where center ice is now. Or smoked a fatty or two near home plate at Coors Field."[8]

Rasta knew that I would appreciate an update on the railyards. Just as railyards and subway yards around the United States and Europe have long been favorite graffiti hangouts, Denver's railyards for many years served as the primary, illicit playground for the local hip hop graffiti scene.[9] A large elongated swath of forsaken land stretching along the South Platte River, home to hobos but few others, the yards offered a plethora of abandoned walls and structures on which to write graffiti, and an ideal blend of privacy and visibility in doing so. On the other side from the river, the yards also abutted "LoDo," the old derelict warehouse district of lower downtown Denver, home to the sort of cheap rental spaces appreciated by down-and-out graffiti writers and, I can attest, home to the sort of working-class Bohemian bar in which a writer might score a free beer, even while reaching for it with paint-covered hands. Perhaps most important, bordered as they were by the river and by old walls and warehouse abutments, the yards offered the dark salvation of automotive inaccessibility; they were a place where a graffiti writer traveling by foot could simply walk or run away from police officers in a car, even roll away from them by hopping one of the yards's slow-moving freight trains. The importance of this last dynamic Rasta and I both well understand. Painting at a more vulnerable location outside the yards, Rasta was arrested, jailed, and sentenced to 120 hours of community service. A couple of years later, Eye Six and I were heading to the yards to execute a piece, but changed our minds and ended up in a warehouse district alley; as a result, I ended up busted, with a conviction for "destruction of private property" and a year's probation.[10]

As Rasta's letter suggests, though, it was not just the railyards in general that stood as a symbol and a site of the local graffiti underground, of this illicit community cloaked in its own spatial marginality; particular places, particular cultural spaces inside the yards carried precise, powerful meanings as well. Now it's true that my geographic orientations from those days may be less than precise, since our railyard adventures were generally carried out in the dark, and with the help not only of those LoDo bars, but of many an accompanying Old English ("Eight Ball") and Mickey's forty-ounce malt liquor. (In

GENERAL SESSION SUMMONS AND COMPLAINT
IN THE COUNTY COURT IN AND FOR THE CITY AND COUNTY OF DENVER AND STATE OF COLORADO, THE CITY AND COUNTY OF DENVER BY AND ON BEHALF OF THE PEOPLE OF THE STATE OF COLORADO, PLAINTIFF, AND/OR THE PEOPLE OF THE STATE OF COLORADO, PLAINTIFF, VS.

Figure 5.1: Caught and convicted for "destruction of private property"—but, from the evidence, the passion for destruction is a creative passion, too. Eye Six and Skript, "Busted" piece, Denver, Colorado. Photo by Jeff Ferrell.

fairness to Rasta, I'll note that he has long since given up the stuff.) Still, as best I can figure, the much-publicized "redevelopment" of the railyards and of LoDo during the 1990s and early 2000s has led to three significant geographical transformations of the graffiti underground's railyard spaces. Put more bluntly, redevelopment and gentrification have landed three mammoth structures precisely on top of the old graffiti underground, leaving its most sacred locations crushed directly beneath them.

For all we know, Rasta says, we "smoked a fatty or two near home plate at Coors Field." If indeed we did, we did so while painting one particularly significant stretch of railyard wall, and while drinking forties as we stood lookout so others could paint. Coors Field, the home of the Colorado Rockies baseball team and one of the jewels of LoDo redevelopment, sits squarely on the rubble of what was once one of the Denver graffiti underground's primary "walls of fame." In the hip hop underground, walls of fame function as social and aesthetic gathering places, places where writers come to paint their best work, and to have it seen, critiqued, and on occasion painted over by other writers. At the edge of the railyards—and as Rasta suggests, just near the spot where Coors Field's home plate now punctuates the baseball diamond—stood this well-known and much-utilized wall of fame, a concrete canvas painted time and again by Mac, Voodoo, Eye Six, and other kings of the Denver scene.[11]

"Also for we all know," Rasta recalls, "we were painting the Mickey Thompson Wall where center ice is now." Center ice is an easy clarification; Rasta refers to the Pepsi Center, current home to Denver's professional ice hockey team, the Colorado Avalanche. Now buried under that ice rink, the Mickey Thompson Wall requires a bit more explanation, given its complex history as cultural space. Each fall during the early 1990s, the Mickey Thompson Off-Road Rally would arrive in Denver, a night of racing that would fill Mile High Stadium, just across the river from the railyards, with a cacophony of cars, trucks, motorcycles, rabid fans, and horrific engine noise. The powerful night-lighting of the stadium for this event filled something else: the railyards on the other side of the Platte. And so, at an abandoned wall in the middle of the railyards, a wall sitting at just such an angle as to catch the rays from Mile High head-on, the graffiti underground would gather for a night of piecing

each time Mickey Thompson came to town. Appropriating light from the culture of the car in order to paint a wall to which we'd walked, stealing legal illumination for purposes of illicit decoration, we would enjoy the rare aesthetic pleasure and artistic precision of well-lit yet private piecing at the Mickey Thompson Wall. But actually, Rasta abbreviates; the underground name for this second wall of fame came to be, in full, the Mickey Thompson *Dope* Wall, after the discovery one Mickey Thompson night of a giant female marijuana plant growing nearby. Elated, all the writers present that night assumed that, given the remarkable size of the plant, they'd shortly be both high and rich. Though it turned out that the plant was only hemp—the sort of non-intoxicating "ditch weed" that grows along rivers and creeks throughout the West and Midwest— the image stuck, and from this night on that wall, that space, became the Mickey Thompson Dope Wall.

Long before the Mickey Thompson Dope Wall, though, there existed another site of even greater subcultural symbolism and meaning, a site that in fact defined the earliest emergence of Denver's hip hop graffiti underground. Downriver a bit from the Dope Wall sat a cavernous old railroad maintenance building, abandoned by the railway but taken over by Denver's original graffiti kings as a place to hang out and piece. Dubbed the "Bomb Shelter" after the underground term for graffiti writing, the building's cultural and subcultural meanings eventually accumulated to the point that one local art publication described it as the "unofficial Denver Museum of Graffiti." Local art aficionados collected its broken, graffiti-covered bricks when it was demolished in anticipation of urban redevelopment, and graffiti writers painted tributes to the building and its aesthetic occupants, even images of bombs, on nearby walls.

As Rasta's letter suggests, those broken bricks now lie buried under Elitch's, an amusement theme park that serves as Denver's own little Disneyland. Remembering the disheveled, do-it-yourself beauty of the Bomb Shelter, loathing the sanitized corporate excitement of the amusement park, I've long imagined a ride that might well run among Elitch's rollercoasters and souvenir stands. In honor of the old railyards, it would be a little train, and in honor of the yard's old hobos—as ruthlessly and systematically removed from those yards as were the writers of the graffiti underground—a couple of mechan-

ical hobo robots, let's say Hobo Bill and Hobo Bob, would stand waving and smiling snaggle-toothed from the middle of the little circular railroad track. The Bomb Shelter would be back, too, only this time in miniature, made from premolded plastic and painted in festive colors. Popping in and out of its doorway, shooting-gallery style, would be some one-dimensional graffiti writer cut-outs, costumed in baggy pants and bandanas, little defused cans of Krylon in their hands. And passing by the Bomb Shelter, a suburban mother and daughter, in town and enjoying the miniature train ride, the daughter now startled and excited.

"Look mom, graffiti writers!"

"That's right, honey, they're mindless, immoral vandals."

THE TOWERING INFERNO

Even without that imaginary train ride, it's obvious there's plenty to do these days in LoDo and in the old yards. Coors Field, the Pepsi Center, Elitch's, the Ocean Journey Aquarium—all are places of popular, prefab entertainment and, as Rasta says, "all places I will not visit." To begin with, Rasta's right; as profitable corporate entities, underwritten by a whorish confluence of private and public money, named for watery beer and sugary soda pop, "they have e nuf $ without me helping out." Then there's the claustrophobia; even those cavernous baseball parks and sports arenas seem to me small, self-contained, pay-as-you-go spaces in comparison to the old yards, wide open to penniless vagabonds, underground artists, and adventurers of all sorts. But mostly I couldn't bear the archeology of it all. These new places of mainstream corporate amusement are built, quite literally, on the old, ruined foundations of alternative cultural space; these sites of prepackaged pleasure rest on the rubble of a subculture defined by its own pleasures, by a defiantly do-it-yourself melange of art, edgework, and criminality.

Yet, for all their glossy erasure of alternative history, none of these corporate spaces constitutes the railyards's most significant site of cultural transformation. To find this site, one need not rummage around under sports arenas and amusement parks. This site is still standing right in the middle of the railyards—towering, even.

During my years in the Denver graffiti underground, the Towering Inferno served as the most significant of all cultural spaces. Named by members of the underground after an Irwin Allen disaster film from the 1970s, the Inferno was an old seven-story flourmill, built from heavy concrete in the early years of the twentieth century, buttressed on one end by grain elevators, and long abandoned. Homeless folks lived in its basement, hung out often on its old ground-level loading ramps—men mostly, but also women and their children, and runaway boys and girls. With freight trains rolling slowly down the tracks only a few feet away, the Inferno made an easy stop for wanderers and itinerant hobos, assuming they could get past the railyard dicks. For a while, in fact, a local relief agency acknowledged this dynamic by leaving food for the homeless on the loading ramps; we would often arrive to find a little row of brown paper lunch bags, their tops neatly turned down, waiting on the ramps.

Local street gangs also moved in and out of the Inferno, partying there, leaving behind empty forties on the floor and gang graffiti on the walls. Skinhead swastikas sometimes showed up on the upper floors and the roof. The distinctive markings of the Bloods and Crips were especially common in certain rooms deep inside the Inferno; on occasion the North Side Mafia ventured across the river to leave a tag or two as well, written in the sharp-edged calligraphy of Latino and Latina gangs. And among the codes of honor that kept a certain order in the Inferno was an aesthetic one: Hip hop graffiti writers took the same care to paint over skinhead markings and images—"fuck you anyway" being the motivation and message—as they did to avoid painting over the Bloods, Crips, and North Side Mafia, lest the painting be misunderstood as a sign of ethnic disrespect.

Despite the variety of folks utilizing the Inferno, though, its occupation and aesthetics rested mostly on the hip hop graffiti underground. I and other members of the underground all but lived there, visiting time and again to piece, to check out or photograph others' pieces, or just to hang out and socialize. We knew where to hide from cops or other intruders; how to lift and slide the heavy metal interior doors shut behind us, when needed; how to avoid, even while walking in the dark, the multitude of holes left behind when the old mill machinery was removed from the floors—and especially how to avoid the open elevator shaft that spilled down through each floor. As

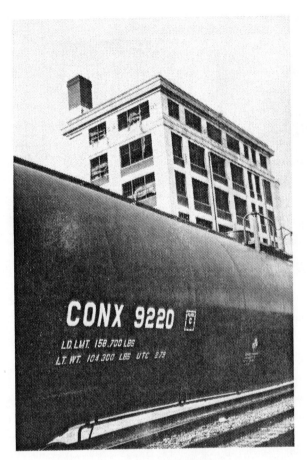

Figure 5.2: The Towering Inferno, Denver, Colorado.
Photo by Jeff Ferrell.

a result, almost every wall of any size in the Inferno became a wall of fame. In fact, the whole damn history of the Denver graffiti underground was layered onto those walls, as year after year writers returned to paint new pieces over and around old ones.

For graffiti writers and other underground artists, the aesthetic experience of the Inferno was absolutely addictive, even beyond the painting that they regularly contributed to it. Years before, a local artist had created a Christo-like installation by running long rolls of bright

Figure 5.3: Entrance to the Towering Inferno, Denver, Colorado.
Photo by Jeff Ferrell.

yellow burlap in and out of the broken windows on the Inferno's upper floors. Now, as we pieced along the Inferno's interior walls, long faded remnants of the burlap would whip behind us in the Denver wind, blowing around the interior and out of the big, busted windows. And should the disordered beauty of this experience grow old, there was always the roof. Accessible only by way of a steep, narrow set of stairs, stairs slicked by years of pigeon shit and lacking even a rudimentary handrail, the roof was an adventure simply to reach, especially when those stairs were climbed in middle-of-the-night darkness. But once there, kicking back, resting after the ascent, the full beauty and horror of the city was ours to enjoy: The river and the Rocky Mountains to the west, the skyscrapers of downtown to the south and east, the long open sweep of the railyards, the freight trains inching by below. But also, between us and the mountains, the freeway, often congested to the point of becoming a parking lot. And all around us, especially obvious from our high lonesome vantage point, Denver's notorious Brown Cloud, a grimy haze settling over the city.

From the view of city officials and developers, the railyards in those days were an urban void, an abandoned wasteland, a dirty and dangerous place—and the dirtiest and most dangerous place in those yards, the darkest void, was the Towering Inferno. Yet precisely because the Inferno had been abandoned by city officials, because it had been left to stand outside the political economy of urban development, it functioned as a richly occupied *public space*. While the Inferno wasn't inherently "public" in the sense of the streets, sidewalks, airwaves, and other spaces examined in previous chapters, it also wasn't subject to the exclusionary controls and commercialization that increasingly afflict these spaces—and so, ironically, remained an available public resource. Open to all comers, the Inferno offered shelter from the storm, sans entrance fees or "entertainment location areas" or FCC interference, and so produced an eclectic and diverse community of outcasts.

For those of us who knew it, who occupied it with our experiences and our art, the Inferno was a place of possibilities, a homemade refuge for outsiders of all sorts, a significant cultural space of our own making. Postmodernists sometimes speak, metaphorically, of "playing amidst the ruins" of modernism, of using cultural rubble as the raw material for cultural innovation. We were playing amidst the ruins, all right—not metaphorically, but spatially, sensually, publicly.[12] Through that play, we remade an old flourmill into a Towering Inferno, reinvented those ruins as a gallery for art and adventure, kept busy "puttin' up wallpaper for winos and bums," as Eye Six says[13]— and along the way, converted it all into an alternative cultural space whose magic was its marginality.

And then the ruins were ruined.

THE FLOUR MILL LOFTS

By the time the urban developers discovered the Towering Inferno, they faced a situation that they feared might be beyond repair, even with all their political connections and state grant money. "People forget," says Bill Mosher, head of the Downtown Denver Partnership, "that Denver . . . was sick, sick, sick" in those days, and that LoDo was then known as Denver's skid row "because that is exactly what

it was."[14] The Towering Inferno was thought to be the worst of the lot. "It was a trashed-out shell straight out of Beirut in the '80s," argues one local commentator; a building that "anchored the most desolate part of the valley."[15] Dana Crawford, the developer who finally took on the Towering Inferno, agrees. "Everything had to be redone," she recalls. "The interior was completely covered in graffiti. They had to fill the concrete floors—there were a thousand holes where the milling equipment went through. The windows were completely gone. It was just a total wreck."[16]

To tackle that total wreck and others like it, developers and city officials settled on a strategy of urban revanchism—a strategy of taking back, physically and symbolically, that which they had lost to hobos, gang members, and graffiti writers. Urban geographer Neil Smith writes that "the revanchist city" is one characterized by the "destruction of the public sphere," and is "a city of occasionally vicious revenge wrought against many of the city's most dependent—unemployed and homeless people, racial and ethnic minorities, women and immigrants, gays and lesbians, the working class. It has everything to do with a defense and reconstruction of lines of identity privilege."[17] As seen earlier, Samuel R. Delany has in this light described the revanchist retaking, the cultural cleansing, of New York's Times Square, as city officials and developers criminalized and ultimately evacuated Times Square's sexually, ethnically, and economically eclectic population in the interest of homogeneous gentrification.[18] A continent away in Denver, the vicious revenge against the down-and-out, the parallel restoration of railyard privilege and homogeneity, began with a familiar set of moves: authorities rezoned land, developed roads into the old yards, erected fences, filled holes, repaned windows in the Towering Inferno and buildings like it.

Like Times Square, though, this revanchist strategy required more than physical repair; it required cultural cleansing, spatial cleansing. So, the Denver authorities ran the hobos out of the Towering Inferno, out of the railyards, and demolished the old hobo camps along the South Platte—when, like the authorities along Tempe's Mill Avenue and New York's Times Square, Denver's leaders suddenly and conveniently grew concerned about the "public health" threat posed by these sick spaces and the infirm who occupied them. They likewise accelerated the already high-profile local cam-

paign against graffiti, arresting writers and aggressively painting over graffiti in the area of LoDo and the railyards. In fact, many at the time found it interesting that the Bomb Shelter, the original locus of Denver's graffiti underground, was one of the first old railyard buildings to be bulldozed, long before formal redevelopment began.

But if urban geographers could figure out what was up, so could urban graffiti writers. Talking about a nearby LoDo wall of fame, Z13—like Rasta, one of the founders of the local scene—told me: "That wall along the creek there—of course, the reason there's so much interest in that is because they're redeveloping that whole area. . . . Back when we did the wall of fame, it was just like, just previous, before they started working in that area, so it was still okay. But then once they started doing some work out there, all that had to go."[19] That wall of fame did go, as did the ones now broken beneath Coors Field and the Pepsi Center, and the ones inside the Towering Inferno. Like the "mural death squads" sent out by Chamorro's post-Sandinista government in Nicaragua to expunge the image and history the Sandinistas had encoded in their pervasive public art, the clean-up crews sent out by Denver's antigraffiti campaign, the construction crews organized by local developers, systematically erased the unsightly history of hip hop graffiti in Denver.[20] When they had finished, the railyards and LoDo's skid row had become something new, a shining "symbol of urban renaissance."[21] And the Towering Inferno? It had become the Flour Mill Lofts.

Sitting as they are in a location that now features some of Denver's highest real estate prices, the Flour Mill Lofts have quickly become one of the city's most exclusive and desirable addresses. All of the lofts have been sold—fetching from $400,00 to $1.2 million—and as one local news article breathlessly reports, "that's before you bring in your architect and interior designer."[22] The residents of the Flour Mill Lofts, a related article notes, are as eclectic and vibrant as their new neighborhood; after all, "it takes all kinds. Scratch the surface . . . and a fascinating mix of people emerges."[23]

Take for example Jill Crow. Arts patron, member of the 3M and Weyerhauser families, former resident of Denver's Country Club district, Jill purchased a 3,000 square foot penthouse suite in the new Lofts as soon as it became available. Bringing in her own team of architects and interior designers, she customized her new home with

personal touches: a wall of water, a Buddha, and the image of "Delta Queen," whom she describes as "this marvelous old black lady looking from her screen door with her ballet slippers hanging from her door—that's her dream." The hip hop history of the Inferno now expunged, she also brought in a stone mason to construct a bit of faux history: a corner fireplace, integrated with the building's old bricks such that it "appears to have been in the loft for decades, even centuries."[24]

With the completion of this cultural remodeling, Jill began to host gatherings, including a Democratic fundraiser featuring senators Dianne Feinstein, Patty Murray, and Barbara Mikulski. "It adds value to the community," said Mikulski during her visit to the penthouse. "What Jill has done is both ingenious and creative. It has it's own charm." But while the compliments are nice, Jill Crow has her own, more personal reasons for living in the Flour Mill Lofts. With no apparent irony, she notes that she left the Country Club for the Lofts, for a building cleansed of its own cultural history, because "I wanted more of a cultural experience." More than anything, though, she feels that when one enters a home, it "should tell you something about the person you are going to encounter." And for Jill Crow her home atop the exclusive Flour Mill Lofts, her home high above a cityscape purged of hobos and gang members and graffiti writers, tells the single most important story about her: "My interest in diversity, caring about equality."[25]

Just below Jill, participants also in this fascinating mix of people, live Scott and Jan deLuise. Scott is a public adjuster and assessor, Jan an accountant, and together they operate Matrix Business Consulting—but their real calling is their loft. At 5,800 square feet, it occupies an entire floor of the building, granting Jan and Scott a 360-degree view of redeveloped Denver. Like Jill Crow's penthouse, their loft features exposed "vintage" bricks, and their own happy touches: heavy antique furniture, a Venetian crystal chandelier, a leather-covered circular couch, Persian rugs, and a cherrywood-trimmed kitchen featuring a custom $3,000 pizza oven. (Note to Scott and Jan: I'm pretty sure I pissed, more than once, right about where your oven now operates—all that malt liquor, you know.) "We love it here," says Jan. "We are close to the city, we can hop right over . . . and be in the city doing what city people do, with plays and restaurants and the opera." Adds Scott: "I'm spoiled rotten."[26]

Still, all's not perfect. While the local papers gush over Jan and Scott, over their pretty panoramic views to the west of the Rocky Mountains and the South Platte, reporter Laura Watt feels compelled—in the interest of objectivity, of course—to mention also that which remains pretty, um, vacant. "On the other side," she says, "not so pretty, railroad tracks run just alongside the building, and vacant land, still to be developed, gives the place an isolated feel." Worse, the mural death squads seemed to have missed some of the old graffiti. Taking Laura on a tour of the loft, wanting to give her the inside scoop, Scott lets her in on a little desecrated secret; as she reports, toward the end of the tour he "opens a side door to reveal a stairwell covered in graffiti." But rushing to restore her article's upbeat tone, Watt offers in the next sentence a counterpoint and a conclusion: "He closes the door, and the past is shut out."[27]

Certainly it must seem shut out. Those thick concrete walls and sturdy vintage bricks that make the building, in its developers words, "the Rock of Gibraltar"; the new double-paned windows where the breeze once blew through; the elevator that only operates when "summoned from above"; the living spaces that are not only exclusive but soundly exclusionary—all must surely suggest to Jill, to Scott and Jan, that they can indeed close the door on the past.[28]

But maybe not. Maybe someday they'll be forced to face the fraud, to confront the historical contradictions, that underwrite their lives atop the Lofts: The way in which their conspicuous consumption of "cultural diversity" as some pretty liberal commodity rests on the destruction of the once-thriving and diverse cultures that defined the railyards and the Inferno. The way in which their lives "in the city doing what city people do" exclude, by careful design, what other city people once did in the city—long before Jill and Jan and Scott had ever heard of the Flour Mill Lofts. The way in which their sad search for an authentic "urban experience," for perhaps even a sanitized taste of the urban margins, negates the experiences of those whose home once was the margins, and leaves the Loft's residents with a sense of the city as exclusionary as the company they keep, as faux as that corner fireplace. The way in which their all-consuming privilege in fact exhausts the city's margins, closes down its public spaces, as effectively as the cops and developers who shepherd the privileged onto Mill Avenue, into Times Square, and into the railyards.

Hell, maybe one of these days Kropotkin himself will show up to point out these contradictions to the Lofts' residents. Speaking in the Paris of 1877, six years after the fall of the Paris Commune and the restoration of privilege there, Kropotkin observed that,

> Year in and year out thousands of children grow up in the midst of the moral and material filth of our great cities, in the midst of a population demoralized by hand to mouth living. . . . Their home is a wretched lodging today, the streets tomorrow. . . . And at the other end of the ladder, what does the child growing up on the streets see? Luxury, stupid and insensate, smart shops, reading matter devoted to exhibiting wealth, a money-worshiping cult developing a thirst for riches, a passion for living at the expense of others.[29]

So, yeah, maybe one of these days Kropotkin will arrive at the Flour Mill Lofts, offer the same sort of speech, yelling up at the penthouses and the pizza ovens. Maybe one of these days the street kids of Denver, Kat and Leif from Mill Avenue in Tempe, James Davis and Caycee Cullen and Tracy James, the old hobos and graffiti writers of the railyards, will look up the ladder and see the Flour Mill Lofts, will see the stupid luxury of its accommodations and the spoiled-rotten passion of its inhabitants for living at the expense of others. Maybe they'll remember the past, put the future in the way of the present, and reopen the Inferno as a public festival of the oppressed.

REIGNITING THE INFERNO: THE FESTIVAL OF THE OPPRESSED

As seen in the ongoing direct action of Critical Mass, Reclaim the Streets, and other anarchist groups, in their talk of "the bicycle revolution" and "the ghosts of past revolutions," revolution for anarchists suggests not so much a single, historical moment of insurgence as an insurrectionary process that is already and always underway, never to be completed or resolved, only to be embraced and enjoyed. In fact, a century before Critical Mass and Reclaim the Streets, Bakunin invoked this same sort of endlessly disorderly

process, defining anarchy in terms of an emergent "unfettered popular life," and arguing that "what we understand by revolution is unleashing what are known as dangerous passions and destroying what the same jargon refers to as 'public order.'"[30] The accounts collected here demonstrate that this revolution against public order, and for public life, is indeed well underway, flaring to life with Project S.I.T. and skate punks, called up by buskers and pirate radio operators, flowing under and against new arrangements of authority and control, eroding the spatial supports that undergird them.

So, as this revolution unfolds along Tempe's Mill Avenue and on Flagstaff's downtown street corners, in the middle of London's Trafalgar Square and in Berkeley's orange-coated intersections, over Human Rights Radio and Slave Revolt Radio, it seems not too much to imagine, to hope, that it might find the Flour Mill Lofts as well. And what if it did? What if this revolution were able to reignite the Towering Inferno, and in so doing burn down the facade of privilege and exclusivity that is the Flour Mill Lofts? What if, like Reclaim the Streets, we could reclaim the Inferno, inaugurate there what the Spanish anarchist Durruti called "la justicia de los errantes," the justice of the wanderers? What if we could indeed put the future in the path of the present?

Well, first we might need a meeting—but not just any meeting. In fact, this meeting would be modeled on the one held by the Club Saint-Leu, on May 6, 1871, during the Paris Commune. At the meeting, Citizen Boilot placed an intriguing motion on the agenda, a motion that foreshadowed by a century or so the Yuppie Eradication Projects of today. "Ought we shoot the rich or merely make them give back what they have stolen from the people?" the motion read. A debate followed: "Citizeness Richon, a woman of the streets, was of the opinion that one should have no regard for 'the Croesuses of this world'. Another woman speaker advocated that all rich people have their incomes leveled to the sum of 500 francs. Finally, after prolonged discussion, the meeting decided that they should limit themselves to *making the rich cough up*, leaving it open whether to shoot them later."[31] Like the members of Club Saint-Leu, those attending The Towering Inferno Reignition meeting—gutter punks, buskers, skate punks, street artists, bicyclists, anarchists of all sorts—might well agree to simply evict the Flour Mill Lofts' rich

inhabitants from their luxury suites, to make them cough up the cultural space they've stolen, and to leave their ultimate disposition for later. Like The Clash, pounding out the lyrics to the punk anthem "Garageland," those present wouldn't particularly need to know where the rich are going, or what the rich are doing—so long as they're not doing it any longer in what was once, and is now once again, the Towering Inferno.[32]

With the rich run out of the railyards, we might begin reigniting the Towering Inferno by repossessing their furniture. Some could be thrown from upper-floor windows, simply for the pleasure of watching it deconstruct upon impact; I suspect Jill Crow's Buddha in particular would approve. Other pieces, especially those made from good quality hardwood, from the sort of cherrywood that once framed Scott and Jan's kitchen, could be burned for warmth during Denver's snowy winters. Any of the rest that we don't need—the big circular couch and heavy old antiques from Scott and Jan's loft, oversized credenzas and armoires freed from other lofts—would, in memory of Claremont Road, be shoved out into the nearby streets, stopping the cars of suburban sports fans in town for a Rockies game at Coors Field or the Avalanche at the Pepsi Center, creating a little living room instead. And all those BMWs and Lincoln Navigators waiting in the adjoining Flour Mill Lofts parking garage—such an important resource. Their engines having been disabled, their parts recycled, they'll be rolled out into the sun, wonderful miniature green houses for growing fruit and flowers, complete with retractable windows allowing for nuances of climate control.

The wealthy and their accoutrements disposed of, the welcoming back of the hobos would follow. Before the railyards' redevelopmental purge, of course, wanderers and freight hoppers huddled in the Inferno's burned-out basement, or lived along the river in the sort of do-it-yourself accommodations described in chapter two. In fact, cutting through the yards some years ago, I came upon an object that pushed this idea of do-it-yourself accommodations—and do-it-your-self accommodation to circumstance—beyond some minimalist extreme. Spotting a new piece of four-by-eight-foot plywood lying on the ground in front of me, I stopped and took notice—in those days, any new object in the railyards was distinctly out of place. Kicking at it, flipping it over, I discovered underneath neatly folded clothes and

blankets, a few tins of food, and a carefully hand-lettered note: "This Is My Home—Please Do Not Disturb." I set what little money I carried next to the note, replaced the plywood, and walked on, amazed at the dignified ingenuity of those on the margins and disgusted at the desperation of their marginality.

But no more—at least not in the railyards. Now all those thousands of square feet that Jill and Jan and Scott were kind enough to have redecorated can provide a home, even a touch of the good life, for the homeless. The faux fireplace will offer some real warmth. The custom pizza oven will bake good, crusty bread, even a cannoli or two in honor of Denver's immigrant history—I doubt memories of my decade-old piss will bother those who have been living rough. Kat and Leif, gutter punks from Tempe and Denver, runaway and throwaway kids from anywhere, will have a place to crash, too, should they want it. Sitting around the corner fireplace, feasting on fresh-baked bread, we'll consider the festival of the oppressed underway, the new Paris Commune proclaimed—and, as the Communards did on March 28, 1871, we'll proclaim it "a day of peace and joy, excitement and solemnity, splendour and merriment . . . the festive wedding day of the Idea and the Revolution."[33]

While we're at it, we may as well welcome back the Beats. Neil Cassady's old man wandered drunk down LoDo's Larimer Street long before anyone thought of "urban development," stumbled along decades before the street itself was reinvented as upscale "Larimer Square," singing the Wobblies' old hymn, "hallelujah, I'm a bum, hallelujah, bum again" as he went. Kerouac joined Neil Cassady in Denver, suffered with Ginsberg through the Denver Doldrums, "stumbled along . . . among the old bums and beat cowboys of Larimer Street," drank in Colfax Avenue bars, dug the Rocky Mountains and the jazz blowing out of Five Points, out past the railyards.[34] Decades later the hip hop underground made sure the Denver Beats were remembered. Speaking for the public record, in an interview Rasta, Eye Six, and I did for an alternative newspaper, Eye Six talked about reading Kerouac's The Dharma Bums, about the ways it taught him to "choose your own vision." Better yet, Voodoo painted a railyards portrait of Kerouac, visible to hobos and commuters alike from atop one of the old viaducts, and wrote under it a fond farewell: "Hit the Road, Jack."[35]

Now Jack can return, can hang out at the Inferno on his way to one coast or the other. Old Tom Joad, of late resurrected by Bruce Springsteen and by Rage Against the Machine, can live again here as well.[36] All the other lost souls, all the other "sordid hipsters of America," too: Samuel Delany, the gay men and sexual communities, hustled out of Times Square; Rupert, a Seattle homeless man dedicated to saving animals and salvaging urban discards; Sue, a fifteen-year-old, green-mohawked punk who succinctly describes high school life so far as "print up anarchist literature, get screwed, and don't care about good grades anymore"; other women, twice Sue's age, battered by men, by the street, by both; every jazz player, every hip hop poet, we can find.[37]

Along with sordid hipster sleeping quarters, we can carve from Scott and Jan's stupid luxury a host of public cultural spaces. Remodeling meaning, encoding playful equality in place of their objectified elitism, we'll draw on artist Vito Acconci's gleefully human-scale designs for public space, and by all means architect Antonio Gaudi's Casa Batllo, completed in 1907 in Barcelona, with its beautifully absurd dragon-scale roof and undulating walls.[38] Borrowing from Gaudi's virtuosity in creating public mosaics from bits of ceramic and tile, we'll build in chess boards, so as to encourage the sort of multiethnic, all-night "street chess" games now emerging in the parks and donut shops, and along the beaches, of Los Angeles.[39] Decorated, redesigned in this way, these spaces will fill not only with all-night chess, but with the sort of all-night "art sessions" we once held in the Denver graffiti underground, all-night jams of the sort Kerouac or Monk might dig, jams full of drinking, talking, and aesthetic free-association. Barry and other buskers, converting the adjacent space into an impromptu rehearsal hall, into Denver's own 821 Sixth Avenue, will provide an appropriately fluid soundtrack.

Lest we turn too much in toward ourselves, we can always invite other groups, other collectives, to share the Inferno. The Club Saint-Leu is of course always welcome, as are other clubs of the old Paris Commune: the Club Communal, with its mandate, "people, govern yourselves directly"; the Club Ambrose, one of whose members suggests that we "blow up Paris rather than surrender"; and an unnamed women's club, its speaker launching "a diatribe against all Governments as such."[40] We can always make room for the Anarchist

Student Union of Irvington High School in Irvington, California—as a mainstream news report on the Union helpfully explains, "proponents say anarchy has become increasingly attractive to young people in part because much of their behavior—skateboarding, smoking, being late to school, punk rock fashion—has been criminalized."[41] And The Frank Little Club, last heard broadcasting over Free Radio Berkeley, can perhaps also organize a Towering Inferno chapter. If only they could bring Frank with them. Leader of many a Wobbly free speech fight, organizer of lumberjacks and oil workers, Frank Little would kick every remaining two-bit developer and high-minded interior designer out of LoDo. But he can't make it. He was murdered a while back—dragged behind an automobile, hung from a railroad trestle—by a bunch of vigilantes in Butte, Montana.

In any case, as old Wobs like Frank Little would remind us, there's more to the festival of the oppressed than art sessions and anarchist club meetings. The Communards of Paris knew it, too: "After the poetry of triumph, the prose of work."[42] So, we'll convert part of the Inferno's burned-out basement into a new Baatt Cave, modeling it on the Baatt Cave Bicycle Library in Berkeley, chocking it full of old bike parts pulled from dumpsters and recycled from aging two-wheelers. Like activists around the United States and Europe, we'll draw on our stockpile of spokes and sprockets to repair and rebuild bikes, then give them away to any who will ride them. And as this work continues, as new critical masses fan out from the Inferno, reshuffling and reinventing the movement of people through Denver, we can begin to enjoy the sort of city described by anarchist comic book antihero Mr. Nobody while cycling through Venice—a city "constantly new and unknowable. City of dreams."[43]

Other basement areas can support different sorts of working recycling projects—projects like artist Richard Sowa's floating home built from 100,000 recycled plastic bottles, or the West Coast community-based program that hires jobless kids to recycle plastic and convert it into "dome homes" for homeless folks.[44] Elsewhere in the basement, a print and copy shop will be kept humming. In the spirit of Critical Mass, the Inferno will operate as a xerocracy, a media collective in which any who wander through retain the right to produce as many words and images as they wish. The Inferno's print shop can also assist in producing the sort of "street papers" now

proliferating around the United States and the world—newspapers like New York's *Street News* and San Francisco's *Street Sheet*, written by, for, and about those whose lives unfold in the spaces of the street.[45] Of course, since those spaces are increasingly privatized and redeveloped, since as seen in chapter two even the selling of street papers in many such spaces is now outlawed, perhaps our first headline should read "This Space For Sale." If not, then like London's Reclaim the Streets, we can print a special edition of *The Denver Post*, headlined "General Election Canceled," or maybe "Mayor Recalled." "LoDo Condemned" wouldn't be a bad choice, either.

In all of this work of rebuilding bikes, recycling plastic, rechanneling the flow of information, the models of collective labor and workers' self-management invented by the Wobblies and the anarchists of the Spanish Revolution can offer an alternative to the habituated drudgery of the contemporary fast-food prep line, the atomized existence of the corporate cubicle. As Critical Mass activists would remind us, though, and as anarchist notions of direct action and innovation suggest, those models can't offer a blueprint. After all, as Augustin Souchy wrote during the Spanish Revolution, "One cannot . . . conceive of socialization and collectivization in accordance with a detailed preconceived plan. In fact, practically nothing was prepared in advance, and in this emergency situation everything had to be improvised. As in all revolutions, practice takes precedence over theory." So, as always, we'll build the road as we wander down it, all the while relying, as did the Spanish collectives, mostly on a Kropotkian "spirit of good will and mutual aid." We can't just busy ourselves reconstructing bikes and recycling plastic, either. As Souchy added, "The immediate task of the revolutionaries on the day after the revolution is to feed the people."[46]

Based on my experience, dumpster diving in the poshly redeveloped LoDo neighborhoods, behind the chichi stores now circling the Inferno, will begin to fill out the menu; over the years I've not only furnished myself and my living quarters from these treasure troves of conspicuous consumption, but salvaged a cornucopia of food for myself and others. Beyond this, we'll need a garden, an outdoor supplement to those auto-greenhouses we've built from the BMWs of the Inferno's former occupants. No orderly rows in the garden, of course; just an ecologically cacophonous combination of corn, cab-

bage, peppers, grapevines, apple trees; flowers not in the dustbin but among the vegetables, marigolds for the tomatoes; and here and there bike sculptures like the ones decorating the Bicycle Republic in Berkeley, bike scarecrows made from handlebars and sprockets too fucked up to recycle, scarecrow sculptures of the sort erected and then ignited at each year's Burning Man festival in Nevada's Black Rock Desert. But most of all the hemp—the hemp plant progeny of the Mickey Thompson Dope Wall, hemp fields scattered along the river, little hemp plots planted elsewhere around LoDo in the surreptitious "guerrilla gardening" style of Reclaim the Streets and Steinbeck's on-the-road Okies, with their "secret gardening in the evenings, and water carried in a rusty can."[47]

As the hemp gets high, as it overgrows surveyors' stakes and square-cut lawns, it won't just provide seeds, oil, raw material for rope and *ropas;* it'll create its own sort of cultural space. Charles Jenks has described the 1972 razing of Pruitt-Igoe, the notorious slum-in-the-sky St. Louis housing complex, as "the death of modern architecture"—that is, the death of the rationalist, dehumanizing principles of slab block construction, glass wall skyscrapers, and council tenancies. Like others concerned with the ongoing public meaning of urban ruins, he has further suggested that Pruitt-Igoe's remains might well have been preserved as a crumbled monument to rationalist arrogance and failure—in the same way that the Communards of Paris, had they held on, might have preserved the monumentally broken remains of Napoleon's fallen Vendôme Column.[48] On a recent pilgrimage to the old Pruitt-Igoe site, though, I discovered a different sort of monument, a different reclamation of meaning, despite the clearing away of the ruins. In the decades since Pruitt-Igoe was pulled down, the cleared site has been largely left to its own devices, such that it is now overgrown with weeds, wild plants, and trees, some of the trees rising thirty or forty feet in the intervening years. The high chainlink fence around the site, the little illegal footpaths radiating into the site from tears in the fence, confirm that this is not Pruitt-Igoe Park, not some public space regulated by the city of St. Louis, but instead a space shaped by the organic absence of regulation and redevelopment. In this sense, the space is cultural as well as "natural," a manifest negation of its former meaning, an embodied Bakunian dialectic of destruction and creation. And in this sense all that hemp, growing up

and around the reignited Inferno, overgrowing the aesthetics of LoDo's new luxury, will blossom into a monument of cultural negation as well.

The erratic growth of the garden, the hemp fields and the bike sculptures, the spaces modeled after Gaudi and Acconci will provide the new Inferno a nice degree of visual subversion. But how else, as Venturi would say, to decorate the shed?[49] After all, this is the festival of the oppressed, a work of both art and rebellion—in Critical Mass's terms, as much a celebration as a protest. The conversion of the Inferno's old ground-level loading ramps into a skate park can begin the process. Grinding the railings, gliding along the walkways, flying up and off the concrete ramps, skaters will decorate the Inferno time and again with fleeting moments of airborne beauty. Their space of soaring possibility can in turn appropriately be decorated with hip hop graffiti; as kids like Cycle and Crisis explained earlier, "both skaters and [graffiti] writers view the environment differently from everyone else . . . it's about an eternal search for a feeling, a vibe, an attitude that's found in the curve of a letter or the way you grind over the death box . . . it's this essence that true writers and skaters know as style." So, as they've done for the "mole people" living in the tunnels beneath New York City, graffiti writers can provide some visual backdrop, some of Eye Six's spray-paint wallpaper, for those searching out a feeling, a vibe, a style found only on the edge.[50] While they're at it, the Inferno's writers might find inspiration in Amsterdam's old Groote Keyser squat, where the "long hallway in the basement looked great after the punks stood there spray-painting the hell out of it all day." They may also recall Freedom's epochal "The History of Graffiti" mural, painted in one of those New York City tunnels, and decide to reinscribe along the skaters' ramps the lost history of Denver's hip hop graffiti underground.[51]

The Inferno's doors and windows will also need redecoration if they are to shed their exclusionary aura and become instead invitations to the festival inside. The windows we'll etch with abstract images and outlines, using the sorts of sharp metal shards that graffiti writers employ in etching their tags into store windows and mirrors. In memory of the Inferno's life before the Flour Mill Lofts, we'll also fly strips of cloth out of windows, but this time some anarchist black mixed in with the faded art-installation yellow. The doors we can

redesign along the lines of Gaudi or Acconci; in the manner of the driftwood and found-sculpture entryways at Eliphante, along Arizona's Oak Creek; or in imitation of the bizarrely stylized stone facing that Evad and I once painted around the Inferno's rooftop doorway.[52] And above each outside door we'll inscribe the new names the Spanish anarchists gave to each of the "bourgeois villas" they liberated during the revolution—names like "Villa Kropotkin" and "Villa Bakunin."[53]

And, oh, the outside walls of the Inferno—those blank expanses of thick grey concrete: such a canvas for sketching out a revolution. Certainly we'll want to unleash the hip hop graffiti underground on those walls, encouraging writers to splash vivid color and visual conversation up and down the Inferno's face. Given the Inferno's size, such a project will allow writers to engage their preferred aesthetics of scale—as Los Angeles writer Sacred says, "I like bigger walls . . . bigger lettering styles . . . everything just bigger"—and thereby to produce public murals of appropriate sweep and grandeur.[54] Freed from constraints of scale, they'll also be freed from the sort of insidious censorship that has often defined "public" graffiti-style art projects in the past, as "public" officials have disallowed murals dealing with police brutality, war, AIDS, and other topics.[55] This time, the graffiti underground will be able to paint the politics it wishes.

But in that regard, a suggestion: Since the hip hop history of Denver will have already been re-recorded along the skate ramps, perhaps the writers can take their history and politics back a bit further—say, all the way to Native America. Scattered around the Navajo Nation, the Rez, these days, in towns like Chinle, Arizona, and on old buildings near no town at all, the visual markers of a remarkable cultural confluence catch the eye. Some of the tags, throw-ups, and murals there revisit familiar hip hop themes, writing "Aerosal Graffiti Krew 99," or "ICP" in honor of the musical group Insane Clown Posse. Others, though, employ the style of hip hop graffiti for larger purposes. Across from the two hangouts in Chinle— the A&W and the Thriftway convenience store—tags and pieces proclaim "Dine Pride," "Native Dine Nation," "Navajo 1," and "FLC" (hip hop shorthand for "Fatherless Crew").[56] Likewise, along the main drag in Mescalero, New Mexico, the hip hop pieces reencode a mostly unnoticed history, with "Indian Power" and "400

Figure 5.4: Native American wall art, Mescalero, New Mexico.
Photo by Jeff Ferrell.

Years of Apache Rock Writing" painted among images of tribal dancers, eagles, and tepees.

Standing beside the road photographing these pieces one day, I ran into one of their creators, a young Native American kid from Mescalero. He dug what I was doing, told me about his other pieces,

but added, "Nah, don't put my name in your book—the cops, you know." Ok, man, fair enough—but maybe some day you can make it to Denver, work with the writers there as they reinscribe the prehistory of the South Platte River valley and the American West, writing your name and your past on the Inferno in letters so big no cop can erase them.[57]

In adding this sort of aesthetic fuel to the Inferno's rekindled fire, writers can not only paint images of alternative ethnic history, but draw on new forms of graffiti writing that have evolved since the early days of the Denver underground. Especially appropriate for the project of reclaiming the lost cultural marginality of the Inferno and other such spaces are the memorial murals, "RIPs" or "rest-in-peaces," that have developed in the graffiti underground since the late 1980s and early 1990s. During that period Rasta 68 began to incorporate headstones and other deadly commemorations into his Denver pieces; at about the same time, Martha Cooper and Joseph Sciorra began documenting personal hip hop memorials emerging on the streets of New York City.[58] In their role as folk artists for marginalized communities, hip hop writers in New York and other cities since that time have increasingly been commissioned to spray-paint street memorials for departed community members. Painted in public settings, on the exteriors of small shops and on handball court walls, these memorials reconstruct the tradition of roadside crosses and shrines described in chapter three and, like these roadside shrines, include personal remembrances, even personal portraits, juxtaposed with iconic images of crosses, doves, hearts, and headstones. Transforming everyday public spaces into locations of collective commemoration, rest-in-peaces also create, as Cooper and Sciorra say, "new public spaces for community ceremony," with friends and family returning to them year after year to celebrate bittersweet birthdays and lost anniversaries.[59]

Home to lost souls, house of anarchy, the Inferno would seem an ideal setting for rest-in-peaces commemorating those overrun by the violence of inequality and authority—if only its old walls can bear them all. Rest-in-peaces for all the victims of Carmageddon: for the seven-year-old schoolboy run down by a BMW; the postal carrier plowed under on the second day of walking her new job; the forty-two-year-old man in a wheelchair crushed beneath the wheels of a

speeding car.[60] A special rest-in-peace for Brian Deneke, painted so that the Cadillac Ranch's row of ten old Caddies becomes instead a row of ten punk headstones. Rest-in-peaces for all the hobos, all the homeless folks starved to death, frozen to death, beaten to death, pushed out of what homes they had along Denver's railyards and Phoenix's freeways and Tempe's Mill Avenue, erased from public view in the interest of redevelopment, then forgotten. Rest-in-peaces for all the old anarchists killed battling the robber barons in the United States, holding out against the Fascists in Spain, standing up to the Bolsheviks at Kronstadt, shoring up the barricades of the Paris Commune. A rest-in-peace for Frank Little, his portrait circled by black cats, by sabbo-tabby kittens, and underneath it Joe Hill's last words from the Utah State Penitentiary, just before the firing squad murdered him: "Don't waste any time in mourning. Organize."[61] Up and down the Inferno, a vast vertical cemetery. Like the Wobs say: We Never Forget.

Among all those black cats and crosses we'll find room for other sorts of decorative commemoration, too. In Los Angeles, Latina muralist and activist Judy Baca has organized "The Great Wall of Los Angeles," a monumental mural collaboration among kids of various ethnic and cultural backgrounds; in East L.A.'s Estrada Courts Housing Project, public artists and neighborhood kids have likewise created murals that embed bits of pre-Columbian iconography, street gang placas, and hip hop imagery in complex, inclusive configurations of meaning and beauty.[62] As diverse images accumulate on the Inferno, it can emerge as Denver's Great Wall. Drawing, like the L.A. murals, on the great Mexican mural tradition of Diego Rivera and David Alfara Siqueiros (who, by the way, was experimenting with spray-paint-on-cement techniques by 1932), incorporating even their iconic imagery, the Inferno's Great Wall can reproduce this tradition in a new world of Native American graffiti, gang logos, and RIPs.[63] As an artist well accustomed to a similar politics of scale and street, perhaps Rigo, the Bay Area Critical Mass muralist, can join in as well.

Even if Rigo can't make it, I hope HL86 and Bob Waldmire can. Longtime member of Denver's graffiti underground and larger alternative art community, an aesthetic wanderer more comfortable on the streets than in a gallery, HL86 is good with a Krylon can, better at cutting elaborate, sharp-edged stencils—and an acknowledged mas-

Figure 5.5: HL86's Mona Lisa, pen and ink, 1995.

ter with pen and ink. His hand-crafted works inhabit my house; his streetwise Mona Lisa, baseball cap turned backward, throwing signs, always hangs near my desk. Bob Waldmire is every bit as good. Creator of remarkably beautiful and detailed pen and ink maps, maps that record lost natural environments and forgotten cultural history, Waldmire spends many months each year on the road, selling or trading his artwork and looking for new places and people worth remembering. Both would add significantly to the Inferno's visual mélange of alternative meaning, with the Mona Lisa of the streets, the maps of subordinated spaces, blown up to the size of billboards and inked onto the walls. Both expert calligraphers, HL86 and Bob Waldmire might also be talked into inscribing on the Inferno the jagged lines of anarchist history, big black-lettered words from Kropotkin and Bakunin and Goldman and the Wobblies, "The Passion for Destruction Is a Creative Passion, Too" wrapped around the Inferno's top floor. Of course, we wouldn't be able to offer Bob Waldmire and HL86 the sort of high-end residency programs, many of them in redeveloped city spaces, that wealthy benefactors now provide some artists.[64] Then

again, I doubt either of them would submit to much in the way of "residency" requirements anyway; they'd probably settle for a stop-over, a meal, and a seat at the next art session.

With all this paint and print going up, we'll also want to leave at least a little open space for subversive projection. Back in 1989, Washington, D.C.'s, Corcoran Gallery of Art canceled an exhibition of Robert Mapplethorpe's photographs, under pressure from what Allen Ginsberg at the time called "control-addiction . . . cultural Mafia . . . alcohol-nicotine kingpins" like Jesse Helms and Joseph Coors. In response, supporters of Mapplethorpe, of art and artistic freedom, defiantly projected giant images from the exhibition onto the outside walls of the Corcoran.[65] More recently and less contro-versially, residents of Baltimore's Little Italy have begun holding free, open-air street showings of films on Friday nights, projecting *La Strada* and *Cinema Paradiso* onto the parking lot wall of a local Italian restaurant, and in the process resurrecting open-air movie traditions from the old country.[66] The Inferno will make a nice backdrop as well. For old time's sake, we'll project some Mappletho-rpe and Fellini onto it, along with graffiti images, underground skate movies, homemade BASE jump videos, and *Return of the Scorcher*. We'll be sure and show *The Loneliness of the Long Distance Runner*, too—especially that one scene of unadulterated anarchist defiance in which the delinquent kid, about to win the big distance race for his reformatory and his headmaster, stops just short of the finish line.[67] Watching that scene thrown up on the Inferno, of course, everyone will understand that he's undermined his only hope for freedom—but that in the same moment he's undermined the labyrinth of rules and regulations, the daily degradations of obsequi-ousness and obedience, the phony ideologies of competitive loyalty to the institution and the state through which his freedom and that of others have long been bought and sold.

Any little leftover spaces on and around the Inferno we'll fill in with the dinosaur bones, the fossil-fuel fossils, of car culture, decom-missioned automotive detritus reinvented as art. Like the Toronto street artists who've bolted iron plaques and "book sculptures" to city walls,[68] we'll bolt old hubcaps to the Inferno's walls—circles of concave chrome suitable for catching light and throwing back sparks. Like auto repair shop employees all over the United States, we'll weld

old mufflers and springs into a new generation of "muffler men," these brought together not to praise the car, but to bury it.[69] Like old Black Canyon Smitty out in Arizona, we'll cut silhouette sculptures out of rusty gasoline storage tanks, and prop them up all around the Inferno.[70] And as ecologists and community activists are doing around the world, we'll plant up and down the Inferno's walls the sorts of verdant "vertical gardens" that both cool buildings and clean the surrounding air.[71] The results of all this—the murals, the rest-in-peaces, the projections and inscriptions, the car part art, and the lush vertical gardens—will, I suspect, be spectacular. On the good days, with just the right bank of dark storm clouds rolling in off the Rockies, the Inferno will morph into an anarchist monster—not Godzilla menacing Tokyo, mind you, but a giant tattooed Chia Pet gone bad, towering over LoDo, stalking Dana Crawford, Jill Crow, Scott and Jan deLuise as they stumble, panic-stricken, toward the safety of their next loft conversion.

Of course, we may not get all of this infernal decoration done anytime soon; like Cycle says about skaters and graffiti writers, "no need to punch a timeclock here—we work on our own schedules."[72] But even if we take a break to play some music or tend the hemp, the proximate redecoration of the Inferno, the aesthetic reclamation of LoDo and the railyards from developers and urban dilettantes, will continue apace—because, as it turns out, the South Platte is not the only river running through the old yards. Hard up against the east flank of the Inferno, not fifty feet from it on the "vacant" side Laura Watt mentioned, railroad tracks do in fact still carry freight trains through the yards, one after the other, day after day. And as they roll by, these trains coalesce into a river of alternative meaning, carrying with them a steady confluence of subversive signs and images, as inevitable in their arrival as they are uninvited.

Hip hop graffiti writers, you see, have not only developed rest-in-peaces and other new forms of graffiti writing over the past decade or so; they've also moved the focus of their writing to freight trains. As seen in Denver's case, railyards have been hip hop playgrounds all along, but now they've become underground staging areas as well. Tagging freight cars and locomotives, utilizing the big monochromatic sides of boxcars as mobile canvases for throw-ups and pieces, for "whole-car" pieces that fill the entire side, writers who once could

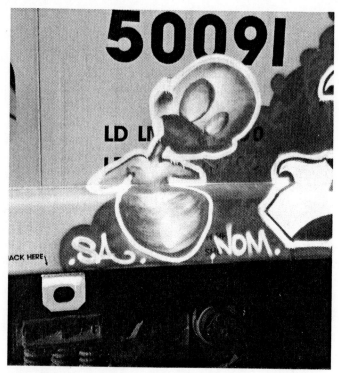

Figure 5.6: Freight train hip hop graffiti. Photo by Jeff Ferrell.

"go citywide" by writing on subway cars now "go nationwide" with their work on freight trains. In fact, I can attest to writers' success these days at moving their images well on down the line. Over the past few years I've kept on the move myself, tracking freight trains and their aesthetic cargo across the American West. Running alongside a long, slow-moving freight train winding its way up the Tehachapi Loop above Tehachapi, California, camera and notepad in hand, I've managed to record at least some of the tags and pieces on it, including one piece apologetically signed, "Sorry Too Fuckin Dark + Windy." Driving wildly down two-lane roads, Neil Cassady-style, in pursuit of a fast-moving West Texas freight train, catching up to it as it slows to a stop in the little town of Slaton, I've jumped out and sprinted to photograph its pieces before they pull away again. Outside

Claude, Texas, I've not only found and photographed a huge, imported "EVN" whole-car piece, signed "EVN Crew 1998 Canada Swimming With Sharks," but two cars down, a portable rest-in-peace, signed "Rest in Peace Liam Wood Bham." Plowing through swampy ditches, climbing chain-link fences to get at trains parked along sidings in Missouri, Kansas, Oklahoma, Nevada, New Mexico, Colorado, Arizona, Utah, I've time and again found hip hop graffiti relocated from Wyoming, Quebec, New York, Illinois—an endless interstate love song written from one writer to another.[73]

Mostly, though, I've spent hundreds of hours—some legally, some not—recording freight train graffiti in big urban railyards. There the trains come together, slow down, stack up, their cars at times disconnected and recombined, momentarily put aside or made up for new runs. And, because of this, it is in these yards that two of freight train graffiti's essential spatial dynamics unfold. In yards that remain at least illicitly accessible to writers, the concentration of trains within such circumscribed space provides the ideal situation for writers wishing to catch up on the latest out-of-town writing, and for writers themselves looking to paint large quantities of soon-to-be-disseminated graffiti. But even in heavily policed yards, yards effectively dead to writers, the graffiti itself remains alive. As trains are made up, pieces on particular cars come to be juxtaposed with those on others, creating elusive, rolling "walls of fame." As slow-moving trains pass, as trains are temporarily parked near one another, pieces likewise come together in ephemeral convergences of image and meaning, their cross-cutting colors often framed by the open door of a nearby freight car.

One Canadian graffiti writer—who figures that, despite being confined to a wheelchair, he's painted maybe 5,000 freight cars—speaks of freight train graffiti as a seductively elusive art form, "an issue of synchronicity. . . . That's my favorite theme, synchronicity."[74] And beyond any other location, it's in the urban railyards that his 5,000 cars most readily accumulate, that his elusive synchronicities are most likely to unfold. No matter how carefully the authorities police inner-city railyards that lie in proximity to redeveloped urban spaces, these synchronicities will remain; the hip hop graffiti underground will roll in time and again. And no matter what Dana Crawford and Denver's antigraffiti campaigners may imagine, no matter what Laura Watt

Figure 5.7: Freight train hip hop graffiti. Photo by Jeff Ferrell.

reports in the local newspaper, the authorities were never really able to close the door on the past, to run hip hop graffiti out of Denver's railyards. As the Wobblies did in their free speech fights, the hip hop underground made up for every writer arrested with another trainload of trouble. They're still at it, too.

Speaking of the Wobs and the rail-riding "footloose rebels" that populated their free speech fights, the cops and developers might be surprised to learn that they didn't really run the hobos out of the Denver yards, either. Even with their South Platte camps destroyed and the Inferno shut down, hobos themselves of course kept rolling through the yards in that endless river of freight cars. More important for issues of cultural space, so did their graffiti. Long before hip hop writers discovered freight trains, long before itinerant skate punks climbed aboard, hobos were both riding freight trains and encoding them with the symbolic discourse of their lives. That song old man Cassady sang along Larimer Street is a song of the rails:

I can't buy a job,
For I ain't got the dough,
So I ride in a box-car,
For I'm a hobo.

Hallelujah, I'm a bum,
Hallelujah, bum again,
Hallelujah, give us a handout—
To revive us again.[75]

Riding those boxcars, wandering the rails, hobos over the years developed elaborate systems of visual notation, a shared medium for holding together an inherently dislocated social world. Marking images and icons on the sides of freight cars, they declared personal identity, issued warnings, and kept up a conversation with their fellow travelers.

Today this hobo graffiti continues; typically a white or black line drawing accompanied by some form of personal identification, it also intertwines with the freight train graffiti of the hip hop underground. Running up Tehachapi Loop, for example, I didn't find just hip hop graffiti on that slowly ascending train. Carefully drawn in among the pieces and tags was a square-jawed face under a big cowboy hat, a face I'd seen on trains countless times before, this time signed "Collages Tour British Isles" in one spot, "Pointless Repetition NLR" in another. "The Rambler" was there also, his distinctive line drawings of effervescing champagne glasses marked with his signatures of time and place: "The Rambler Gila Bend Arizona 3-22-95," "The Rambler Mauriceville Texas 4-9-92." In fact, chasing after freight trains the past few years, I've seen The Rambler's drawings so many times I feel like we're friends. And he has some other friends as well, all of whom I've found riding the rails with him, laid up with him in the railyards, from California to Kansas: Pancho of the Frisco, Wild Man 10-93, Baby Carp, Big Bubba 88, Lil Bubba, 4-96 Buster, Mr. Bass 2-26-93, 95 Sahl, Salvage King (True Heir to Salvageland), Photo-Bill, Lady in Red Robin Denver Colo, 98° Phx Kid, 6-86 Denver Kid, Hopper, Sam, Mr. Clean. So while we're welcoming the hobos back to Denver's reclaimed railyards, creating some comfortable space for them in the reignited

Figure 5.8: Freight train hobo graffiti: The Rambler.
Photo by Jeff Ferrell.

Inferno, it's worth remembering: They've been there all along. Hell, The Rambler's spent more time in the Denver railyards over the years than I have, certainly more time than Jan and Scott have, his subterranean homesick blues sung from every passing freight.

To really dig those blues, I've found, one needs to be right there along the tracks, catching the creak of the freightcars and slow clack of the wheels as they back The Rambler's lonesome lead. The careful lettering of hobo graffiti, the perfect curves of a hip hop tag, the kaleidoscopic colors of a whole-car piece—all take on a beautiful intimacy when encountered up close. But watching all these illicit images accumulate along the length of big freight trains, seeing them accordion out by the thousands across wide urban railyards, I've also come to appreciate the sort of wide-angle view that can take in their collective power. Working our way up the Inferno, painting murals and planting vertical gardens as we go, we of course ultimately ascend to just such a view. The Inferno's rooftop, the summit of those old pigeon-shit steps, affords a breath-taking perspective on the fluid

transformations of cultural space rolling by below, an elevated understanding high above that ongoing river of illicit meaning. For this and other reasons, the roof will be one of the Inferno's most significant spaces to reclaim and remake, even if it's the last to be surmounted.

Beyond the perspective they offer, rooftops and other high spots, it will be remembered, constitute important cultural spaces within the hip hop graffiti underground, as writers find edgy excitement and aesthetic visibility in "tagging the heavens" above the city. In the early days of the Denver underground, Eye Six was known for his "hang and tag" technique, hanging off the top of a building or billboard, swinging out, holding on with one hand and tagging with the other so as to hit a spot of the greatest possible inaccessibility. Likewise, a bewildered Oakland police officer reported that the same "Kids of Destruction" who tagged a city truck in broad daylight would also "go as far as to hang from ropes and ledges just to put their tags on highway bridges and the sides of buildings."[76] Of course, as Hunter S. Thompson figured out decades ago in regard to "the edge" between life and death, between now and later, "the only people who really know where it is are the ones who have gone over"—people like Ozie, a nineteen-year-old San Diego writer who broke both ankles and his left arm when he fell 100 feet while tagging the heavens on a freeway overpass. ("I don't know what could be so important that he had to go up there," commented yet another bewildered law enforcement official.)[77] Reclaiming the roof of the Inferno, we can invite Eye Six back up, Ozie and the Kids of Destruction, too. This time, though, the edge will only be as risky as the writers want it, since for a change heaven won't be off-limits to outsiders.

BASE jumpers—another group of edgeworkers generally forced to storm the gates of heaven—will also have free run of the roof, a key to heaven, all the while operating under their usual proviso to "do whatever the fuck you want." At only seven stories, the Inferno may be a bit of a brief descent for even the best BASE jumpers—but at least the black flag of anarchy flapping in the Denver breeze will help with setting wind direction. And, even if the BASE jumping must be relocated to a place of higher liberation, the Inferno's roof will find other purposes. Those vertical gardens can grow up and over, creating one of the "green roof" rooftop gardens that are beginning to sprout atop cities throughout North America.[78]

Radio Free Inferno can find a home up there, too. Its antenna reaching high off the top of the Inferno, the station will be well positioned to jam LoDo's existing frequencies of consumption and privilege, to introduce some sonic disturbance into LoDo's overpriced equilibrium. Reborn just a few blocks from the intermittent pirate radio station the Denver graffiti underground once operated, Radio Free Inferno can provide the soundtrack for this new uprising, this new festival of the oppressed, as off-beat and eclectic as are the festival's participants. Like San Francisco Liberation Radio, Radio Free Inferno will take itself out into the surrounding streets, recording the gentle cacophony of buskers, catching the staccato rhythm of street protests, endlessly enlarging those alternative sonic spaces over the airwaves. In honor of Robert F. Williams and Radio Free Dixie, of Tracy James and Slave Revolt Radio, of 821 Sixth Avenue, Radio Free Inferno will send out a steady stream of Dexter Gordon, Art Blakey, Coltrane, Mingus, Monk—especially Monk—mixing all that spherical virtuosity with news, criticism, sound samples of police sirens, Klan rallies, Malcolm X speeches. And Radio Free Inferno will take dedications: For Mbanno Kantako and Human Rights Radio, a little old-school NWA. For Kat and Leif and James Davis, for every punk kid that ever ran out of patience, Rage Against the Machine's "Guerrilla Radio," The Clash, The Sex Pistols, X, Rancid, Against All Authority. For Carmelita, some world beat mixed with sweet mariachi static. And for Neil Cassady and his old man, for Larimer Street's long-lost beats and hobos, a few lines from Ginsberg and Kerouac, a few verses from "Hallelujah on the Bum," howled out defiantly from high above the Denver night.

More than anything, though, the Inferno's reclaimed roof will offer once again the panoramic perspective on the city, the sweeping sense of spatial possibility, that Jill and Jan and Scott bought away from the hobos, graffiti writers, and gang members who once shared it. With the Inferno's reignition, that rooftop vista will be retaken, reinvented as public space, rebuilt as an urban overlook open once again to all the city's outsiders. By the time we ascend that far in the transformation from Flour Mill Lofts to Inferno, though, we might hope to be looking out on a transformed city as well, a city similarly reconstructed around the festival of the oppressed. We might hope to see a series of urban spaces in which the past and the future have indeed gotten in the way of the present.

As seen in the following chapter, such a city would be a place in which homeless folks, gutter punks, and skate punks would no longer be herded from public spaces and hidden from public view, but instead granted at a minimum the city's inhabitable margins, those "holes and gaps, breathing spaces" that Peter Marin describes.[79] In such a city, residents of all sorts would no longer be taught to fear such marginal spaces, nor encouraged to consume their sanitized remains, but would instead embrace them as places of disorderly human contact, places of creativity and cultural innovation, "where uncertainty and unpredictability provide the conditions . . . that define how newness comes into the world."[80] In this city, the streets themselves would no longer operate as avenues of enforced sameness, but as open cultural spaces, enlivened by the flow of bicyclists and walk-about flâneurs, dis-organized into collective Critical Mass rides and sidewalk celebrations, animated by the ongoing invention of new communities.[81] Here social justice would intertwine with spatial justice, human freedom with the freeing of cultural space.

If this is the sort of city we someday see from atop the Inferno, it'll be my pleasure to draft a report for all those not yet or no longer on the scene. And since Rasta was kind enough to catch me up on the railyards, I'll send the first copy to him, addressed to wherever he might be by then.

Rasta,
You would not believe the city now. Bakunin's riding a skateboard, grinding away at those big walls around the old city hall. Kropotkin's out tending the hemp fields, helping out in the factories and workshops, digging all the mutual aid that's going around. Emma's found her inner fabulousness with Caycee and Emily; the other day she went on a run with the Reclaim the Streets folks, dancing down the middle of what used to be the freeway, planting trees. The old Wobs and Beats are back in town, too, hanging out down by the trains, smoking fatties, digging all the graffiti. Seems like everybody's riding a bicycle. Well, not everybody—a bunch of people have taken to just walking wherever they go. Other folks are out rebuilding what's left of the billboards, altering the advertising slogans, painting

day-glo murals over all those SUV ads. And man, there's music everywhere.

Looks like the festival of the oppressed is in full swing; guess the passion for destruction was a creative passion after all.

And me? I'm still tearing down the streets.

—Skript

Open City

The contemporary battle for public space, the fight for open urban community, continues to unwind down a long front of controversy and conflict. From Tempe's sidewalk-sitting Mill Avenue to the polyphonic street corners and parks of Flagstaff and Amsterdam, from the illicit airwaves of the Bay Area to the reclaimed streets of London—even inside Denver's once-and-future Towering Inferno—conflicts over cultural space bubble up through the routinized muck of everyday life. Continuing to emerge and accumulate, these conflicts begin to suggest new political economies of urban life, new mechanisms of spatial and social control. At the same time they demonstrate new strategies of resistance to such control, and new frameworks for undertaking an alternative, liberatory urban politics. As with Murray Melbin's innovative conceptualization of the night as an unsettled temporal frontier, these conflicts suggest that the city's public spaces remain an uncertain urban terrain, a spatial frontier along which control and insubordination clash as those resisting the manifest destiny of cultural colonization fight and fall back.[1]

While such battles are clearly disconnected by their distinctly local nature—it is after all a long way from making music on a Flagstaff street corner to dancing in Trafalgar Square—they're just as clearly

connected by the identities and ideologies of their participants. As seen throughout these conflicts, political and economic authorities time and again ground their control of public space in the proclaimed necessity of economic development and urban redevelopment; reference shared ideologies of restored urban civility and exclusionary community; and exhibit a thinly disguised passion for regulatory order and top-down control. On the other side of the street, those resisting the authorities share not just an experiential taste for anarchic insubordination, but on-the-ground anarchist strategies of do-it-yourself culture and direct action and, in many cases, sophisticated understandings of anarchist history and theory as well.

Perhaps most significantly for an alternative politics of the street, those resisting the closure of public space span personal and situational differences through the inclusive complexity of their own underground identities. Together, they invent a loosely integrated underworld in which microradio operators double as homeless advocates, skate punks morph into political activists, BASE jumpers become illicit videographers, graffiti writers broadcast pirate radio, and Critical Mass riders roll down the streets one day and Reclaim the Streets the next. Of course, as a longtime occupant of this eclectically insubordinate underworld, I've happily attempted to embody the same cross-cutting spatial sensibility, wandering through the anarchy of my life amid the intersecting identities of graffiti writer, busker, bicyclist, Critical Mass rider, pedestrian, and pirate radio broadcaster.

All of these identities, all of these conflicts over public space and public meaning are in turn undergirded by deeper oppositions, as fundamental as they are complex: inclusion versus privilege, anarchy versus authority, emergence versus order. As the latest arrangements of spatial authority are made, as ever more exclusionary patterns of privilege are encoded and enforced in the spaces of the city, street denizens and street activists regularly move to unravel this emerging spatial order. In so doing they reinvent essential political dynamics inside the spaces of everyday life, throwing up anarchist defiance in the face of legal and economic might, inventing practical resistance to expanding structures of control, undermining frameworks of spatial authority with moments of innovation and spontaneity, confronting communities of privilege and exclusion with a peripatetic festival of the oppressed. For that matter, thinking about corporate owners

consistently campaigning against street folks and gutter punks, about big SUVs overrunning bicycles, about the Flour Mill Lofts usurping the Towering Inferno, about the FCC and National Association of Broadcasters attacking microradio stations, I'm tempted to invoke yet another fundamental opposition—to characterize what's going down in the streets as, well, class warfare. While the Wobblies would no doubt agree, I suspect Mbanno Kantako and Tracy James and Robert F. Williams, Mildred Jones and Napoleon Williams, would call it something else—maybe race war, or cultural genocide.

So, with that much at stake in the fight for public space, other fundamental oppositions, fundamental questions, also arise. Who, for example, is tearing down the streets? Criminal justice officials, business leaders, and developers would point with certainty to street people, graffiti writers, Critical Mass riders, BASE jumpers, and pirate radio operators as those responsible for destroying city life, sullying civic virtue, undermining urban community, and tearing down the safety of the streets and sidewalks. Reclaim the Streets members, bicycle militants, and homeless activists would suggest instead that urban developers, city planners, and residents of gentrified neighborhoods destroy the possibility of community-level street life by creating a claustrophobic world of overpriced housing, overcrowded freeways, and overregulated public space. They would in response advocate, quite literally, tearing down the streets as they now exist—and especially as they are now becoming—and rebuilding them along the lines of open spaces, bicycle paths, and affordable housing. Gutter punks and skate punks would likewise argue that those who outlaw sitting, sleeping, or skating in the streets effectively tear down the vitality of street life. Pirate radio operators and street musicians would remind us that the streets exists not just as physical space, but as a contested ether of sonic space and communication, and would therefore point to the role of local governments and the FCC in closing down the city's lively cacophony.

And speaking of that cacophony, how should a city sound, anyway? How should it look? If the notion of cultural space offers anything of use, it's the understanding that, unavoidably, we imbue the urban spaces we occupy with meaning and emotion, with efflorescences of beauty and human design. Whose, though, and of what sort? Such questions, it seems, lie at the heart of who we are as

residents of a city, as members of an urban community. Questions of meaning, beauty, and emotion can of course be answered theologically or epistemically. But, especially in the shared experience of the city, they must also be answered spatially.[2]

And so one last question, a question that, in paraphrasing Brecht's infamous speculation on the morality of owning banks versus robbing them, gets at the very core of the battle for urban space: Which is the worse crime, to outlaw public space, or to open public space to outlaws?[3]

OCCUPIED TERRITORY

As the city's caretakers work to outlaw open public space, to set aside the streets for cars and consumers, the political economy of their operation could hardly be more obvious. Throughout the cases considered in the previous chapters, we see the essential role of downtown business owners, merchants' associations, economic development departments, tourism agencies, trade groups, and high-dollar urban developers in orchestrating campaigns against the poor and the politically marginalized. We see such campaigns operating to cleanse the cultural spaces of the city, to flush out the smelly "human carnage" and annoying "extra static" that interferes with the promotion of upscale consumption and the enhancement of business and property value. And we see bought-and-sold city mayors, subservient city councils, local criminal justice agencies, even federal bureaucracies backing such campaigns with new statutes and aggressive strategies of enforcement.

In these campaigns, force is never far away; the ready brutality of contemporary street justice is as apparent as the arrangements of power that underwrite it. Again, consider the cases seen in the previous chapters, a collection that of course incorporates only a small fraction of the streets' daily degradations. In that collection alone, New York City police officers round up, arrest, and strip search street folks caught loitering or committing other "quality of life" crimes; city officials in Tempe and other cities outlaw those who would sit on the sidewalk, or skateboard down it; San Francisco cops bust Food Not Bombs gatherings, drag Critical Mass riders off their bikes, wrestle

them to the ground, arrest them; flak-jacketed "multi-jurisdictional task forces," armed SWAT teams, raid one microradio station after another, confiscating equipment and information. And that's not to mention the passive aggression of countless new "environmental controls," all those thorny shrubs and angry lawns, the old neighborhoods bulldozed into cultural ruin—and the endless string of everyday arrests for impeding traffic, writing graffiti, public camping, panhandling, trespassing.

So, whatever else is at issue, this much is clear: The contemporary outlawing of open city space heralds an expansion of legal and cultural control into the farthest, most marginalized corners of public life, a widening of the net and tightening of the mesh such that the very existence of alternative street communities comes to be criminalized.[4] It does indeed reveal the workings of a class war, a race war, straight up—a ground war against the city's outsiders and outlaws that encodes class and racial inequality in the spatial experiences of everyday life, enforcing and reinforcing a long history of scandalous social injustice.[5] And in this sense open public space that's been shut down, that's been outlawed, constitutes occupied territory—a once unsettled, or at least less settled, territory now overrun by a conquering army of cops and developers, invaded by a happy horde of Flour Mill Lofts residents and upscale consumers that follows, herdlike, behind the street-sweeping phalanx of law, enforcement, and development. This occupied territory, this political and economic appropriation of the contemporary city, couldn't be more obvious if a Nazi battle flag fluttered from atop the Eiffel Tower.

Or could it? Actually, unless you live on the streets, or for some reason pick up books like this one, you might not notice the occupation at all. For one thing, you might find yourself so thoroughly and pleasurably lost in the precise, preplanned indulgences of the city's closed-down spaces that you couldn't be bothered to look. Redeveloped downtowns, gentrified residential neighborhoods, the singing certainty of the city's approved airwaves, the insulated interior of one's own automobile all constitute cultural spaces in which relations of power and control are produced and reproduced—but not baldly, not blatantly. The containment of people and their identities within these spaces, the constitution of their choices around agendas of obedience and consumption, emerge within a subtly dangerous

dynamic whereby such choices are marketed as appropriate, desirable decisions within an always more attractive way of life. For many, such spaces are not intimidating, but inviting, even seductive; they pull you in, and often do so, ironically, by appropriating, sanitizing, shrink-wrapping for ready resale the very urban culture—local flavor, street cool, city excitement—they displace.

After all, strange as it seems to me as a punkass anarchist, people actually pay for the privilege of entering Disneyland—and not just the original, but the Disneyfied urban enclosures of the newly plasticized city. Taken at face value, two moments from the early days of punk—The Sex Pistols's "Belsen Was a Gas" ode to a Nazi deathcamp, and the incorporation of the Nazi swastika into punk street couture—constituted a gross insensitivity to human history. Taken as cultural commentary, they constituted something more disturbing: the suggestion, in the words of Greil Marcus, that "history books to the contrary . . . fascism had won the Second World War; that contemporary Britain was a welfare-state parody of fascism, where people had no freedom to make their own lives—where, worse, no one had the desire."[6] And if that was Britain in the 1970s, the United States in the 2000s seems more a Disney-state parody of fascism, a place where people volunteer for prettified urban concentration camps defined by regulation, surveillance, and preprogrammed entertainment. In "The Punitive City," his brilliant 1979 essay on social control, Stan Cohen asked, "just how isolated and confining does an institution have to be before it is a prison rather than, say, a residential community facility?" Today, a paraphrase: Just how redeveloped does Belsen have to be, how upscale and entertaining, before no one notices it's a death camp?

In that same essay, Cohen noted that within the punitive city, attempts are made to "increase the visibility—if not the theatricality—of social control . . . here, in our very own community."[7] At the same time, though, a distinct counterdynamic in contemporary social control suggests a second factor that inhibits our noticing the closure and enclosure, the sanitized surveillance, of public space: When accomplished effectively, spatial closures don't increase the visibility of social control over time, but decrease it, leaving little or nothing to notice. In this book's first chapter, I invoked Engels's notion of social problems "shifted elsewhere" as a way of describing a postmodern

police state that addresses injustice by herding and hiding its victims, by erasing them and their subversive meanings through physical and symbolic relocation. And this is precisely what subsequent chapters have confirmed: in the occupied city, outsiders and their cultures are expurgated, "disappeared," rendered invisible and inaudible.

It's of course not surprising that political and economic authorities are content to shift their problems elsewhere—to hide the homeless, to erase graffiti writers and their writings from public places, to silence microradio stations and regulate street musicians, to expunge injustice from only the surface of the city. Such strategies reflect not just a failure of humanity and political will on their part, not just a shortsighted mortgaging of the future against the profitability of the present, but the larger political economy of late capitalism. Increasingly, the corporate economy sells not physical commodities, but lifestyles and the illusion of lifestyle satisfaction—and the urban economy operates likewise, selling imaginary echoes of urban culture through the fraudulent authenticity of "historic districts" and Flour Mill Lofts. Political campaigns and criminal justice initiatives function similarly, offering not honest solutions but instead cheap mythologies of safety, symbolic constructions of the common good. And so, the cultural spaces essential to this image-driven political economy are managed in the same fashion, through a policing of perception, a removal of unpleasant interlopers, a surreptitious encoding of social control in thorny shrubs, repainted buildings, and the absence of noticeable disorder.

But for all that, it's worth remembering that real battles are being fought in this shallow unreality of image and perception. As researcher Michael Keith argues, we can best understand the politics of the city by rejecting "any simplistic opposition between 'real' and imagined or metaphoric spaces of identity."[8] As seen throughout the preceding chapters, even the most postmodern of cultural space battles remain grounded in those very spaces, embodied in the lived sensuality of people and places. In fact, the policing of image and perception matters precisely *because* politics and economy have not drifted off into free-floating abstractions, but have instead remained practices grounded in daily life, contested in the domain of street corners, sidewalks, radio stations, and abandoned buildings. As those who seek to shut down public space and those who seek to liberate it both know,

the streets still matter—and matter enough to be remade as image and ideology.

The ideologies underwriting the closure of public space function much the same as do tony downtown shopping districts, the shifting elsewhere of social problems, and the exclusionary images of "community" introduced in chapter one: to obfuscate the workings of social control, and to distract attention from the occupation of urban territory. The "broken windows" thesis promulgated by Wilson and Kelling in the 1980s, for example—the thesis that broken windows, graffiti, and other petty problems somehow promote more serious forms of criminality and undermine a sense of community—quickly became the basis for the aggressive clampdown on graffiti, panhandling, loitering, and other "quality of life" crimes in New York City and elsewhere.[9] This is of course astoundingly bad criminology—whatever their particular orientations, most criminologists agree that crime originates not out of broken windows, but from some mix of economic inequality, discordant cultural values, subcultural marginalization, and official overreaction. Worse, "broken windows" is damn good demagoguery, assigning the blame for street crime not to poverty and marginalization, but to the poor and the marginalized. A particularly slippery piece of dishonesty, it in turn justifies the removal of such groups from the spaces they occupy, and in a still slicker trick, hides the occupied gentrification of these spaces—windows repaired, graffiti removed—inside an ideology of crime prevention and restored "community."

According to this same ideological orientation, there's yet another key factor in restoring community to the city's streets and sidewalks: "civility." In fact, the concept of civility seems to function as a sort of master narrative for those who would shut down disorderly public space; they consistently hide their revanchist operations behind this vacuous and disingenuous notion. Local authorities like Rod Keeling, head of the Downtown Tempe Community business association, argue that initiatives targeting the homeless have "really changed the civility of the street."[10] National authorities agree. No less a scholar of the social order than George W. Bush argues in his inaugural address that "civility is not a tactic or a sentiment. It is the determined choice of trust over cynicism, of community over chaos."[11] In this light, sociologist Sharon Zukin notes that, throughout the many

contemporary campaigns to cleanse and close down public space, "the common denominator is 'civility.' Urban designs try to use visual aesthetics to evoke a vanished civic order associated with an equally vanished, or at least transformed, middle class. They use civility, in turn, to evoke a vanished social homogeneity."[12]

A vanished social hegemony, too. I mean, let's be honest: when the powerful and privileged talk of restoring "civility" and "community," it's not too difficult to break the code. Talking of civility, they mean order, an absence of upheaval and unrest, a world in which the marginalized go quietly into the good night of injustice. Talking of restoring such civility and the communities that fostered it, they reference a time when kids knew their place, and knew it wasn't out upsetting paying customers as they made their way down the street; a time when fewer uppity minorities dared to display their lives and cultures in plain view. Now, knowing the history of the Wobblies, the civil rights movement, antiwar protests, and zoot-suit riots, it's not at all clear that such a time ever existed. As is often the case, the nostalgia may be mostly for a time that never was. Yet what's important, and revealing, is not the accuracy of this yearning but its affect, and the fundamental falsehoods it references in regard to order, consensus, and community. The irony is important as well. As seen throughout the previous chapters, programs designed to police cultural spaces, to restore civility and community in such spaces, in fact reinforce patterns of spatial inequality, day-to-day economic and ethnic apartheid, and street-level abuse that are not only uncivil but obscene.[13] How much civility is there in a strip search, or in a SWAT raid? These days, how much community is offered the homeless?

The Wobblies always said that "charity is the sprinkling of cologne on the dunghills of capitalism," a sprinkling meant to mask the ever-present stench of injustice and inequality.[14] Invocations of civility and community are today's cheap cologne, sprinkled over the stinking accumulations of spatial injustice and public enclosure that increasingly shape the contemporary city. Perfumed in this way, the city's revanched spaces come to be occupied by the privileged and powerful not just physically, but ideologically and perceptually, their exclusionary meanings masked behind mythologies of safety and development. They come to exist as cultural spaces defined by a decidedly disingenuous set of cultural imperatives.

And thus this book. I consider it my calling to ensure that the oily odor of arrogance and injustice wafts out past the perfume, to see to it that folks smell the stench and consider its source. This calling can of course be undertaken in a humanist fashion, by providing a published forum for the ideas and experiences of anarchists, buskers, skate punks, gutter punks, Critical Mass activists, microradio operators, and others generally dismissed from accepted understandings of public space. It can also be undertaken a bit more aggressively. Completing an earlier book, I wrote in a draft of the final chapter that we must "make the authorities out to be the dangerous fools that they are."[15] Seeing this, the publisher's copyeditor wrote in the margin, "You can't say that." But I can, and did, and will again: We can begin to waft away the cologne of "civility" and "community" by ruthlessly unwrapping the contradictions that those in authority aren't quite able to manage, by exposing the cheap lies and manifest absurdities that they pass off as common sense and public policy in regard to city space.

Though I'll mostly leave it to the reader to remember these absurdities from previous chapters, a few highlights bear repeating. Covenants in planned communities outlaw the U.S. flag, dictate the color of house paint and decorative gravel, and thereby mandate a sort of Belsen with flowerbeds. Civil gang injunctions prohibit those targeted from climbing fences, standing near beer cans or each other, appearing in public. Public officials and the daily newspaper in Phoenix define homelessness as a landscaping and image issue. Officials in Tempe confine buskers within city-designated "entertainment location areas," outlaw sitting on the sidewalk, and then boast of the city's "pulsating street scene" and "culture...abundantly on display." In San Francisco, the mayor's administration, arguing that Critical Mass is the cause of traffic congestion, attempts to cut a deal with the leaders of a leaderless dis-organization, and a city supervisor, worried over a "disorderly society where anything goes," proposes to ban standing on street corners. The National Association of Broadcasters contends that, due to the growth of microradio, "thousands of people won't be able to hear their hometown radio stations"; the FCC backs this concern with armed raids on microradio stations. And in Denver, Jill Crow moves into a 3,000 square foot penthouse suite atop the thoroughly sanitized and privatized Flour

Mill Lofts because she desires "more of a cultural experience," and, by God, because of her "interest in diversity, caring about equality."

Dangerous fools indeed. But of course it's not enough to wipe off the perfume, to shake off the seductions of privilege, civility, community. If Marx had been an anarchist, he might've put it this way: The writers have only exposed the contradictions; the point is to reclaim the streets, liberate occupied territory, and open the city.[16]

OPEN CITY

In 1945, about the time the Allies were liberating Belsen, Roberto Rossellini decided to make a movie. Freed from his enforced filmmaking duties under the Fascists, Rossellini set about to document the abuses that Rome and its citizens had endured under the Italian Fascists and their Nazi buddies, and at the same time to document the resiliency of everyday resistance to Fascist occupation. Filming just beyond the reach of the retreating German army, shooting scenes in city streets off-limits only a few days before, employing a mix of cinematic professionals and everyday citizens, Rossellini made a movie that inaugurated a new wave of postwar "neorealist" filmmaking. And, acknowledging both the subject and circumstances of his filmmaking, he titled his movie *Roma Citta' Aperta*—or in its English title: *Open City*.[17]

Anarchists and others fighting to free public space these days make the same movie. Staging scenes amid an occupying (though, sadly, not retreating) army of cops and developers, they work to create a new wave of liberatory urbanism, to celebrate the possibilities of an open city and an eclectic urban community—and like Rossellini, they engage ordinary citizens, and go with them out into the streets, in order to confront the subject and circumstances of their endeavor.

In the same way that *Open City*'s graphic, semidocumentary scenes of wartime violence and destruction shocked Western audiences, but also taught them a new vocabulary of cinematic realism, the scenes of creative destruction practiced by anarchist street fighters today upset many who encounter them—but at the same time perhaps begin to teach them a new political vocabulary. That contemporary conflicts over public space offer many such scenes has been made clear through-

out the previous chapters, whose accounts coalesce into a veritable litany of destruction, disruption, and illegality. Homeless folks violate loitering and trespass laws, committing along the way innumerable "quality of life" crimes, while their supporters stage illegal sit-down protests on their behalf. Street buskers play without permits, wander outside their "entertainment location areas," disrupt the orderly flow of sidewalk traffic. Punks sport "Destroy Everything" T-shirts, and skaters and skate punks take over swimming pools and grind away at handrails, while BASE jumpers commandeer bridges and radio towers on their ascent to illegal exits. Critical Mass riders impede street traffic and cork intersections. Reclaim the Streets activists trash automobiles, disable construction machinery, jackhammer the pavement, and stage illegal street parties. Microradio operators jam the airwaves with illegal sounds in much the same way that hip hoppers and hobos inscribe freight cars and city walls with illegal images.

This litany confirms the trajectory suggested in chapter one—a jagged anarchist trajectory that, running from the past into the present, continues to conform to the contours of Bakunin's passion for destruction. Little wonder the advocates of enforced "civility" are appalled. Their adversaries in the streets seem oblivious to the civility demanded of ordinary citizens, seem to respect the majesty of the law as little as the sanctity of private property, seem pleased to embrace the Wobblies' defiant expatriation: "We are not 'undesirable citizens.' We are not citizens at all." [18] Answered in part throughout the preceding chapters, the question nevertheless comes up again: What sort of politics could animate, much less justify, such a voracious appetite for destruction? [19]

Stan Cohen's typology of vandalism begins to suggest an answer. As noted briefly in chapter one, Cohen finds among the various forms of illegal property destruction one of particular significance: "ideological vandalism." As Cohen argues, those on the disenfranchised margins regularly utilize such vandalism as a "conscious tactic" to "challenge symbolically" one or another of the existing arrangements of exclusionary power. More broadly, Cohen argues, ideological vandalism often challenges "the very content of the rules" themselves. In this sense such vandalism doesn't simply bust up buildings or break windows; it violates the idea and the practice of property and privilege, and, beyond this, desecrates structures of everyday life that have become so culturally encoded as to attain the status of the sacred. This account of

ideological vandalism, of course, just as precisely describes the ongoing project of Situationists and other anarchists (Cohen mentions Luddites and Paris Communards as well): a revolution of and against everyday life. And, in the same way, it nicely describes the "vandalism" of Critical Mass riders and Reclaim the Streets activists, of pirate radio operators and graffiti writers—a disruption and destruction aimed not just at automobile traffic or commercial airwaves, but at the taken-for-granted assumptions that undergird them.[20]

In this light, Cohen ends his consideration of vandalism with the notion that "society creates its own vandalism." Seen in this light, the liberatory vandalism of Reclaim the Streets activists and pirate radio operators emerges at least in part out of the very spatial controls and enclosures designed to prevent it; as the Situationists were fond of saying (and of writing on Paris walls), "The society that abolishes every adventure makes its own abolition the only possible adventure." And caught up in this political dynamic, intentionally ideological vandalism of this sort couldn't be more different from the "mindless," misdirected vandalism often attributed to schoolchildren and street kids. Or maybe the two couldn't be more alike. Upon close examination, school kids' "mindless" breaking of school windows seems in many cases to symbolize a nascent insubordination against the authoritarian incarceration that these days passes for education. Likewise, the stereotypical dismissal of hip hop graffiti writers as mindless dogs marking their territory, as vandals "operating at a level in the animal chain not too far removed from that that we observe in lower animals," falls apart in the face of their endlessly creative anarchy.[21] After all, society creates its own vandalism in more ways than one; and anarchist attacks on societal arrangements don't operate just at the level of big Critical Mass rides and Reclaim the Streets actions, but inside the many little moments of everyday life.

And anyway, who cares? Who cares about finding the finest of distinctions between "ideological" and "non-ideological" vandalism— because, we might remember, it's all just violence against property, and the laws that protect it, not against people. Looking again at the "violent" vandalism and destructiveness of anarchist street fighters, an obvious pattern emerges: no one's getting hurt. And it's not just that the destruction's aimed in most every case at shopping mall handrails, sidewalks, car-choked streets, corporate airwaves, governmental regu-

lations, and other targets far removed from "property" in the sense of someone's little shack or old shirt; it's that the destruction launched by these groups aims directly at restoring humanity, human relations, and human communities, not at destroying them. It suggests that one way to disentangle the dehumanizing conflation of property and people, to confront the confusion of consumption with community, to dismantle the hierarchy of commodification by which law and property stand above people and places, is to assiduously destroy the former while affirming the latter. More than one commentator has noted that, in an effort to capture the perpetrator of turn-of-the-millennium eco-arson attacks on multimillion-dollar homes carved into the mountain pre- serves around Phoenix, authorities offered a reward far in excess of any local reward ever offered for the apprehension of a serial rapist or murderer. The fiery vandalism and the juicy reward meant to stop it tell equally revealing stories about the imbalance of people and prop- erty, only from different angles, and both recall a photo of street graffiti I saw years ago. "I don't believe in nothing," it said. "I feel like they ought to burn down the world. Just let it burn down baby."[22]

Beyond this, the destruction unleashed by those fighting for public space aims at restoring humanity because it's aimed at inventing new spaces in which human relations can flourish, at busting open the city and breathing the life of human engagement back into it. Critical Mass car jams, Reclaim the Streets barricades, the disorderly conduct of buskers and homeless activists all create open spaces of alternative human interaction and community as they destroy the shut-down spaces of law, property, and privilege; all confirm Bakunin's dictum that the destructive urge is a creative urge, too. Making space for the marginalized, inventing space outside the law, they undermine the outlawing of public space and confront the further marginalization of its occupants.

In this book's introductory chapter, the Paris Commune's pulling down of the Napoleonic Vendôme Column emerged as perhaps the most hallowed of direct actions in the ongoing battle for free and egalitarian public space. Considering the contemporary politics and morality of destruction in the battle for public space, what might we justifiably pull down today? What symbols of inequality and empire might satisfy the creative appetite for destruction, and in their destruc- tion open the city to new meanings? I'd suggest the scoreboards of

corporate ballparks, the awnings of exclusive restaurants, the billboards advertising cars and consumption, the statues of politicians and perfume-spewing philanthropists. We might have Rossellini film this destructive fight to create an open city—and we might follow Vilimius Malinauskas's lead as well. The Lithuanian son of a father shipped off by the Soviets to his death in Siberia, Malinauskas is moving the massive statues of Marx, Lenin, and Stalin that once towered over town squares in Lithuania to a new location: his "Leninland" theme park. There, Malinauskas hopes, the statues, along with replicas of gulags and "cattle truck-style train carriages," will help his society "come to terms with its past."[23]

Were such a theme park to emerge from pulled-down public monuments in the United States, it could help us come to terms not only with our past, but with the present's ever-expanding archipelago of spatial gulags. And if we were to name it after the architect of this archipelago, we wouldn't want to call it Leninland, but Developerland—or, maybe more accurately, Disneyland.[24] Another feature would distinguish it as well: a sense of play and pleasure amid the ruins. When the Communards pulled down the Vendôme Column, there were "few recriminations," according to an eyewitness report; instead, a brass band played the Marseillaise to entertain the crowd, and afterward, photographs were taken of proud families posed around the Column's rubble.[25] Likewise, when Critical Mass or Reclaim the Streets activists destroy the everyday autocentrism of the streets, when buskers and BASE jumpers and skate punks violate spatial boundaries, when homeless advocates sit down on the sidewalks or serve food illegally, the dynamic is one of play, self-made pleasure, affirmation, spontaneity. The destruction of order and privilege, the cracking open of closed spaces, results not in mean-spirited recrimination, not in the revenge of the oppressed—but in the *festival* of the oppressed. The movie, always, remains more comedy than tragedy.

For those fighting the closure of public space, playful pleasure constitutes both the terms of engagement on which they are willing to fight, and also the sense of possibility, the imagination of an open city, for which they fight. Unfettered festivals in the streets, moments of spontaneous dancing and free-form music serve as sensual subversions, undermining the taken-for-granted order of everyday life and inviting passersby into the pleasures of playful insubordination. At the same

time, they suggest—even for a while demonstrate—what else, what more daily life might be were it not interrupted by such subversions but defined by them. In this sense, the playful pleasures put forth as means and ends within the anarchist fight for public space are more than good fun; they're profoundly political.

But then, what pleasures aren't? Consuming the prepackaged pleasure-chunks offered up by a corporate theme park, aimlessly enjoying the smooth locomotion of "ridin' along in an automobile," exploring the darkly interior excitement of sado-masochism—as different as they are, all engage issues of authority, privilege, and identity; all trace particular interconnections between power and play; and all therefore constitute political acts of no little consequence.[26] So, those in attendance at the festival of the oppressed don't invent the politics of pleasure; they just reinvent it. They create pleasures that subvert the atomized passivity of mass consumption by remaining open, inclusive, and collective, by their building of new, open communities inside the shell of old order. As seen with BASE jumpers, they make up free-falling festivals, do-it-yourself entertainments, bike rides, busking and skateboarding adventures that reclaim a degree of autonomy and pleasurable independence from the alienating controls of law, work, and money. And, like the Situationists, they fight to reconfigure the city itself as a big, open, outlaw playground, no entrance fee required. "Never Work" went the old Situationist slogan, scrawled on a Paris wall in 1953; scrawled again on banners and walls in the Paris of 1968; restated by The Sex Pistols and punks and other "lazy sods" a few years later. But if no work, then . . . play? Of course. Our "underlying philosophy was one of experiment and play" wrote Situationist Christopher Gray—and as Greil Marcus adds, "play with all of culture, and the city itself as the field."[27]

The sense of spontaneity that anarchists treasure, the "dis-organization" and "organized coincidences" on which Critical Mass riders and other street fighters thrive, likewise operate politically, as a means to a different world and as a component of what that different world might become. Played out in the real politics of the street, "spontaneity" suggests not some pure form of absolute disorder, but rather a subversion, a subterfuge, an inside joke about the tenuous tension between structure and emergence. The dash in "dis-organization" gives it away; unlike "disorganization," "dis-organization" suggests some small

degree of planning and forethought—but only enough to engender conditions conducive to spontaneity, conditions in which planning and forethought can happily be abandoned. "We will only organize the detonation," said the Situationists back in chapter three. "The free explosion must escape us and any other control forever."[28]

And even that much organization, it should be noted, is undertaken reluctantly. Strange as it must seem in a world dominated by power-hungry piss ants and petty bureaucrats made big from pushing people around, I've consistently found those involved in anarchist street battles willing to make phone calls, put up fliers, decorate bicycles, and otherwise "dis-organize" events only because they want to see some spontaneous hell raised, not because they want to see their own status raised to "leader" or "organizer."[29] When, amid this dis-organized process, mistakes are made, that's fine, too—especially if they're mistakes that could've been corrected with better planning, more control, less participation. After all, spontaneity's the ideal, the ethos, if never the absolute, and seeing the city explode into a sparkle of open spaces is always more of a pleasure—and always more the point—than organizing the detonation.

This practice of spontaneity, experimentation, and playful dis-organization replicates in contemporary cultural space battles the old anarchist strategy of direct action and the notion that an inclusive process, properly unleashed, will find its own progressive direction. It also begins to define what an anarchist "movement" for the liberation of public space might mean. As already mentioned, the cases collected in this book document a loose anarchist underworld held together— when it is held together—mostly by the cross-cutting, inclusive identities of its residents. Microradio operators, homeless advocates, Critical Mass riders, skate punks, and others cross paths, trade identities, find affiliations, offer mutual aid, not because the Politburo moves them around as pawns in the master plan, but for the most part because they share the same sympathies and antipathies, and so find themselves fighting to free the same public spaces. Like the Wobblies taking on a free speech fight in the old days, they put the word out, ride the rails in, and coalesce into a moment of dis-organized resistance before fading away like Nestor Makhno lost in the Ukraine.

While getting the word out can be as simple as reading the signs— the uprooted developers' stakes, the sounds of a drum circle, the

anarchist and punk graffiti on city walls—it can also necessitate networks of alternative media. Yet here again, the underground's media web spins more around spontaneity than structure. As seen earlier, the "xerocracy" of Critical Mass and other groups functions as a mediated manifestation of anarchist practice, an inclusive, do-it-yourself democracy in which any and all are encouraged to produce playful images and circulate alternative ideas. And, emerging in this way, the underground's media remains in the service of the street. Time and again I've been struck by the technological sophistication and media savvy of microradio operators, by the effortless expertise of Critical Mass riders and homeless activists as they operate video cameras, compile video documentaries, and program web sites. They're hardly lost in a game of Carmegeddon, though. Instead, they're answering Keith's call to bridge the duality between real and imagined spaces. Bringing underground media and alternative images to bear on the resolutely real spaces of the street, they help shape a cultural movement for remaking the city's cultural spaces.

The loose dis-organization of this movement for the liberation of public space offers a number of advantages. It keeps the line of anarchy jagged and subversive, the unfolding history in part a secret one, so that no one quite knows all that's going on—including mayors like Willie Brown, and even authors of books on anarchy and cultural space. It ensures, as in the past, that if mistakes are to be made within this "movement," they'll tilt toward inclusion and disorder, thereby avoiding the usual social movement mistakes of exclusion and encrustation. And because of these advantages, we begin to see that a spontaneous, playful movement of this sort can effect some serious change in the nature of public space, and in so doing move the city toward new forms of spatial justice and urban community.

God knows it's a long road from present spatial arrangements to any broad construction of spatial justice or inclusive community,[30] but with each anarchic accomplishment, with each sidewalk-sitting ban successfully challenged or "entertainment location area" sonically violated, a sort of provisional street justice emerges. Riding atop the growing class divide, the privileged have certainly locked up the best of everything: finest food, biggest SUVs, grandest homes, sweetest private views of mountain and sea. Each anarchist success, however small in scope, suggests that they don't quite have public space locked

up, too. It suggests at least a bit of spatial justice, whereby the one thing remaining for many folks pushed down to the other end of the divide—a "home" in the street, a place to earn a few bucks busking, maybe a little comfort in the street's small pleasures—isn't also appropriated by the privileged.

Hidden away in their gated communities, secure in their Lincoln Navigators, those at the top aren't often forced to confront the prerequisites and consequences of their privilege, either. They can easily cruise to the country club without passing a maquilidora, avoid the stench of environmental racism by choosing neighborhoods never soiled with toxic waste, have their travel planner leave the Nike plants of 'Nam off their world tour itinerary. Winning a few battles to keep high-end Tempe sidewalks open to the homeless, to make Navigators share the Bay Area streets with bicycles, at least forces the privileged on occasion to confront their unjust consequences, even to encounter humane alternatives. As detailed in chapter one, Emma Goldman's companion Ben Reitman was made to run a gauntlet of abuse in which he was stripped, kicked, beaten, burned, tarred, and sexually assaulted, all for supporting the Wobblies' 1912 free speech fight against the spatial controls of San Diego business owners and legal authorities. Nothing so violent here. But the successful defense of open public space creates its own gauntlet, a gauntlet of inequality, difference, and uncertainty for the privileged to navigate on their way to and from their exclusions, a gritty if playful detour through the festival of the oppressed.

Of course this isn't enough. Winning a few sidewalk battles, forcing some spatial discomfort into the lives of the terminally comfortable are pleasures in their own right, important counter-punches in the ongoing fight for public space, and certainly confirmation that the revolution of everyday life remains already (and always) underway. But what if we could string together a few more of these spatial revolts, create a critical mass of everyday public insubordination against the larger spatial order? What if we could move a bit further toward spatial justice, if we could reverse the city's revanchist occupation and invent instead an open city animated by new communities of public life?

The previous chapter's speculative construction of such a community in and around the reignited Towering Inferno suggests that

this open city would be defined, and certainly enlivened, by eclectic configurations of marginality and difference. Many urban theorists today agree—and in agreeing, offer not only a vision of an anarchically open city, but a direct rebuttal of contemporary trends toward spatial homogenization, public closure, and enforced "civility" within corporate communities. Building from Foucault's notion of "heterotopias," Edward Soja writes of the human potential inherent in "heterogeneous spaces of sites and relations," spaces that, by being "lived and socially constructed," bridge the gaps between individual and collective identity, physical and cultural history. And, Soja argues, to the extent that such spaces rest "on the margins of hegemonic power," they "enable one's radical subjectivity to be activated, and practised in conjunction with the radical subjectivities of others. They are spaces of inclusion rather than exclusion, sites where radical subjectivities can multiply, connect, and combine in multi-centred communities of identity and resistance."[31]

As seen in earlier chapters, Samuel Delany likewise contrasts the narrow homogeneity of "networking" with the generous diversity of unanticipated "contact" in open public spaces, and Michael Keith argues that "a positively understood invocation of urbanism has to be about opening oneself up to difference . . . where uncertainty and unpredictability provide the conditions of possibility for the mutations, hybridity, and combinations that define how newness comes into the world."[32] Urbanist Kian Tajbakhsh affirms that the promise of the open city does indeed flower in "the hybrid spaces of identity"—and writing years earlier about urban environments and "a new anarchism," sociologist Richard Sennett was even more to the point. The "great promise of city life," he argued, was the "new kind of confusion" it offered, its "channels for experiencing diversity and disorder"—which, to Sennett's way of thinking, more than justified "extricating the city from preplanned control."[33]

Together, these perspectives on the open city recall that same delicate tension embodied in the notion of "dis-organization," a creative detonation of hybrid urban identities within the politics of organized disorder. They also suggest the unthinkable to those corporate developers and city officials whose notions of "community" and "civility" require the enforcement of homogeneity and the regulation of public interaction: urban communities in fact built from

difference and held together by disorder. In such communities, the play and interplay of diverse populations within unregulated public space, and thus the essential unpredictability and ambiguity of city life, no longer constitute threats to community and civility, but instead become the very definition of open, inclusive community life. Over time this harmonious urban cacophony builds, reverberates, feeds back on itself such that a gentle, interactive order emerges within city life, an order predicated on the ongoing disorder of public space. Left to the spontaneity of our own urban lives, we create among ourselves cross-cutting, creolized identities not entirely our own; we shape an urban community that holds together not because its members are sorted and separated, but because, out of ongoing contact in the open spaces of the city, they become one another.[34]

This inclusive, transformative cacophony echoes experiences seen throughout the preceding chapters: buskers and their listeners coming together inside the music; neighborhoods discovering their diverse identities in the illicit sounds of microradio; Critical Mass riders finding collective courage and pleasure on the fly; BASE jumpers creating community out of danger and disorder. It also implies a new appreciation of those who've dis-organized all this disorder. The loosely spun underground web of cross-cutting identities that constitutes the contemporary anarchist "movement" for the liberation of public space and the creation of open cities offers us something more than activism; it offers a working model of the hybrid identities and inclusive communities that would in fact animate such a city. In this sense, microradio operators who double as homeless activists or Black Power militants, graffiti writers who become community artists and advocates, Critical Mass riders who invent alternative media, Reclaim the Streets activists who find common cause with striking workers all constitute pioneers—hell, embodiments—of a new sort of heterotopian urbanism.

Citing bell hooks, Edward Soja writes of embracing the margins of power, the margins of the city, as "locations of radical openness and possibility."[35] The anarchist vision of an open city, and the cases of public space conflict considered in the previous chapters, confirm his focus. Throughout the many contemporary campaigns to close and criminalize public space, a commitment to heterotopian community, an openness to contact, confusion, and uncertainty has endured—but

mostly at the margins. It has endured, even thrived, among those run off the roads, driven out of the railyards, swept from the sidewalks and streets, jailed for various public and sonic disorders. And so, like Soja, we find the seeds of an open city among those most marginalized, among those most thoroughly excluded from the occupied territory of today. Like Jean Genet, embracing his "wretched life" as a beggar and thief, a life marginalized by sexual preference, poverty, and politics, we too must embrace and celebrate those at the urban margins—and, like Genet, find that there "the most sordid signs" of marginalization instead become "signs of grandeur" and promise.[36]

Discovering the beauty and promise of the city in its margins, crafting communities from the disorder of public space, embracing the adulterated identities of those who crisscross urban boundaries, we return once again to the festival of the oppressed—because, if today's many illicitly intertwined moments of busking, skating, BASE jumping, bicycling, and microbroadcasting harbinger the open city, so does the carnival of public celebration that emerged in the streets of Paris in 1871. The Situationists understood that the Paris Commune "created a city free of planning, a field of moments, visible and loud, the antithesis of planning: a city that was reduced to zero and then reinvented every day." Long before the Situationists, Peter Kropotkin understood as well. Affirming in an 1880 essay the creativity inherent in the "grand work of destruction," arguing against the stale "machine of the State," the great Russian anarchist pointedly included a friend's firsthand account of the Paris Commune—an account that suggests the sort of transformative disorder we might someday hope to encode in the spaces of the city:

> I will never forget those delightful moments of deliverance. I came down from my upper chamber in the Latin Quarter to join the immense open-air club which filled the boulevards of Paris from one end to the other. Everyone talked about public affairs; all mere personal preoccupations were forgotten; no more was thought of buying or selling; all felt ready, body and soul, to advance towards the future. Men of the middle-class even, carried away by the general enthusiasm, saw with joy a new world opened up. "If it is necessary to make a social revolution," they said, "make it then. Put all things in common; we are ready for it."[37]

But maybe we're not ready for it; maybe we won't manage to detonate a revolution, social or spatial. Emma Goldman's definition and disclaimer regarding anarchism, included in this book's introductory chapter, is worth repeating here: "Anarchism is not . . . a theory of the future. It is a living force in the affairs of our life, constantly creating new conditions . . . the spirit of revolt, in whatever form, against everything that hinders human growth."[38] So, anarchism offers no clear avenue to an open city—only the conviction that the spirit of revolt remains always a pleasure, that the revolution is in some ways won as soon as you begin to fight it. And besides, even if all else fails, even if you can't dance with Emma at the revolution, one possibility remains.

Just walk away.

WALK AWAY

Along with Emma Goldman's account of anarchism, chapter one included a brief account of my approach to writing this book—an approach based mostly on walking the city and its spaces. And when I'm not bicycling—which, compared to other transportation forms, might itself be thought of as walking on two wheels—this remains my orientation to writing and to living. Moreover, this peripatetic approach has emerged as not just the method of this book, but as a continuity that in part defines its subject matter. Graffiti writers, hobos, buskers, skaters, Reclaim the Streets activists, and others all shamble through the city on foot, sometimes mounting bikes or skateboards, sometimes hitching rides on freight trains or cars or buses, but mostly walking the urban environment. The prevalence of this flat-footed urban engagement among anarchists and others fighting for open public space suggests something more than necessity; it begins to reveal the importance of walking as a form of anarchist practice and spatial revolt. As argued previously, it implies that to move through space is somehow to remake it.

At its most basic, walking constitutes something like the Zen of Anarchism, perhaps the simplest act of do-it-yourself living, direct action, and engagement with the spatial politics of the everyday. Walking begins to strip away vestiges of privilege and pretension, to

Figure 6.1: Walk away: "The 'Blanket Stiff,'"
published in the *Industrial Worker*, April 23, 1910.

free its participants from the awful encumbrance of property, to put them on a path toward humble, ground-level give-and-take with those they encounter. My old friends HL86 and Rasta 68, urban artists and urban wanderers, used to chide me for the extravagance of my transportation—and my transportation was only a bicycle. Too much property to have with you in the city, they'd say; too much trouble, something to attract unwanted attention, to be stolen if not locked up; something to drag you down while moving around. The more often I left my bike at home and walked with them, often for hours, endlessly, around the city, the more I understood: the simpler your locomotion, the cleaner your encounter with the city. Like the group of skate punks said earlier, wandering off on their own cross-country sojourn: "Less Is More."

One is many, too. In southern Italy, the *passeggiata*—the informally dis-organized evening stroll through the city's spaces—serves city dwellers as a collective moment of cordiality and calm, "an intricate pattern of footsteps that binds together their community." In the United States, walking salons likewise bring people together for portable intellectual feasts, on the assumption that mental creativity follows in the steps of corporal mobility.[39] In the Bay Area, Boston, and other cities around the United States, politics follows as well. "Fed-up people are actively taking the city's streets and sidewalks back" through BayPeds, Walk San Francisco, Walk Boston, and other pedestrian associations that mirror the two-wheeled mission of Critical Mass.[40] Yet even a solitary walk in the city becomes, almost always, a social experience, a community experience, generating as it does a democracy of unexpected encounters, a collapsing of personal experience and predictability into the collective peripeteia of the city. Walkers "follow the thicks and thins of an urban 'text' they write without being able to read it," says cultural theorist Michel de Certeau, a text "shaped out of fragments of trajectories and alterations of spaces.... Their intertwined paths give their shape to spaces. They weave places together."[41]

Single or interwoven with others, the path of the walker leads also to an anarchist ethnography and epistemology of urban life. Peripatetic wanderings through the city enact a politics of attentiveness to the city's people and communities, to the sounds and smells that fill its spaces, such that these wanderings become Peripatetic in the old Aristotelian sense as well—walking lessons in perception and understanding. Unlike the office-bound, academic "treetop fliers" described by criminologist Mark Hamm, unlike the totalizing voyeurs that de Certeau locates atop the World Trade Center or for that matter the millions locked inside their fast-moving cars, those who walk the city's spaces participate in the perceptions of those around them, in the jostle of alternative identities, experiencing in the process the lived sensuality of the city's spaces.[42]

And it's not just the human pace and interpersonal proximity that opens walking to the lives of others; as with buskers, it's walking's vulnerability to the larger, rhythmic flow of the street. In good anarchist fashion, walking exists as a do-it-yourself process that's not yours to do alone, but instead to negotiate among others, within

intersecting patterns of social movement, cultural meaning, and certain surprise. As such, walking creates a sort of subversive vulnerability, a critical epistemology of the street that, by situating those on foot inside the complex humanity of the city's spaces, gives lie to the tree-top claims of mayors and developers. Inside those spaces, I've found, neatly packaged ideologies regarding the desirability of corporate community and enforced civility stop making sense as I walk past yet another loitering arrest, stroll along with some skate punks past a "No Skateboarding" sign, sidestep one more supercharged SUV cutting me off in the crosswalk. What's true on the dance floor, or at Emma's revolution, is true on the sidewalk: move your feet, and your mind will follow.

As de Certeau suggests, to walk urban space in this way isn't just to understand it; it's to remake it. Sometimes one who walks the city with a sense of epistemic purpose is identified by the old term *flâneur*, in reference to the tradition of coming to know the city by navigating its streets. But that old term carries a second, sharper sense also: the flâneur as a despicable dawdler, an aimless urban wanderer. And it's this sense I most happily embrace. Slowly wandering the city, hanging around its open spaces, talking with its people subverts more than ready-made ideologies. It confronts the past and present machinery of law that manufactures exclusionary notions of "loitering" and "vagrancy" and "trespass." It embraces that most hallowed and subversive of Situationist slogans: "Never Work." It replicates the old Wobbly idea of sabotage as a "withdrawal of efficiency," undermining the enforced panic of contemporary life, forcing a slowdown on the urban assembly line. It sure as hell affirms the pleasure of personal dis-organization. And it begins to retake occupied territory, to construct an open city, to reassemble public space and public community as something more, and less, than death camp Disneyland.

Walking the city's spaces in this way ignites the revolution of everyday life, sets in motion the festival of the oppressed, as surely as a Critical Mass ride or Reclaim the Streets rally. And if, shambling along, you find time to grind a handrail, tag a freight car, tune in the local microradio station, shove a couch out into an intersection—if you keep in mind that the passion for destruction is a creative passion, too—it's not a bad way to go about tearing down the streets.

Notes

CHAPTER ONE

1. Quoted in Kerry Lengel, "From Street to Studio in Only 15 Years," *The Arizona Republic*, June 22, 2000, page 14.
2. See Roberto Sanchez, "Homeowners Group Tells Resident He Can't Fly the Flag," *The Arizona Republic*, November 14, 1996, page B1; Roberto Sanchez, "Homeowner Sued Over Yard Flagpole," *The Arizona Republic*, January 10, 1997, pages B1, B2; E. J. Montini, "His Banner Yet Waves, But Not Here," *The Arizona Republic*, July 2, 2000, page B1.
3. David G. Savage, "Civil Liberties Back on the Street," *ABA Journal* 85 (1999): 50.
4. Matthew Mickle Werdegar, "Enjoining the Constitution: The Use of Publc Abatement Injunctions Against Urban Street Gangs," *Stanford Law Review* 51, no. 2 (1999): 1-28 (quotation page 18; reprint pagination). See Raoul V. Mowatt, "Gang Members' Rights Curbed by Court Ruling," *The Arizona Republic*, February 1, 1997, pages A1, A29; Matt Lait, "Ganging Up on Gangs," *Los Angeles Times*, May 28, 1999, page B2.
5. In Arleen Jacobius, "Court Approves Gang Injunctions," *ABA Journal* 83 (1997): 34; Victoria Harker, "Action To Curb Gang Targets Area, Residents Claim," *The Arizona Republic*, October 22, 1999, page B5. See similarly *Law Enforcement News*, "No Free Ride for Minor Offenders in Houston," 22, no. 439 (February 14, 1996): 3. Interestingly, a number of key police officers now implicated in the Los Angeles Police Department's Rampart scandal were instrumental in gaining civil gang injunctions in that area; in one case, "some of the most persuasive police testimony used by prosecutors to obtain a sweeping anti-gang injunction" was based on a "chilling portrayal" of gang violence offered by these officers—a portrayal later proven entirely false. See Rich Connell and Robert J. Lopez, "Rampart Probe May Put Gang Injunction at Risk," *Los Angeles Times*, September 19, 1999, pages A1, A21, A22 (quote page A1).
6. Al Taylor, *Crime Prevention Through Environmental Design* (instructional packet), no date (c. 1999), no pagination.
7. The Arizona Crime Prevention Association, *Arizona Building Security Standards*, May 1993, page 21; David Anderson, "Crime, Fear, Community Safety and the Future," *Enterprise Quarterly* (Winter 1999): 12-15 (quotation page 15). See relatedly Oscar Newman, *Defensible Space: Crime Prevention through Urban Design* (New York: Macmillan, 1972); James Q. Wilson and George Kelling, "The Police and Neighborhood Safety: Broken Windows," *Atlantic Monthly* 127 (1982): 29-38.
8. *Arizona Building Security Standards*, pages 21-24.

9. Quoted in Tricia Henry, *Break All Rules!: Punk Rock and the Making of a Style* (Ann Arbor: UMI Research Press, 1989), page 61.

10. Stephen Fjellman, *Vinyl Leaves: Walt Disney World and America* (Boulder, CO: Westview, 1992), page 399.

11. In Joseph A. Kirby, "Disney Hitting the Big Apple with New Development Plans," *The Arizona Republic*, August 8, 1995, page E3; see Elizabeth Larson, "Walt's World," *Utne Reader* 62 (March/April 1994): 38, 40.

12. Samuel R. Delany, *Times Square Red, Times Square Blue* (New York: New York University Press, 1999), pages xi, 144, 194.

13. In Steve Wilson, "Home Buyers Celebrate Strong Sense of Community," *The Arizona Republic*, September 19, 1999, page A2; Thomas Mallon, "This Old Mouse," *GQ* (October 1999): 171-175 (quote page 174); Diane Gehrke White, "Lifestyle Entices Buyers," *The Arizona Republic*, August 1, 1999, page D3.

14. Sue Doerfler, "Disney To Launch Housing Development," *The Arizona Republic*, June 8, 1996, pages AH1, AH6 (quote page AH1); Tom Vanderbilt, "Mickey Goes to Town(s), *The Nation* 261, no. 6 (August 28/September 4, 1995): 197-200 (quote page 197).

15. See Mallon, "This Old Mouse," page 171; Mary Shanklin, "'Imagineered' Town Strikes Some as Fantasy," *The Arizona Republic*, October 5, 1996, page EV8.

16. In John Geirland, "Bradbury's World: Fewer Cars, More Restaurants," *The Arizona Republic*, December 13, 1998, pages E15, E16 (quote page E15); see Ray Bradbury, *Fahrenheit 451* (New York: Simon and Schuster, 1951).

17. In Joel Kotkin, "Retailer Brews Up Anti-Chain Strategy," *The Arizona Republic*, October 27, 1999, pages E1, E4 (quote page E4); Lark Borden, "Hip Theme Park Chucks Childish Fantasy for 'Eclectic California Attitude,'" *The Arizona Republic*, January 28, 2001, pages T1, T3 (quote page T3).

18. Karl Marx, "The Eighteenth Brumaire of Louis Bonaparte," in Robert Tucker, editor, *The Marx-Engels Reader* (New York: W. W. Norton, 1972), pages 436-525 (quotation page 436).

19. Sharon Zukin, "Cultural Strategies of Economic Development and Hegemony of Vision," in Andy Merrifield and Erik Swyngedouw, editors, *The Urbanization of Injustice* (New York: New York University Press, 1997), pages 223-243 (quotes pages 227, 240). See Michael Sorkin, editor, *Variations on a Theme Park: The New American City and the End of Public Space* (New York: Hill and Wang, 1992).

20. Raúl Homero Villa, *Barrio-Logos: Space and Place in Urban Chicano Literature and Culture* (Austin: University of Texas Press, 2000), pages 134-136.

21. Camilo José Vergara, *The New American Ghetto* (New Brunswick, NJ: Rutgers University Press, 1995), pages 68-69.

22. Mitchell Dunier, *Sidewalk* (New York: Farrar, Straus and Giroux, 1999), pages 231-239.

23. Joe Hermer and Alan Hunt, "Official Graffiti of the Everyday," *Law and Society Review* 30, no. 3 (1996): 455-480 (quote page 465).

24. Quoted in John Handley, "We're Asking Our Housing to Hold the Fort," *Chicago Tribune*, May 19, 1996, pages B1, B7 (quote page B7); Kathleen Ingley, "Gates Swing Both Ways for Residents," *The Arizona Republic*, July 7, 1996, pages B1, B5 (quote page B5); Timothy Egan, "Gates of Wrath," *The Arizona Republic*, September 4, 1995, page A10. See *The Arizona*

Republic, "Scottsdale Community Thwarts Census Takers," December 7, 1995, page B2.

25. See for example Mallon, "This Old Mouse," page 174; Associated Press, "Airing Laundry Against the Law," *The Arizona Republic,* February 22, 1998, page A23; Rick Bragg, "Porch- Furniture Ban 'Ultimate Yuppiefication,'" *The Arizona Republic,* January 4, 1998, page A14.

26. See Haya El Nasser, "Helicopters Take Commuters High Above Gridlock," *USA Today,* March 8, 2000, page 3A.

27. Quoted in Tim Vanderpool, "Secession of the Successful," *Utne Reader* 72 (November/December 1995): 32-33 (quote page 32). See Evan McKenzie, *Privatopia: Homeowner Associations and the Rise of Residential Private Government* (New Haven, CT: Yale University Press, 1994).

28. Quoted in Handley, "We're Asking Our Housing to Hold the Fort," page B7; see Michelle DeArmond, "Leaving LA? Cities Discussing Secession," *The Arizona Republic,* March 28, 1999, page A13; Associated Press, "NY Rich Want Own County," *The Arizona Republic,* November 29, 1996, page B7.

29. Neil Smith, "Social Justice and the New American Urbanism: The Revanchist City," in Merrifield and Swyngedouw, *The Urbanization of Injustice,* pages 117-136 (quote page 130).

30. Mike Davis, *City of Quartz* (London: Verso, 1990); Mike Davis, *Ecology of Fear: Los Angeles and the Imagination of Disaster* (New York: Vintage, 1998), pages 12, 61.

31. Melinda Stone, "Landscape of Conjecture." *Public Art Review* 10, no. 2 (Spring/Summer 1999): 30-32.

32. On the aesthetics of authority, see Jeff Ferrell, *Crimes of Style: Urban Graffiti and the Politics of Criminality* (Boston: Northeastern University Press, 1996). The contemporary "war on drugs" in the United States of course offers a similarly instructive and disturbing example of this dynamic.

33. Jeff Ferrell, "Youth, Crime and Cultural Space," *Social Justice* 24, no. 4 (1997): 21-38. See relatedly Tony Jefferson, "Cultural Responses of the Teds: The Defence of Space and Status," in Stuart Hall and Tony Jefferson, editors, *Resistance Through Rituals: Youth Subcultures in Post- War Britain* (London: Hutchinson, 1976), pages 81-86, on "the culture attached to the land." Postmodern and cultural geographers, public artists, and others have likewise explored the cultural dynamics of public space; see for example Michael Keith, "Street Sensibility? Negotiating the Political by Articulating the Spatial," in Merrifield and Swyngedouw, *The Urbanization of Injustice,* pp. 137-160; Malcolm Miles, *Art, Space, and the City: Public Art and Urban Futures* (New York: Routledge, 1997).

34. Walter Benjamin, "The Work of Art in the Age of Mechanical Reproduction," in Hannah Arendt, editor, *Illuminations* (New York: Harcourt, Brace, and World, 1968), pages 219-253.

35. Zukin, "Cultural Strategies," page 240.

36. See Stuart Hall, Chas Critcher, Tony Jefferson, John Clarke, and Brian Roberts, *Policing the Crisis: Mugging, the State, and Law and Order* (London: Macmillan, 1978).

37. Michel Foucault, "Space, Power and Knowledge," in Simon During, editor, *The Cultural Studies Reader* (London: Routledge, 1993), pages 161-169 (quote pages 164-165).

38. James P. Spradley, *You Owe Yourself a Drunk: An Ethnography of Urban Nomads* (Boston: Little, Brown, 1970), page 1.

39. Stanley Cohen, "Property Destruction: Motives and Meanings," in Colin Ward, editor, *Vandalism* (New York: Van Nostrand Reinhold, 1973), pages 23-53 (quote page 39). See relatedly David F. Greenberg, "Delinquency and the Age Structure of Society," *Contemporary Crises* 1 (1977): 189-223.

40. Ward, *Vandalism*, pages 103, 107, 115.

41. Lewis Mumford, *The Culture of Cities* (New York: Harcourt, Brace, 1938), pages 272-273, 278. For a historical update, see Mike Davis, "Fortress Los Angeles: The Militarization of Urban Space," in Sorkin, *Variations on a Theme Park*, pages 154-180.

42. Walter Firey, "Sentiment and Symbolism in Ecological Variables" (1945), reprinted in Sandor Halebsky, editor, *The Sociology of the City* (New York: Charles Scribner's Sons, 1973), pages 115-127 (quotes pages 116, 127).

43. Engels as quoted in Smith, "The Revanchist City," page 136, emphasis in original.

44. William J. Chambliss, "A Sociological Analysis of the Law of Vagrancy," *Social Problems* 12 (1964): 67-77 (quote pages 74-75). This is of course not to mention the enclosure of the commons in England, the highland clearances in Scotland, and other historical cases in the closure and reinvention of public space.

45. See Greil Marcus, *Lipstick Traces: A Secret History of the Twentieth Century* (Cambridge, MA: Harvard University Press, 1989).

46. Stuart Edwards, editor, *The Communards of Paris, 1871* (Ithaca, NY: Cornell University Press, 1973), page 10.

47. "Declaration to the French People," April 19, 1871, in Edwards, *The Communards of Paris*, pages 81-83.

48. Karl Marx, *The Civil War in France* (Peking: Foreign Language Press, 1966), page 80. See also for example Friedrich Engels, "Versus the Anarchists" and "On Authority," in Robert C. Tucker, *The Marx-Engels Reader* (New York: W. W. Norton, 1972), pages 660-665.

49. "Burning the Guillotine," April 6, 1871, in Edwards, *The Communards of Paris*, page 150.

50. Quoted in Edwards, *The Communards of Paris*, page 40; see pages 146-149. See Cohen, "Property Destruction," pages 36-40.

51. This phrase is attributed to Lenin who, it is also said, in 1917 "counted the days to see whether the Bolsheviks could hold onto power longer than had the Communards." See Edwards, *The Communards of Paris*, pages 39, 42.

52. "Paris as a Festival" and "The Revolutionaries' Optimism," in Edwards, *The Communards of Paris*, pages 140-144.

53. See Edwards, *The Communards of Paris*, pages 144-146.

54. See Mike Presdee, *Cultural Criminology and the Carnival of Crime* (London: Routledge, 2000); Jean Genet, *The Thief's Journal* (New York: Grove Press, 1964), page 19: "Never did I try to make of it something other than what it was, I did not try to adorn it, to mask it, but, on the contrary, I wanted to affirm it in its exact sordidness, and the most sordid signs became for me signs of grandeur."

55. Emma Goldman, *Anarchism and Other Essays* (New York: Dover, 1969), page 63.

56. See Joyce L. Kornbluh, *Rebel Voices: An IWW Anthology* (Chicago: Charles H. Kerr, 1988); Jeff Ferrell, "The Brotherhood of Timber Workers and the Culture of Conflict," *Journal of Folklore Research* 28, no. 2/3 (1991): 163-177; Jeff Ferrell and Kevin Ryan, "The Brotherhood of Timber Workers

and the Southern Lumber Trust: Legal Repression and Worker Response," *Radical America* 19, no. 4 (1985): 55-74.

57. Reproduced in Kornbluh, *Rebel Voices*, pages 73-74 (author unknown).

58. Reproduced in Kornbluh, *Rebel Voices*, pages 76-77 (author unknown).

59. Paul F. Brissenden, *The I.W.W.: A Study in American Syndicalism* (New York: Columbia University Press, 1919), page 282. See also Jeff Ferrell, "East Texas/Western Louisiana Sawmill Towns and the Control of Everyday Life," *Locus* 3, no. 1 (1990): 1-19, on Wobbly battles to open other public spaces.

60. John Steinbeck, *In Dubious Battle* (Toronto: Bantam, 1972), page 120; see Emma Goldman, *Living My Life* (New York: Dover, 1970), pages 494-502.

61. See Kornbluh, *Rebel Voices*, pages 127-157; Philip S. Foner, *The Industrial Workers of the World, 1905-1917* (New York: International Publishers, 1965), pages 153-155.

62. See for example Salvatore Salerno, "Soapboxing the Airwaves," in Ron Sakolsky and Stephen Dunifer, editors, *Seizing the Airwaves: A Free Radio Handbook* (San Francisco: AK Press, 1998), pages 165-171.

63. Goldman, *Anarchism and Other Essays*, page 65; "'His Honor' Gets His," in Kornbluh, *Rebel Voices*, page 105.

64. Quoted in Henry, *Break All Rules!*, page 108.

65. Quoted in Esther Schrader, "Rowdy Teenage Punkers Scaring Disneyland Patrons," *The Arizona Republic*, September 28, 1997, page A25. Regarding progressive punk festivals and concerts, see for example Larry Rodgers, "Punks for Peace," *The Arizona Republic*, July 6, 2000, pages 9-10; Chris Ziegler, "The OC Solidarity Festival," *OC Weekly* (Costa Mesa, CA), July 28- August 3, 2000, page 80.

66. Katy Otto, "Elizabeth Elmore" (Interview), *Punk Planet* 36 (March/April 2000): 40-43 (quote page 42); see also pages 36-38, 108-113. Similarly, singer Allison Wolfe of the punk/riot grrrl band Bratmobile explains, "Back when I was in college and taking classes in women's studies, you couldn't use the word 'girl'. Feminism was too stuffy, and I didn't like that. My whole goal in Bratmobile was to make feminism more punk and punk more feminist," in Eric Searleman, "Bratmobile Retools, Hits Road Again," *The Arizona Republic*, February 22, 2001, page 13, 16 (quote page 13). See also Lauraine Leblanc, *Pretty in Punk: Girls' Gender Resistance in a Boys' Subculture* (New Brunswick, NJ: Rutgers University Press, 1999).

67. Marcus, *Lipstick Traces*, page 140; see pages 140-147, 426-427; Catherine McDermott, *Street Style: British Design in the 80s* (New York: Rizzoli, 1987), page 62. See Greil Marcus, "Life's a Riot," *World Art*, November 1994, pages 70-74; Neil Nehring, *Flowers in the Dustbin: Culture, Anarchy, and Postwar England* (Ann Arbor: University of Michigan Press, 1993); Guy Debord, *Society of the Spectacle* (Detroit: Black and Red, 1983).

68. McLaren quoted in Marcus, *Lipstick Traces*, page 9.

69. *Industrial Worker*, October 24, 1912, page 2.

70. For a recent application of Kropotkin's ideas in the area of spatial analysis, see Shaun Huston, "Kropotkin and Spatial Social Theory: Unfolding an Anarchist Contribution." *Anarchist Studies* 5, no. 2 (October 1997): 109-130.

71. Michael Bakunin, *Michael Bakunin: Selected Writings*, Arthur Lehning, editor (New York: Grove Press, 1974), page 23.

72. Bakunin, *Selected Writings*, page 58.

73. See Jeff Ferrell, "Anarchist Criminology and Social Justice," in Bruce A. Arrigo, editor, *Social Justice/Criminal Justice* (Belmont, CA: West/Wadsworth, 1999), pages 93-108.

74. As Lou Reed once said, "Why does anyone give a fuck what I like! *I* don't give a fuck what I like!" Lou Reed in *Punk* magazine, January 1976, as quoted in Henry, *Break All Rules!*, page 99, emphasis in original. Or for that matter theologian Dietrich Bonhoeffer, writing with a bit more elegance from inside a Nazi prison: "What does one's attitude mean, anyway? In short, I know less than ever about myself, and I'm no longer attaching any importance to it. I've had more than enough psychology, and I'm less and less inclined to analyse the state of my soul. . . . There is something more at stake than self-knowledge," in Dietrich Bonhoeffer, *Letters and Papers from Prison* (New York: Macmillan, 1972), page 162.

75. See relatedly Keith, "Street Sensibility?" pages 142-146; Michel de Certeau, "Walking in the City," in Simon During, editor, *The Cultural Studies Reader* (London: Routledge, 1993), pages 151-160.

CHAPTER TWO

1. City of Flagstaff, *Cityscape*, 1999, pages 24-5.

2. Machine Age Postcards, "Museum Club," 1994. This is of course the same Route 66 along which the marginalized and unwanted hard-travelled in the 1930s, and in so doing transformed the road itself, remade the human geography of the continent, and paved an avenue for subsequent transformations.

3. Arizona State Parks, "Riordan Mansion," brochure, no date.

4. From Flagstaff real estate ads of this period: "Sunken family room; open beams, tongue and groove . . . fireplace . . . cozy southern exposure . . . $139,900." "Light, bright, split floorplan; sunken living room . . . huge cedar deck; $425,000." *Flagproperty Magazine*, February 2000.

5. A spokeswoman for the group Friends of Walnut Canyon unknowingly suggests a similar irony by worrying that, in a region saturated with early Native American wall painting, urban development near Walnut Canyon would mean that "the canyon would be ruined . . . the place would be covered with graffiti." Quoted in Kathleen Ingley, "Flagstaff to Draw Line on Growth," *The Arizona Republic*, March 5, 2000, pages A1, A8 (quote page A8).

6. Edward Abbey, *The Monkey Wrench Gang* (New York: Avon, 1975). Coconino Community College courses during this period include ITC 298, "Special Topics: Habitat for Humanity," and GLG 111, "Geology of Northern Arizona." Coconino Community College, "Summer 2000 Schedule of Classes," pages 14, 17.

7. Friends in and around the Flagstaff Police Department have described this squad, and these homeless sweeps, to me in some detail. My repeated formal requests for an interview with the commander of this squad were denied.

8. Greil Marcus, *Lipstick Traces: A Secret History of the Twentieth Century* (Cambridge, MA: Harvard University Press, 1990).

9. Thomas Ropp, "Phoenix Crews Brace for Damage Transients Cause to Landscaping," *The Arizona Republic*, November 10, 1997, pages A1, A6.

10. See for example Michael Sorkin, editor, *Variations on a Theme Park: The New American City and the End of Public Space* (New York: Hill and Wang, 1992); Camilo José Vergara, *The New American Ghetto* (New Brunswick, NJ: Rutgers University Press, 1995); Jeff Ferrell, "Urban Graffiti: Crime, Control, and Resistance," *Youth and Society* 27, no.1 (1995): 73-92.

11. See for example Robert C. Ellickson, "Controlling Chronic Misconduct in City Spaces: Of Panhandlers, Skid Rows, and Public-Space Zoning." *Yale Law Review* 105 (1996): 1165-1248.

12. See for example Ellickson, "Controlling Chronic Misconduct in City Spaces"; Gregg Barak and Robert Bohm, "The Crimes of the Homeless or the Crime of Homelessness?" *Contemporary Crises* 13 (1989): 275-288; George Howland, Jr., "The New Outlaws: Cities Make Homelessness a Crime," *The Progressive* 58, no. 5 (1994): 33-35; June B. Kress, "Homeless Fatigue Syndrome: The Backlash Against the Crime of Homelessness in the 1990s," *Social Justice* 21, no. 3 (1994): 85-108.

13. Marin quoted in Gary McDonogh, "The Geography of Emptiness," in Robert Rotenberg and Gary McDonogh, editors, *The Cultural Meaning of Urban Space* (Westport, CT: Bergin and Garvey, 1993), pages 3-15 (quote page 14).

14. Bob Petrie, "Tempe May Squeeze Out Homeless," *The Arizona Republic*, September 17, 1995, pages A1, A12 (quote page A1).

15. "Suit Filed as Atlanta Roundup of Homeless Looms," *The Arizona Republic*, July 4, 1996, page A16; Associated Press, "Police Crack Down," *The Arizona Republic*, July 12, 1996, page C9; Evelyn Nieves, "Homeless Defy Cities' Drives to Move Them," *The New York Times*, December 7, 1999, pages A1, A16.

16. Quoted in Ron Chepesiuk, "Atlanta Goes for the Gold," *The Progressive* 60, no. 8 (1996): 34-35 (quotation page 35). Atlanta also displaced thousands of low-income residents from their homes as part of Olympic Games preparations.

17. Howland, "The New Outlaws: Cities Make Homelessness a Crime," page 34; Nieves, "Homeless Defy Cities' Drives to Move Them," pages A1, A16.

18. Michael Steinberg, "Homes Not Jails," *The Progessive* 58, no. 11 (1994): 11.

19. See Richard Edmondson, "The Permit Game," *SFLR News*, October 31, 1999; and various reports on Food Not Bombs in *SFLR News*, October 30, 1999.

20. Quoted in Mary Ann Lickteig, "San Francisco Delays Plan to Confiscate Shopping Carts," *The Arizona Republic*, October 13, 1999, page A26. See "Mayor Backs Down on Shopping Cart Seizures—For Now," *SFLR News*, October 17, 1999.

21. Joseph A. Kirby, "Disney Hitting the Big Apple with New Development Plans," *The Arizona Republic*, August 8, 1995, page E3; Nieves, "Homeless Defy Cities' Drives to Move Them," pages A1, A16; Associated Press, "Giuliani's Policies on Homeless Criticized," *The Arizona Republic*, December 22, 1999, page A14; "Strip-Search Victims Agree to Settlement," *The Arizona Republic*, January 11, 2001, page A4; Samuel R. Delany, *Times Square Red, Times Square Blue* (New York: New York University Press, 1999).

22. Associated Press, "Rappers are Rapping NYC Mayor Giuliani," *The Arizona Republic*, June 19, 1999, page A23.

23. In Chris Fiscus, "Phoenix Closes Central Park Areas to Drifters, Crime," *The Arizona Republic*, March 6, 1996, pages B1, B2 (quotation page B1).

24. Chris Fiscus, "Phoenix Approves Crackdown on Beggars," *The Arizona Republic*, May 1, 1996, page B1; Chris Fiscus, "Jail Time Possible for Street Vendors," *The Arizona Republic*, December 4, 1996, pages B1, B2.

25. Fiscus, "Phoenix Approves Crackdown," page B1; Dennis Wagner, "Cracking Down on Beggars," *The Arizona Republic*, April 16, 1996, pages B1, B3 (quotation page B1).

26. Anonymous in Arizona, "More Core" (Letter to the Editor), *Thrasher* 198 (July 1997): 12.

27. Lauraine Leblanc, "Punky in the Middle," in Jeff Ferrell and Neil Websdale, editors, *Making Trouble: Cultural Constructions of Crime, Deviance, and Control* (New York: Aldine de Gruyter, 1999), pages 203-229; Lauraine Leblanc, personal correspondence with the author, December 14, 1998; see Lauraine Leblanc, *Pretty in Punk: Girls' Gender Resistance in a Boys' Subculture* (New Brunswick, NJ: Rutgers University Press, 1999).

28. Quoted in Associated Press, "'Gutter Punks Degrade French Quarter," *Arizona Daily Sun*, November 3, 1995, page 9. The headline writer's choice of verbs is, to say the least, revealing. See relatedly Jana Birchum and Dave Cook, "Down on the Drag," *Texas Monthly* 25, no. 1 (January 1997): 128-133.

29. Diana Balazs, "Valley Downtowns Taking Off," *The Arizona Republic*, November 17, 1999, pages A1, A12 (quote page A1); William Hermann, "Dowtown Tempe Fills Need for 'Someplace,'" *The Arizona Republic*, March 4, 1998, pages A1, A10 (quote page A10).

30. Author telephone interview with Randall Amster (March 14, 2000). Unless otherwise noted, all subsequent comments from Randall Amster are taken from this interview.

31. Quoted in Chris Fiscus and William Hermann, "Mom-Pop Shops Losing Ground to Chain Stores," *The Arizona Republic*, September 12, 1999, page A18. See Michael Clancy, "Changing Tempe Writes Bookstore's Last Chapter," *The Arizona Republic*, March 18, 2000, page E1. One of the Changing Hands bookstore's original owners says, "Part of my heart has been cut out. Dowtown Tempe will not be better off with Changing Hands, but Changing Hands will be better off without dowtown Tempe."

32. Quoted in Chris Fiscus, "'Brickyard on Mill,'" *The Arizona Republic*, March 2, 2000, pages B1, B7 (quote page B7).

33. Elvia Diaz, "Lake Brings New Life to Neighborhood," *The Arizona Republic*, February 7, 2000, pages A1, A11. Elvie Diaz and John Stanley, "Tempe Center Size Debated," *The Arizona Republic*, September 18, 1999, pages A1, A4 (quote page A4).

34. Quoted in David Cannella, "Slackers Congregate for Run of the Mill," *The Arizona Republic*, May 31, 1996, pages A1, A10. Notably, among the numerous Tempe police reports involving arrests for urban camping, one from March 1999 records the arrest of a twenty-one-year-old for urban camping, and adds that the man "told officers he was 'purposefully protesting the urban camping ordinance.'" See http://www.public.asu.edu/~aldous/policereports.html.

35. Melissa L. Jones, "'Ambassador' to Homeless," *The Arizona Republic*, April 5, 1999, pages B1, B2. Author telephone interview with Rhonda Bass (July 9, 1999). Unless otherwise noted, subsequent comments from Rhonda Bass are taken from this interview.

36. Article V, Sec. 29-70, Ord. No. 98.57, December 17, 1998. (Between 7 AM and 10 PM weekdays, 7 AM and 1 AM Fridays and Saturdays).

37. Victor Barajas, "Tempe's Got the Hookup," *The Arizona Republic*, August 19, 1999, pages B4-B5.

38. Author interview with Leif and Kat, Tempe, Arizona (March 6, 1999). Unless otherwise noted, all subsequent comments from Leif and Kat are taken from this interview.

39. See http://www.public.asy.edu/~aldous/sit-ins.htm; Delany, *Times Square Red, Times Square Blue*.

40. Laura Trujillo, "Sit-in Targets Tempe Law," *The Arizona Republic*, January 31, 1999, page B5.

41. See Elvia Diaz, "Federal Judge Strikes Down Tempe Law Against Sitting on Sidewalks," *The Arizona Republic*, February 1, 2000, page B2.

42. "Animal Ban Urged in Downtown Tempe," *The Arizona Republic*, January 9, 1997, page B1; David Cannella, "Proposed Dog Ban Aims at 'Slackers,' Tempe Critics Say," *The Arizona Republic*, January 11, 1997, pages B1, B3.

43. Quoted in Bob Petrie, "Tempe Set To Ban Sidewalk Sitting," *The Arizona Republic*, December 17, 1998, pages B1, B2 (quotations page B2).

44. As Randall Amster says, "they were trying to demonize the street kids by saying these gutter punks all have their scruffy dogs who shit all over the sidewalks." Similarly, a new French animal sterilization law aims at "eliminating pit bulls from France within 10 years," since "pit bulls have become status symbols in low-income districts around France where tough-looking young men often brandish their pets like switchblades." Associated Press, "French Law on Sterilizing Dogs Aimed at Eliminating Pit Bulls," *The Arizona Republic*, January 8, 2000, page A24.

45. Downtown Tempe Community, Inc., "Downtown Tempe People and Parking Guide" (no date).

46. Ordinance No. 98.59; Sections 24-16, 24-29, 24-30, of the Tempe City Code, amended (December 17, 1998).

47. Quoted in Bob Petrie, "Tempe May Ask Musicians to Pay to Play," *The Arizona Republic*, October 29, 1998, pages B1, B2 (quotation page B2).

48. Regarding the ongoing alteration and remaking of cultural space, it's worth noting that Joe's had at this time (fall 1998) just undergone a makeover, the decades-old deer, antelope, and elk trophy-heads on the walls having come down as part of a general retooling of Joe's toward a more upscale clientele. No more elk heads decorated with tinsel at Christmas, no more deer heads strung with orange and black bunting at Halloween.

49. Author field interview with Chuck (September 12, 1998), Flagstaff, Arizona.

50. As sung by The Skillet Lickers. See *The Skillet Lickers/Old Time Tunes Recorded 1927-1931* (County 506). New York: County Records, no date.

51. Author interview with Barry Smith, Flagstaff, Arizona (March 13, 2000). Unless otherwise noted, subsequent comments from Barry Smith are taken from this interview.

52. Or as a Phoenix street vendor says, in regard to his sense of safety and assurance among his colleagues, "I tell you what it is. It's etiquette. We have it out here on the street." Quoted in Jim Gintonio, "The BOB Bazaar," *The Arizona Republic*, July 24, 1999, pages D1, D5 (quotation page D1).

53. See Becker's classic account of musicians' status hierarchies in Howard S. Becker, *Outsiders* (New York: The Free Press, 1963), pages 79-119.

54. Quoted in Petrie, "Tempe May Ask Musicians To Pay To Play," page B2.
55. Ron Parks, "Busking," *Border/Lines* 19 (1990): 7-8 (quotations page 8). See relatedly *Public Art Review* 11, no. 2 (Spring/Summer 2000), on the various forms of "public hearing."
56. Becker, *Outsiders*, pages 95-97 (quotation page 96).
57. Quoted in Jeff Ferrell, *Crimes of Style: Urban Graffiti and the Politics of Criminality* (Boston: Northeastern University Press, 1996), pages 75, 104.
58. Hunter S. Thompson, *Hell's Angels* (New York: Ballantine, 1967), page 333.
59. Brenda Jo Bright, "Remappings: Los Angeles Low Riders," in Brenda Jo Bright and Liza Bakewell, editors, *Looking High and Low: Art and Cultural Identity* (Tucson: University of Arizona Press, 1995), pages 89-123 (quotation page 91). Rodriguez quoted in Bright, "Remappings," page 99.
60. Quoted in G. Beato, "The Lords of Dogtown," *Spin* 15, no. 3 (March 1999): 114-121 (quotation page 119; bracketed insertion in original).
61. Ryan Henry, "Clone," *Thrasher* 217 (February 1999): 98; Boone Doggle, "Two Feet" (Letter to the Editor), *Thrasher* 217 (February 1999): 10.
62. Justin McClellan, "EF Minus" (Letter to the Editor), *Thrasher* 209 (June 1998): 8, 10; "Photograffiti," *Thrasher* 215 (December 1998): 127.
63. Stanley Cohen, "Property Destruction: Motives and Meanings," in Colin Ward, editor, *Vandalism* (New York: Van Nostrand Reinhold, 1973), pages 23-53. See David F. Greenberg, "Delinquency and the Age Structure of Society," *Contemporary Crises* 1 (1977): 189-223.
64. Skip Engblom quoted in Beato, "The Lords of Dogtown," page 119; Tony Alva quoted in Beato, pages 120, 117.
65. Tony Alva quoted in Beato, "The Lords of Dogtown," page 120. See also Mike Davis, *City of Quartz* (London: Verso, 1990), and Mike Davis, *Ecology of Fear: Los Angeles and the Imagination of Disaster* (New York: Vintage, 1998), on the tragic eco-aesthetics of Southern California.
66. Glen E. Friedman quoted in Beato, "The Lords of Dogtown," page 120. While The Sex Pistols and other punks seem clearly to have used Nazi iconography only for its value in creating shock and estrangement, the case of Jay Adams is not so clear. In the early 1980s he was arrested and convicted for the boot-kicking assault of a gay couple.
67. Photograph in Beato, "The Lords of Dogtown," page 118.
68. Michael Burnett, "Joe Pino," *Thrasher* 217 (February 1999): 78-83.
69. "Trash," *Thrasher* 217 (February 1999): 120-121.
70. Consolidated Skateboards, *No Tomorrow* (videotape). Consolifoot, Inc., 1998.
71. In *Thrasher* 217 (February 1999): 122-123.
72. "New England Tries to Adapt to Sound of Skateboards," *The New York Times*, October 18, 1998, page A33.
73. Cycle, quoted in "Understanding the Urban Blight," *Thrasher* 209 (June 1998): 85.
74. Author interview with James Davis, Flagstaff, Arizona (July 26, 1999). Unless otherwise noted, all subsequent comments from James Davis are taken from this interview.
75. Toy Machine Bloodsucking Skateboard Company, *Welcome to Hell* (videotape). No date.
76. See "Skating Causes Controversy," *The Lumberjack*, October 8, 1997, page 1.
77. Among the stickers are "Work in Love Not Hate; Organize To Smash the State; Learn/Teach"; "Remember We're Still Here: Support Anarchist and

Class War Prisoners"; and a sabotage sticker, featuring an old Wobbly wooden shoe image and "Sabotage means to push back, pull out or break off the fangs of Capitalism," a quotation from Wobbly leader "Big Bill" Haywood; see Joyce L. Kornbluh, editor, *Rebel Voices: An IWW Anthology* (Chicago: Charles H. Kerr, 1988), page 64; Jeff Ferrell and Kevin Ryan, "The Brotherhood of Timber Workers and the Southern Lumber Trust: Legal Repression and Worker Response," *Radical America* 19, no. 4 (1985): 62. James Davis also suggested that I check out the politics of *Big Brother* skate magazine; sure enough, there in an article on skating in New Zealand is a sidebar on the history of Guy Fawkes Day, and the suggestion that "I'd like to think that he was just a flat-out anarchist"; see *Big Brother* 46 (March 1999): 53.

78. "Understanding the Urban Blight," *Thrasher* 209 (June 1998): 81.

79. "the only people for me are the mad ones, the ones who are mad to live. . . ." Jack Kerouac, *On the Road* (New York: New American Library, 1957), page 9. See also Eye Six's perspectives on Kerouac and the beats in Ferrell, *Crimes of Style*, page 42.

80. See Stephen Lyng, "Dangerous Methods: Risk Taking and the Research Process," in Jeff Ferrell and Mark S. Hamm, editors, *Ethnography at the Edge* (Boston: Northeastern University Press, 1998), pages 221-251; "Parachutist Falls Into Glass Awning," *Austin American Statesman*, September 7, 1981, page 12.

81. See Thompson, *Hell's Angels;* Stephen Lyng, "Edgework: A Social Psychological Analysis of Voluntary Risk Taking," *American Journal of Sociology* 95 (1990): 851-886.

82. See Harry Mok, "Fleeing Parachutist Drowns After Illegal Yosemite Jump," *The Arizona Republic*, July 17, 1999, page A5; Kiley Russell, "Parchutist Dies in Yosemity Leap," *The Arizona Republic*, October 23, 1999, pages A1, A20; The Associated Press, "Parachutist Dies in Yosemite," *Fort Worth Star-Telegram*, October 23, 1999, page 5A.

83. See Ferrell, *Crimes of Style;* Jeff Ferrell, "Criminological *Verstehen:* Inside the Immediacy of Crime," *Justice Quarterly* 14, no. 1 (1997): 3-23; Lyng, "Edgework."

84. See David Ferrell, "Chasing Thrills at 1,400 Feet," *Los Angeles Times*, June 1, 1997, pages A1, A28, A29; Joanne Chen, "Risky Business," *Vogue* (April 1999): 326-333, 388.

85. See Jeff Ferrell, Dragan Milovanovic, and Stephen Lyng, "Edgework, Media Practices, and the Elongation of Meaning: A Theoretical Ethnography of the Bridge Day Event," *Theoretical Criminology* 5, no 2 (2001): 177-201.

86. Kerouac, *On the Road*, page 11.

87. Peter Von Ziegesar, "Brothers," *DoubleTake* 6, no. 1 (2000): 14-16 (quotation page 16).

88. Michael Ybarra, "Don't Ask, Don't Beg, Don't Sit," *The New York Times*, May 19, 1996, page D5; Nieves, "Homeless Defy Cities' Drives to Move Them," page A16.

89. "1.35 Million Kids Likely Homeless in Year, Study Says," *The Arizona Republic*, February 1, 2000, page A6; Evelyn Nieves, "Fatal Beatings of U.S. Homeless Are Increasing," *The Arizona Republic*, December 26, 1999, page A36. See relatedly the discussion of mainstream authoritarian politics and skinhead violence in Mark S. Hamm, "Hammer of the Gods Revisited: Neo-Nazi Skinheads, Domestic Terrorism, and the Rise of the New

Protest Music," in Jeff Ferrell and Clinton R. Sanders, editors, *Cultural Criminology* (Boston: Northeastern University Press, 1995), pages 190-212.

90. In Nieves, "Homeless Defy Cities' Drives to Move Them," page A16. Self-righteously attacking those whom the injustices of today's society have forced into the streets, the Rev. Amos Brown might do well to heed the words of his namesake, the great Old Testament prophet Amos: "But let justice roll down like waters, and righteousness like an everflowing stream" (Amos 5:24, Revised Standard Version).

CHAPTER THREE

1. Tooker Gomberg, "So-fa . . . So Good! Arrested for Squatting a Couch," *Car Busters* 5 (Summer 1999): 13.
2. Bikesummer Editorial Collective, "Bike Summer" (1999): 2.
3. Steve Ongerth and Radio Free Berkeley, "Challenging the Manufacture of Consent," *Z Magazine* 8, no. 10 (1995): 21.
4. Issue Number 5, Summer 1999.
5. Gomberg, "So-fa . . . So Good!," page 13. See Angela Bischoff, and Tooker Gomberg, "Ten Commandments for Changing the World," *Alternatives Journal* 26, no. 4 (Fall 2000): 19-20.
6. Greil Marcus, *Lipstick Traces: A Secret History of the Twentieth Century* (Cambridge, MA: Harvard University Press, 1989), page 178; Debord and Wolman, quoted in Marcus, *Lipstick Traces*, page 179; "By organizing industrially we are forming the structure of the new society within the shell of the old." Preamble of the Industrial Workers of the World (the Wobblies), 1908, reprinted in Joyce Kornbluh, editor, *Rebel Voices: An IWW Anthology* (Chicago: Charles H. Kerr, 1988), pages 12-13.
7. Charles Kelly, "Parking Garages Rise as Icons of the Desert," *The Arizona Republic*, May 14, 2000, pages F1, F5 (quotations page F1).
8. See *The Arizona Republic*, January 8, 2000.
9. See Philip Brasher, "Open Space 'Gobbled Up,'" *The Arizona Republic*, December 7, 1999, page A4; John Hughes, "Off-Road Vehicles Under Fire," *The Arizona Republic*, December 8, 1999, page A4; "Highway Hurts Wolf Pack in Park, Scientist Says," *The Arizona Republic*, February 9, 2000, page A9; Seth Borenstein, "Gloomy Global Warming Report Issued," *The Arizona Republic*, February 21, 2000, page B8. Meanwhile, the First Church of the Nazarene in Little Rock, Arkansas, sets up a drive-through Christmas Nativity scene; and Denver continues to urge its citizens to partake of a drive-through downtown Christmas display, even on high pollution days; see "Church Sets Up Drive-Through Nativity," *The Arizona Republic*, December 6, 1999, page A6.
10. Perry Brissette, "Save the City!" "Bike Summer" (1999): 3.
11. Author interview with Caycee Cullen (August 6, 1999), Berkeley, California. Unless otherwise noted, subsequent comments from Caycee Cullen are taken from this interview.
12. Author interview with Emily Bulmer (August 6, 1999), Berkeley, California. Unless otherwise noted, subsequent comments from Emily Bulmer are taken from this interview.

13. See for example Andy Steiner, "Highway to Heaven," *Utne Reader* 99 (May-June 2000): 28-29; Laura Trujillo, "Place of Tragedy, Place of Rest," *The Arizona Republic*, March 12, 2000, pages F1, F4.

14. Quoted in Trujillo, "Place of Tragedy, Place of Rest," page F4.

15. Carl Sandburg, "Grass," in *The Complete Poems of Carl Sandburg* (New York: Harcourt Brace Jovanovich, 1969), page 136.

16. Quoted in Harry Mok, "California Man Draws Attention to Pedestrian Deaths," *Denver Rocky Mountain News*, June 27, 1999, page 59A. See the web site www.pedsafe.org. See also Anna Sojourner, "Walk!" "Bike Summer" (1999): 5.

17. Gary Genosko, "Dispatched," *Borderlines* 44 (1997): 13-15. See Howard Williams, "Bike Messengers Struggle for Union," "Bike Summer" (1999): 15.

18. Ted White, *Return of the Scorcher: A Celebration of Bike Culture around the World*. (Video) 1992. (Ben Lomond, CA: The Video Project) 28 minutes.

19. Chris Carlsson, Jim Swanson, Hugh D'Andrade, Nigel French, Beth Verdekal, and Kathy Roberts, "How To Make a Critical Mass." 1994 (Booklet, reprinted at www.sflandmark.com).

20. Verdekal and Carlsson in Ted White, *We Aren't Blocking Traffic, We Are Traffic!* (Video) 1999; Situationists as quoted in Marcus, *Lipstick Traces*, pages 179-180.

21. In Carlsson et. al, "How To Make a Critical Mass."

22. Steve Lopez, "The Scariest Biker Gang of All," *Time* 150 (August 11, 1997): 4.

23. In *We Are Traffic!*

24. See for example Jeff Ferrell, "Urban Graffiti: Crime, Control, and Resistance," *Youth and Society* 27, no. 1 (1995): 73-92.

25. See "Bike Summer," page 6. See relatedly the work of Ron English and others at www.POPaganda.com and www.billboardliberation.com. Demonstrating once again the remarkable recuperative powers of mass culture, Chrysler has in turn created a series of fake billboard alterations as part of its campaign for the Plymouth Neon. Billboards featuring an image of the Neon and the caption "Hi" appear to have been altered, graffiti-style, to say "Hip" and "Chill." See David Newman (with Douglas Harper), *Sociology: Exploring the Architecture of Everyday Life* (Thousand Oaks, CA: Pine Forge Press, 1997), page 229.

26. In *We Are Traffic!*

27. In Carlsson et. al, "How To Make a Critical Mass."

28. In Carlsson et. al, "How To Make a Critical Mass."

29. In *We Are Traffic!*

30. Carlsson et. al, "How To Make a Critical Mass"; Caycee Cullen interview.

31. See for example "Bike Summer," "BikeSummer '99 Event Calendar"; Associated Press, "Bikes Free to Ride, Not To Hide," *The Arizona Republic*, January 26, 1997, page A3; Robbie Sherwood, "Bikes Brought Back from Burial," *The Arizona Republic*, November 16, 1997, pages B1, B5.

32. Preamble of the Industrial Workers of the World, in Kornbluh, *Rebel Voices*, pages 12-13.

33. *Reclaiming the Streets—Direct Action Update*. (Videotape); no date, c. 1998-1999.

34. In *We Are Traffic!*. For the Wobblies and other anarcho-syndicalists, sabotage also constituted a key component of direct action. While sabotage does not appear to be integral to direct action strategies among Critical

Mass participants, some have mentioned to me that a bicycle valve adjuster mounted on a short piece of doweling makes an efficient tool for deflating the tires on SUVs and other automobiles.

35. In Stewart Edwards, editor, *The Communards of Paris, 1871* (Ithaca, NY: Cornell University Press, 1973), page 116.

36. Brissette, "Save the City!," page 3.

37. In *We Are Traffic!*.

38. In Carlsson et. al, "How To Make a Critical Mass."

39. In *We Are Traffic!*.

40. See http://xinet.com/bike/couch.

41. Author interview with Jason Meggs (August 6, 1999), Berkeley, California. Unless otherwise noted, subsequent comments from Jason Meggs are taken from this interview.

42. "Tips for a Great Critical Mass Ride," "Bike Summer," page 2.

43. Carlsson et. al, "How To Make A Critical Mass."

44. See for example, "The Freedom Machine: A History of Women, Beauty, and Bicycles," Bike Summer seminar, San Francisco, August 1999; the web site http://xinet.com/bike/women; and Colman McCarthy, "Confessions of a Cyclist," *The Progressive* 61, no. 10 (1997): 32-33.

45. Emphasis in original. The flier also offers tips for "♂ on Bikes" on the reverse side, including "speak up against sexism and violence against women always."

46. In *We Are Traffic!*.

47. See "Bike Summer," page 12.

48. Matt Pavich, "Critical Mass," unpublished paper, December 1997.

49. Hunter S. Thompson, *Hell's Angels* (New York: Ballantine, 1967), page 333.

50. Stanley Cohen, *Folk Devils and Moral Panics* (London: MacGibbon and Kee, 1972).

51. Lopez, "The Scariest Biker Gang of All," page 4.

52. In Thompson, *Hell's Angels*, page 41.

53. Associated Press, "Protests Flare in Britain, Germany," *The Arizona Republic*, May 2, 2000, page A6.

54. See Kornbluh, *Rebel Voices*, pages 56-61; Jeff Ferrell, "The Brotherhood of Timber Workers and the Culture of Conflict," *Journal of Folklore Research* 28, no. 2/3 (1991): 163-177.

55. See Edward Abbey, *The Monkey Wrench Gang* (New York: Avon, 1975).

56. Quoted in John Jordan, "The Art of Necessity: The Subversive Imagination of Anti-Road Protest and Reclaim the Streets," in George McKay, editor, *DIY Culture: Party and Protest in Nineties Britain* (London: Verso, 1998), pages 129-151 (quotation page 148).

57. *Solidarity* (newspaper), November 11, 1916.

58. See Catherine McDermott, *Street Style: British Design in the 80s* (New York: Rizzoli, 1987), pages 61-65. See also Alex Seago, *Burning the Box of Beautiful Things: The Development of a Postmodern Sensibility* (Oxford, UK: Oxford University Press, 1995).

59. See Jordan, "The Art of Necessity," page 150; Hillegonda Rietveld, "Repetitive Beats: Free Parties and the Politics of Contemporary DIY Dance Culture in Britain," in McKay, *DIY Culture*, pages 243-267.

60. See McDermott, *Street Style*, pages 61-65.

61. See Jordan, "The Art of Necessity," pages 148-149.

62. Jordan, "The Art of Necessity," page 149; John Ghazvinian, "Dancing in the Streets," *The Nation* 270, no. 16 (April 24, 2000): 23-24; Berkeley/San Francisco Bay Area RTS web site (http://guest.xinet.com/rts).

63. See Rietveld, "Repetitive Beats," pages 248-249.

64. See Aufheben, "The Politics of Anti-Road Struggle and the Struggles of Anti-Road Politics: The Case of the No M11 Link Road Campaign," in McKay, *DIY Culture*, pages 100-128; Jordan, "The Art of Necessity," page 132; Edwards, *The Communards of Paris*, page 162.

65. Beastie Boys (Rick Rubin), "Fight For Your Right To Party," *Licensed to Ill*. Def Jam Records, 1986; Public Enemy (Hank Schocklee and Carl Ryder), "Party For Your Right To Fight," *It Takes A Nation of Millions To Hold Us Back*. Def Jam Records, 1988.

66. See Jordan, "The Art of Necessity," pages 142-146.

67. Aufheben, "The Politics of Anti-Road Struggle," page 128.

68. Quoted in Jordan, "The Art of Necessity," page 140.

69. Aufheben, "The Politics of Anti-Road Struggle," page 110, emphasis in original.

70. Jordan, "The Art of Necessity," pages 141, 146, 151.

71. Berkeley/San Francisco Bay Area RTS web site (http://guest.xinet.com/rts).

72. Berkeley/San Francisco Bay Area RTS web site (http://guest.xinet.com/rts).

73. See Rietveld, "Repetitive Beats," page 246; Jordan, "The Art of Necessity"; Aufheben, "The Politics of Anti-Road Struggle"; author interview with Jason Meggs.

74. Pat Kossan, "May Day Rally Ends Badly," *The Arizona Republic*, May 2, 2000, pages B1, B2.

75. Emily Gurnon, "Turf War Targets 'Yuppies' in SF," *The Arizona Republic*, June 19, 1999, page A26. See Bob Keefe, "SF Residents Fight Dot-Com Invasion," *The Arizona Republic*, November 6, 2000, pages D1, D5; and Po Bronson, "Shouldn't We Listen To What Hacker Attacks Are Trying To Tell Us?" *The Arizona Republic*, February 15, 2000, page B7. Bronson discusses computer hacking in the context of the Yuppie Eradication Project, and quotes Jennifer Granick's contention that computer hacking is "the digital equivalent of keying the yuppies's SUVs."

76. Kim Murphy, "A Revolutionary Movement Hits Small-Town America," *Los Angeles Times*, August 3, 1999, pages A1, A10; Geov Parrish, "The New Anarchists," *Seattle Weekly*, September 2-8, 1999, pages 1-5 (quotation page 2) (www. seattleweekly.com). See Cheri Brooks, "Behind the Black Masks," *Oregon Quarterly* 80, no. 2 (Winter 2000): 16-21. See similarly Corey Dolgon, Michael Kline, and Laura Dresser, "'House People, Not Cars!': Economic Development, Political Struggle, and Common Sense in a City of Intellect," in Michael Peter Smith, editor, *Marginal Spaces: Comparative Urban and Community Research, Volume 5* (New Brunswick, NJ: Transaction, 1995), pages 1-36.

77. Berkeley/San Francisco Bay Area RTS web site (http://guest.xinet.com/rts).

78. All of the above review quotations from www.epinions.com, circa summer/fall 2000.

79. Chris Ziegler, "Death in Texas," *Punk Planet* 36 (March/April 2000): 68-81 (quotation page 71. See Pamela Colloff, "The Outsiders," *Texas Monthly* (November 1999): 118-122, 144-153, who likewise quotes a local Amarillo

mother: "Teenagers here pay a lot of attention to . . . what kind of car you drive. If you can't compete, you're an outcast" (122). For more information on this case see also www.briandeneke.org.

80. Ziegler, "Death in Texas," pages 73-74; Colloff, "The Outsiders," page 121.

81. Ziegler, "Death in Texas," pages 76-79.

82. Ziegler, "Death in Texas," page 81.

83. In Bill Strickland, editor, *The Quotable Cyclist* (New York: Breakaway Books, 1997), page 317.

84. Brissette, "Save the City!" page 3.

85. See McCarthy, "Confessions of a Cyclist," page 33.

CHAPTER FOUR

1. Quoted in Louis N. Hiken, "Foreword" to Lawrence Soley, *Free Radio: Electronic Civil Disobedience* (Boulder, CO: Westview, 1999), page ix. See similarly Tetsuo Kogawa, "Free Radio in Japan: The Mini FM Boom," in Neil Strauss, editor, *Radiotext(e)* (New York: Semiotext(e), 1993), pages 90-96.

2. Starbucks and other corporate chains are likewise notable for design elements meant to seduce and impress the consumer, and yet to hurry said consumer out the door after the purchase is made (and perhaps quickly consumed). In a different context Goffman has described this contradiction as "cooling the mark"—that is, scamming someone for their money smoothly enough that they believe no such scam has occurred.

3. Quoted in Glen Creno, "Del Taco Chain To Bring Unusual Menu to Valley," *The Arizona Republic*, May 6, 1999, pages D1, D5 (quote page D5).

4. Jeff Ferrell and Mark S. Hamm, editors, *Ethnography at the Edge: Crime, Deviance, and Field Research* (Boston: Northeastern University Press, 1998).

5. Quoted in Sam Stephenson, "Nights of Incandescence," *DoubleTake* 5, no. 4 (Fall 1999): 49. See Stephenson's article *in toto*, and W. Eugene Smith's photographs included therein, for a beautifully rendered account of 821 Sixth Avenue (pages 46-61).

6. Stephenson, "Nights of Incandescence," page 50.

7. See for example Peter Manning, "Media Loops," in Frankie Bailey and Donna Hale, editors, *Popular Culture, Crime, and Justice* (Belmont, CA: West/Wadsworth, 1998), pages 25-39.

8. There are olfactory aspects to this space as well. Dave Frishberg notes that, after all-night jam sessions, "I remember coming out of that loft in the morning and being overwhelmed by the aroma of fresh flowers" as the surrounding wholesale flower district began its workday (in Stephenson, "Nights of Incandescence," page 51).

9. See Dennis Martin, "The Music of Murder," *ACJS Today* 12 (1993): 1, 3, 20; Mark S. Hamm and Jeff Ferrell, "Rap, Cops, and Crime: Clarifying the 'Cop Killer' Controversy," *ACJS Today* 13 (1994): 1, 3, 29.

10. This chapter neither seeks nor pretends to be that clearinghouse, either. By intention it is less a comprehensive compendium than a celebration of a type of political activism that, by its very decentralized and emergent nature, resists "capture" by researchers or political authorities. See similar-

ly Jeff Ferrell, "Against the Law: Anarchist Criminology," *Social Anarchism* 25 (1998): 5-15.

11. Gareth Branwyn, "Hardwired," *Artpaper* 11, no. 10 (1992): 7. See also Patrick McKinnon, "Review of *Retrofuturism* #16," *Artpaper* 11, no. 9 (1992): 30.

12. Gareth Branwyn, "Hardwired," *Artpaper* 12, no. 3 (1992): 7. Stuart Klawans, "Urban and Other Anomies," *The Nation* 262, no. 9 (1996): 36. Negativland, "Teletours in Negativland," in Strauss, *Radiotext(e)*, pages 310-318. See also McKinnon, "Review of *Retrofuturism* #16"; Mark Dery, *Culture Jamming* (Westfield, NJ: Open Magazine Pamphlet Series, no date); and the culture jamming/billboard altering work of Ron English, The Billboard Liberation Front, and others, available at www.POPaganda.com and www.billboardliberation.com.

13. Kogawa, "Free Radio in Japan: The Mini FM Boom," page 95.

14. Adilkno, *Cracking the Movement: Squatting Beyond the Media* (Brooklyn, NY: Autonomedia, 1994), pages 47-48. Adilkno is "The Foundation for the Advancement of Illegal Knowledge," a Dutch "free association of authors and researchers" (page 6). Even with the decline of the squatting movement, a handful of "free radio" stations that had emerged from it continued to survive and develop, including The Free Keyser; see Geert Lovink, "The Theory of Mixing: An Inventory of Free Radio Techniques in Amsterdam," in Strauss, *Radiotext(e)*, pages 114-122.

15. Hillegonda Rietveld, "Repetitive Beats: Free Parties and the Politics of Contemporary DIY Dance Culture in Britain," in George McKay, editor, *DIY Culture: Party and Protest in Nineties Britain* (London: Verso, 1998), pages 243-267 (quotation page 248).

16. Thomas Harding, "Viva Camcordistas! Video Activism and the Protest Movement," in McKay, *DIY Culture*, pages 79-99.

17. Evelyn Messinger, "Tiny Television," *The Nation* 269, no. 18 (1999): 37-38. Messinger also notes the actions of France's Medias Libres, who commemorated Bastille Day with pirate television broadcasts and a wall of television sets erected in front of the (Orwellian) Ministry of Culture and Communication.

18. See "But Can He Dance?" *The Nation* 262, no. 4 (1996): 7. See also Soley, *Free Radio*, page 104.

19. See Jeff Barnard, "Ken Kessey Hitting the Road Again," *The Arizona Republic*, February 2, 1999, page D3. Kessey also endorses "publishing on the Internet, bypassing the publishing houses, and broadcasting smaller pieces of performance art on pirate radio and television" (D3).

20. These videotapes also feature hip hop graffiti; see for example *The Shiggar Fragger Show!*, vol. 5, 1998 (Hip Hop Slam Video). See relatedly Soley, *Free Radio*, page 105. See the following chapter for more on hip hop graffiti.

21. Jeff Zilm, "Nomad Radio," in Strauss, *Radiotext(e)*, pages 189-190 (quotations page 189). One of Red Asphalt Nomad's broadcasts repeatedly intruded the phrase "steal your next meal" into the audio portion of commercial television broadcasts.

22. Soley, *Free Radio*; Danny Schechter, "(Low) Power to the People," *The Nation* 268, no. 19 (1999): 10; Mike Townsend, "On Human Rights Radio's 11th Anniversary, November 25, 1998," reprinted in *SFLR News*, December 18, 1999; Danny Schechter, "Fresh Airwaves," *The Nation* 270, no. 6 (2000): 6-7.

23. Townsend, "On Human Rights Radio's 11th Anniversary"; Schechter, "(Low) Power to the People," puts the number of microradio stations shut down by the FCC during an 18-month period at 360.

24. See Townsend, "On Human Rights Radio's 11th Anniversary"; Soley, *Free Radio*, pages 71-77.

25. See Soley, *Free Radio*, pages 71-77; Townsend, "On Human Rights Radio's 11th Anniversary"; Steve Ongerth and Radio Free Berkeley, "Challenging the Manufacture of Consent," *Z Magazine* 8, no. 10 (1995): 18-22.

26. Townsend, "On Human Rights Radio's 11th Anniversary"; Ongerth and Radio Free Berkeley, "Challenging the Manufacture of Consent," page 18; "Cranking Up State Repression—Raid on Human Rights Radio," *SFLR News*, September 30, 2000; "FCC Raids the Father of the Micro Radio Movement," *SFLR News*, October 2, 2000; "Human Rights Radio Shut Down for Second Time in Two Months," *SFLR News*, December 1, 2000. As Kantako says in regard to the latest federal raids on Human Rights Radio, "Y'all stay on the air out there because I know what they're doing—they're hoping that by attacking me everybody'll pack up the tents. But this is the time to tweak the transmitters and get 'em pumping as tough as they can pump, you know what I'm sayin'?" (*SFLR News*, October 2, 2000).

27. Townsend, "On Human Rights Radio's 11th Anniversary."

28. *SFLR News*, December 18, 1999. Author interview with Richard Edmondson, August 9, 1999, San Francisco, California. Unless otherwise noted, subsequent remarks by Richard Edmondson are taken from this interview. See Ongerth and Radio Free Berkeley, "Challenging the Manufacture of Consent," page 18; Ron Sakolsky and Stephen Dunifer, editors, *Seizing the Airwaves: A Free Radio Handbook* (Edinburgh/San Francisco: AK Press, 1998), p. vi.

29. Konnadi Kantako, Mbanna Kantako, Jr., and Ebony Kantako, "'Ghetto Radio' Rap Song," in Sakolsky and Dunifer, *Seizing the Airwaves*, pages 101-106 (quotation page 105).

30. Such guidelines appear for example in Sakolsky and Dunnifer, *Seizing the Airwaves*, pages 206-208.

31. Author interview with Richard Edmondson, 9 August 1999, San Francisco, California.

32. Jackie Dove, "Diary of a Micro Broadcaster," *SFLR News*, August 26, 1999.

33. See http://www.slip.net/~dove and http://interzone.org/radio.

34. "And Then They Let You Die in the Streets," *SFLR News*, October 9, 1999; Richard Edmondson, *Rising Up: Class Warfare in America from the Streets to the Airwaves* (San Francisco: Librad Press, 2000).

35. Author interview with Stephen Dunifer, August 10, 1999, Berkeley, California. Unless otherwise noted, subsequent remarks by Stephen Dunifer are taken from this interview.

36. See Soley, *Free Radio*, chapter seven; Ongerth and Radio Free Berkeley, "Challenging the Manufacture of Consent."

37. "Free Radio Berkeley-IRATE to Offer Broadcasting Skills Workshops," *SLFR News*, January 9, 2000. See Ron Sakolsky, "Frequencies of Resistance: The Rise of the Free Radio Movement," in Sakolsky and Dunifer, *Seizing the Airwaves*, page 79.

38. See author interview with Stephen Dunifer; Sakolsky, "Frequencies of Resistance"; Soley, *Free Radio*, chapter eight.

39. Will Hermes, "The One-Watt Wonder," *Utne Reader* (May/June 1998): 22-23.
40. Author interview with Tracy James, August 10, 1999, Berkeley, California. Unless otherwise noted, subsequent remarks by Tracy James are taken from this interview.
41. Ongerth and Radio Free Berkeley, "Challenging the Manufacture of Consent," page 20; see also page 18: "long time anarchist Stephen Dunifer"; "I could only be listening to the radical-anarchist, illegal broadcast of . . . Free Radio Berkeley." See also for example Soley, *Free Radio*, page 88: "Stephen Paul Dunifer, Berkeley anarchist and radical activist."
42. And as the back cover of *Seizing the Airwaves* says: "Let us conjure up a vision of a Wild Radio Stampede disrupting the territorialized lines of Authority artificially drawn in the air surrounding Mother Earth. . . . If seizing the airwaves is a crime, then welcome to the millennial police state."
43. Rage Against the Machine, *The Battle of Los Angeles* (New York: Epic/Sony, 1999).
44. For example, Radio Free Memphis broadcasts an IWW "Solidarity Forever" labor show; and the Wobblies also support their own "insurgent" web site. See Soley, *Free Radio*, page 106; Paul Leggiere, "Wobblies on the Web," *The Progressive* 60, no. 1 (1996): 16.
45. Salvatore Salerno, "Soapboxing the Airwaves: An Interview with Internal eXile," in Sakolsky and Dunifer, *Seizing the Airwaves*, pages 166, 169.
46. Sakolsky, "Frequencies of Resistance," page 80.
47. Timothy B. Tyson, *Radio Free Dixie: Robert F. Williams and the Roots of Black Power* (Chapel Hill, NC: University of North Carolina Press, 1999), page 283. See Robert F. Williams, *Negroes with Guns* (New York: Marzani and Munsell, 1962).
48. Programs broadcast on Radio Free Dixie were also rebroadcast on stations like KPFA, and circulated by way of taped bootleg copies. In addition, thousands of copies of Williams's *The Crusader* newsletter were also published in Cuba and smuggled back into the United States; see Tyson, *Radio Free Dixie*, pages 288, 290.
49. Tyson, *Radio Free Dixie*, pages 293, 294.
50. Sakolsky, "Frequencies of Resistance," page 73; Tyson, *Radio Free Dixie*, page 289.
51. Inna Valin and Kelly Wann, editors, *Infinite Degree of Freedom* (Denver and Seattle [Issue #3], 1989).
52. See Mike Padgett, "Small Radio Station Defies FCC," *The Arizona Republic*, November 30, 1995, pages B1, B2; Bill Dougan, "Low-power FM Operations Hold Alternative to 'Broadcast Trash,'" *The Arizona Republic*, July 21, 1995, page B6.
53. See Soley, *Free Radio*, pages 81-82.
54. Soley, *Free Radio*, pages 77-81 (quote page 77); Lorenzo Komboa Ervin, "Attack on Black Liberation Radio," in Sakolsky and Dunifer, *Seizing the Airwaves*, pages 117-120. And as Williams says of the FCC fine: "I told them if I got $17,500, come and get it. . . . Hell, if I had $17,500, I'd have a better radio station than this" (in Soley, *Free Radio*, page 78).
55. See Soley, *Free Radio*, pages 83-84.
56. Mary Tolan, "FCC OKs Community Radio Plan," *Arizona Daily Sun*, January 21, 2000, pages 1, 7; Danny Schechter, "(Low) Power to the

People," *The Nation* 268, no. 19 (May 24, 1999): 10; Nan Rubin, "Low Blow to Low-power Radio," *The Nation* 269, no. 1 (July 5, 1999): 4; Danny Schechter, "Fresh Airwaves," *The Nation* 270, no. 6 (February 14, 2000): 6-7.

57. Quoted in Alexander Cockburn, "Beat the Devil," *The Nation* 261, no. 3 (February 20, 1995): 227-228 (Townsend quote page 228).

58. Richard Edmondson, "Coming Soon to a Theater Near You: The FCC's Decision on Micro Radio," *SFLR News*, January 9, 2000.

59. Quoted in Sakolsky, "Frequencies of Resistance," pages 76-77. See Ron Sakolsky, "Black Liberation Radio," *Index on Censorship* 22, no. 2 (1993): 8-9, 16; Jerry Landay, "'We're Part of the Restoration Process of Our People: An Interview with Mbanna Kaantako," in Sakolsky and Dunifer, *Seizing the Airwaves*, pages 94-99.

60. Tony Green, "White Boys, Black Noize," *Spin* 15, no. 3 (March 1999): 54.

61. Alexander Cockburn, "Free Radio, Crazy Cops and Broken Windows," *The Nation* 265, no. 20 (December 15, 1997): 9; Soley, *Free Radio*, pages 122-129.

62. Karl Marx, "The Eighteenth Brumaire of Louis Bonaparte," in Robert Tucker, editor, *The Marx-Engels Reader* (New York: W.W. Norton, 1972), pages 436-525

63. Bertolt Brecht, "The Radio as an Apparatus of Communication," in Strauss, *Radiotext(e)*, pages 15-17.

64. Soley, *Free Radio*, pages 77, 80, 82.

65. Brecht, "The Radio as an Apparatus of Communication," pages 15, 17.

66. Soley, *Free Radio*, pages 91, 98.

67. Kogawa, "Free Radio in Japan," page 95. Kogawa also argues that this is the same sort of "provisional home" once created for the public by "street entertainers and peddlers."

68. Lovink, "The Theory of Mixing: An Inventory of Free Radio Techniques in Amsterdam," in Strauss, *Radiotext(e)*, page 116.

69. Bruce Reese, Chairman and CEO of Bonneville International Corporation, quoted in *SFLR News*, January 9, 2000; Eddie Fritts, President, National Association of Broadcasters, quoted in Schechter, "(Low) Power to the People," page 19; FCC attorney David Silberman, quoted in Ongerth and Free Radio Berkeley, "Challenging the Manufacture of Consent," page 19.

70. Quoted in Tyson, *Radio Free Dixie*, page 288.

71. Quoted in Sakolsky, "Frequencies of Resistance," page 76.

CHAPTER FIVE

1. In Jeff Ferrell, *Crimes of Style: Urban Graffiti and the Politics of Criminality* (Boston: Northeastern University Press, 1996), page 176.

2. Clean Denver, *Denver Graffiti Removal Manual* (Providence, RI: Keep Providence Beautiful, 1988), page 5.

3. See Michael Walsh, *Graffito* (Berkeley: North Atlantic Books, 1996), pages 98-99; Jeff Ferrell, "Urban Graffiti: Crime, Control, and Resistance," *Youth and Society* 27, no. 1 (1995): 73-92.

4. C. Atlanta and G. Alexander, "Wild Style: Graffiti Painting," in Angela McRobbie, editor, *Zoot Suits and Second-Hand Dresses* (Houndmills, UK: Macmillan, 1989), page 166.

5. Asyl'm quoted in Bob Bryan, *Graffiti Verite' 2: Freedom of Expression? (GV2)* (Los Angeles: Bryan World Productions, 1998) (video); see Jeff Ferrell, "Review of Graffiti Verite' 2," *Public Art Review* 10, no. 2 (Spring/Summer 1999): 34-35. Creator quoted in Ferrell, "Urban Graffiti," page 79.

6. In Walsh, *Graffito*, pages 16, 32.

7. See Ferrell, "Urban Graffiti," page 79; Ferrell, *Crimes of Style*, page 106.

8. Rasta 68, personal correspondence with author, August 23, 1999. See Jeff Ferrell, *Crimes of Style: Urban Graffiti and the Politics of Criminality* (New York: Garland, 1993) (original hardcover edition).

9. See Jeff Ferrell, "Freight Train Graffiti: Subculture, Crime, Dislocation," *Justice Quarterly* 15, no. 4 (1998): 587-608.

10. For an account of this episode, see Jeff Ferrell, "Criminological *Verstehen*: Inside the Immediacy of Crime," *Justice Quarterly* 14, no. 1 (1997): 3-23.

11. Pieces by Mac and Voodoo from this wall of fame can be seen in Ferrell, *Crimes of Style*. Interestingly, in yet another moment of ongoing cultural transformation, this Voodoo piece later came to be featured in a series of advertisements for Northeastern University Press.

12. See relatedly Erick Trickey, "Romancing the Ruins," *Utne Reader* 100 (July/August 2000): 82-85.

13. In Ferrell, *Crimes of Style*, page 104.

14. In David Osborne, "Inner City Reborn as Denver Residents 'Kiss 'Burbs G'Bye,'" *The Arizona Republic*, January 6, 1999, page B7.

15. Laura Watt, "Sky's the Limit at Flour Mill," *The Denver Post*, November 1, 1999, pages 1F, 3F.

16. In Lori Tobias, "Power Loft," *Denver Rocky Mountain News*, December 5, 1999, pages 8F, 9F, 15F (quotation page 9F); see relatedly John Rebchook, "'Doctor' Checks Building's Condition," *Denver Rocky Mountain News*, March 16, 1999, page 3B.

17. Neil Smith, "Social Justice and the New American Urbanism: The Revanchist City," in Andy Merrifield and Erik Swyngedouw, editors, *The Urbanization of Injustice* (New York: New York University Press, 1997), pages 117-136 (quotation pages 129-130).

18. Samuel R. Delany, *Times Square Red, Times Square Blue* (New York: New York University Press, 1999).

19. Author interview with Z13, December 6, 1990, Denver, Colorado.

20. See Joel Sheesley and Wayne Bragg, *Sandino in the Streets* (Bloomington: Indiana University Press, 1991); David Kunzle, "The Mural Death Squads of Nicaragua," *Z Magazine* 6 (April 1993): 62-66; Jeff Ferrell, "The World Politics of Wall Painting," in Jeff Ferrell and Clinton R. Sanders, editors, *Cultural Criminology* (Boston: Northeastern University Press, 1995), pages 277-294.

21. Osborne, "Inner City Reborn," page B7.

22. Watt, "Sky's the Limit," page 1F.

23. Laura Watt, "Give Me the LoDo Life," *The Denver Post*, November 1, 1999, page 1F.

24. Tobias, "Power Loft," page 15F.

25. Tobias, "Power Loft," page 8F, 15F.

26. Lori Tobias, "No Run of the Mill," *Denver Rocky Mountain News*, May 21, 2000, pages 8F, 9F. Their Flour Mill Loft neighbors, real estate brokers

Dee Chirafisi and Jim Theye, are likewise known for their "famous homemade pizza," served on dishes brought over from Sicily and Tuscany; see Barbara Thompson, "Relaxed Reveling," *Denver Rocky Mountain News*, August 27, 2000, page 5F.

27. Watt, "Sky's the Limit," page 3F.

28. Tobias, "Power Loft," page 9F; Tobias, "No Run of the Mill," page 8F.

29. Peter Kropotkin, "Prisons and Their Moral Influence on Prisoners" (1877), in Emile Capouya and Keitha Tompkins, editors, *The Essential Kropotkin* (New York: Liveright, 1975), page 53.

30. Michael Bakunin, "Four Anarchist Programmes," in Arthur Lehning, editor, *Michael Bakunin: Selected Writings* (New York: Grove, 1974), pages 169-170.

31. "Report of a Meeting of the Club in the Church of Saint-Leu, 6 May 1871," in Stewart Edwards, editor, *The Communards of Paris, 1871* (Ithaca, NY: Cornell University Press, 1973), page 105, emphasis in original.

32. The Clash, "Garageland," *The Clash* (New York: CBS Records/Epic, 1979).

33. "Proclamation of the Paris Commune on 28 March," in Edwards, *The Communards of Paris*, pages 74-75.

34. Jack Kerouac, *On the Road* (New York: Signet, 1955), pages 32, 36, 41, 171; Joyce Kornbluh, *Rebel Voices: An IWW Anthology* (Chicago: Charles Kerr, 1988), pages 71-72.

35. Jeff Ferrell, "Bombers' Confidential: Interview with Eye Six and Rasta 68," *Clot* 1 (1990): 10; see Ferrell, *Crimes of Style*, page 81, which also includes a photograph of Voodoo's "Hit the Road, Jack" piece.

36. See John Steinbeck, *The Grapes of Wrath* (New York: Viking, 1939); Bruce Springsteen, *The Ghost of Tom Joad* (New York: Columbia, 1995); Rage Against the Machine, *Rage Against the Machine* (New York: Epic, 1992).

37. Kerouac, *On the Road*, page 46; Diane Pasta, "Urban Guardian," *Utne Reader* 99 (May/June 2000): 38-40; Lauraine Leblanc, *Pretty in Punk: Girls' Gender Resistance in a Boys' Subculture* (New Brunswick, NJ: Rutgers, 1999), pages 74, 250.

38. See Philip Nobel, "Architecture Builds on Sense of Touch," *The Arizona Republic*, May 8, 1999, page EV5; Charles Jencks, *The Language of Post-Modern Architecture* (New York: Rizzoli, 1977), pages 97-101.

39. See "Late-night Street Chess Thrives in Los Angeles Cafes, Parks," *The Arizona Republic*, September 12, 1999, page A24.

40. In Edwards, *The Communards of Paris*, pages 99, 103, 110.

41. Dana Hull, "High School Anarchists," *San Jose Mercury News*, January 24, 2000, page 14.

42. In Edwards, *The Communards of Paris*, page 75.

43. In Josh Lukin, "I'm Not Your Boss: The Paradox of the Anarchist Superhero," *Anarchist Studies* 5, no. 2 (1997): 131-155 (quotation page 152).

44. See Alan Metrick, "Build Your Own Tropical Isle," *Utne Reader* 101 (September/October 2000): 100; Michael Zunzin, "The Gang Truce: A Movement for Social Justice," *Social Justice* 24, no. 4 (1997): 258-266.

45. See for example Nick Garafola, "The Word from the Curb," *Utne Reader* 101 (September/October 2000): 110-111; Rebecca Vilkomerson, "Where Are Poor People Supposed To Go in San Francisco?" *Street Sheet*, November 2000, page 8.

46. Augustin Souchy, "Workers' Self-Management in Industry," in Sam Dolgoff, editor, *The Anarchist Collectives: Workers' Self-Management in the Spanish Revolution, 1936-1939* (New York: Free Life Editons, 1974), pages

78-79; Augustin Souchy, "Collectivizations in Catalonia," in Dolgoff, *The Anarchist Collectives*, page 89.

47. Steinbeck, *The Grapes of Wrath*, page 244.

48. Jencks, *The Language of Post-Modern Architecture*, page 9. See relatedly Paul Keegan, "Blowing the Zoo to Kingdom Come," *Lingua Franca* 2, no. 2 (1991): 1, 16-21; William Claiborne, "Chicago Plan Would Raze Tenements," *The Arizona Republic*, October 3, 1999, page A26; Jon Spayde, "The Resurrection of Ruins," *Utne Reader* 92 (March/April 1999): 67; James Dickinson, "Liminal Zones: Ruins and Monuments in the Contemporary City," paper presented at the Southwestern Social Science Annual Meetings, Houston, Texas, March 1996.

49. Robert Venturi, Denise Scott Brown, and Steven Izenour, *Learning from Las Vegas: The Forgotten Symbolism of Architectural Form* (Cambridge, MA: MIT Press, 1972), pages 87-103.

50. See Jennifer Toth, *The Mole People: Life in the Tunnels Beneath New York City* (Chicago: Chicago Review Press, 1993), pages 119-134.

51. Adilkno, *Cracking the Movement: Squatting Beyond the Media* (Brooklyn, NY: Autonomedia, 1994), page 49; Henry Chalfant and James Prigoff, *Spraycan Art* (New York: Thames and Hudson, 1987), page 13.

52. See Sam Lowe, "Eliphante a Gigante Artwork," *The Arizona Republic*, September 17, 2000, page F5.

53. Jose Peirats, "The Revolution of the Land," in Dolgoff, *The Anarchist Collectives*, page 116.

54. In Bryan, *Graffiti Verite'* 2.

55. See "News Briefs," *Public Art Review* 10, no. 1 (Fall/Winter 1998): no page number, on cases in Venice, California, and St. Louis; Ferrell, *Crimes of Style*, pages 130-133, on Denver cases.

56. My thanks to Dennis Billy for sharing these research findings with me.

57. My thanks to Gilbert Ferrell for assistance in the Mescalero research.

58. See for example the photograph of Rasta's "Look" piece in Ferrell, *Crimes of Style*; Martha Cooper and Joseph Sciorra, *R.I.P.: Memorial Wall Art* (New York: Henry Holt, 1994). See also Camilo José Vergara, *The New American Ghetto* (New Brunswick, NJ: Rutgers University Press, 1995), pages 142-145.

59. Cooper and Sciorra, *Memorial Wall Art*, page 14; see also Susan A. Phillips, *Wallbangin': Graffiti and Gangs in L.A.* (Chicago: University of Chicago Press, 1999), pages 177-182. Relatedly, Sojin Kim, *Chicano Graffiti and Murals: The Neighborhood Art of Peter Quezada* (Jackson: University Press of Mississippi, 1995), page 56, notes in regard to Quezada's photographs of street murals and gang members that, "Black and blue ink on the masking tape or Post-it notes describe the photos. In red, sometimes in purple, Quezada has added, where necessary, 'R.I.P.' and the date of death. Gang members often come to Quezada looking for photographs of their friends who have died, as he is sometimes the only source for their visual memory."

60. Christine Leonard, "Boy Crossing Street Killed By Car," *The Arizona Republic*, October 7, 2000, page B2; "Postal Carrier Dies of Hit-Run Injuries," *The Arizona Republic*, October 17, 2000, page B2; "Man in Wheelchair Struck, Killed by Taxi," *The Arizona Republic*, September 19, 2000, page B2. See also Brent Whiting, "Sisters Hurt in Hit-Run as They Walk to School," *The Arizona Republic*, October 7, 2000, page B1, which

reports on two schoolgirls run down by "a Ford Taurus bearing a sign on its front liscence plate that read 'Fear This,'"

61. See Kornbluh, *Rebel Voices*, pages 130, 152.

62. See Ferrell, "World Politics of Wall Painting," page 278; Marcos Sanchez-Tranquilino, "Space, Power, and Youth Culture: Mexican American Graffiti and Chicano Murals in East Los Angeles, 1972-1978," in Brenda Jo Bright and Liza Bakewell, editors, *Looking High and Low: Art and Cultural Identity* (Tucson: University of Arizona Press, 1995), pages 55-88; Patt Morrison, "Defending the Mural Capital of America," *Los Angeles Times Magazine*, April 5, 1988, page 7.

63. See Moira F. Harris, "Daughters of 'The New Democracy': The Legacy of an Image," *Public Art Review* 10, no. 2 (Spring/Summer 1999) 23-27; Kari Lydersen, "The Writing on the Wall," *In These Times*, February 7, 2000, pages 21-23; "Mural Saved from Oblivion," *Art in America* 86, no. 5 (1998): 31.

64. See for example Ann Wilson Lloyd, "Modern Residency Programs Giving Artists a New Outlook," *The Arizona Republic*, October 17, 1999, page E4.

65. In Richard Bolton, editor, *Culture Wars* (New York: New Press, 1992), pages 92, 319-320.

66. See Francis X. Clines, "Open-Air Movies Build Community," *The Arizona Republic*, August 14, 1999, page A19.

67. Tony Richardson (director) and Alan Sillitoe (screenwriter), *The Loneliness of the Long Distance Runner* (UK: Woodfall Film Productions, 1962).

68. See Ferrell, "The World Politics of Wall Painting," page 278.

69. See Rita Reif, "There Can Be Art in Car Parts, Too: Take Muffler Men," *The New York Times*, November 21, 1999, page D45. Similar sculptures can be found along the amazing Art Alley in Mountainair, New Mexico (Art Alley Project, P.O. Box 340, Mountainair, New Mexico, 87036).

70. See Sam Lowe, "Tanks for the Memories, Black Canyon Smitty," *The Arizona Republic*, November 15, 1999, pages D1, D8.

71. See Brad Bass and Roger Hansell, "Climbing the Walls," *Alternatives Journal* 26, no. 3 (Summer 2000): 17-18.

72. Quoted in "Understanding the Urban Blight," *Thrasher* 209 (June 1998): 85.

73. See Ferrell, "Freight Train Graffiti."

74. In Allen Abel, "Train Painting," *Utne Reader* 101 (September/October 2000): 38-40 (quotation page 39).

75. See Kornbluh, *Rebel Voices*, pages 71-72.

76. In Walsh, *Graffito*, page 98.

77. Hunter S. Thompson, *Hell's Angels: A Strange and Terrible Saga* (New York: Ballantine, 1966), page 345; Angie Chuang, "Alledged Tagger Falls 100 Feet," *Los Angeles Times*, June 12, 1997, pages B1, B5 (quotation page B5).

78. See Jessica Kwik, "Gardens Overhead," *Alternatives Journal* 26, no. 3 (Summer 2000): 16-17.

79. Marin quoted in Gary Mcdonogh, "The Geography of Emptiness," in Robert Rotenberg and Gary McDonogh, editors, *The Cultural Meaning of Urban Space* (Westport, CT: Bergin and Garvey, 1993), pages 3-15 (quote page 14).

80. Michael Keith, "Street Sensibility?: Negotiating the Political by Articulating the Spatial," in Andy Merrifield and Erik Swyngedouw, editors, *The Urbanization of Injustice* (New York: New York University Press, 1997), pages 137-160 (quotation page 143); see Edward Soja, "Margin/Alia: Social

Justice and the New Cultural Politics," in Merrifield and Swyngedouw, *The Urbanization of Injustice,* pages 180-199; Delany, *Times Square Red.*

81. See Keith, "Street Sensibility?" pages 142-146; Lisa Rochon, "Walkabout," *Alternatives Journal* 26, no. 3 (Summer 2000): 21-22.

CHAPTER SIX

1. Murray Melbin, *Night as Frontier* (New York: Free Press, 1987).

2. As Keith argues in reference to public urban spaces, "but such spaces can never be assumed, we have always to answer Harvey's question 'in whose image is the city made?' The public sphere is always, almost self evidently, marked by traces of its historicity and spatiality." Michael Keith, "Street Sensibility? Negotiating the Political by Articulating the Spatial," in Andy Merrifield and Erik Swyngedouw, editors, *The Urbanization of Injustice* (New York: New York University Press, 1997), pages 137-60.

3. See Jeff Ferrell, *Crimes of Style: Urban Graffiti and the Politics of Criminality* (Boston: Northeastern University Press, 1996), pages 178-186.

4. See Stanley Cohen, "The Punitive City: Notes on the Dispersal of Social Control," *Contemporary Crises* 3 (1979): 339-363; Stuart Henry, editor, *Social Control: Aspects of Non-state Justice* (Aldershot, UK: Dartmouth, 1994); Jeff Ferrell, "Review of *Social Control,*" *Social Pathology* 2, no. 1 (1996): 42-47.

5. See Jeff Ferrell, "Trying To Make Us a Parking Lot: Petit Apartheid, Cultural Space, and the Public Negotiation of Ethnicity," in Dragan Milovanovic and Katheryn Russell, editors, *Petit Apartheid in Criminal Justice* (Durham, NC: Carolina Academic Press, 2001), pages 55-67.

6. Greil Marcus, *Lipstick Traces: A Secret History of the Twentieth Century* (Cambridge, MA: Harvard University Press, 1989), page 118. See relatedly the graffiti sprayed on the wall of Britain's Buckstone Browne (Animal) Research Establishment a few years later: "Death Camp—Animal Belsen!" In Jill Posener, *Spray It Loud* (London: Pandora, 1982), page 71.

7. Cohen, "The Punitive City," pages 344, 360. See also Stanley Cohen, *Folk Devils and Moral Panics* (London: Macgibbon and Kee, 1972/1980); Harold Garfinkel, "Conditions of Successful Degradation Ceremonies," *American Journal of Sociology* 61 (1956): 420-424.

8. Keith, "Street Sensibility?" page 139.

9. See James Q. Wilson and George Kelling, "The Police and Neighborhood Safety: Broken Windows," *Atlantic Monthly* 127 (1982): 29-38; see D. W. Miller, "Poking Holes in the Theory of 'Broken Windows,'" *The Chronicle of Higher Education* 47, no. 22 (February 9, 2001): A14-A16.

10. Quoted in Melissa L. Jones, "'Ambassador' to Homeless," *The Arizona Republic,* April 5, 1999, pages B1, B2 (quotation page B2).

11. Associate Press, "Text of President Bush's Inaugural Address," *The Arizona Republic,* January 21, 2001, page A18.

12. Sharon Zukin, "Cultural Strategies of Economic Development and Hegemony of Vision," in Merrifield and Swyngedouw, *The Urbanization of Injustice,* pages 223-243 (quotation pages 235-236). Zukin here provides a dead-on description of planned nostalgia communities like Disney's Celebration as well; see chapter one of this book.

13. See Ferrell, "They're Trying to Make Us a Parking Lot."

14. *Industrial Worker,* July 11, 1913, page 2. See similarly the *Industrial Worker,* October 10, 1912, page 4: "A politician, no matter what his name, don't smell so sweet."

15. See Ferrell, *Crimes of Style,* pages 191-192.

16. See Karl Marx, "Theses on Feuerbach," thesis eleven: "The philosophers have only interpreted the world, in various ways; the point, however, is to change it," in Robert C. Tucker, editor, *The Marx-Engels Reader* (New York: W. W. Norton, 1972), page 109.

17. Roberto Rossellini, *Open City (Roma Citta' Aperta),* 1945; Uberto Arato, photographer.

18. *Industrial Worker,* October 24, 1912, page 2.

19. Guns 'n Roses, *Appetite for Destruction* (Los Angeles: Geffen, 1987).

20. Stanley Cohen, "Property Destruction: Motives and Meanings," in Colin Ward, editor, *Vandalism* (New York: Van Nostrand Reinhold, 1973), pages 23-53 (quotations page 39).

21. Cohen, "Property Destruction," page 53, and see page 40; Denver Deputy Mayor Bill Roberts, quoted in Ferrell, *Crimes of Style,* page 136; see David F. Greenberg, "Delinquency and the Age Structure of Society," *Contemporary Crises* 1 (1977): 189-223.

22. Photo reproduced in Laurie Taylor, "The Meaning of the Environment," in Ward, *Vandalism,* pages 54-63 (photo page 57). See Julie Cart, "Anti-Sprawl Arsons Put Arizonans on Edge," *Los Angeles Times,* February 11, 2001, page A1.

23. Kate Connolly, "Cold Thaw: Theme Park for Communist Icons," *Guardian Weekly,* December 30, 1999 - January 5, 2000, page 17.

24. Alexander Solzhenitsyn, *The Gulag Archipelago* (London: Collins and Harvill, 1974).

25. Vuillaume, "The Destruction of the Vendome Column," in Stewart Edwards, editor, *The Communards of Paris, 1871* (Ithaca, NY: Cornell University Press, 1973), pages 146-148 (quotation page 147); see page 40.

26. See Mike Presdee, *Cultural Criminology and the Carnival of Crime* (London: Routledge, 2000); Chuck Berry, "No Particular Place to Go," *St. Louis to Liverpool* (Chicago: Chess [LP-1488], 1964).

27. Marcus, *Lipstick Traces,* page 171; see pages 175, 427; Gray quoted in Marcus, *Lipstick Traces,* page 171; The Sex Pistols, "Seventeen," *Never Mind the Bollocks, Here's the Sex Pistols* (London: Virgin, 1977).

28. Quoted in Marcus, *Lipstick Traces,* pages 179-180.

29. See The Clash, "(Working for the) Clampdown," (Strummer/Jones), *London Calling* (London: CBS/Epic, 1979)

30. See Kristi S. Long and Matthew Nadelhaft, editors, *America Under Construction: Boundaries and Identities in Popular Culture* (New York: Garland, 1997).

31. Edward Soja, "History: Geography: Modernity," in Simon During, editor, *The Cultural Studies Reader* (London: Routledge, 1993), pages 135-150 (quotation pages 142-143); Edward W. Soja, "Margin/Alia: Social Justice and the New Cultural Politics," in Merrifield and Swyngedouw, *The Urbanization of Injustice,* pages 180-199 (quotation page 192).

32. Samuel R. Delany, *Times Square Red, Times Square Blue* (New York: New York University Press, 1999); Keith, "Street Sensibility?" page 143.

33. Kian Tajbakhsh, *The Promise of the City: Space, Identity, and Politics in Contemporary Social Thought* (Berkeley: University of California Press,

2001), page 183; Richard Sennett, *The Uses of Disorder: Personal Identity and City Life* (New York: Norton, 1970), pages 108, 198.

34. See Larry Tifft and Dennis Sullivan, *The Struggle To Be Human: Crime, Criminology, and Anarchism* (Orkney, UK: Cienfuegos Press, 1980); Jeff Ferrell, "Anarchist Criminology and Social Justice," in Bruce A. Arrigo, editor, *Social Justice/Criminal Justice* (Belmont, CA: West/Wadsworth, 1999), pages 93-108; Christopher R. Williams and Bruce A. Arrigo, "Anarchaos and Order: On the Emergence of Social Justice," *Theoretical Criminology* 5, no. 2 (2001): 223-252.

35. Soja, "Margin/Alia," pages 191-192; see bell hooks, *Yearning: Race, Gender, and Cultural Politics* (Boston: South End Press, 1990).

36. Jean Genet, *The Thief's Journal* (New York: Grove, 1964), page 19.

37. Marcus, *Lipstick Traces*, page 147; Peter Kropotkin, "Revolutionary Government," in Roger N. Baldwin, editor, *Kropotkin's Revolutionary Pamphlets*. (New York: Dover, 1970), pages 237, 239.

38. Emma Goldman, *Anarchism and Other Essays* (New York: Dover, 1969), page 63.

39. Adam Goodheart, "Passing Fancy," *Utne Reader* 103 (February 2001): 31-34 (quotation page 31).

40. See Anna Sojourner, "Walk!" "Bike Summer," page 5.

41. Michel de Certeau, "Walking in the City," in During, *The Cultural Studies Reader*, pages 151-160 (quotation pages 153, 157). See Michel de Certeau, *The Practice of Everyday Life* (Berkeley: University of California Press, 1984); Lisa Rochon, "Walkabout," *Alternatives Journal* 26, no. 3 (Summer 2000): 21-22; Keith, "Street Sensibility?" pages 145-146.

42. Mark S. Hamm, "Review of *Incapacitation*," *Justice Quarterly* 13, no. 3 (1996): 525-530; de Certeau, "Walking in the City," pages 151-153. See Keith, "Street Sensibility?" pages 143-144; Jeff Ferrell and Mark S. Hamm, editors, *Ethnography at the Edge: Crime, Deviance, and Field Research* (Boston: Northeastern University Press, 1998); Frank P. Williams III, *Imagining Criminology: An Alternative Paradigm* (New York: Garland, 1999).

Index

Abbey, Edward, 94, 132
Acconci, Vito, 200
Adams, Jay, 73, 256n
Ader, 181
adrenaline rush, 73, 79, 84, 88, 126, 181
 of BASE jumping, 83
 of Critical Mass ride, 126
 and edgework, 84
 of graffiti writing, 181
 and skating, 73
aesthetics of authority, 14, 16
Against All Authority, 30, 218
AK Press, 168
Alva, Tony, 72-73, 75
Amster, Randall, 48, 51-55, 58, 87, 89-90
anarchy, anarchism, 20-35, 52-53, 67-69,
 70, 76-78, 87, 96-97, 107, 111-113,
 117, 122-123, 125, 129-137, 139, 155,
 164-166, 168-170, 173, 175-176, 181-
 182, 197, 200-202, 205, 208-211, 222,
 226, 231, 233, 236-238, 240-241, 243,
 245
 anarchist community, 30, 32-33, 177,
 236, 238-242, 245
 anarchist "movement," 96-97, 106,
 237-238, 241
 anarchist revolution, 145-147
 Anarchist Student Union, 200-201
 and BASE jumping, 84-87
 and busking, 67-68
 and Critical Mass, 107, 111-113, 117,
 122-123, 125, 131
 Démanarchie, 47
 eco-anarchists, 40, 132, 139
 "enlightened anarchy," 146
 experiential anarchy, 77, 84-85, 113,
 181
 and graffiti writing, 181-182
 and microradio, 164-166, 168-170,
 173, 175-176
 and outlaw motorcyclists, 129-131
 and the politics of play and pleasure,
 235-236
 and Reclaim the Streets, 133-137
 and skaters, 70, 76-78, 257n
 Spanish anarchists, 30-31, 168, 197,
 202, 205, 208
 and walking, 243-246
"Anarchy in the U.K.," 30, 65
"angry lawns," 13
anti-globalization movement, 34, 52
architects, architecture, 8, 13, 18, 22, 70,
 81, 193, 200, 203-204, 235
 "architectural Stalinism," 13
 "architecture of imperialism," 18
 "death of modern architecture," 203
 and parking garages, 100
Architecture (magazine), 100
Area 51, 13
"Are You Sure Hank Done It This Way,"
 63
Asyl'm, 181
atomization of social life, 100-101
Auto-Free Times (magazine), 95
automobiles, 99-105, 121, 138, 141-145,
 185-186, 190, 198,
 "car addiction," 145
 culture of the automobile, 117, 129,
 138, 143, 185-186, 210-211, 258n,
 262n
 ecology of the automobile, 99-100
 as serial killers, 104, 207-208
 and social atomization, 100-101, 105
 sociology of the automobile, 100-101
 see also Carmageddon

Baca, Judy, 208
Badikian, Ben, 158
Bakunin, Michael, 31-33, 75, 79, 81, 122,
 140, 144, 181, 196-197, 203, 209, 219,
 232, 234
 Villa Bakunin, 205
Baldwin, Craig, 155

Barbie Liberation Organization, 155
Barron, Louis, 22
Barry, 56-69, 125, 128
Bart S., 82-83, 86
BASE jumping, BASE jumpers, 79-87,
 217
 and anarchism, 84-87
 and Bridge Day, 80-87
 and DIY media, 85
 and El Capitan Mountain, 84
 regulation and criminalization of, 84
 and "Sky Punks," 86
 subculture of, 85
Bass, Rhonda, 49
Bay Area Rapid Transit (BART), 93
Beastie Boys, 136
Beats, 79, 199, 218-219
Becker, Howard, 68
Belsen, 226, 230-231
"Belsen Was a Gas," 226
Bemsha Swing, 152
Benjamin, Walter, 16
Berkus, Barry, 12
Beta, Liz E., 71
bicycling, 2-3, 33-34, 77, 91-95, 99-100,
 105-131, 201, 203, 219, 223, 243-244
 Baatt Cave Bicycle Library, 113, 201
 Bicycle Liberation Radio, 92-93, 110,
 139
 bicycle messengers, 94, 104-105
 Bicycle Republic, 113, 118, 203
 BMXers, 67, 123
 and busking, 68
 and microradio, 149-150
 regulation and criminalization of, 3,
 70
 Rinky-Dink bicycle-powered sound
 system, 135, 156
 and skating, 77
 and women's liberation, 119
 see also Critical Mass
Bikesummer 1999, 94, 115
 Bikesummer Ad Hoc Organizing
 Committee, 94, 96
 Bike Summer newspaper, 94-95, 101
billboard alteration, 109, 182, 219-220,
 259n
Bischoff, Angela, 92-93
"Blackberry Blossom," 57
Black Flag, 73
Blair Witch, The, 166-167
Blakey, Art, 152
Bliss, George, 105
body stencils, 104-105
boheme, la, 21, 183
Bolsheviks, 31, 208, 250n

Bonhoeffer, Dietrich, 252n
book sculptures, 210
Boone Doggle, 71
Bradbury, Ray, 8
Bradley, Robert, 2
Brecht, Bertolt, 175, 224
Brissette, Perry, 100, 115, 146
"broken windows" thesis, 228
Brookmeyer, Bob, 152
Brown, Amos, 90, 258n
Brown, Janice Rogers, 4, 15
Brown, Willie, 44-45, 108, 128, 238
Bryant, Clifton, 103
Bulmer, Emily, 101, 109, 112
Burning Man festival, 203
buses and bus stations, 40-41, 46, 102, 143
Bush, George W., 228
buskers, busking, 2, 10, 55-69, 125, 150,
 161
 in Amsterdam, 57
 and anarchy, 67-68
 in Austin, 56-57
 in Flagstaff, 55-67
 in London, 57-58
 on microradio, 161
 on Mill Avenue, 55
 in New York City, 63
 in Prague, 57, 62
 regulation and criminalization of, 2,
 10, 55-56, 58-61, 63

Cadillac Ranch, 143, 208
camcordistas, 156
Camp, Dustin, 144-145
"Canaille, La" ("The Rabble"), 22
Cannery Row, 9
Car Busters (magazine), 95
Carlsson, Chris, 107, 114, 116
Carmageddon, 141-145, 207-208, 238
 see also automobiles
carnival, 116, 137-138, 242
Cassady, Neal, 79, 87, 156, 199, 212, 214,
 218
Center for Land Use Interpretation, 13
Certeau, de, Michel, 245-246
Chambliss, William, 19, 24
Chomsky, Noam, 156, 158,161
Chuck, 56, 59
Circle Jerks, 73
civil disobedience, 52, 97
civil gang injunctions, see under gangs
civil rights movement, 52, 229
civility, 9, 32, 228-232, 240-241, 246
Clash, The, 28, 30, 65-67, 198, 218
class warfare, 223, 225
Clayton, 111, 122, 125, 128, 168

Clone, 71
Club Ambrose, 200
Club Communal, 200
Club Saint-Leu, 197, 200
Cocoa Brovaz, 45
Cohen, Stanley, 18, 72, 130, 226, 232-233
community, 1-4, 6-10, 13-14, 30-34, 88,
 146, 150, 162, 176-177, 221-224, 228-
 231, 234, 236, 238-242, 246
 anarchist community, 30, 32-33, 177,
 236, 238-242, 245
 gutter punk community, 30, 50-51
control, 12-14, 16, 32, 129, 150, 191, 221-
 222, 225-228, 239-240
 soft control, 49
 see also environmental design and
 control
Coolidge, Matthew, 13
Cooper, Martha, 207
couches, couch relocation, 92-93, 116,
 132-133, 198, 246
 see also Reclaim the Streets
Creator (CRE8), 181
Criminal Justice and Public Order Act,
 138
Crisis, 78, 204
Critical Mass, 91, 94-95, 98-99, 101, 105-
 131, 138, 219
 and anarchism, 107, 111-113, 117,
 122-123, 125, 131
 Austin Critical Mass, 127
 Bay Area Critical Mass, 105, 108-109,
 113, 116-117, 128, 132-133
 Commute Clot, 105
 and corking, 107, 109, 112
 and direct action, 112-114, 124-125
 as festival of the oppresssed, 115-117
 Flagstaff Critical Mass, 106-107, 111,
 121-129
 gender politics of, 114-121, 124, 125,
 260n
 as organized coincidence, 106
 police harassment of, 95, 97, 107-109,
 121, 126-129
 and resistance, 108-109, 111
 and skaters, 124, 128
 Women's Critical Mass, 91, 113, 116,
 119
 and "xerocracy" (fliers, websites,
 DIY media), 94, 106-107, 110-
 112, 113, 116, 120-123, 135, 201,
 238
 see also bicycling
Cronin, Coral, 47
Crow, Jill, 193-194
cruising, 70

anticruising ordinances, enforce-
 ment, and zones, 48, 70
Cullen, Caycee, 91, 101, 107, 108, 112,
 113, 117-121, 145
cultural genocide, 223
cultural space, 14, 17, 25-26, 34, 45, 73, 95-
 96, 115, 136, 138, 141, 146, 150, 154,
 163, 170, 177, 179-180, 182-185, 187-
 188, 191, 200, 214, 217, 219, 221, 223-
 225, 227, 229, 237-238
 see also public space, spatial justice
culture jamming, 109, 154-156, 182
curfew sweeps, 48
Cycle, 204, 211

Davis, James, 75-79, 84, 87, 128
Davis, Jan, 84
Davis, Mike, 13
"Dead Flowers," 57, 60
Deadheads, 49
"Death or Glory," 65
Del Taco, 151-152
Delany, Samuel R., 6, 10, 11, 16, 52, 192,
 240
Deneke, Brian, 143-144, 208
 Brian Deneke Memorial Committee,
 145
Desolation Row, 34
détournement, 98
dharma bums, 51, 79
Dharma Bums,The, 94, 199
direct action, 27-28, 33-34, 44, 52-53, 88,
 97, 112-114, 124-125, 127, 130, 133-
 134, 141, 155-156, 168-169, 173, 196,
 202, 222, 234, 237, 243
 "Direct Action Gets the Goods," 27-
 28, 169
 Direct Action Movement, 156
 and propaganda of the deed, 113
 versus representational politics, 27,
 133-134, 141
 see also DIY
Disney, 6-9
 Celebration, 7-9, 11, 22
 Disneyland, 6, 8, 29, 32, 45, 47, 70, 89,
 186, 226, 235, 246
 Downtown Disney, 8-9
 EPCOT center, 8
 and urban redevelopment and design
 projects, 6-9, 14, 45
 see also Disneyfication, theme parks
Disneyfication, 8, 10, 11, 15, 28, 53, 89, 226
 see also Disney
dis-organize, dis-organization, 20, 94, 96,
 122, 124, 132, 236-238, 240-241, 245-
 246

see also organized coincidences
DIY (do-it-yourself), 28-30, 32, 46, 64, 96,
 122, 134, 165-166, 175-178, 180, 182,
 187, 198, 222, 236, 238, 243, 245
 "The DIY Files," 29
 DIY lovemaking, 29
 DIY media, 24, 85, 110-112, 135, 154-
 156, 158, 170, 175, 177-178, 238
 DIY Movement, 156
 DIY music, 65, 68, 93
 DIY shelter, 38-42, 198-199
 DIY soapmaking, 29
 DIY spatial policing, 62-63, 77, 86,
 107, 255n
 DIY transportation, 34
 and graffiti, 180, 182, 187
 and microradio, 165-166, 175-178
 walking as, 243-245
 see also direct action
Dominique, Jean, 165
DoubleTake (magazine), 87
Douglass, Frederick, 167
Dove, Jackie, 161
Downtown Denver Partnership, 191
Downtown Phoenix Partnership, 45
Downtown Tempe Community (DTC),
 46, 49, 51, 53-55
Dread, Stevie, 74
drums, drum circles, 51, 52, 237
dumpster diving, 202
Dunier, Mitchell, 10, 14
Dunifer, Stephen, 163-169, 173
Durkheim, Emile, 9
Durruti, 197

Earth First!, 162
edgework, 81-82, 84-85, 87, 137, 187
 the edge, 217
 and experiential anarchy, 84-85
Edmondson, Richard, 159-163, 165, 167,
 172-173
Edwards, Stewart, 20
821 Sixth Avenue, 152-153, 200
Eisner, Michael, 7, 9
Eliphante, 205
Elmore, Elizabeth, 29
Emergency Broadcast Network, 155
Energy and Equity, 94
Engels, Friedrich, 19, 21, 226
environmental design and control, 5-6, 12-
 13, 15, 18, 225
 and barrier planting, 5-6, 8, 12-13, 18
ethnicity and ethnic identity, 4-5, 10, 23,
 42, 65-67, 69-70, 101, 152-153, 157-
 159, 167-172, 175-176, 188, 192, 205-
 207, 223, 225, 229

and microradio, 157-159, 167-172,
 175-176
Evad, 205
"Everywhere You Go," 24
existential ethnography, 33-34
Eye Six, 69, 180, 183, 185, 199, 217

fascism, 51, 160-161, 226, 231
feminism, feminists, 23, 29, 251n
festival of the oppressed, 22-23, 30, 64,
 115-117, 136-137, 196, 199, 204, 218,
 220, 222, 235-236, 239, 242, 246
 see also Paris Commune
Feyerabend, Paul, 81
Firey, Walter, 18-19, 21
First Amendment rights, 54
Flagstaff, 37-41
flâneurs, 219, 246
 see also walking
Flour Mill Lofts, 191-196
folk devils, 130
Food Not Bombs, 44, 47, 52, 77, 87, 122,
 162
42nd Street (New York City), 6-7
Foucault, Michel, 17, 240
Friedman, Glen E., 73
"Fuck the Police," 52-53, 153, 158

Gambalie, Frank III, 84
Gandhi, 52
gangs, 4-5, 180, 188, 208
 civil gang injunctions, 4-5, 15, 247n
garage bands, 28
"Garageland," 198
gardens, gardening, 202-203
 guerilla gardening, 139, 203
 rooftop gardens, 217
 secret gardening, 203
 vertical gardens, 211
gated communities, 11-12
Gaudi, Antonio, 200
gay and lesbian culture, 6-7, 29, 54, 119,
 161, 192, 200, 210, 242, 256n
Genet, Jean, 22, 242
Genosko, Gary, 104
Geography of Nowhere, The, 94
Ginsberg, Allen, 79, 199, 210, 218
Giuliani, Rudolph, 6-7, 9, 45, 47
Goldman, Emma, 23, 26, 28, 29, 30, 32-33,
 97, 147, 219, 239, 243, 246
 and Reclaim the Streets, 147, 219
Gomberg, Tooker, 92-93, 95-96, 132
gospel music, 151
graffiti, 1-2, 45, 96, 136, 153-154, 177, 179-
 193, 195, 199-200, 204-205, 211-217,
 233-234, 238, 252n

and anarchy, 181-182, 238
anti-graffiti campaigns, 1-2, 45, 177, 180-182, 192-193
and the Bomb Shelter, 186-187, 193
busted for, 1-2, 10, 183-184
and DIY, 180, 182, 187
Freedom's "The History of Graffiti," 204
freight train hip hop graffiti, 211-214
hip hop graffiti underground, 1-2, 34, 69, 153-154, 179-191, 199-200, 204-205, 208, 211-214, 217-218, 233
hobo graffiti, 214-216
Kids of Destruction crew, 181, 217
Mickey Thompson Dope Wall, 185-186, 203
and microradio, 153-154, 177
Native American graffiti, 205-207
in Paris 1968, 96, 233, 236
and railyards, 179-191, 211, 213
and Reclaim the Streets, 136
rest-in-peaces (street memorials), 207-208, 213, 269n
and skaters, 73-74, 75, 78
and the Towering Inferno, 188-191, 195
walls of fame, 185-186, 189, 193, 213
Granick, Jennifer, 108
Grapevine (newspaper), 45
Gravity Girl, Gravity Girls, 79, 85
Gray, Christopher, 236
Great Wall of Los Angeles, The, 208
Greenpeace, 96
"Grievous Angel," 60
GrindKing, 74
gutter punks, 15, 30, 34, 46-55, 71
in Montreal, 47
in New Orleans, 47
in Tempe, 49-55
see also punks, punk music and culture

Haggard, Merle, 61
"Hallelujah on the Bum," 199, 214-215, 218
Hamm, Mark, 245
Haussmann, Baron, 21
Hayduke, George, 40, 132-133
hegemony, 99, 229, 240
hemp, 186, 203-204
Herman, Ed, 158
heterotopias, 240
Hill, Joe, 26, 69, 129, 131, 133, 208
HL86, 208-210, 244

homeless folks and homeless activists, 15, 27, 37-45, 90, 154, 161-164, 183, 186-188, 192, 198-199, 201-202, 208, 214-216, 229
Chicago Coalition for the Homeless, 90
Coalition for the Homeless, 45, 162
criminalization of; anti-homeless laws and law enforcement, 43-55, 90, 228, 254n
fatal assaults on, 90
hand-made shelters of hobos and the homeless, 38-42, 192, 198-199
hobo graffiti, 214-216
and microradio movement, 161-164
and skaters, 71
and street papers, 45, 201-202
and the Towering Inferno, 188
homeowners' associations, 4, 11
Homes Not Jails, 44
hooks, bell, 241
Housing Works, 45

identity, identities, 222, 240-242, 245
Illich, Ivan, 94
Immediasts, The, 155
Industrial Workers of the World (IWW, the Wobblies), 23-31, 33, 40, 52, 69, 78, 79, 97-98, 107-108, 113, 122, 127, 130-134, 138, 168-169, 176, 199, 201-202, 214-215, 219, 229, 232, 237, 239, 246
and the Brotherhood of Timber Workers, 34
IWW free speech fights, 24-26, 108, 127, 130, 169, 201, 214, 237, 239
Little Red Songbook, 23
and microradio, 168-169, 176
and move-on laws, 25-26, 127
and outlaw motorcyclists, 130
soapboxing, 26
soapboxing the airwaves, 27, 168
Internal eXile, 168
IWW, see Industrial Workers of the World

"Jack Hammer," 10
James, Tracy, 167-169
jazz, 152-153, 168-171, 199-200, 218
Jenks, Charles, 203
Jennings, Waylon, 63
Joad, Tom, 200
Jones, Mick, 28
Jones, Mildred, 171-172, 175
Jordan, John, 137
justicia de los errantes, la, 197

Kantako, Mbanna, 157-159, 170, 173, 178, 264n
Kat, 50-51, 55
Keeling, Rod, 50-51, 53-54, 228
Keith, Michael, 227, 238, 240
Kelton, Ken, 104
Kerouac, Jack, 79, 87, 94, 199-200, 218
Kesey, Ken, 156
King, Martin Luther, Jr., 52
Kirk, Rasaan Roland, 153
Klu Klux Klan, 75, 168, 169
"Know Fear," 85
Kogawa, Tetsuo, 150, 176
KPFA, 161-163, 164
Kronstadt, 208
Kropotkin, Peter, 31, 33, 196, 202, 219, 242
 Villa Kropotkin, 205
Kubweza, Jahi, 172
Kunstler, James Howard, 94

"landscape of suspicion," 13
Leif, 50-51, 55
Leninland, 235
Limpwrist, 29
l'Isle-Adam, Villiers, de, 22, 23
Little, Frank, 26, 201, 208
 The Frank Little Club, 168, 201
loitering, 43, 56, 70, 121, 228, 246
"London's Burning" ("Flagstaff's Burning"), 65-66
Loneliness of the Long Distance Runner, The (film), 210
Lopez-Madrigal, Jose, 181
Los Illegals, 10
lowriders, 70
Lud(d), Ned, 40
Luddites, 233
deLuise, Jan and Scott, 194-195
Lyng, Steve, 81-82, 84, 86

Mac, 185
Mail on Sunday (newspaper), 134
Makhno, Nester, 31, 34, 237
Malinauskas, Vilimius, 235
Mapplethorpe, Robert, 210
Marcus, Greil, 226, 236
Marin, Peter, 43, 219
Marley, Bob, 66
Marsh, Stanley III, 143
Marx, Karl, 9, 21, 31, 97, 231, 235
McKenzie, Evan, 11
McLaren, Malcolm, 29-30, 73, 134-135
McLeish, Phil, 137
McLuhan, Marshall, 135
meaning, 14, 17, 19, 82, 222, 224, 227, 229, 234, 246

media hacking, 154-156
media jamming, 154-156
Meggs, Jason, 114, 116, 118, 145
Melbin, Murray, 221
melting pot, 12
Meredith, Thomas, 105
microradio, microradio movement, 77, 91-92, 122, 135, 149-150, 153-178, 218
 and anarchism, 164-166, 168-170, 173, 175-176
 and animal rights, 161
 Arizona Free Radio, 171
 Berkeley Liberation Radio, 92-93, 164
 Bicycle Liberation Radio, 92-93, 110, 139
 and bicycling, 149-150
 Black Liberation Radio stations, 158-159, 171-172, 175
 and direct action, 168, 169, 173
 and DIY, 165-166, 175-178
 Dutch free radio movement, 155, 176, 263n
 FCC and police response to, 92-93, 157-160, 163-164, 167, 171-177
 The Free Keyser, 155
 Free Radio Berkeley, 92, 95, 159, 163-170, 173, 176, 201
 "'Ghetto Radio' Rap Song," 159
 and hip hop graffiti underground, 153-154, 218
 and the homeless, 161-163
 Human Rights Radio (aka WTRA, Zoom Black Magic Radio, Black Liberation Radio), 157-159
 and the Industrial Workers of the World, 168-169, 176
 Interference FM, 135
 IRATE, 165
 Japanese microradio movement, 155, 176
 KIND Radio, 162
 KBUZ Radio, 156
 Lutz Community Radio, 174
 Microradio Empowerment Coalition, 157
 Radio Free ACT UP, 161
 Radio Free Dixie, 169-170, 178, 265n
 Radio Free Inferno, 218
 Radio Free Venice, 171, 175
 Radio Haiti, 165
 Radio Libre, 176
 Radio Stalin, 156
 Radio TeleVerdad, 165
 and Reclaim the Streets, 135

and resistance, 158, 164, 166-167,
 176-177
RTS Radio, 135
San Francisco Liberation Radio, 159-
 163, 173
Slave Revolt Radio, 167-168
and squatters, squatters movement,
 155, 157
Steal This Radio, 157
Tampa's Party Pirate, 174
Tree FM, 135
Mill Avenue, 46-55, 70
 proposed cat and dog ban, 54, 255n
 sitting ban on, 49-53
Milovanovic, Dragan, 82, 86
Mingus, Charles, 152
mole people, 204
Monk, Thelonious, 152-153, 168, 200, 218
monkey wrench, 132-133
Monkey Wrench Gang, The, 94
moral panic, 130
Morello, Tom, 132
Mr. Nobody, 201
Muir, Jim, 73
Muir, Mike, 73
Mumford, Lewis, 18
mural death squads, 193, 195
mutual aid, 31-32, 202, 237
"My Wandering Boy," 24

National Association of Broadcasters, 172,
 177
Negativland, 155
Nellis Range, 13
neorealist filmmaking, 231
"Never Mind the Bollocks, Here's the Sex
 Pistols," 133-134
New River Gorge Bridge, 79-80
Newton, Huey P., 170
New York Times, The, 75, 90

Oles, Chris, 144
Omar, 182
On the Road, 87
organized coincidences, 96, 106, 236
 see also dis-organize, dis-organization
outlaw motorcyclists, 69, 81, 129-131
 and Critical Mass, 129-131
Overton, Hall, 152-153
Ozie, 217

Padilla, Manuel, 4-5, 10
Palmer, Jesse, 114
panhandling, 43, 56, 59
Parenti, Michael, 158

Paris Commune, 20-22, 32, 114, 136-137,
 196-197, 199-201, 203, 208, 233-235,
 242
 Situationist understanding of, 29, 242
Paris upheavals of 1968, 29, 96, 137
Parks, Ron, 68
Parsons, Graham, 60
passeggiata, 245
Pearl Jam, 156
pedestrians, 100, 104, 142-143
 BayPeds, 245
 killed by automobiles, 104, 269n-
 270n
 Pedestrian Poetry Project, 94
 as victims of Carmageddon, 142-143
 see also walking
Père Duchêne, Le (newspaper), 114
Père-Lachaise cemetery, 22
Pino, Joe, 74
pirate radio, *see* microradio
police state, 13-15, 17
 postmodern police state, 17, 226-227
postmodernists, postmodernism, 17, 153,
 191, 226-227
Project S.I.T., 52-53
projected images, 210
Proudhon, P. J., 136
Pruitt-Igoe Public Housing Project, 18,
 203
Public Enemy, 136, 158
public space, 1-6, 12-14, 17, 21-22, 30, 32,
 34, 43, 45, 52-53, 57, 60, 72, 74, 96,
 101, 115, 180, 191-192, 195, 200, 207,
 218-219, 221-225, 227-231, 234-239,
 241-243, 246, 249n, 250n,
 see also cultural space, spatial justice
"Punitive City, The" 226
punks, punk music and culture, 6, 28-31,
 46-47, 63, 67, 93, 97, 125, 134, 143-
 145, 164, 201, 204, 226, 236, 251n
 in Amarillo, 143-145
 L.A. punk scene and skaters, 73
 and Reclaim the Streets, 133-134
 "Sky Punk," 86
 see also gutter punks
Punk (magazine), 6
Punk Planet (magazine), 29

"quality of life," quality of life crimes, 5,
 6, 9, 13, 15, 45, 224, 228

Rage Against the Machine, 132, 168, 200,
 218
Rambler, The, 215-216
Rancid, 30, 218

Rasta 68, 179, 182-183, 185-187, 193, 199, 207, 219, 244
raves, 138
Reclaim the Streets, 131-141
 and anarchism, 133-137
 and Aufheben, 137
 and Claremont Road, 132, 136-137, 198
 Compost the Streets, 139-140
 and direct action, 136
 and DIY media, 135, 139
 and *Evading Standards* (newspaper), 135
 and the festival of the oppressed, 136-137
 "Never Mind the Ballots, Reclaim the Streets," 133-135
 and "pixies," 136
 and resistance, 135-136
 Situationist influences on, 134-135, 137
Reclaiming the Streets-Direct Action Update (video), 114
Red Asphalt Nomad, 156
Reed, Lou, 252n
Reid, Jamie, 29, 134-135
Reitman, Ben, 26, 239
relative work, 81
representational politics, 27, 127, 133-134, 141
Resist and Exist, 30
resistance, 19, 88, 99, 108-109, 111, 135-137, 150, 158, 164, 166-167, 176-177, 221-222, 231, 237, 240
 to the automobile, 99
 and Critical Mass, 108-109
 cultural resistance, 68
 leaderless resistance, 108, 135-136, 164, 166
 and microradio, 158, 164, 166-167, 176-177
 passive resistance, 52
 and skaters, 72, 76
 sonic resistance, 150-152, 158
Return of the Scorcher (film), 105, 210
revanchism, revanchist city, 12, 115, 192, 228-229, 239
revolution, 23, 30, 94-96, 105, 114, 137-138, 145-147, 169, 175, 196-197, 199, 202, 205, 233, 239, 242-243, 246
 anarchist revolution, 145-147, 196-197, 199, 242-243
 cultural revolution, 146-147, 175
 of everyday life, 29, 233, 239, 246
 and Reclaim the Streets, 137-138
 "revolutionary urbanism," 29

Russian revolution, 31
 Spanish revolution, 202
Rick, 81-82
Rigo, 109, 208
Rinky-Dink bicycle-powered sound system, 135, 156
Rising Up: Class Warfare in America from the Streets to the Airwaves, 163
Rivera, Diego, 208
roadside shrines, 101-105
 and descansos, 101
Robeson, Paul, 170
Rodriguez, Luis, 158
Rodriguez, R., 70
Rossellini, Roberto, 231, 235
Rotten, Johnny, 30, 125
Route 66, 56, 103, 252n
Rupert, 200

sabotage, 24, 125, 131-133, 136, 246, 257n, 259n-260n
 sabot (wooden shoe), 132-133
 "sabo-tabby kitten," 131, 208
 "The Wooden Shoe Kid," 132
Sacred, 205
Sakolsky, Ron, 157, 168, 169
Sandburg, Carl, 103-104
Sandinistas, 193
Schiller, Herbert, 158
Sciorra, Joseph, 207
Screwball, 45
Scum, 51
Seattle anti-WTO protests, 34, 97, 163
 microradio coverage of, 163
secession, 11-12
Seizing the Airwaves, 168
Sennett, Richard, 240
Sex Pistols, The, 29-30, 33, 65-67, 73, 125, 133-134, 218, 226, 236
Shiggar Fraggar Show (video), 156
"Sing Me Back Home," 61
Siqueiros, David Alfaro, 208
Sistron, Yves, 8
Situationists, 29-30, 96-98, 107, 134-135, 137, 233, 236-237, 242, 246
skaters, skateboarders, 70-79, 124, 204
 as anarchists, 70, 76-78, 257n
 and Critical Mass, 124, 128
 Dogtown skaters, 72-74, 75
 and graffiti, 73-74, 75, 78
 "Know Skateboarding," 72
 regulation and criminalization of, 70-72, 74, 75, 76-77, 128, 201
 and resistance, 72, 76
Skript, 179, 182, 220
Smith, Neil, 12, 192

Smith, W. Eugene, 152-153
Soja, Edward, 240-241
"Soldier's Joy," 56-57, 66
Soley, Lawrence, 157
solidarity, 62-63, 112-13, 145
Sonic Outlaws (film), 155
Souchy, Augustin, 202
Sowa, Richard, 201
Spanish Civil War, 30-31
spatial justice, 238-242
 see also cultural space, public space
Spradley, James P., 17
Springsteen, Bruce, 200
squatters, squatters movement, 132, 136,
 155, 157, 204
Steinbeck, John, 26, 203
Stone, Melinda, 13
"Stop Driving" stop signs, 97-99, 109
street artists, 6, 109, 208
street chess, 200
street films, 210
street papers, 45, 201-202
Subcomandante Marcos, 94-95
Suburban Press, The, 135
Sue, 200
Suicidal Tendencies, 73
Sustainable Transport (magazine), 95
Swansan, Jo, 159
Swanson, Jim, 115, 125
"symbolic economy," 16

Tajbakhsh, Kian, 240
Take Back the Night march, 91, 119
tattoos, 34, 52, 87, 118
Templeton, Ed, 76
Tex-Mex music, 152
theme parks, 6, 8, 48, 186-187, 235
 see also Disney
Thompson, Hunter S., 69, 81, 129-130,
 217
Thrasher (magazine), 71, 74, 78
Time (magazine), 108, 130, 135
Times Square, 6-7, 9, 11, 14, 192
Towering Inferno, The, 187-220, 239
Townsend, Mike, 157-158, 173
Trafalgar Square, 131, 133, 146
Transportation Alternatives (magazine), 95
Transworld Skateboarding (magazine), 75
trespass, 43, 126, 246
Twenty Inch Crank, The, 91-95, 132, 139,
 149-150

urban ecology, 18, 115
Urban Institute, 90
urban nomads, 17

vagrancy, vagrancy laws, 19, 24, 43, 246
vandalism, 18, 72, 232-234
 aesthetic component of, 18
 "ideological vandalism," 18, 232-234
Vanderbilt, Tom, 8
Vendôme Column, 21-22, 203, 234-235
Veneigem, Raoul, 138
Venturi, Robert, 204
Verdekal, Beth, 107, 112, 115, 117, 125
Vergara, Camilo José, 10
Viera-Gallo, Jose Antonio, 145
vigilantes, 26, 201
Villa, Raúl Homero, 10
"voluntary risk taking," 81
von Ziegesar, Peter, 87
Voodoo, 185, 199

Waldmire, Bob, 208-210
walking, 33-34, 186, 219, 243-246
 as anarchist practice, 243-246
 as critical spatial practice, 33, 243-246
 and peripatetic understanding, 245-
 246
 Walk Boston, 245
 Walk San Francisco, 245
 walking salons, 245
 see also flâneurs, pedestrians
Walnut Canyon, 39
Ward, Colin, 18
Watt, Laura, 195, 211, 213
"Welcome to Hell" (video), 76
White, Ted, 105
Whyte, Jack, 27

Wild 98.7, 174
Willhelm, Sidney, 158
Williams, Napoleon, 171-172, 175
Williams, Robert F., 169-170, 178
Wobblies, see Industrial Workers of the
 World
Wussow, Doc, 3-4, 8, 11

X, 30, 218
xerocracy, see under Critical Mass

Yuppie Eradication Project, 139, 197,
 261n

Z Magazine, 95
Z13, 193
'zines, 28, 104, 155, 170
 bicycle messenger 'zines, 104
 Infinite Degree of Freedom, 170
 Iron Feather Journal, 155
 Sniffin Glue, 28
Zukin, Sharon, 9, 228